ART SPEAK

ART SPEAK

A Guide to Contemporary

Ideas, Movements, and Buzzwords

Robert ATKINS

Abbeville Press Publishers New York

This book is dedicated to Sylvia and Leonard Atkins and to Steven Watson,
in appreciation of their loving support.

Editor: Nancy Grubb
Designer: Scott W Santoro/WORKSIGHT
Production Editor: Laura Lindgren
Picture Editor: Robin Mendelson
Production Supervisor: Hope Koturo

First edition

Library of Congress Cataloging-in-Publication Data
Atkins, Robert.
 ArtSpeak: a guide to contemporary ideas, movements, and buzzwords.
1. Art, Modern—20th century—Dictionaries.
I. Title. II. Title: ArtSpeak
N6490.A87 1990 700'.9'045 89-18465
ISBN 1-55859-127-3
ISBN 1-55859-010-2 (pbk.)

"Artspeak" is a trademark of Art Liaison, Inc., 253 West 28th Street, Suite 407,
New York, New York 10001, the publisher of "Artspeak" magazine, and is used by
arrangement with Art Liaison, Inc.

CONTENTS

MOVEMENTS	1950	1960	1970	1980
ABSTRACT EXPRESSIONISM	• • • • • • • • • • • •			
COBRA	• • • •			
BAY AREA FIGURATIVE STYLE	• • • • • • • • • • • • • •			
ASSEMBLAGE	• •			
ART INFORMEL	• • • • • • • • • • •			
JUNK SCULPTURE	• • • • • • • • • • •			
COLOR-FIELD PAINTING		• • • • • • • • • • • • • • • • •		
CHICAGO IMAGISM		• •		
NEO-DADA		• • • • • • • • • • • • • • • •		
CERAMIC SCULPTURE		• •		
SITUATIONISM		• • • • • • • • • • • • • • •		
NOUVEAU REALISME		• • • • • • • • • •		
POP ART		• • • • • • • • • • • • •		
HARD-EDGE PAINTING		• • • • • • • • • • • • •		
ACTION/ACTIONISM		• • • • • • • • • • • • • • • • • • • •		
SNAPSHOT AESTHETIC		• • • • • • • • • • • • • • • • • • •		
PRINT REVIVAL		• •		
FLUXUS		• • • • • • • • • • •		
SHAPED CANVAS		• • • • • • • • • • •		
MINIMALISM		• • • • • • • • • • • • • • • • •		
HAPPENING		• • • • • • • •		
OP ART		• • • • •		
LOS ANGELES "LOOK"		• • • • • • • • •		
PROCESS ART		• • • • • • • • • • • • •		
ART AND TECHNOLOGY		• • • • • • • • • • • • • •		
FUNK ART		• • • • • • • • • • • • • •		
PHOTO-REALISM		• • • • • • • • • • • • • •		
ARTE POVERA		• • • • • • • • • • • • • • • • •		
CONCEPTUAL ART		• • • • • • • • • • • • • • • • •		
EARTH ART		• • • • • • • • • • • • • • • • •		
NEW REALISM		• • • • • • • • • • • • • • • •		
NARRATIVE ART		• •		
VIDEO ART		• •		
ARTISTS' BOOKS			• • • • • • • • • • • •	
BODY ART			• • • • • • • • • • • •	
LIGHT-AND-SPACE ART			• • • • • • • • • • • •	
FASHION AESTHETIC			• •	
FEMINIST ART			• •	
PERFORMANCE ART			• •	
PUBLIC ART			• •	
"BAD" PAINTING			• • • • • • • • • •	
SOUND ART			• • • • • • • • • •	
HIGH-TECH ART			• • • • • • • • • • • • • • • • • • • •	
INSTALLATION			• •	
MEDIA ART			• • • • • • • • • • • • • • • • • • • •	
POLITICAL ART			• •	
CRAFTS-AS-ART			• • • • • • • • • • • • • • • • • • • •	
SOTS ART			• •	
NEW IMAGE			• • • • • • • • • • •	
PATTERN AND DECORATION			• • • • • • • • • • •	
FABRICATED PHOTOGRAPHY			• • • • • • • • • • • • • • • •	
MANIPULATED PHOTOGRAPHY			• • • • • • • • • • • • • • • • • •	
GRAFFITI ART				• • • • • • • • • •
NEO-EXPRESSIONISM				• • • • • • • • • •
TRANSAVANTGARDE				• • • • • • • • • • •
APPROPRIATION				• • • • • • • • • •
EAST VILLAGE ART				• • • • • • •
NEO-GEO				• • • • •

Words in CAPITALS are defined in the entries (pages 35–160).

ABSTRACT EXPRESSIONISM

Mid-1940s through 1950s

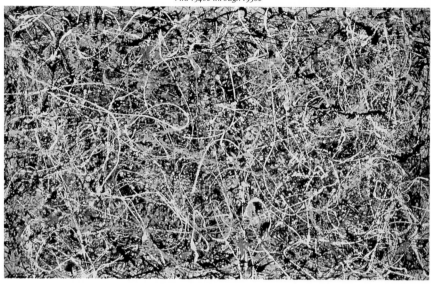

1945

THE WORLD

Franklin D. Roosevelt dies; Harry S. Truman becomes U.S. president.

U.S. drops atomic bomb on Hiroshima and Nagasaki.

World War II ends.

United Nations Charter signed in San Francisco.

U.S. Federal Communications Commission (FCC) sets aside twelve channels for commercial television.

Roberto Rossellini directs *Open City*, establishing neo-realism in film.

JACKSON POLLOCK (1912–1956).
No. 1, 1949. Duco and aluminum on canvas, 63 1/8 x 102 1/8 in. Museum of Contemporary Art, Los Angeles; The Rita and Taft Schreiber Collection. Given in loving memory of my husband, Taft Schreiber, by Rita Schreiber.

THE ART WORLD

Jean Dubuffet coins the term ART BRUT.

The Dutch painter Hans van Meegeren is convicted of forging paintings by the seventeenth-century Dutch artist Jan Vermeer.

Influential Henri Matisse retrospective, Paris.

Salvador Dali designs the dream sequence for Alfred Hitchcock's film *Spellbound*.

1946

THE WORLD

French war in Vietnam begins.

Nuremburg trial ends in conviction of fourteen Nazi war criminals.

Winston Churchill delivers a controversial speech in Fulton, Missouri, warning of the threat that lies behind a Communist "iron curtain."

BAY AREA FIGURATIVE STYLE

Late 1940s to early 1960s

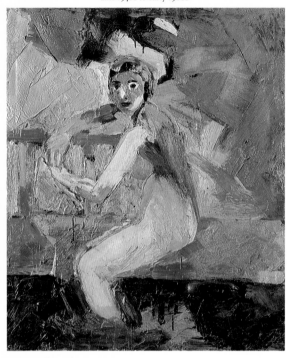

JOAN BROWN (b. 1938).
Lolita, 1962. Oil on canvas, 72 x 60 in. Private collection.

Xerography is invented.

THE ART WORLD

The term ABSTRACT EXPRESSIONISM is first applied to contemporary New York painting, by Robert Coates.

1947

THE WORLD

India becomes independent from Great Britain and is partitioned into India and Pakistan.

Jackie Robinson becomes the first African-American to be hired by a major league baseball team.

THE ART WORLD

Institute of Contemporary Arts is founded in London.

1948

THE WORLD

Marshall Plan is passed by U.S. Congress, providing $17 billion in aid for European economic recovery.

Truman is elected U.S. president.

Organization of American States (OAS) is established.

Mahatma Gandhi is assassinated in India.

State of Israel is founded.

Transistor is invented.

THE ART WORLD

Georges Braque receives first prize at Venice Biennale.

1949

THE WORLD

North Atlantic Treaty Organization (NATO) is established.

Mao Ze-dong proclaims People's Republic of China.

USSR tests its first atomic bomb.

Apartheid is enacted in South Africa.

Simone de Beauvoir publishes *The Second Sex*.

George Orwell publishes *1984*.

THE ART WORLD

First COBRA exhibition, Amsterdam.

1950

THE WORLD

Korean War begins.

Senator Joseph McCarthy charges that the U.S. State Department has been infiltrated by Communists.

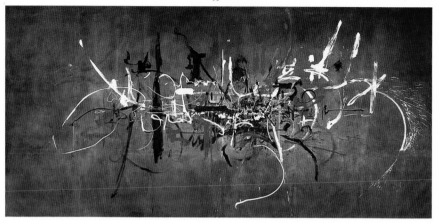

GEORGES MATHIEU (b. 1921).
The Capetians Everywhere, 1954. Oil on canvas, 9 ft. 7 in. x 19 ft. 7 in.
Musée National d'Art Moderne, Centre Georges Pompidou, Paris.

FCC authorizes color-television broadcasts in U.S.

THE ART WORLD

The Irascibles, a group of AVANT-GARDE New York artists, protest the conservative policies of the Metropolitan Museum of Art.

Arshile Gorky, Willem de Kooning, and Jackson Pollock represent U.S. at Venice Biennale.

1951

THE WORLD

Churchill becomes British prime minister again.

Ethel and Julius Rosenberg are sentenced to death for espionage (executed in 1953).

First transcontinental television broadcast, San Francisco to New York.

Rachel Carson publishes *The Sea around Us*, which spurs environmental awareness.

THE ART WORLD

Last COBRA exhibition, Liège.

The influential *Dada Painters and Poets*, edited by Robert Motherwell, is published.

Jean Dubuffet spreads the ART BRUT gospel with his "Anticultural Positions" lecture at the Chicago Arts Club.

Festival of Britain signals postwar cultural renewal in London.

1952

THE WORLD

Dwight D. Eisenhower is elected U.S. president.

Elizabeth II assumes British throne.

U.S. explodes first hydrogen bomb.

Chinese Premier Jou En-lai visits Moscow.

Samuel Beckett publishes *Waiting for Godot*.

THE ART WORLD

Michel Tapié publishes *Un Art autre* (*Another Art*), which popularizes the term ART INFORMEL.

Harold Rosenberg coins *Action painting* as a synonym for ABSTRACT EXPRESSIONISM.

Independent Group is formed at Institute of Contemporary Arts, London; it will be instrumental in the development of POP ART.

COLOR-FIELD PAINTING
Mid-1950s to late 1960s

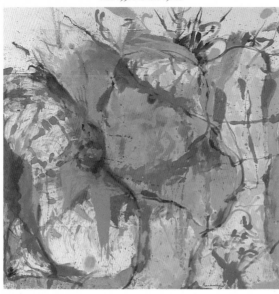

HELEN FRANKENTHALER (b. 1928).
Before the Caves, 1958. Oil on canvas, 102 3/8 x 104 3/8 in. University Art Museum, University of California at Berkeley; Anonymous gift.

1953

THE WORLD

Soviet premier Joseph Stalin dies, succeeded by Georgy M. Malenkov; Nikita S. Khrushchev is appointed first secretary of the Communist party.

Korean War ends.

Dag Hammarskjöld becomes United Nations secretary-general.

Double-helix structure of DNA is discovered.

Alfred Kinsey publishes *Sexual Behavior in the Human Female*; Hugh

Hefner founds *Playboy* magazine.

THE ART WORLD

First São Paulo Bienal.

1954

THE WORLD

Gamal Abdal Nasser seizes power in Egypt.

Algerian War begins.

U.S. Supreme Court rules segregation by race in public schools unconstitutional.

U.S. Senate censures Joseph McCarthy.

The French are defeated at Dienbienphu; Vietnam is

divided into the Democratic Republic of Vietnam and the Republic of Vietnam; U.S. involvement begins.

THE ART WORLD

GUTAI group is founded in Osaka.

Peter Voulkos establishes ceramics center at Otis Art Institute, Los Angeles.

1955

THE WORLD

African-Americans boycott segregated city buses in Montgomery, Alabama.

President Juan Domingo Perón is ousted in Argentina.

Warsaw Treaty Organization is formed to counter NATO.

Commercial television broadcasts begin in Britain.

THE ART WORLD

First Documenta, Kassel, Germany.

The Family of Man, an exhibition of 503 pictures from 68 countries at New York's Museum of Modern Art, is the photographic event of decade; its message is "We are all one."

1956

THE WORLD

Eisenhower is re-elected U.S. president.

Nasser is elected president of Egypt and nationalizes the Suez Canal, which results in war with England,

France, and Israel.

USSR crushes resistance in Poland and Hungary.

Japan is admitted to the U.N.

Transatlantic cable telephone service is inaugurated.

Elvis Presley makes *rock 'n roll* a household phrase.

Allen Ginsberg publishes *Howl*, is tried for obscenity, and acquitted.

John Osborne's play *Look Back in Anger* is produced in London, marking the debut of Britain's Angry Young Men.

THE ART WORLD

Richard Hamilton's collage *Just What Is It That Makes Today's Home So Different, So Appealing?* regarded as the first POP ART work, is shown at the Institute of Contemporary Arts, London.

Frank Lloyd Wright builds controversial Solomon R. Guggenheim Museum in New York (completed in 1958).

NEO-DADA

Mid-1950s to mid-1960s

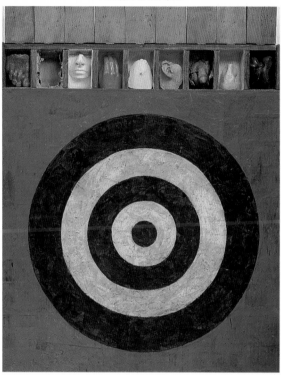

JASPER JOHNS (b. 1930).
Target with Plaster Casts, 1955. Encaustic and collage on canvas with plaster casts, 51 x 44 x 3 1/2 in. Leo Castelli, New York.

1957

THE WORLD

Common Market (European Economic Community) is established.

USSR launches Sputnik I and II, the first man-made satellites.

The first large nuclear-power plant in America opens at Shippingport, Pennsylvania.

Jean-Paul Sartre coins the term *anti-novel* to describe a non-narrative AVANT-GARDE form.

THE ART WORLD

Tatyana Grosman founds Universal Limited Art Editions in West Islip, Long Island, triggering the PRINT REVIVAL.

SITUATIONIST International is founded in Paris.

Contemporary Bay Area Figurative Painting, Oakland Museum.

ZERO is founded in Düsseldorf to stimulate dialogue between artists and scientists.

CERAMIC SCULPTURE

Since mid-1950s

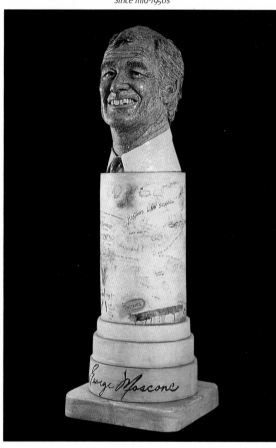

ROBERT ARNESON (b. 1930).
Portrait of George, 1981. Polychrome ceramic, 94 x 31 1/2 x 31 1/4 in.
Foster Goldstrom, New York.

1958

THE WORLD

Charles de Gaulle is elected first president of France's Fifth Republic.

Pope John XXIII, a liberal, succeeds Pius XII.

Race riots in Notting Hill, London.

National Aeronautics and Space Administration (NASA) is established in the U.S.

Xerox produces first commercial copying machine.

Claude Lévi-Strauss publishes *Structural Anthropology*.

Soviets pressure Boris Pasternak to retract his acceptance of Nobel Prize for *Doctor Zhivago*.

THE ART WORLD

The term NEO-DADA first appears, in *Artnews*.

Jules Langsner coins the term HARD-EDGE PAINTING.

Lawrence Alloway first uses the term POP ART in print.

1959

THE WORLD

Cyprus is granted independence; Archbishop Makarios is elected its first president.

Fidel Castro overthrows Fulgencio Batista regime in Cuba.

Saint Lawrence Seaway opens.

French New Wave cinema becomes a force in international film.

U.S. Postmaster General bans D. H. Lawrence's *Lady Chatterley's Lover* on grounds of obscenity.

THE ART WORLD

Robert Frank's book *The Americans* introduces the SNAPSHOT AESTHETIC.

18 Happenings in 6 Parts, Reuben Gallery, New York.

First Biennale of Young Artists, Paris.

14

Daniel Spoerri founds Editions M.A.T. (Multiplication Arts Transformable) to produce MULTIPLES, Paris.

1960

THE WORLD

Leonid Brezhnev becomes president of USSR.

Nixon-Kennedy debates demonstrate importance of television in politics.

John F. Kennedy is elected U.S. president.

Belgium grants freedom to the Congo (now Zaire); UN forces intervene to keep peace.

Optical microwave laser constructed.

THE ART WORLD

The term POSTMODERNISM appears in Daniel Bell's *End of Sociology.*

Pierre Restany coins the term NOUVEAU REALISME.

June Wayne founds Tamarind Lithography Workshop, Los Angeles.

First exhibition of Frank Stella's SHAPED CANVASES, Leo Castelli Gallery, New York.

Groupe de Recherche d'Art Visuel (GRAV) founded to encourage art-science inter-action, Paris.

Yves Klein uses nude women as "brushes" in a public performance at Galerie Internationale d'Art Contemporain, Paris.

Jean Tinguely's *Hommage*

NOUVEAU REALISME

Late 1950s to mid-1960s

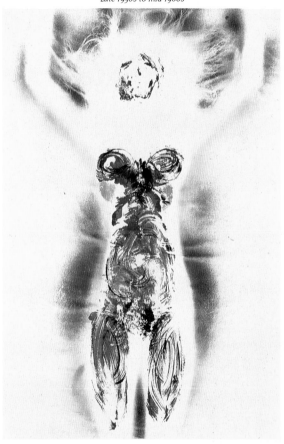

YVES KLEIN (1928–1962).
Shroud Anthropometry 20—Vampire, 1960. Pigment on canvas, 43 x 30 in. Private collection.

to New York self-destructs at the Museum of Modern Art.

1961

THE WORLD

Yuri Gargarin (USSR) orbits Earth in the first manned space flight.

Alan Shepard makes the first American manned space flight.

U.S. President Kennedy acknowledges responsibility for Cuban exiles' failed invasion of Cuba at the Bay of Pigs.

Berlin Wall erected.

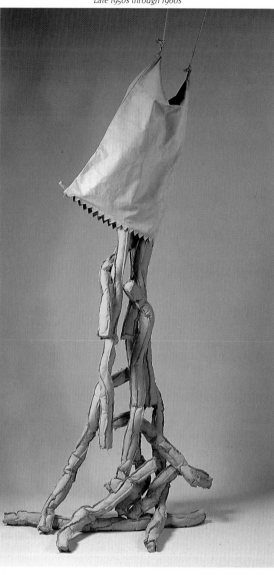

CLAES OLDENBURG (b. 1929).
Falling Shoestring Potatoes, 1965. Painted canvas and kapok, 108 x 46 x 42 in. Walker Art Center, Minneapolis; Gift of the T. B. Walker Foundation, 1966.

Birth-control pills become available.

Henry Miller publishes *Tropic of Cancer* in U.S. after a nearly thirty-year ban for obscenity.

Dancer Rudolf Nureyev defects from USSR.

THE ART WORLD

The term FLUXUS first used by George Maciunas.

ASSEMBLAGE named by William Seitz and Peter Selz for the exhibition *The Art of Assemblage*, Museum of Modern Art, New York.

1962

THE WORLD

Cuban missile crisis triggered by American discovery of Soviet missile bases in Cuba. President Kennedy demands their removal and orders a blockade; Soviet Premier Khrushchev agrees to remove them and dismantle bases.

Pope John XXIII opens Vatican Council II in Rome to promote Christian unity.

U.S. Supreme Court declares mandatory prayer in public schools unconstitutional.

First transatlantic television broadcast via Telstar satellite.

Georges Pompidou is appointed premier of France.

The sedative thalidomide is linked to thousands of birth defects.

Exhibition of POP ART, *The New Realists*, Sidney Janis Gallery, New York.

POP ART appears on the covers of *Time, Life, Newsweek.*

1963

THE WORLD

John F. Kennedy is assassinated in Dallas; Lyndon B. Johnson becomes U.S. president.

Pope Paul VI succeeds Pope John XXIII.

Civil rights demonstrations in Birmingham, Alabama, culminate in the arrest of Martin Luther King, Jr.; 200,000 "Freedom Marchers" rally in Washington, D.C.

Nuclear test ban signed by the U.S., USSR, and Britain.

De Gaulle blocks Britain's entry into the Common Market.

Michael De Bakey first uses an artificial heart during surgery.

Betty Friedan publishes *The Feminine Mystique.*

THE ART WORLD

First exhibition of television sculpture by Nam June Paik, Wuppertal, Germany.

Soviet authorities begin campaign to suppress "artistic rebels."

Andy Warhol establishes his studio, the Factory, and shoots his first film, *Sleep.*

HARD-EDGE PAINTING

Late 1950s through 1960s

KENNETH NOLAND (b. 1924).
Inner Green, 1969. Acrylic on canvas, 97 7/8 x 28 7/8 in.
Courtesy Salander-O'Reilly Galleries, Inc.

Marcel Duchamp: A Retrospective Exhibition, Pasadena Museum, Pasadena, California, marks postwar emergence of widespread interest in DADA's *eminence gris.*

1964

THE WORLD

Khrushchev replaced as Soviet prime minister by Alexei Kosygin and as party secretary by Brezhnev.

Johnson is elected U.S. president.

U.S. Congress passes Civil Rights Act, prohibiting discrimination for reason of color, race, religion, or national origin in places of public accommodation, and initiates the "War on Poverty."

17

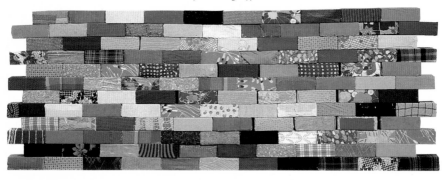

MICHELANGELO PISTOLETTO (b. 1933).
Wall of Rags, 1968. Bricks and rags, 39 3/8 x 102 3/8 x 8 5/8 in.
Gian Enzo Sperone, New York.

People's Republic of China explodes its first atomic bomb.

Free Speech movement begins in Berkeley, California.

Music becomes international language of youth; the British beat is exemplified by the Beatles, the Motown sound by the Supremes.

Martin Luther King, Jr., is awarded the Nobel Peace Prize.

Sartre declines the Nobel Prize in Literature.

Marshall McLuhan publishes *Understanding Media: The Extensions of Man.*

THE ART WORLD

The term OP ART is coined by the sculptor George Rickey.

Robert Rauschenberg receives first prize at Venice Biennale.

Vatican sends Michelangelo's *Pietà* to the New York World's Fair.

Post-Painterly Abstraction, Los Angeles County Museum.

1965

THE WORLD

India and Pakistan fight for control of Kashmir.

U.S. bombs North Vietnam; students demonstrate in Washington, D.C.

The Black Muslim leader Malcolm X is assassinated in New York.

Race riots in Watts district of Los Angeles.

THE ART WORLD

The term MINIMALISM comes into common usage.

First artist's VIDEO by Nam June Paik shown at Cafe à Go Go, New York.

National Endowment for the Arts (NEA) and National Endowment for the

Humanities (NEH) are established, Washington, D.C.

Exhibition of OP ART, *The Responsive Eye*, Museum of Modern Art, New York.

1966

THE WORLD

Indira Gandhi becomes India's prime minister.

National Organization of Women (NOW) is founded by Betty Friedan; Black Panthers is founded by Huey P. Newton and Bobby Seale.

2,000 Madrid University students clash with police in demonstration.

Cultural Revolution begins in China (ends 1969).

Mao Ze-dong publishes *Quotations of Chairman Mao.*

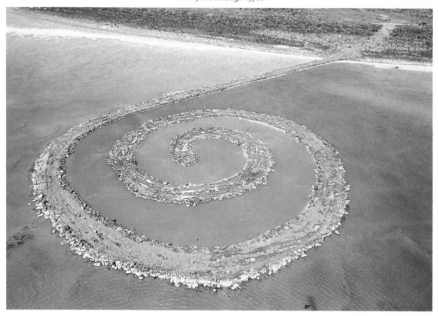

THE ART WORLD

Primary Structures, Jewish Museum, New York.

Experiments in Art and Technology (EAT) is founded in New York.

Systemic Painting, Guggenheim Museum, New York.

Robert Venturi publishes his influential POSTMODERN treatise, *Complexity and Contradiction in Architecture.*

Exhibition of Edward Kienholz's *Back Seat Dodge '38* creates furor because of its sexual content; Board of Supervisors nearly closes down Los Angeles County Museum of Art.

ROBERT SMITHSON (1938–1973).
Spiral Jetty, 1970. Black rocks, salt crystal, earth, red water, algae, length: 1,500 ft., width: 15 ft. Estate of Robert Smithson.

1967

THE WORLD

Six-Day War between Israel and Arab countries.

Bolivian troops kill Cuban revolutionary Ernesto "Che" Guevara.

China explodes its first hydrogen bomb.

Widespread antiwar demonstrations in U.S.

Race riots break out in U.S.

Christiaan N. Barnard performs first heart-transplant operation.

Rolling Stone begins publication.

THE ART WORLD

The term ARTE POVERA is coined by Germano Celant.

The term CONCEPTUAL ART is popularized.

Funk, University Art Museum, Berkeley, California.

Center for Advanced Visual Studies opens at Massachusetts Institute of Technology, Cambridge.

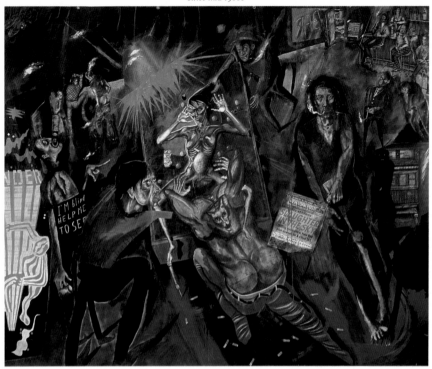

NEA establishes ART IN PUBLIC PLACES program.

1968

SUE COE (b. 1951).
Woman Walks into Bar—Is Raped by 4 Men on the Pool Table—While 20 Men Watch, 1983. Mixed media on paper mounted on canvas, 91 x 113 in. Mr. and Mrs. Werner Dannheiser.

THE WORLD

USSR invades Czechoslovakia.

Student uprisings in Europe and U.S.; general strike in Paris.

Robert F. Kennedy and Martin Luther King, Jr., are assassinated.

Pierre Trudeau becomes prime minister of Canada.

Richard Nixon is elected U.S. president.

Tet offensive by North Vietnamese army and the Viet Cong; My Lai massacre.

THE ART WORLD

Cybernetic Serendipity: The Computer and the Arts, Institute of Contemporary Arts, London.

The Machine as Seen at the End of the Mechanical Age, Museum of Modern Art, New York.

POP ART dominates Documenta 4, Kassel.

Andy Warhol is shot by Valerie Solanis, founder and sole member of SCUM (Society for Cutting Up Men), and nearly dies.

Earth Art, White Museum, Cornell University, Ithaca, New York.

Marcel Duchamp dies; his last work, *Etant donnés*

(1946–66), will be permanently installed in the Philadelphia Museum of Art.

1969

THE WORLD

Violent riots in Northern Ireland between Protestants and Roman Catholics.

U.S. troops begin to be withdrawn from Vietnam.

Golda Meir becomes fourth prime minister of Israel.

U.S. spacecraft *Apollo 11* lands on moon; Neil Armstrong steps out onto the moon.

Human ovum is successfully fertilized in test tube.

Woodstock and Altamont music festivals.

Native Americans seize Alcatraz Island, San Francisco.

Stonewall Rebellion in New York triggers Gay Liberation.

THE ART WORLD

Exhibitions of PROCESS ART: *When Attitudes Become Form*, Berne Kunsthalle, and *Procedures/Materials*, Whitney Museum of American Art, New York.

Judy Chicago founds first FEMINIST ART program, at California State University, Fresno.

First ALTERNATIVE SPACES open in New York.

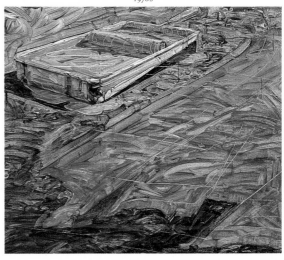

NEIL JENNEY (b. 1945).
Coat and Coated, 1970. Acrylic on canvas, 50 x 57 3/4 in. The Corcoran Gallery of Art; Museum purchase through funds of the Friends of The Corcoran Gallery of Art and the National Endowment for the Arts, Washington, D.C., a federal agency.

First entirely CONCEPTUAL exhibition, Seth Siegelaub gallery, New York.

Art-Language begins publication, London.

1970

THE WORLD

U.S. bombs Communist strongholds in Cambodia.

Antiwar demonstrations in the U.S.; the National Guard kills four students at Kent State University in Ohio.

Marxist Salvador Allende is elected president of Chile.

Nigerian civil war ends.

Twenty million Americans participate in first Earth Day.

Kate Millet publishes *Sexual Politics*.

THE ART WORLD

Exhibitions of CONCEPTUAL ART: *Information*, Museum of Modern Art, and *Software*, Jewish Museum, both New York.

Happenings and Fluxus, Kölnischer Kunstverein, Cologne.

Museum of Conceptual Art is founded by Tom Marioni in San Francisco.

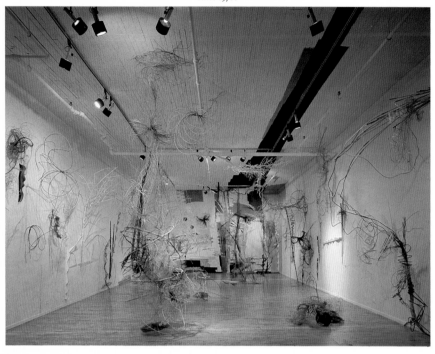

Exhibitions of SOUND ART: *Sound* (1969–70), Museum of Contemporary Crafts, New York, and *Sound Sculpture As*, Museum of Conceptual Art, San Francisco.

Conceptual Art/Arte Povera/Land Art, Galleria Civica d'Arte Moderna, Turin.

JUDY PFAFF (b. 1946).
Deep Water, 1980. Mixed-media installation. Holly Solomon Gallery, New York.

1971

THE WORLD

200,000 march on Washington to demand end of Vietnam War.

Idi Amin seizes power in Uganda.

East Pakistan achieves sovereignty and becomes Bangladesh.

U.S. Lt. William Calley convicted of premeditated murder of civilians in My Lai.

New York Times publishes the "Pentagon Papers."

Women are granted the right to vote in Switzerland.

Astronomers confirm the "black hole" theory.

Cigarette advertisements are banned from U.S. television.

Germaine Greer publishes *The Female Eunuch.*

THE ART WORLD

ART AND TECHNOLOGY program (1967–71) culminates in exhibition, Los Angeles County Museum of Art.

Robert Pincus-Witten coins the term POST-MINIMALISM.

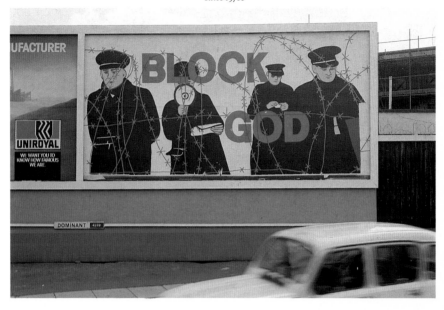

Hans Haacke's exhibition about New York real estate ownership is canceled by Guggenheim Museum, New York.

LES LEVINE (b. 1935).
Block God, 1985. Printed outdoor billboard, 10 x 22 ft. Mott Art U.S.A., Inc.

1972

THE WORLD

Watergate scandal begins with apprehension of Republican operatives in Democratic National Headquarters.

President Nixon visits China and USSR.

U.S. Supreme Court rules the death penalty unconstitutional.

Nixon is re-elected U.S. president.

Arab terrorists kill two Israeli Olympic athletes in Munich; take nine others hostage, all of whom are killed in shoot-out with police and military.

Gloria Steinem founds *Ms.* magazine (monthly publication is suspended in 1989).

The military draft is phased out in the U.S.

Moog (electronic music) synthesizer patented.

THE ART WORLD

First exhibition of ARTISTS' BOOKS, Nigel Greenwood Gallery, London.

Retrospective exhibition of photographs by Diane Arbus at Museum of Modern Art, New York, so disturbs viewers that some spit on the pictures.

Documenta 5 offers international survey of new art, including PHOTO-REALISM, Kassel.

Exhibition of CONCEPTUAL ART: *"Konzept"-Kunst*, Offentliche Kunstsammlung, Basel.

SOTS ART named by Komar and Melamid in Moscow.

1973

THE WORLD

U.S., North Vietnam, South

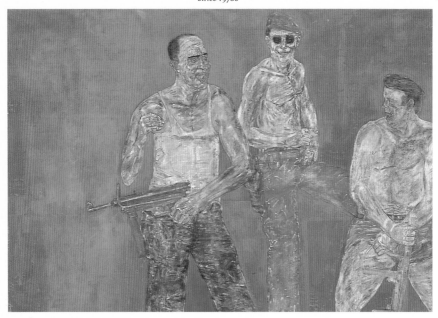

LEON GOLUB (b. 1920).

Mercenaries II, 1979. Acrylic on loose canvas, 120 x 144 in. Montreal Museum of Fine Arts; Purchase, Horsley and Annie Townsend Bequest.

Vietnam, and the National Liberation Front's provisional government sign peace treaty in Paris.

Chilean President Salvador Allende is overthrown by military junta and either commits suicide or is assassinated.

Arab oil-producing nations embargo shipments to the U.S., Western Europe, and Japan in retaliation for their support of Israel.

U.S. Supreme Court rules a state may not prevent a woman from having an abortion during the first six months of pregnancy.

THE ART WORLD

The term ARTISTS' BOOKS is coined by Dianne Vanderlip for the exhibition *Artists Books*, Moore College of Art, Philadelphia.

Auction of Robert and Ethel Scull's collection signals meteoric rise in prices for contemporary art, New York.

1974

THE WORLD

On the verge of impeachment, Nixon resigns; Gerald Ford becomes U.S. president.

Worldwide inflation and recession.

Author Aleksandr Solzhenitsyn is deported from USSR.

Patricia Hearst is kidnapped.

India becomes sixth nation to explode a nuclear device.

THE ART WORLD

International conference on VIDEO ART, "Open Circuits," is held at Museum of Modern Art, New York.

Soviet officials mow down an open-air show of unofficial art in Moscow, which becomes known as the "Bulldozer" show.

1975

THE WORLD

Civil wars in Lebanon, Angola, and Ethiopia.

Generalissimo Francisco Franco dies; Juan Carlos I becomes king of Spain.

Phnom Penh falls to Khmer Rouge troops, U.S. Embassy closes and Americans leave Cambodia.

THE ART WORLD

First exhibition of GRAFFITI ART, Artists Space, New York.

Body Works, Institute of Contemporary Art, Chicago.

1976

THE WORLD

First functional synthetic gene constructed at Massachusetts Institute of Technology, Cambridge.

Mao Ze-dong and Jou En-lai die.

North and South Vietnam are reunited after twenty-two years of separation; renamed the Socialist Republic of Vietnam.

Jimmy Carter is elected U.S. president.

THE ART WORLD

Christo's twenty-four mile *Running Fence* in northern California catapults the

ARTISTS' FURNITURE

Since 1970s

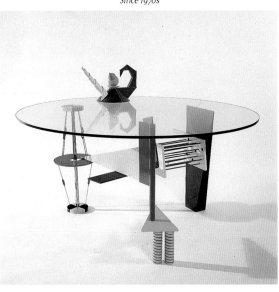

PETER SHIRE

Rod and Transit, 1984. Anodized aluminum, steel, glass, height: 29 in.; diameter: 60 in. Collection of the artist.

artist to fame.

Women Artists: 1550–1950, Los Angeles County Museum of Art.

Robert Wilson and Philip Glass first present the PERFORMANCE ART spectacle *Einstein on the Beach* at the Festival d'Avignon in France.

1977

THE WORLD

Egyptian president Anwar Sadat flies to Israel on peace mission, the first Arab leader to visit the Jewish state since its founding in 1948.

U.S. signs treaty to relinquish control of Panama Canal to Panama.

Military deposes Zulfikar Bhutto in Pakistan.

Nobel Peace Prize is awarded to Amnesty International; the 1976 Nobel Peace Prize is belatedly awarded to the Irish women Mairead Corrigan and Betty Williams.

Disco craze begins with the film *Saturday Night Fever*.

THE ART WORLD

Exhibition of EARTH ART, *Probing the Earth*, Hirshhorn Museum and

Mid-1970s to early 1980s

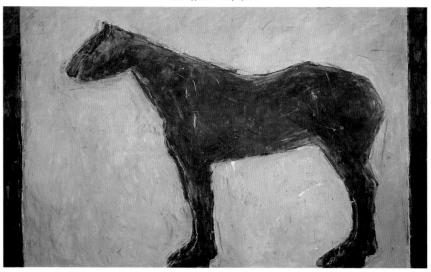

Sculpture Garden, Washington, D.C.

Susan Sontag publishes *On Photography*.

Centre National d'Art et de Culture Georges Pompidou (popularly known as the Beaubourg) opens in Paris.

U.S. tour of *The Treasures of Tutankhamen*, the biggest of the so-called blockbusters.

SUSAN ROTHENBERG (b. 1945).
Hector Protector, 1976. Acrylic and tempera on canvas, 67 x 111 5/8 in. Gagosian Gallery, New York.

Civil war begins in Nicaragua.

First "test-tube baby" is born in Britain.

Karol Cardinal Wojtyla becomes Pope John Paul II.

THE ART WORLD

"Bad" Painting, New Museum of Contemporary Art, New York.

New Image Painting, Whitney Museum of American Art, New York.

I. M. Pei's East Building, for modern art, opens at the National Gallery of Art, Washington, D.C.

1978

THE WORLD

Former Italian premier Aldo Moro is kidnapped and killed by Red Brigade terrorists.

Reverend Jim Jones and over 900 followers commit suicide at People's Temple, Guyana.

1979

THE WORLD

Israel and Egypt sign peace treaty.

Margaret Thatcher becomes Britain's prime minister.

USSR invades Afghanistan.

Seven-year war ends in Rhodesia (now Zimbabwe).

After the shah flees Iran, the Ayatollah Khomeini establishes an Islamic government; American hostages are held.

Major nuclear accident at Three Mile Island, Pennsylvania.

Mid-1970s to early 1980s

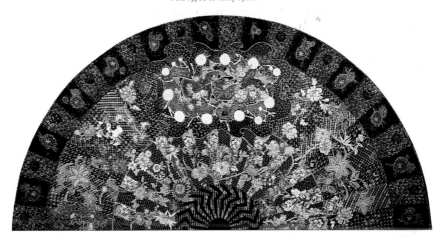

Pioneer II photographs
Saturn's rings.

Christopher Lasch publishes
The Culture of Narcissism,
about the "me generation."

THE ART WORLD

Frederic Edwin Church's
Icebergs (1861) is auctioned
for $2.5 million, a record
price for an American
painting.

Judy Chicago's *Dinner Party*
opens at San Francisco
Museum of Modern Art.

Hara Museum of
Contemporary Art opens in
Tokyo.

1980

THE WORLD

Ronald Reagan is elected
U.S. president.

Green Party is formed in
Germany to politicize eco-
logical issues.

Voters in Quebec reject

MIRIAM SCHAPIRO (b. 1923).
Black Bolero, 1980. Fabric, glitter, paint on canvas, 6 x 12 ft. Art Gallery of
New South Wales, Australia; Purchased 1982.

separatism.

Indira Gandhi becomes
prime minister of India in
dramatic political come-
back.

Archbishop Oscar Romero is
assassinated in El Salvador;
civil war rages.

THE ART WORLD

Venice Biennale features
major survey of interna-
tional POSTMODERN architec-
ture, *The Presence of the
Past.*

Exhibition of NEW WAVE art,
Times Square Show, New
York.

Pablo Picasso retrospective
at Museum of Modern Art,
New York, is seen by over
one million viewers.

1981

THE WORLD

François Mitterand
becomes president of
France.

Pope John Paul II and
President Reagan are
wounded in assassination
attempts.

President Sadat is
assassinated by Moslem
extremists in Egypt.

Martial law is declared
in Poland, suspending
operation of the new
Solidarity trade union.

Massive nuclear-disarma-
ment demonstrations in
London, Paris, Brussels,
Potsdam, and Amsterdam.

GRAFFITI ART

Mid-1970s to mid-1980s

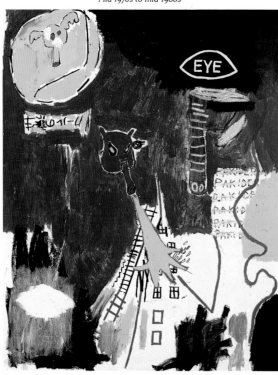

JEAN-MICHEL BASQUIAT (1960–1988).
Pakiderm, 1984. Oil and acrylic on canvas, 86 x 68 in. The Eli and Edythe L. Broad Collection, Los Angeles.

MTV debuts on U.S. television.

THE ART WORLD

Picasso's *Guernica* returns to Spain following resumption of democracy there, in accordance with the artist's wishes.

Fun Gallery opens in the EAST VILLAGE, New York (closes 1985).

Exhibition of NEO-EXPRESSIONISM, *A New Spirit in Painting*, Royal Academy, London.

1982

THE WORLD

USSR President Brezhnev is succeeded by Yuri Andropov.

Falklands War fought by Britain and Argentina over British possession of south Atlantic islands.

Equal Rights Amendment, prohibiting discrimination on the basis of sex, fails to be ratified by a sufficient number of U.S. state legislatures.

AIDS (Acquired Immune Deficiency Syndrome) is named by the U.S. Centers for Disease Control; 1,208 AIDS deaths are reported in U.S. by end of year.

Mexico defaults on international bank loans, triggering Third World debt crisis.

THE ART WORLD

Transavanguardia, Italia-America: Mostra, Galeria Civica, Modena.

Completion of Michael Graves's Portland Public Services Building draws attention to POSTMODERNISM in architecture.

Extended Sensibilities: Homosexual Presence in Contemporary Art, New Museum of Contemporary Art, New York.

1983

THE WORLD

Rául Alfonsin is elected president of Argentina, a rejection of the military government and the "disappearance" of thousands.

U.S. invades Grenada; overthrows Marxist regime.

237 U.S. Marines killed in Beirut by truck-bomb driven by pro-Iranian Shiite Moslems.

Lech Walesa, Solidarity leader, receives Nobel Peace Prize.

THE ART WORLD

Exhibition of GRAFFITI ART at Boymans—van Beuningen Museum, Rotterdam; *Post-Graffiti*, Sidney Janis Gallery, New York.

Museum of Contemporary Art opens, Los Angeles.

1984

THE WORLD

Reagan is re-elected U.S. president.

Massive rioting and school boycotts begin in South Africa; Anglican Bishop Desmond Tutu receives Nobel Peace Prize for non-violent campaign to end apartheid.

Gas leak from Union Carbide chemical plant kills some 2,500 in Bhopal, India.

Famine in Ethiopia threatens the lives of six million.

THE ART WORLD

Difference: On Representation and Sexuality, New Museum of Contemporary Art, New York.

Neue Staatsgalerie opens in Stuttgart.

1985

THE WORLD

Mikhail Gorbachev becomes general secretary of the Soviet Communist party; initiates campaigns for perestroika and glasnost.

NEO-EXPRESSIONISM

Late 1970s to mid-1980s

GEORG BASELITZ (b. 1938).
Die Mädchen von Olmo II (The Girls from Olmo II), 1981.
Oil on canvas, 98 1/2 x 98 1/2 in. Musée National d'Art Moderne, Centre Georges Pompidou, Paris.

1.6 billion people watch the Live Aid concert by satellite from London and help raise funds to alleviate African famine.

Rajiv Gandhi becomes prime minister of India in electoral landslide.

1986

THE WORLD

Philippine President Ferdinand Marcos is overthrown by "People Power"; Corazon Aquino becomes president.

The illegal diversion of funds to Iran for the release of hostages and the arming of Nicaraguan contras—known as the Iran-Contra scandals—comes to light in U.S.

U.S. bombs Libya in response to terrorism in the Middle East.

Accident at Chernobyl nuclear plant in USSR results in evacuation of 135,000.

The U.S. space shuttle Challenger explodes, killing entire crew.

Olof Palme, prime minister

FRANCESCO CLEMENTE (b. 1952).
Francesco Clemente Pinxit (detail,one of 24 miniatures), 1981. Natural pigment on paper, 24 miniatures: 8 3/4 x 6 in. each. Virginia Museum of Fine Arts, Richmond; Gift of Sydney and Frances Lewis.

of Sweden, is assassinated.

THE ART WORLD

Exhibition of NEO-GEO, Sonnabend Gallery, New York.

The Spiritual in Art: Abstract Painting, 1890–1985, Los Angeles County Museum of Art.

Sots Art, New Museum of Contemporary Art, New York.

"Artisco" trend of artist-produced INSTALLATIONS for nightclubs peaks at Area, New York, with temporary works by Jean-Michel Basquiat, Francesco Clemente, Keith Haring, Julian Schnabel, Andy Warhol, and others.

Centro de Arte Reina Sofía opens in Madrid.

Museum Ludwig opens in Cologne, Germany.

1987

THE WORLD

Palestinian uprising (or *Intifada*) protesting economic and social inequality begins in occupied territories and West Bank of Israel.

U.S. congressional "Iran-Contra" hearings are televised.

Stock market crashes in New York.

Largest gay-lesbian demonstration for civil rights in history, Washington, D.C.

James Gleick publishes *Chaos: Making New Science*.

THE ART WORLD

NAMES Project Quilt, devoted to those who have died of AIDS, is first shown, on the Mall, Washington, D.C.

Art against Aids is launched; raises over $5 million in first two years.

Andy Warhol dies; his assets, auction, retrospective exhibition, foundation, diaries, museum, and possible forgeries keep him in the news for the next two years.

Hispanic Art in the United States, Museum of Fine Arts, Houston.

Vincent van Gogh's *Irises* (1889) auctioned for record $53.9 million, New York.

1988

THE WORLD

George Bush is elected U.S. president.

USSR begins to pull its troops out of Afghanistan.

Iran-Iraq war ends.

THE ART WORLD

National Gallery of Canada moves into Moshe Safdie–designed building, Ottawa.

"Unofficial" Soviet art begins to be widely exhibited in U.S. and Western Europe.

New York City Department of Consumer Affairs forces art galleries to post prices.

Instituto Valenciana de Arte Moderna (IVAM) opens in Valencia, Spain.

Luigi Pecci Center of Contemporary Art opens in Prato, Italy.

1989

THE WORLD

Oil spill from Exxon tanker *Valdez* causes ecological disaster in Alaska.

Pro-democracy demonstrations in China are violently suppressed.

Momentous shifts in policies and governments

APPROPRIATION
1980s

SHERRIE LEVINE (b. 1947).
Untitled (After Vasily Kandinsky), 1985. Watercolor on paper, 14 x 11 in. Mary Boone Gallery, New York.

throughout Eastern Europe (symbolized by the opening of the Berlin Wall) signal the diminution of Communism and a redefinition of the balance of power in Europe.

U.S. Supreme Court narrows abortion rights; pro-choice demonstrations are held throughout the country.

Battle against the world-wide AIDS epidemic is being lost; more than 66,000 dead in U.S. (a greater toll than the Vietnam War).

Abortion pill developed in France.

U.S. invades Panama.

Samuel Beckett dies.

THE ART WORLD

Exhibition of SITUATIONIST art, *On the Passage of a Few People through a*

U.S. Senator Jesse Helms writes legislation to bar public funding of "obscene" art.

Willem de Kooning's *Interchange* (1955) is auctioned for $20.7 million, setting a record for a work by a living artist.

RODNEY ALAN GREENBLAT (b. 1961).
Fireplace, 1983. Mixed media with found fireplace, 50 x 49 x 17 in.
Private collection.

Rather Brief Moment in Time, Centre Georges Pompidou, Paris.

Les Magiciens de la terre, Centre Georges Pompidou, Paris.

Richard Serra's PUBLIC ART work, *Tilted Arc*, is removed from its New York site after years of legal wrangling.

Corcoran Gallery of Art, Washington, D.C., cancels exhibition of Robert Mapplethorpe's photographs, setting off anti-censorship protests.

To the uninitiated, contemporary art can seem as indecipherable as Egyptian hieroglyphics. Gallery- and museum-goers are frequently confronted with a perplexing variety of art, ranging from Arte Povera to Neo-Geo to video installations. Strange terms like *semiotics*, *Outsider art*, and *appropriation* may pierce the decorous hush of a gallery. Even reading about art can be an arduous task, given the jargon-ridden prose favored by so many critics. Ironically, in this era of ever-increasing fascination with contemporary art, interest far exceeds comprehension. Today's art *is* hard to understand, and that's why contemporary art—like every professional discipline—requires a specialized vocabulary for all but the most rudimentary communication.

ArtSpeak is the key to that specialized vocabulary. It identifies and defines the terminology essential for understanding art made since World War II. That language is made up of art movements, art forms, and critical terms explained here in short, alphabetically arranged essays. Many, but not all, of the entries are divided into the journalistic categories of **WHO, WHEN, WHERE,** and **WHAT.**

WHO is a list of the principal artists involved with a movement or art form. Capitalized names indicate the pioneers or virtuosos of that approach. The nationality of non-American artists appears in parentheses after their names. (Exceptions have been made for foreign-born artists such as Willem de Kooning and Nam June Paik, whose creative lives have largely been lived in the United States.) Certain artists appear in several entries. The prodigious German artist Joseph Beuys, for instance, is listed under Action/Actionism, assemblage, Conceptual art, Fluxus, installation, media art, and process art.

WHEN signifies the moment of greatest vitality for a particular attitude toward, or method of, art making. Pop art, for example, is associated with the 1960s, but Pop artists continued making Pop art after 1969, and they are likely to continue to do so well into the twenty-first century.

WHERE identifies the cities, countries, or continents in which a movement was centered.

WHAT defines the nature, origins, and implications of the art movements or art forms. Cross references to other entries are CAPITALIZED.

What's the best way to use this volume? That depends on who you are. *ArtSpeak* has been designed for different kinds of readers. The expert can use it to find specific facts—say, the name of the curator who coined the term *New Image painting* or the location of the first feminist art program. The student, collector, or casual art buff will find it useful to read the book from beginning to end and then return to it as needed, guidebook fashion.

ArtSpeak's aim is to provide access to contemporary art. Equipped with the necessary vocabulary, viewers will enjoy the stimulation provided by knowledgeable interaction with today's art. What follows that is pure pleasure.

ABSTRACT/ABSTRACTION

The adjective *abstract* usually describes artworks—known as *abstractions*—without recognizable subjects. Synonyms for *abstract* include *nonobjective* and *nonrepresentational.*

Abstract painting was pioneered between 1910 and 1913 by the Russian-born Wassily Kandinsky in Munich and, in Paris, by the Czech František Kupka and the Frenchman Robert Delaunay. Kandinsky, the most influential of the three, was the first to plunge into pure or total abstraction. The Russian CONSTRUC-TIVIST Vladimir Tatlin was the first artist to create three-dimensional abstractions, which assumed the form of reliefs produced between 1913 and 1916. Since then, abstract paintings and sculpture have been produced by thousands of artists, in styles ranging from EXPRESSIONISM to MINIMALISM.

Many people, in fact, equate modern art with abstraction. But even though the MODERNIST mainstream has tended toward the abstract, numerous artists—Salvador Dali, Georgia O'Keeffe, Willem de Kooning, and Pablo Picasso among them—have bucked its currents and pursued their own, nonabstract inclinations.

In addition to its meaning as an adjective, *abstract* is also a verb. *To abstract* is to generalize. For instance, imagine a dozen drawings of the same face that grow increasingly abstract as particulars are deleted. The first drawing shows the subject in detail—wrinkles, freckles, and all. The second is more sketchy and focuses on the subject's eyes. By the tenth drawing, even the subject's sex is indeterminate. Finally, the twelfth drawing is a perfect oval with no features, which we take to be a face. This is the *process* of abstraction. Abstraction and REPRESENTATION are at the opposite ends of a continuum. The first drawing described is representational, the twelfth is abstract, and the others fall somewhere in between. The tenth drawing is more abstract than the second. The adjective *abstract* and the noun *abstraction* often refer to works, like the twelfth drawing, that are entirely abstract. But the *entirely* is usually omitted.

An abstract image can be grounded in an actual object, like the twelve drawings of the face. Or it can give visual form to something inherently nonvisual, like emotions or sensations. Red, for example, can represent anger or passion. The idea that a musical, visual, or literary sensation has an equivalent in another medium of expression was a popular nineteenth-century idea called *synesthesia,* which helped fuel the drive toward abstraction.

Abstractions come in two basic variations. The first is geometric, or hard edge, which often suggests rationality and is associated with such modern movements as Constructivism and CONCRETE ART. The second is the looser and more personal style usually known as *organic.* Works in this style that evoke floral, phallic, vaginal, or other animate forms are termed *biomorphic.* Organic abstraction is associated with such modern movements as German Expressionism and ABSTRACT EXPRESSIONISM.

ABSTRACT EXPRESSIONISM

▷ **WHO** William Baziotes, Willem DE KOONING, Adolph Gottlieb, Philip Guston, Franz Kline, Lee Krasner, Robert Motherwell, Barnett Newman, Jackson POLLOCK, Mark ROTHKO, Clyfford Still, Mark Tobey

▷ **WHERE** United States

▷ **WHEN** Mid-1940s through 1950s

▷ **WHAT** The term *Abstract Expressionism* originally gained currency during the 1920s as a description of Wassily Kandinsky's ABSTRACT paintings. It was first used to describe contemporary painting by the writer Robert Coates, in the March 30, 1946, issue of the *New Yorker.* Abstract Expressionism's most articulate advocates, the critics Harold Rosenberg and Clement Greenberg, originated the names *Action painting* and *American-style painting,* respectively. In the United States, *Abstract Expressionism* (or simply *Ab Ex* or even *AE*) was the name that stuck. The European variant was dubbed ART INFORMEL by the French critic Michel Tapié in his 1952 book *Un Art autre (Another Art).*

Abstract Expressionism was the first art movement with joint European-American roots, reflecting the influence of European artists who had fled Hitler-dominated Europe (Max Ernst, Fernand Léger, Matta, and Piet Mondrian among them). Abstract Expressionists synthesized numerous sources from the history of modern painting, ranging from the EXPRESSIONISM of Vincent van Gogh to the abstraction of Kandinsky, from the saturated color fields of Henri Matisse to the ORGANIC forms and fascination with the psychological unconscious of the SURREALIST Joan Miró. Only geometric and REALIST art played no part in this mixture of intensely introspective and even spiritual elements, often painted on mural-size canvases.

Abstract Expressionism was less a STYLE than an attitude. The calligraphic poured (or "drip") paintings by Jackson Pollock, for instance, share little

visually with the intensely colored, landscapelike fields by Mark Rothko. Of paramount concern to all the Abstract Expressionists was a fierce attachment to psychic self-expression. This contrasted sharply with the REGIONALISM and SOCIAL REALISM of the 1930s but closely paralleled postwar existential philosophy's championing of individual action as the key to modern salvation. In existentialist fashion Harold Rosenberg described the Action painter's canvas as "an arena to act in," in his influential essay "The American Action Painters," published in the December 1952 issue of *Artnews*.

The term *Abstract Expressionist* has been applied to some postwar photography, sculpture, and ceramics, but in such cases it rarely clarifies meaning. Neither photography nor the welded CONSTRUCTIVIST works that constitute the best sculpture of that era allow for the spontaneous interaction with art-making materials that characterizes Abstract Expressionism. The term is appropriately applied to the CERAMIC SCULPTURE of Peter Voulkos.

ACADEMIC ART

Academic art once meant simply the "art of the Academy"—that is, art based on academic principles. Having now acquired a negative connotation, it is often used to describe an artist or artwork that is long on received knowledge and technical finesse but short on imagination or emotion.

Art academies originated in late sixteenth-century Italy, replacing the medieval guild-apprentice system previously used to train artists and raising their social status in the process. Academies such as London's Royal Academy of Arts and Paris's Académie des Beaux-Arts institutionalized art training and established a strict hierarchy of subjects. History painting (biblical or classical subjects) ranked first, then portraits and landscapes, and finally still lifes. Academic artists—who were almost invariably men—were initially taught to draw from white plaster casts of classical statues and then progressed to drawing from nude models, acquiring additional skills in a carefully programmed sequence.

The British Pre-Raphaelites and French Impressionists were among the first to reject academic standards and practices, taking aim not only at the academic aesthetic but also at the Academies' stranglehold on patronage in the cultural capitals of Western Europe. By the turn of this century public attention was starting to shift from artists associated with the Academy and toward those of the AVANT-GARDE. Not until the 1970s was there a revival of interest in the work of nineteenth-century academic artists such as Adolphe William Bouguereau.

The POSTMODERN attention to discredited historical forms has also extended to discredited academic STYLES. Artists such as the Russian expatriates Komar and Melamid and the Italian Carlo Maria Mariani employ such styles to comment, often ironically, on contemporary subjects and on the notion of style itself.

ACTION PAINTING—*see* ABSTRACT EXPRESSIONISM

ACTION/ACTIONISM

▷ **WHO** Joseph BEUYS (Germany), Günter Brus (Austria), Yves KLEIN (France), Piero MANZONI (Italy), Otto Mühl (Austria), Hermann NITSCH (Austria), Arnulf Rainer (Austria), Alfons Schilling (Austria), Rudolf Schwarzkogler (Austria)

▷ **WHEN** Late 1950s to mid-1970s

▷ **WHERE** Europe

▷ **WHAT** The idea of the artist as actor and the related interest in artistic process were twin outgrowths of ABSTRACT EXPRESSIONISM and its European variant ART INFORMEL. The notion of the painting as a record of the artist's encounter with it inspired some artists to act out their artworks. HAPPENINGS, FLUXUS events, and Actions were three such live approaches—all precursors of PERFORMANCE ART. Happenings were precisely choreographed, formally arranged events that eluded explicit interpretation. Fluxus's diverse activities evolved from an open-ended poetic sensibility inflected with Zen, DADA, and Beat elements. *Actions* was a catchall term for live works presented inside galleries or on city streets by artists like Yves Klein and Piero Manzoni.

Action artists grappled with concerns that ranged broadly from the spiritual and aesthetic to the social and political. About 1960 Klein started to make paintings with living "brushes"—nude women doused in paint and "blotted" onto canvas. Manzoni signed various individuals, transforming them into living sculpture. During the early 1970s Joseph Beuys created the Free University, a multidisciplinary informational network, and called it a "social sculpture."

A preoccupation with the artist's role as shaman and the desire for direct political action outside the art world characterized Actions, linking them with what is known in German as *Aktionismus* or "Actionism." It usually refers to a group of Viennese artists who created thematically related Actions starting about 1960. Artists such as Günter Brus, Otto Mühl, Hermann Nitsch, Alfons

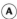

ACTION/ACTIONISM

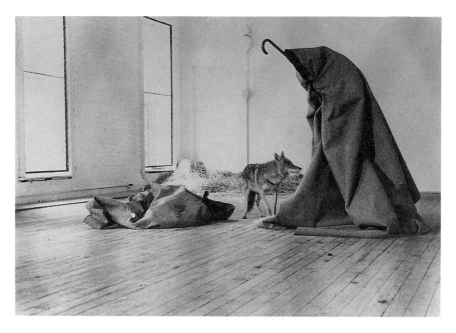

JOSEPH BEUYS (1921–1986).
I Like America and America Likes Me, 1974.
Photograph by Caroline Tisdall.

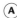

Schilling, and Rudolf Schwarzkogler explored Freudian themes of erotic violence in ritualistic performances utilizing bodily materials such as blood, semen, and meat. A typical Action—presented by Schilling to a small audience in Vienna on March 16, 1963—opened with the presentation of a skinned and bloody lamb. A white cloth on the floor was covered with the animal's entrails. Blood was repeatedly poured on the lamb, which was swung around by the legs, splashing the audience and the gallery. The artist threw raw eggs against the walls and chewed a rose. Such histrionic events were sometimes enacted especially for the camera.

In their exploration of the psyche's darkly destructive side, these events were a reaction against the canonization of creativity that typified Abstract Expressionism and Art Informel. Actions and Aktionismus are the bridge between those movements of the 1950s and the performance and BODY ART that would follow in the late 1960s and the 1970s.

ALLEGORY

An allegory is an image or a story that refers to something else entirely—usually concepts such as good or evil. Although symbols and allegories are related—the term *symbolize* rather than *allegorize* is standard usage—a crucial distinction separates them. Many symbols have their origins in visual reality: the cross symbolizing Christianity, for instance, and the heart symbolizing love. Allegories, on the other hand, have no such basis: consider the correspondence between Venus and romantic love. The most straightforward allegories are known as *personifications*, figures that stand for ideas like good government or the seven deadly sins. The traditional use of such imagery deepened an artwork's meaning by referring to information outside the work, but it also demanded that the audience be educated enough to understand those references.

The use of allegory was a staple of Western art until the MODERNIST determination to purge art of literary content made it seem old-fashioned. Nonetheless, modern artists such as Max Beckmann, Georges Braque, Giorgio de Chirico, Max Ernst, Paul Gauguin, Fernand Léger, José Clemente Orozco, Pablo Picasso, and Odilon Redon used allegories in numerous paintings to comment on the human condition. Few allegorical references appeared in art from the 1950s to the mid-1970s, except in work by NEW REALIST painters such as Jack Beal. POSTMODERNISM changed that. The return of historical imagery and FIGURATIVE—as opposed to ABSTRACT—art made the return of allegory almost inevitable.

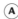

The premier allegorical artists of the late twentieth century are Italian and German—Francesco Clemente, Enzo Cucchi, Jörg Immendorff, Anselm Kiefer, and Helmut Middendorf among them. Obsessed with the effects of Nazism, German artists have attempted to reclaim their cultural past in a society committed to repudiating all that transpired before 1946. The paradigmatic figure in this regard is Kiefer, whose works use biblical history, historical sites, Teutonic myth, Johann Wolfgang von Goethe's *Faust* (1808/32), and other cultural emblems as allegories of contemporary German life. Because Kiefer's allegorical representations are unfamiliar to most of his viewers, even in Germany, they are often difficult to interpret. What the American painter Robert Colescott aptly termed his art historical "masterpieces in Black face" are more accessible allegories of racism.

ALTERNATIVE SPACE

Alternative spaces first appeared in New York in 1969 and 1970 with the founding of 98 Greene Street, Apple, and 112 Greene Street, all of which were small-scale nonprofit institutions run by and for artists. These independent organizations were considered a necessity in an era of widespread artistic experimentation inimical to many museums, commercial galleries, and artist-run cooperatives. Alternative spaces also championed feminism and ethnic diversity by presenting work by women artists and artists of Asian, African, and Latin descent. Throughout the 1970s alternative spaces proliferated in major American, Canadian, and (to a lesser extent) Western European cities. (In Canada they are known as pàrallel galleries.) The PLURALISM of that decade is virtually unimaginable without alternative spaces as a site for INSTALLATIONS, VIDEO, PERFORMANCE, and other CONCEPTUAL ART forms.

By the early 1980s the nature of such organizations had diversified. Recent art-school graduates could still find storefront venues for their video and performance endeavors, but some alternative spaces had evolved into highly structured institutions with large staffs and funding from foundations, municipalities, and the National Endowment for the Arts. *Artists' organization* or *artist-run organization* is now the preferred nomenclature, and the organization that represents American alternative spaces is the National Association of Artists' Organizations (NAAO), based in Washington, D.C.

Ironically, the generation of the early 1980s began to regard such institutions as "the establishment," far removed from the art world's commercial center of gravity. This attitude led EAST VILLAGE artists in New York to open more or less conventional galleries as showplaces for their work.

ANTI-ART—*see* DADA

APPROPRIATION

▷ **WHO** Mike BIDLO, David Diao, Komar and Melamid, Jeff Koons, Igor Kopystiansky (USSR), Louise Lawler, Sherrie LEVINE, Carlo Maria Mariani (Italy), Sigmar Polke (Germany), Richard PRINCE, Gerhard Richter (Germany), David SALLE, Julian SCHNABEL, Peter Schuyff, Elaine Sturtevant

▷ **WHEN** 1980s

▷ **WHERE** United States and Europe

▷ **WHAT** To appropriate is to borrow. Appropriation is the practice of creating a new work by taking a pre-existing image from another context—art history, advertising, the media—and combining that appropriated image with new ones. Or, a well-known artwork by someone else may be represented as the appropriator's own. Such borrowings can be regarded as the two-dimensional equivalent of the FOUND OBJECT. But instead of, say, incorporating that "found" image into a new COLLAGE, the POSTMODERN appropriator redraws, repaints, or rephotographs it. This provocative act of taking possession flouts the MOD-ERNIST reverence for originality. While modern artists often tipped their hats to their art historical forebears (Edouard Manet borrowed a well-known composition from Raphael, and Pablo Picasso paid homage to Peter Paul Rubens and Diego Velázquez), they rarely put such gleanings at the intellectual center of their work. A sea change occurred when Campbell's soup cans and Brillo boxes began to inspire artworks; POP ART was appropriation's precursor and Andy Warhol its godfather.

Like collage, appropriation is simply a technique or a method of working. As such, it is the vehicle for a variety of viewpoints about contemporary society, both celebratory and critical. In perhaps the most extreme instances of recent appropriation, Sherrie Levine rephotographed photographs by Edward Weston and made precisely rendered facsimiles of Piet Mondrian's watercolors. Her work questions conventional notions of what constitutes a masterpiece, a

master, and indeed, art history itself. By choosing to appropriate only the work of male artists, this FEMINIST ARTIST asks viewers to consider the place of women within the art historical canon, and, in the case of Weston's nude photographs of his young son, to consider whether the gender of the photographer affects how pictures are viewed.

Jeff Koons, one of the few appropriators working in three dimensions, has his sculpture fabricated in stainless steel or porcelain to replicate giveaway liquor decanters and KITSCH figurines. Other artists such as David Salle and Julian Schnabel use appropriation to create a dense network of images from history, contemporary art, and POPULAR CULTURE. The multilayered, pictorial equivalent of free association, their art frequently defies logical analysis.

ART AND TECHNOLOGY

▷ **WHO** Helen and Newton Harrison, Robert Irwin, Gyorgy KEPES, Piotr Kowalski (France), Julio Le Parc (France), Nam June Paik, Otto PIENE (Germany), Robert Rauschenberg, Bryan Rogers, Nicolas Schöffer (France), James Seawright, TAKIS (France), James Turrell

▷ **WHEN** Mid-1960s to mid-1970s

▷ **WHERE** United States, primarily, and Western Europe

▷ **WHAT** Technology is a staple subject of MODERN art. Artistic responses to technology have ranged from celebration (by the Italian Futurists) to satire (by the DADA artists Marcel Duchamp and Francis Picabia). Visions of technological utopia were nurtured by the CONSTRUCTIVISTS, who imagined a future union of art with architecture, design, and science. In the late 1950s and the 1960s European artists picked up where the Constructivists had left off. Numerous groups—most notably ZERO, founded in Düsseldorf in 1957, and Groupe de Recherche d'Art Visuel (GRAV), founded in Paris in 1960—presented light sculpture, KINETIC SCULPTURE, and other machinelike artworks. Most of these groups disbanded by the late 1960s without having made the crucial connection with scientists that characterizes the art-and-technology phenomenon. ZERO's founder, Otto Piene, and many of the others then moved to the United States.

By the late 1960s the United States had produced the world's most advanced technology. At the same time POP ART was providing an optimistic vision of

contemporary life, CONCEPTUAL ART was offering a model of problem solving and engagement with non-art systems of thought, and the modern faith in science and technology was at its peak.

Several particularly effective collaborations between artists and scientists were initiated. Experiments in Art and Technology (EAT) was founded in 1966 by the Swedish engineer Billy Klüver and the artist Robert Rauschenberg. New York–based EAT, which still exists, has linked hundreds of artists and scientists and has presented numerous programs—the most famous being *Nine Evenings*, which was held at New York's 69th Regiment Armory in October 1966 and featured the participation of John Cage, Buckminster Fuller, Gyorgy Kepes, and Yvonne Rainer, among others. The Art and Technology program at the Los Angeles County Museum of Art (1967–71) paired seventy-eight well-known artists with scientific-industrial facilities in California and then exhibited the results, some of them multimedia or environmental pieces involving sound, light, and kinetic elements. In 1967 Kepes opened the Center for Advanced Visual Studies at the Massachusetts Institute of Technology, which continues to promote dialogue among resident artists and Cambridge-area scientists.

The 1970s began with the enthusiasm generated by the moon landing, but soon technology came to be associated with environmental destruction, the use of napalm in Vietnam, and the near meltdown of a nuclear reactor at Three-Mile Island. As a result, many artists—along with much of the American public—grew disenchanted with technology.

See HIGH-TECH ART, LIGHT-AND-SPACE ART

ART BRUT

The French artist Jean Dubuffet came up with the term *Art Brut* (pronounced broot) in 1945. It means "raw art" and refers to the art of children, NAIVE artists, and the mentally ill (in this regard Dubuffet was strongly influenced by Hans Prinzhorn's 1922 book *Bildnerei der Geisterkranken,* or *The Art of the Insane*). Dubuffet found the work of these nonprofessionals refreshingly direct and compelling. "[It is] art at its purest and crudest . . . springing solely from its

ART BRUT

JEAN DUBUFFET (1901–1985).
The Cow with the Subtile Nose, 1954. Oil and enamel on canvas, 35 x
45 3/4 in. Collection, The Museum of Modern Art, New York; Benjamin
Scharps and David Scharps Fund.

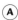

maker's knack of invention and not, as always in cultural art, from his power of aping others or changing like a chameleon," he wrote in the essay "Art Brut Preferred to the Cultural Arts"(1949). In fact, we know now that schizophrenic and naive artists frequently pattern their art after extremely well-known paintings and sculptures.

Finding inspiration for his own art in the work of these nonprofessionals, Dubuffet began using quirky materials (including mud and a paste of asphalt and broken glass), odd methods (scraping and slashing into this paste), and a crude but expressive drawing style. Ironically, the term *Art Brut* has come to be applied to Dubuffet's anything-but-naive art. An enthusiastic proselytizer of the authenticity and humanity he saw in Art Brut, he lectured widely on the subject; a 1951 address at the Chicago Arts Club radically altered the course of CHICAGO IMAGIST art. Dubuffet also collected thousands of examples of Art Brut, which are now in a museum devoted to them, opened by the city of Lausanne, Switzerland, in 1976.

ART INFORMEL

▷ **WHO** Alberto Burri (Italy), Jean Fautrier (France), Hans HARTUNG (France), Georges Mathieu (France), Pierre SOULAGES (France), Nicolas de Staël (Belgium), Antoni Tàpies (Spain), Bram van Velde (Netherlands), Wols (France)

▷ **WHEN** 1950s

▷ **WHERE** Paris

▷ **WHAT** The term *Art Informel* was originated by the French critic Michel Tapié and popularized in his 1952 book *Un Art autre* (*Another Art*). A Parisian counterpart of ABSTRACT EXPRESSIONISM, Art Informel emphasized intuition and spontaneity over the Cubist tradition that had dominated SCHOOL OF PARIS painting. The resulting ABSTRACTIONS took a variety of forms. For instance, Pierre Soulages's black-on-black paintings composed of slashing strokes of velvety paint suggest the nocturnal mood of Europe immediately after the war.

Tachisme (from the French *tache* or blot) is a subset of Art Informel that yielded works related to Jackson Pollock's Abstract Expressionist poured (or "drip") paintings. The Tachiste Georges Mathieu abandoned brushes entirely, preferring to squeeze paint directly from the tube onto the canvas.

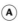

Translating *Art Informel* as "informal art" or "informalism" is misleading. The point is not that artists renounced their concern for FORMAL values but that they rejected the discipline and structure of geometric abstraction in favor of a less cerebral approach.

ART-IN-PUBLIC PLACES—*see* PUBLIC ART

ARTE POVERA

▷ **WHO** (all Italian) Giovanni Anselmo, Alighiero Boetti, Luciano Fabro, Jannis Kounellis, Mario MERZ, Giulio PAOLINI, Giuseppe Penone, Michelangelo PISTOLETTO, Gilberto Zorio

▷ **WHEN** Mid-1960s through 1970s

▷ **WHERE** Italy

▷ **WHAT** Coined by the Italian critic Germano Celant in 1967, the term *Arte Povera* (pronounced *ar*-tay poh-*vair*-uh), which means "Poor Art," refers to usually three-dimensional art created from everyday materials. The associations evoked by humble cement, twigs, or newspapers contrast sharply with those summoned up by the traditional sculptural materials of stone and metal. It wasn't only materials that concerned the Arte Povera artist, though, and many artworks fashioned from "poor" or cast-off materials are not Arte Povera.

Metaphorical imagery culled from nature, history, or contemporary life was frequently employed by Arte Povera artists. Coupling idealism about the redemptive power of history and art with a solid grounding in the material world, they typically made the clash—or reconciliation—of opposites a source of poignancy in their work. Michelangelo Pistoletto, for instance, evoked the issue of class stratification by presenting a plaster statue of Venus de Milo contemplating a pile of brightly colored rags in his *Venus of the Rags* (1967). He gathered the rags near the gallery, siting his INSTALLATION in the geographical and sociological terrain of a specific neighborhood.

The term *Arte Povera* is now applied almost exclusively to Italian art, although that was not Celant's original intent. It could aptly be used to describe the work of non-Italian PROCESS artists—including Joseph Beuys, Hans Haacke, Eva Hesse, and Robert Morris—who have used unconventional materials and forms to make metaphorical statements about nature or culture.

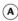

ARTISTS' BOOKS

▷ **WHO** ART & LANGUAGE (Great Britain), John Baldessari, George BRECHT (Germany), Marcel Broodthaers (Belgium), Nancy Buchanan, Victor Burgin (Great Britain), John Cage, Ulises Carrion (Mexico), Hanne Darboven (Germany), Marcel Duchamp (France), Felipe Ehrenberg (Mexico), Robert Filiou (France), Hamish Fulton (Great Britain), General Idea (Canada), Dick HIGGINS, Anselm Kiefer (Germany), Alison Knowles, Margia Kramer, Sol LeWitt, George Maciunas, Mario Merz (Italy), Richard Olson, Richard Prince, Martha Rosler, Dieter ROTH (Germany), Ed RUSCHA, Paul Zelevansky

▷ **WHEN** Late 1960s through 1970s

▷ **WHERE** International

▷ **WHAT** *Artists' books* refers not to literature about artists nor to sculptures constructed from books but to works by visual artists that assume book form. The term is credited to Dianne Vanderlip, who organized the exhibition *Artists Books* at Moore College of Art, Philadelphia, in 1973. The same year Clive Philpott, the librarian at the Museum of Modern Art, put the synonymous term *book art* into print in the "Feedback" column of the July–August issue of *Studio International*. The first major show of artists' books had been mounted in 1972 at the Nigel Greenwood Gallery in London.

Precursors of artists' books date back at least as far as William Blake's illus-trated epics from the early nineteenth century and—closer at hand—Marcel Duchamp's *Green Box* of the 1930s. Primary prototypes for contemporary artists' books include Ed Ruscha's POP-inspired foldout photo-books from the mid-1960s (one pictures every building on the Sunset Strip) and Dieter Roth's multivolume collection of meticulously filed debris from the street.

An artist's book may have images without words or narratives without images. It may assume sculptural form as a pop-up book or investigate the nature of the book format itself. It may take the DOCUMENTATION of ephemeral PERFOR-MANCES or INSTALLATIONS as its point of departure. The thematic concerns of artists' books ranged as widely as those of the PLURALIST late 1960s and 1970s, with autobiography, NARRATIVE, and humor being favored.

Many artists working mainly in other media turned to books as a form suited to expressing ideas too complex for a single painting, photograph, or sculpture. FLUXUS and CONCEPTUAL artists who wanted to communicate ideas in accessible, inexpensive formats were also attracted to artists' books. Compared to the

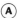

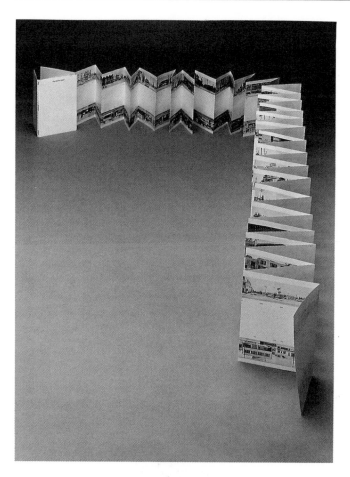

EDWARD RUSCHA (b. 1937).
Every Building on the Sunset Strip, 1966. Photo-book in continuous
strip, 7 1/8 x 5 5/8 in. (closed). Los Angeles County Museum of Art
Library Special Collections.

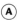

more precious products of the PRINT REVIVAL, artists' books seemed the essence of populism—even if the public-at-large did not always recognize them as art.

ARTISTS' FURNITURE

▷ **WHO** Harry Anderson, Scott BURTON, Stephen De Staebler, R. M. Fischer, Frank Gehry, David Ireland, Yayoi Kusama (Japan), Kim MacCONNEL, Main and Main, Judy McKie, Howard Meister, Memphis (Italy), Isamu NOGUCHI, Peter Shire, Robert Wilhite, Robert Wilson

▷ **WHEN** Since the late 1970s

▷ **WHERE** Primarily the United States

▷ **WHAT** *Artists' furniture* is furniture designed and often made by painters, sculptors, craftspersons, or architects, generally as one-of-a-kind pieces available only in galleries. Scott Burton created sculptural seating for indoor or outdoor sites as PUBLIC ART. R. M. Fischer's witty oversize lamps are constructed from FOUND OBJECTS and debris.

Examples of furniture by artists, including Pablo Picasso and Constantin Brancusi, date back at least as far as the early twentieth century. Although artists and architects of that era frequently designed furniture as part of populist programs initiated after the Revolution in the Soviet Union and at the Bauhaus school in Germany, the results were not generally regarded as art. The development of POSTMODERNISM in the 1970s and the blurring of the boundaries that had traditionally separated craft and art set the stage for the acceptance of artists' furniture as a hybrid art form.

See CRAFTS-AS-ART

ASSEMBLAGE

▷ **WHO** Karel Appel (Netherlands), Arman (France), Tony Berlant, Wallace Berman, Joseph BEUYS (Germany), Louise Bourgeois, John Chamberlain, Bruce CONNER, Joseph Cornell, Edward KIENHOLZ, Donald Lipski, Marisol, Louise NEVELSON, Robert Rauschenberg, Richard Stankiewicz, H. C. Westermann

▷ **WHEN** Despite its early twentieth-century origins, assemblage moved above ground only during the 1950s

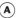

BRUCE CONNER (b. 1933).
Child, 1959–60. Wax figure with nylon, cloth, metal, and twine in a
high chair, 34 5/8 x 17 x 16 1/2 in. Collection, The Museum of Modern
Art, New York; Gift of Philip Johnson.

▷ **WHERE** International but especially in the United States

▷ **WHAT** The three-dimensional counterpart of COLLAGE, *assemblage* similarly traces its origin to Pablo Picasso. In collaboration with Georges Braque, he created the first assemblage in 1912 with his sheet-metal *Guitar*, three years before the DADA artist Marcel Duchamp attached a bicycle wheel to a stool and called it a READYMADE. Previously known simply as "objects," assemblages were named by Peter Selz and William Seitz, curators at the Museum of Modern Art, for the exhibition *The Art of Assemblage* in 1961.

Assemblage involves the transformation of non-art objects and materials into sculpture through combining or constructing techniques such as gluing or welding. This radically new way of making sculpture turned its back on the traditional practices of carving stone or modeling a cast that would then be translated into bronze.

The use of non-art elements or even junk from the real world often gives assemblages a disturbing rawness and sometimes a poetic quality. Assemblage shares with Beat poetry of the late 1950s a delight in everyday things and a subversive attitude toward "official" culture.

Assemblage can be mysterious and hermetic, like the shrouded figures of Bruce Conner, or aggressively extroverted, as in the biting tableaux of down-and-outers by Edward Kienholz. Assemblages are not always REPRESENTATIONAL: John Chamberlain fashions ABSTRACT sculptures from crumpled auto fenders, and Louise Nevelson made enigmatic and sensuous painted-wood abstractions. Assemblage is a technique, not a STYLE.

AUTOMATISM—*see* SURREALISM

AVANT-GARDE—*see* MODERNISM

"BAD" PAINTING

▷ **WHO** James Albertson, Joan BROWN, Robert Colescott, Cply, Charles Garabedian, Neil JENNEY, Judith Linhares, Earl Staley

▷ **WHEN** 1970s

▷ **WHERE** United States

▷ **WHAT** *"Bad" Painting*—with ironic quotation marks—was the name of a 1978 exhibition curated by Marcia Tucker at the New Museum of Contemporary Art in New York. With its expressive, sometimes deliberately crude paint handling and intimations of narrative, "bad" painting was more an approach than a movement. Its subjects were predominantly FIGURATIVE, ranging from Joan Brown's scenes of holiday romances to Charles Garabedian's broadly brushed renderings of classical architecture and fragmented figures. The often autobiographical and eccentric imagery of "bad" painting contrasted sharply with the emotionally detached MINIMALISM and CONCEPTUALISM that a critical consensus deemed the "good" art of that day.

"Bad" painting had precedents in the highly personal, sometimes humorous postwar painting and sculpture of Philip Guston, Red Grooms, the CHICAGO IMAGISTS, and the BAY AREA FIGURATIVE and FUNK artists. In turn, it helped pave the way for the return of non-ABSTRACT painting in the 1980s.

BAY AREA FIGURATIVE STYLE

▷ **WHO** Elmer BISCHOFF, Joan Brown, Richard DIEBENKORN, Frank Lobdell, Manuel Neri, Nathan Oliveira, David PARK, Paul Wonner

▷ **WHEN** Late 1940s to mid-1960s

▷ **WHERE** San Francisco Bay Area

▷ **WHAT** The Bay Area figurative style embodies the attraction *and* repulsion many artists felt toward the ABSTRACT EXPRESSIONISM emanating from New York. The attraction was made evident through thick paint surfaces, expressive color, and GESTURAL brushwork, the repulsion through the rejection of total ABSTRACTION in favor of FIGURATIVE imagery. Bay Area figurative style artists tended to portray figures not as specific individuals but as elements in a still life, a generalizing approach that reflected the existentialist ZEITGEIST of the early 1950s.

Postwar San Francisco boasted the United States' most up-to-date art scene outside New York. As Abstract Expressionism was emerging in the late 1940s, local artists learned about it from the New York painters Ad Reinhardt, Mark Rothko, and Clyfford Still, all of whom taught at the California School of Fine Arts (now the San Francisco Art Institute) between 1946 and 1950. Their Californian colleagues at the school, David Park and Elmer Bischoff, emulated their abstract, gestural approach and transmitted it to star pupil Richard Diebenkorn.

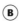

By the mid-1950s all three Californians had made the radical move away from abstraction and back to paintings of the figure or landscape. Bischoff's account of this about-face to critic Thomas Albright (in the December 1975 issue of *Currant*) was typical: "The thing [Abstract Expressionism] was playing itself dry; I can only compare it to the end of a love affair." For the generation of Bay Area painters who began their careers in the mid-1950s to early 1960s—including Joan Brown, Manuel Neri, and Nathan Oliveira—Abstract Expressionism was already history. Figurative painting and sculpture remained the dominant local tradition until CONCEPTUAL ART emerged at the end of the 1960s.

See FUNK ART

BIOMORPHISM—*see* ABSTRACT/ABSTRACTION

BODY ART

▷ **WHO** Marina Abramovíc/Ulay (Netherlands), Vito ACCONCI, Stuart Brisley (Great Britain), Chris BURDEN, Terry FOX, Gilbert and George (Great Britain), Rebecca Horn (Germany), Barry Le Va, Tom Marioni, Ana MENDIETA, Linda Montano, Bruce Nauman, Dennis Oppenheim, Gina Pane (Italy), Mike Parr (Australia), Klaus Rinke (Germany), Jill Scott (Australia), Stelarc (Australia)

▷ **WHEN** Late 1960s through the 1970s

▷ **WHERE** United States, Europe, and Australia

▷ **WHAT** A subset of CONCEPTUAL ART and a precursor of PERFORMANCE ART, *body art* is just what its name implies: an art form in which the artist's body is the medium rather than the more conventional wood, stone, or paint on canvas. Body art often took the form of public or private performance events and was then seen in DOCUMENTARY photographs or videotapes.

Frequently motivated by masochistic or spiritual intentions, body art varied enormously: Chris Burden had himself shot; Gina Pane cut herself in precise patterns with razor blades; Terry Fox attempted to levitate after constructing what he termed a "supernatural" gallery environment; and Ana Mendieta created earthen silhouettes of herself in poses reminiscent of ancient goddess figures from the Near East.

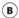
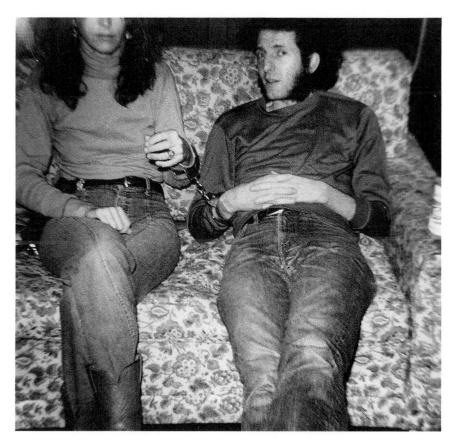

LINDA MONTANO (b. 1942) and **TOM MARIONI** (b. 1937). *Handcuff*, 1973. 3-day performance.

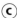

Precedents for body art include some of Marcel Duchamp's early twentieth-century DADA gestures (a star-shaped haircut, for example) and the ACTIONS of Yves Klein and Piero Manzoni during the early 1960s. Body art was at once a rejection of the cool MINIMALISM of the 1960s and an embrace of the body-oriented ferment of that moment. The experimentation with sex, drugs, and psychosexual frankness in society at large was mirrored—and enacted—by body artists.

CAMP—*see* KITSCH

CERAMIC SCULPTURE

▷ **WHO** Robert ARNESON, Billy Al Bengston, Robert Brady, Stephen De Staebler, Viola Frey, John MASON, Jim Melchert, Ron Nagle, Ken PRICE, Richard Shaw, Peter Vandenberge, Peter VOULKOS

▷ **WHEN** Since the mid-1950s

▷ **WHERE** Primarily California

▷ **WHAT** *Ceramic sculpture* refers to three-dimensional artworks made of clay and to the campaign that elevated clay from a crafts material (even in the hands of Pablo Picasso or Joan Miró) to the stuff of sculpture. The granddaddy of that campaign was Peter Voulkos, who arrived at the Otis Art Institute in Los Angeles in 1954 and moved on to the University of California at Berkeley in 1959. During the 1950s he and John Mason, Ken Price, and Billy Al Bengston worked on solving the technical problems involved in making clay forms of unprecedented size and shape.

Their work—and that of the ceramic sculptors who followed them—increasingly referred not to traditional craft forms but to HIGH ART: Voulkos's nonfunctional plates and vessels are linked to the GESTURALISM of ABSTRACT EXPRESSIONISM; Mason's floor pieces to MINIMALISM; Richard Shaw's trompe-l'oeil still lifes to NEW REALISM; and Robert Arneson's tableaux and objects to POP ART.

See CRAFTS-AS-ART

CHICAGO IMAGISM

▷ **WHO** Roger Brown, Leon GOLUB, Ellen Lanyon, June Leaf, Gladys Nilsson, James Nutt, Ed Paschke, Seymour Rosofsky, H. C. WESTERMANN

▷ **WHEN** Mid-1950s through 1970s

▷ **WHERE** Chicago

▷ **WHAT** *Imagism* is a blanket term for the FIGURATIVE art characterized by EXPRESSIONISM and SURREALISM that emerged in Chicago following World War II. Images of sex and violence were often rendered in PRIMITIVE- or NAIVE-looking STYLES. They range from Leon Golub's paintings of damaged figures derived from classical sculpture to Gladys Nilsson's and James Nutt's cartoon-style satires of contemporary life. Other artists, including the ASSEMBLAGE maker H. C. Westermann and the painter Ellen Lanyon, created more personal works that had little to do with history or POPULAR CULTURE but frequently incorporated everyday objects and images.

The elder statesman of Chicago Imagism was the local expressionist painter Seymour Rosofsky, and its catalysts were the Chilean Surrealist Matta, who taught at the School of the Art Institute; and Jean Dubuffet, the French ART BRUT painter who delivered an influential lecture called "Anticultural Positions" in 1951 at the Chicago Arts Club. The critic Franz Schulze dubbed the 1950s generation of painters—Golub, Lanyon, Rosofsky—the Monster Roster; the 1960s generation—Roger Brown, Nilsson, Nutt, Ed Paschke, Westermann—branded itself the Hairy Who.

Chicago Imagism's irreverent and frequently incendiary imagery put it in direct opposition to the generally ABSTRACT mainstream centered in New York and Los Angeles. Along with San Francisco–based FUNK and the BAY AREA FIGURATIVE STYLE, Chicago Imagism offered an alternative to that mainstream.

CoBrA

▷ **WHO** Pierre ALECHINSKY (Belgium), Karel APPEL (Netherlands), Cornelis Corneille (Belgium), Asger Jorn (Denmark), Karl Pederson (Denmark)

▷ **WHEN** 1948–51

▷ **WHERE** Northern Europe

▷ **WHAT** Founded in 1948 by the Belgian writer Christian Dotremont and an association of Dutch painters in Amsterdam known as the Experimental Group, CoBrA took its name from the three cities where many of the participants lived—Copenhagen, Brussels, and Amsterdam. Starting in 1948, CoBrA exhibitions were mounted in Amsterdam, Paris, and Liège, and a literary

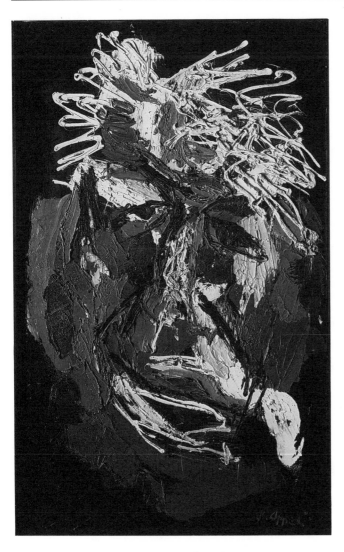

KAREL APPEL (b. 1921).
Portrait of Willem Sandberg, 1956. Oil on canvas, 51 1/4 x 31 7/8 in.
Museum of Fine Arts, Boston; Tompkins Collection.

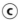

review was published in Denmark. In 1951 this highly influential group disbanded, although individual members continued to work in what had come to be known as the CoBrA STYLE, characterized by violent brushwork and saturated color. Their ABSTRACTED but still recognizably FIGURATIVE imagery was often derived from prehistoric, PRIMITIVE, or FOLK ART. The high-pitched emotional range of their works runs the gamut from ecstasy to horror.

Along with ABSTRACT EXPRESSIONISM, ART BRUT, and ART INFORMEL, CoBrA was part of the international postwar revolt against cerebral art. Geometric abstraction, CONSTRUCTIVISM, and CONCRETE ART were rejected in favor of EXPRESSIONISM. This emotive response to the rationalized techno-horrors of World War II echoed the origins of DADA following World War I.

COLLAGE

The term *collage* comes from the French verb *coller* (to glue). In English it is both a verb and a noun: to collage is to affix papers or objects to a two-dimensional surface, thus creating a collage.

Picasso produced the first HIGH-ART collage, *Still Life with Chair Caning*, in 1912, when he glued onto his canvas a real piece of oilcloth printed with a caning pattern. By doing that instead of painting the caning pattern directly on his canvas, he forever blurred the distinction between reality and illusion in art. After World War I, DADA artists transformed debris from the street into their sometimes disturbing and politicized collages, while SURREALIST artists created collages that reflected their more psychologically attuned sensibilities. German Dada artists also invented a collage technique using snippets of photographs that is known as *photomontage*.

Postwar collage has been put to many different uses. Jasper Johns painted his images of flags and targets on backgrounds of collaged newsprint in order to produce richly textured, GESTURAL-looking surfaces. PATTERN-AND-DECORATION artists such as Miriam Schapiro, Robert Kushner, and Kim MacConnel have used collage to create brashly colorful and sensuous effects. Other postwar artists who have exploited the technique include Romare Bearden, Wallace Berman, Bruce Conner, Richard Hamilton, George Herms, David Hockney, Jess, Howardena Pindell, Robert Rauschenberg, Larry Rivers, Betye Saar, and Lucas Samaras. The sources of their collage materials range from magazine ads and maps to trash and old clothes.

Décollage, the opposite of collage, involves removing images superimposed on

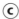

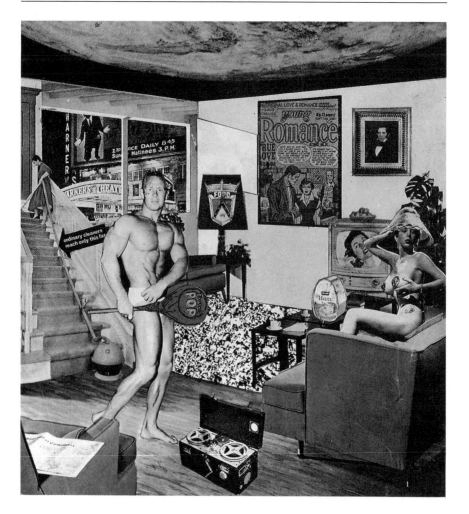

RICHARD HAMILTON (b. 1922).
Just What Is It That Makes Today's Homes So Different, So Appealing?,
1956. Collage on paper, 10 1/4 x 9 3/4 in. Kunsthalle Tübingen,
Tübingen, West Germany; Zundel Collection.

one another. This occurs spontaneously in cities when layers of posters are defaced or weathered, and it is this phenomenon that apparently inspired the pioneering use of *décollage* by the SURREALIST Leo Malet, beginning in 1934. (It has been said that Picasso's and Braque's inspiration for Cubist collage came from the layers of advertising posters that first blanketed Paris during the early twentieth century.) *Décollage* became a popular technique among Parisian NOUVEAU REALISTE artists of the 1950s, including Hérve Télémaque and Mimmo Rotella.

See ASSEMBLAGE

COLOR-FIELD PAINTING

▷ **WHO** Jack Bush (Canada), Nassos Daphnis, Gene Davis, Friedel Dzubas, Helen Frankenthaler, Sam Gilliam, Paul Jenkins, Ellsworth Kelly, Morris Louis, Kenneth Noland, Jules Olitski, Lawrence Poons, Theodoros Stamos

▷ **WHEN** Mid-1950s to late 1960s

▷ **WHERE** United States

▷ **WHAT** As its name indicates, color-field painting has two components—"color" and "field." Rejecting illusions of depth and GESTURAL brushwork, color-field painters applied color in swaths that often span the entire canvas, suggesting that it is a detail of some larger field. Intent on eliminating any distinction between a subject and its background, color-field painters treated the canvas as a single plane. This emphasis on the flatness of the painting mirrored the FORMALIST imperative that painting respect its two-dimensional nature rather than create an illusion of three-dimensionality.

Various other names for color-field painting were coined during the 1950s and 1960s. The most notable was *Post-Painterly Abstraction*, the title of an influential 1964 exhibition at the Los Angeles County Museum, curated by the critic Clement Greenberg. It encompassed what is now called HARD-EDGE PAINTING. Another once-popular term was *Systemic Painting*, the title of a 1966 exhibition curated by Lawrence Alloway at the Guggenheim Museum in New York, which featured color-field and hard-edge painters who made systematic variations on a single geometric motif, such as a circle or chevron. Finally, there is *stain painting*, which should be regarded as a subset of color-field painting:

artists such as Helen Frankenthaler and Morris Louis would stain their unprimed canvases by pouring paint rather than brushing it on, usually while working on the floor instead of on an easel or wall.

Just as Frankenthaler's technique was inspired by Jackson Pollock's poured paintings, so, too, was color-field painting an extension of ABSTRACT EXPRESSION-ISM. Pollock, with his allover compositions, was the first field painter. The inspiration for the dramatic use of color in color-field painting came from the work of the Abstract Expressionists Mark Rothko and Barnett Newman.

Since color-field painting is invariably ABSTRACT, nature-based color has typically been abandoned in favor of more expressive hues. When examined at close range, the expansive canvases of the color-field painters frequently seem to envelop the viewer in a luxuriant environment of color.

COMBINE—*see* NEO-DADA

COMMODIFICATION

MODERN art had been bought and sold since its inception, but not in sufficient quantities or at high enough prices to command much public attention until the 1960s. Many artists reacted against the new boom in contemporary art with an anticapitalist fervor typical of the 1960s. They created works that were barely visible (such as CONCEPTUAL ART), physically unstable (PROCESS ART), geographically inaccessible (EARTH ART), or highly theoretical (MINIMAL ART). Yet their attempts to thwart the market were to no avail: as with the earlier "anti-art" of DADA, no contemporary art form has eluded the grasp of determined collectors. The most visible event to link contemporary art and big money was the auction of Robert and Ethel Scull's collection of POP ART at Sotheby's New York branch in October 1973. Works of the previous fifteen years brought astronomical prices that established contemporary art as a commodity that had become a valuable investment.

It was not until the 1980s that artists took the notion of art-as-commodity for the subject of their work. (A notable exception was the French artist Yves Klein, whose *Immaterial Pictorial Sensitivity* was a series of ACTIONS in 1961–62 that involved "zones" for the exchange of gold and checks, which were then tossed into the Seine.) Current art invoking commodification ranges from

Jeff Koons's replications of throwaway KITSCH figurines in expensive materials to Mark Kostabi's Warhol-derived art "factory," in which employees produce artworks bearing his name.

See EAST VILLAGE, NEO-GEO

COMPUTER ART—*see* HIGH-TECH ART

CONCEPTUAL ART

▷ **WHO** Marina Abramovíc/Ulay (Netherlands), Ant Farm, Art & Language (Great Britain), John Baldessari, Robert Barry, Iain Baxter (Canada), Joseph BEUYS (Germany), Mel Bochner, Daniel Buren (France), Victor Burgin (Great Britain), James Lee Byars, John Cage, Hanne Darboven (Germany), Terry Fox, Hamish Fulton (Great Britain), Hans HAACKE, Howard Fried, General Idea (Canada), Dan Graham, Douglas Huebler, David Ireland, Allan Kaprow, On Kawara, Paul Kos, Joseph KOSUTH, Richard Kriesche (Austria), Suzanne Lacy, Barry Le Va, Les LEVINE, Richard Long (Great Britain), Tom MARIONI, Jim Melchert, Antoni Miralda (Spain), Robert Morris, Antonio Muntadas (Spain), Morgan O'Hara, Dennis OPPENHEIM, Mike Parr (Australia), Dieter Roth (Germany), Allen Ruppersberg, Bonnie Sherk, Imants Tillers (Australia), Richard Tuttle, Bernar Venet (France), Lawrence Weiner, Tarsua Yamamoto (Japan)

▷ **WHEN** Mid-1960s through 1970s

▷ **WHERE** International

▷ **WHAT** The term *Conceptual art* gained currency after "Paragraphs on Conceptual Art" by the MINIMALIST artist Sol LeWitt appeared in the summer 1967 issue of *Artforum.* (Similar ideas had been articulated earlier in writings by the artists Henry Flint and Edward Kienholz.) *Conceptual art*'s chief synonym is *Idea art.*

In Conceptual art the idea, rather than the object, is paramount. Conceptual artists reacted against the increasingly commercialized art world of the 1960s and the FORMALISM of postwar art—especially the impersonality of then-contemporary Minimalism. To circumvent what they saw as the too-narrow limits of art, Conceptualists used aspects of SEMIOTICS, FEMINISM, and POPULAR CULTURE to create works that barely resembled traditional art objects. What the viewer of Conceptual art saw in the gallery was simply a DOCUMENT of the artist's thinking, especially in the case of linguistic works that assumed the form of words

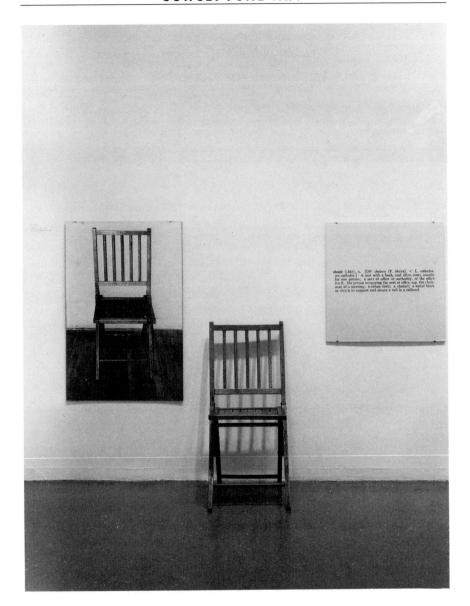

JOSEPH KOSUTH (b. 1945).
One and Three Chairs, 1965. Photograph of chair, wooden folding
chair, and photographic enlargement of dictionary definition of chair,
photo panel: 36 x 24 1/8 in.; chair: 32 3/8 x 14 7/8 x 20 7/8 in.; text panel:
24 1/8 x 24 1/2 in. Collection, The Museum of Modern Art, New York;
Larry Aldrich Foundation Fund.

on a wall. *Conceptualism* soon became an umbrella term used to describe other art forms that were neither painting nor sculpture, such as PERFORMANCE and VIDEO ART, and forms that most viewers saw only in drawings or photographs, such as EARTH ART.

The movement can trace its roots back to the early twentieth-century READY-MADES by the DADA artist Marcel Duchamp, which emphasized the artist's thinking over his manipulation of materials; to the later philosophically oriented ACTIONS of Yves Klein and Piero Manzoni; and to the painted conundrums of Jasper Johns—all of which asked "What is an artwork?" Conceptual art first reached a general audience through two major New York exhibitions in 1970: the Museum of Modern Art's *Information* (curated by Kynaston McShine) and the Jewish Museum's *Software* (curated by Jack Burnham).

The range of Conceptual art thinking is remarkably broad. It encompasses Morgan O'Hara's obsessive documentation of how she spends each waking moment, Robert Morris's construction of a box with the recorded sounds of its own making inside, and John Baldessari's documentation of the letters C-A-L-I-F-O-R-N-I-A, which he placed on the physical locations throughout the state that corresponded to the printed position of each letter on his map. Examples of more socially engaged Conceptualism include Hans Haacke's polling museum visitors for their views of Governor Nelson Rockefeller's support of the Vietnam War, Les Levine's operation of a Canadian-kosher restaurant in New York as an artwork (unbeknownst to its patrons), and Tom Marioni's organization of salon-style gatherings and exhibitions at the Museum of Conceptual Art in San Francisco, which he founded in 1970.

Conceptual art's emphasis on the artist's thinking made any activity or thought a potential work of art, without the necessity of translating it into pictorial or sculptural form. This jettisoning of art objects aroused widespread controversy among artists, viewers, and critics. The artist and theorist Allan Kaprow championed Conceptualism as an interactive form of communication, especially in the wake of visual competition from spectacular, non-art events like the American landing of men on the moon. The critics Robert Hughes (who writes for *Time*) and Hilton Kramer (who wrote for the *New York Times*) looked at Conceptual art and saw an emperor without clothes.

Although the revival of traditional-format painting and sculpture in the late 1970s seems visually far removed from Conceptual art, in fact it absorbed from the earlier movement an interest in story telling, in politics, and in images from art history and popular culture.

CONCRETE ART

▷ **WHO** Josef ALBERS, Max BILL (Switzerland), Jean Dewasne (France), Lucio Fontana (Italy), Richard Paul Lohse (Switzerland), Alberto Magnelli (Italy), Helio Oiticica (Brazil)

▷ **WHEN** 1930s through 1950s

▷ **WHERE** Western Europe, primarily, and the United States

▷ **WHAT** The Dutch artist Theo van Doesburg invented the term *Concrete art* in 1930 to refer to ABSTRACT art that was based not in nature but in geometry and the FORMAL properties of art itself—color and form, in the case of painting; volume and contour, in the case of sculpture. The term was popular before and after World War II, due to the proselytizing of the artist Josef Albers, who emigrated to the United States from Germany in 1933, and of his student Max Bill, who first applied the term to his own work in 1936.

In Concrete art, an appearance of "objectivity" is sought. The artist's personal touch is smoothed over, yielding art objects that sometimes appear to have been made by machine. Individual works vary from the mathematically precise compositions by Richard Paul Lohse, which anticipated OP ART, to Max Bill's undulating three-dimensional abstractions, which suggest the principles of physics and aerodynamics.

Concrete art has lost currency since the 1950s, but the underlying idea that an artwork has value as an independent object, even if it doesn't illuminate social concerns or express an artist's emotions, has been extremely influential. Direct and indirect links connect Concrete art and COLOR-FIELD PAINTING, OP ART, and other CONSTRUCTIVISM-derived styles.

CONSTRUCTIVISM

▷ **WHO** (from the USSR unless otherwise noted) Alexandra Exter, Naum Gabo, El LISSITZKY, Antoine Pevsner, Pablo PICASSO (France), Alexander Rodchenko, Olga Rozanova, Vladimir TATLIN

▷ **WHEN** 1913 through 1920s

▷ **WHERE** Primarily the USSR

▷ **WHAT** This early twentieth-century movement is relevant here because of its decisive influence on MODERN sculpture. *Constructivism* is now often used inaccurately to describe virtually any ABSTRACT sculpture constructed of geometric elements. The term is so frequently misused that the best way to avoid confusion is to examine its original meaning.

Constructivism refers to sculpture that is made from pieces of metal, glass, cardboard, wood, or plastic (often in combination) and that emphasizes space rather than mass. The traditional subtractive or additive ways of making sculpture had focused on mass. (Subtractive means taking away, as in carving wood or stone; additive means building up, as in modeling clay or plaster.)

Constructivism emerged from Georges Braque and Pablo Picasso's Cubist experiments. Translating the angular forms of his paintings and COLLAGES into three dimensions, Picasso created his first sheet-metal-and-wire construction of a guitar in 1912. After the Russian sculptor Vladimir Tatlin saw these works in Picasso's Paris studio a year later, he returned home and began to construct reliefs that were among the first total abstractions in the history of sculpture. He also formulated the influential Constructivist principle of "truth to materials," which asserted that certain intrinsic properties make cylinders the most appropriate shape for metal, flat planes the best for wood, and so on.

In terms of art made during the first quarter of the twentieth century, *Constructivism* is virtually synonymous with *Russian Constructivism.* Many constructions, such as Tatlin's model for the 1,300-foot-high structure *Monument to the Third International* (1919), are prototypes for architectural, stage, or industrial designs. Others are purely abstract but look as though they serve some purpose, such as Alexander Rodchenko's geometric hanging constructions that resemble today's molecular models. These homages to scientific rationality are among the most straightforward representations of the MODERNIST impulse to adapt to the technology of the machine age.

After the Bolshevik Revolution of 1917 the Constructivist artists gained power. Dissension between those interested in a more personal art and those concerned with making utilitarian designs for the masses soon split the group. As the political climate changed in favor of the latter faction in the early 1920s, many of the Russian Constructivists moved to the West. Some went to Germany's technologically oriented Bauhaus school of art and design, ensuring the spread of Constructivist principles throughout Europe and later the United States.

The effect of Constructivism on post–World War II art has been profound. It influenced technique: combining different materials, often by welding, was the chief sculptural method from the 1940s through the early 1960s. Probably more important, it influenced ways of thinking about art in relation to science and technology. That rational approach infused not only KINETIC SCULPTURE, MINIMALISM, and ART-AND-TECHNOLOGY projects but even HARD-EDGE painting and geometric abstraction.

CONTENT

Every work of art ever produced has *content*, or meaning. Analyzing the content of an artwork requires the consideration of subject, form, material, technique, sources, socio-historical context, and the artist's intention (though the artist's interpretation of the work may differ from the viewer's).

There are two widely held misconceptions about content. First, that it is the same as subject. In fact, the subject of a work is just one part of its content. An artist depicts a landscape or a figure, for example, and those are the works' subjects. The subject can usually be identified by sight, whereas the content requires interpretation. Often that interpretation takes into account factors that are invisible in the work, such as the expectations of the patron who commissioned the work or art historical precedents. The content of a landscape might be divine benevolence or humanity's destructive impulses toward the planet. The content of a portrait might range from the glorification of the sitter's social standing to the artist's sexual objectification of the model.

The second common misconception about content is that it is the opposite of form—which includes size, shape, texture, etc. In effective artworks, form and content reinforce one another. For instance, the machine-made look of a HARD-EDGE painting devalues the importance of the artist's personal touch. Psychic depletion is suggested in Alberto Giacometti's pencil-thin figures by both the attenuation of the forms and their pitted metal surfaces.

COOPERATIVE GALLERY—*see* ALTERNATIVE SPACE

COPY ART—*see* HIGH-TECH ART

CRAFTS-AS-ART

▷ **WHO** Rudy AUTIO, Wendell Castle, Dale CHIHULY, Dan Dailey, Marvin Lipofsky, Harvey Littleton, Sam MALOOF, Nance O'Banion, Albert Paley, Peter VOULKOS, Claire Zeisler

▷ **WHEN** First attracted national attention in the 1970s

▷ **WHERE** Primarily the United States

▷ **WHAT** The term *crafts-as-art* refers to the recent elevation of craft materials to art—clay to CERAMIC SCULPTURE, glass to glass sculpture, etc.—and the rise in status of some craftspersons to that of artists.

Until World War II crafts and art were easy to tell apart. Art was generally made of art materials (paint on canvas, bronze, etc.), had serious CONTENT, and served no function around the house. Crafts were made of craft materials (wool, wood, pottery) and were designed to be used.

During the 1950s the lines separating art and craft began to dissolve. Crafts-persons began to create nonfunctioning objects, which became hard to distinguish from sculpture. This move away from the functional occurred first among ceramic sculptors in California and inspired artisans working in glass and metal during the 1960s and 1970s. They, in turn, influenced artists of the 1970s such as Faith Ringgold, Miriam Schapiro, and Christopher Wilmarth to consider new materials. Likewise, many artists of that decade became interested in functional objects, producing ARTISTS' FURNITURE and other hybrid art/non-art forms. A chair being exhibited in a gallery today, for example, may be the work of an artist, an architect, a furniture designer, or a craftsperson.

DADA

▷ **WHO** Jean (Hans) Arp (Germany), Marcel DUCHAMP (France), Max ERNST (Germany), Hannah Höch (Germany), Francis PICABIA (France), Man Ray, Morton Schamberg, Kurt Schwitters (Germany)

▷ **WHEN** 1915 to 1923

▷ **WHERE** New York and Western Europe

▷ **WHAT** Dada, an *early* twentieth-century movement, is included here because the last half-century's art cannot be understood without referring to Dada art forms, ideas, and attitudes.

Dada means a variety of things in a variety of languages, including *hobby horse* in French and *yes, yes* in Slavic tongues. One version of the name's origin has it that in 1916 the poet Tristan Tzara stuck a pen knife in a dictionary at random and it landed on the nonsensical-sounding term.

Dada sprang up during and immediately after World War I; first in the neutral cities of Zürich, New York, and Barcelona, later in Berlin, Cologne, and Paris. It was largely a response to the tragic toll—more than ten million dead—exacted by the "Great War." That the new machine-age technology could wreak such havoc made many wonder whether the price for modernity's material benefits was too high. The Dada artists blamed society's supposedly rational forces of scientific and technological development for bringing European civilization to the brink of self-destruction. They responded with art that was the opposite of rational: simultaneously absurd and playful, confrontational and nihilistic, intuitive and emotive.

Dada, then, is not a STYLE, or even a number of styles, but a world view. Nor were its attitudes embodied only in artworks. Active as citizen-provocateurs rather than studio-bound producers of objects, Dada artists organized incendiary public events. The results varied from the rabble-rousing mixed-media programs at Zürich's Cabaret Voltaire, which anticipated PERFORMANCE ART, to the quasi-philosophical inquiries posed by Marcel Duchamp's many inventions such as the READYMADE.

Jean Arp's chance-derived compositions and Man Ray's threatening objects—an iron with nails on its face titled *Gift* (1921), for example—similarly assaulted traditional notions of what art should be. (Such objects also paved the way for SURREALISM.) Francis Picabia and Duchamp produced paintings, sculptures, and constructions that were more conventional in format, including images of people as machines, which at the time went largely unappreciated.

The aggressive absurdity of much of the Dada art enraged many viewers. Although its critical stance toward bourgeois society is characteristic of MODERN ART, the Dada artists were the most virulent of modernists in their rejection of middle-class morality. (CONCEPTUAL ART and late 1980s artworks examining the role of art as COMMODITY are rooted in Dada ideas and gestures.) Later aptly

dubbed *anti-art*, Dada objects ironically have become valued as priceless masterpieces in today's art world, and Duchamp is now revered, along with Pablo Picasso, as the most influential artist of the twentieth century.

See NEO-DADA

DECOLLAGE—*see* COLLAGE

DECONSTRUCTION—*see* SEMIOTICS

DOCUMENTATION

Documentation has two meanings. Its everyday meaning refers to photographs, videotapes, or written materials related to an artwork's creation, exhibition, or history.

A more complex notion of documentation applies to CONCEPTUAL ART, especially works of EARTH ART and PERFORMANCE ART. Some ephemeral performances or out-of-the-way earthworks—including the private rituals enacted by Vito Acconci or Donna Henes, the geographically inaccessible *Lightning Field* by Walter De Maria, and the short-lived environmental spectaculars by Christo—are known mainly through documentation. When made by the artist himself, this sort of documentation can be art as well as historical record. As such, it is exhibited and sold as art, unlike the work it documents.

EARTH ART

▷ **WHO** Alice Aycock, Christo, Jan Dibbets (Netherlands), Hamish Fulton (Great Britain), Michael HEIZER, Nancy HOLT, Richard Long (Great Britain), Walter De Maria, Ana Mendieta, Mary Miss, Robert Morris, Dennis Oppenheim, Michael Singer, Robert SMITHSON, Alan Sonfist

▷ **WHEN** Mid-1960s through 1970s

▷ **WHERE** Primarily northern Europe and the United States

▷ **WHAT** Earth art, or environmental art, was a broad-based movement of artists who shared two key concerns of the 1960s: the rejection of the commercialization of art, and the support of the emerging ecological movement, with

its "back-to-the-land" antiurbanism and sometimes spiritual attitude toward the planet.

The wide-ranging methods and goals of these artists are best described through examples. Alan Sonfist landscaped urban sites in an attempt to return them to their prehistoric, or natural, states. Nancy Holt constructed astronomically oriented architectural structures suggestive of Stonehenge. Michael Heizer and Robert Smithson moved tons of earth and rock in the deserts of the American West to create massive earth sculptures sometimes reminiscent of ancient burial mounds. Richard Long recorded his excursions through the landscape and the ephemeral arrangements of rocks and flowers he made there in elegantly composed photographs.

Exhibiting photographic DOCUMENTATION of remote works is standard operating procedure for earth artists, as it is for CONCEPTUAL artists. Earth art should also be considered alongside contemporaneous ARTE POVERA and PROCESS ART. While process artists incorporated the rhythms and systems of nature within their work, earth artists actually moved into nature itself. Although aggressive assaults on the landscape like Smithson's spectacular *Spiral Jetty*—a 1,500-foot-long rock-and-salt-crystal jetty in the Great Salt Lake—are the best known of the earthworks, more ecologically sensitive works were produced by artists such as Long, Dennis Oppenheim, Michael Singer, and Sonfist.

EAST VILLAGE

▷ **WHO** Mike BIDLO, Arch Connelly, Jimmy DeSana, John Fekner, Rodney Alan Greenblat, Richard Hambleton, Keith Haring, Marilyn Minter, Nicolas Moufarrege, Peter Nagy, Lee Quinones, Walter Robinson, Kenny SCHARF, Peter Schuyff, Huck Snyder, Meyer Vaisman, David WOJNAROWICZ, Martin WONG, Zephyr, Rhonda Zwillinger

▷ **WHEN** 1981 to 1987

▷ **WHERE** New York

▷ **WHAT** *East Village* means East *Greenwich* Village, until recently a working-class neighborhood in downtown Manhattan. During the early and mid-1980s *East Village* came to stand for an explosion of art, PERFORMANCE ART, and musical activity in the clubs and galleries that helped define the rapidly gentrifying neighborhood.

In terms of visual art, the East Village was characterized by a bustling entrepreneurial scene, with many East Village artists doing double duty as art dealers. This Warholian embrace of commerce was a rejection of the publicly funded activities of the ALTERNATIVE SPACES of the previous decade and a reflection of New York's Wall Street—driven boom economy of the mid-1980s. Collectors of new art garnered considerable publicity, and more than fifty eccentrically named galleries (including Fun, Civilian Warfare, Gracie Mansion, and Nature Morte) sprang up to serve them.

GRAFFITI ART and NEO-EXPRESSIONISM are often associated with the East Village, but other STYLES were made and shown there too. During the mid-1980s CONCEPTUAL and NEO-GEO art began to emerge in the then-fertile environment. The demise of the East Village art scene began in 1985, when the four-year-old Fun Gallery, the first in the neighborhood, closed its doors. By the 1988–89 season, the vast majority of the galleries had either moved to Soho, where rents were now cheaper and patrons more plentiful than in the East Village, or shut down.

ENVIRONMENTAL ART—*see* EARTH ART

ESSENTIALIST—*see* FEMINIST ART

EXPRESSIONISM

Expressionism refers to art that puts a premium on expressing emotions. Painters and sculptors communicate emotion by distorting color or shape or surface or space in a highly personal fashion.

The "opposite" of expressionism is Impressionism, with its quasi-scientific emphasis on capturing fleeting perceptions, such as the appearance of light on a cathedral façade at a specific time of day. Like ABSTRACTION and REPRESENTATION, expressionism and Impressionism are not diametric opposites so much as two ends of a spectrum along which most artworks are positioned.

The adjective *expressionist* is used to describe artworks of any historical era that are predominantly emotive in character. The noun *expressionism* is usually associated with MODERN art but not with any one movement or group of

artists. There have been several expressionist movements; their names are always modified with an adjective, such as German Expressionism or ABSTRACT EXPRESSIONISM, or given another name entirely, such as the "Fauves" (literally the "wild beasts").

Modern expressionism is usually traced back to the works of Vincent van Gogh and the Fauves (Henri Matisse, André Derain, Raoul Dufy, Maurice de Vlaminck), whose idiosyncratic choice of colors was intended to evoke feeling rather than to describe nature. The PRIMITIVIZING art of two early twentieth-century groups—Die Brücke (The Bridge; Erich Heckel, Ernst Kirchner, Karl Schmidt-Rottluff) and Der Blaue Reiter (The Blue Rider; Alexei von Jawlensky, Wassily Kandinsky, Paul Klee, Auguste Macke, Franz Marc, Gabriele Münter)—is known as German Expressionism. The tag ABSTRACT EXPRESSIONIST was applied to American painters of the 1940s and '50s to distinguish them from abstract painters with a more geometric or cerebral—that is, less emotive or intuitive—bent.

In Western society the public regards modern art chiefly as a vehicle for releasing emotion. Despite that widely held view, the current of modern art's mainstream has tended to shift between art emphasizing rational thought and art emphasizing feeling. Following the many CONCEPTUAL ART—derived modes of the 1970s, the expressionist impulse resurfaced with NEO-EXPRESSIONISM, the first of the POSTMODERN movements characterized by an orgasmic explosion of feeling.

FABRICATED PHOTOGRAPHY

▷ **WHO** Harry Bowers, Ellen BROOKS, James Casebere, Bruce Charlesworth, Robert CUMMING, John Divola, Bernard Faucon (France), Fischli and Weiss (Switzerland), Adam Füss (Australia), Barbara Kasten, David Levinthal, Mike Mandel and Larry Sultan, Olivier Richon (Great Britain), Don Rodan, Laurie Simmons, Sandy SKOGLUND, Boyd Webb (Great Britain)

▷ **WHEN** Since the mid-1970s

▷ **WHERE** United States and Western Europe

▷ **WHAT** Although the term *fabricated photography* suggests falsification or fakery, it actually means pictures whose nonhuman subjects have been constructed by the photographer for the sole purpose of being photographed. Imagery varies widely. Ellen Brooks places Barbie-style dolls in miniature tableau settings where they appear to enact the social rituals of contemporary

life. John Divola assaulted an already vandalized lifeguard station with spray paint to create a disturbingly contemporary ruin.

Fabricated photography is a subset of *set-up photography* or *staged photography*, which are more expansive but less frequently used terms. They encompass the type of work described above plus photographs of human or animal actors—such as Cindy Sherman's pictures of herself in costume and William Wegman's images of his dressed-up dogs, Man Ray and Fay Ray. All these approaches reject traditional, observable subjects—Yosemite Falls, a bell pepper, the photographer's lover—in favor of highly theatrical, frankly fictitious ones.

FASHION AESTHETIC

WHO Richard AVEDON, Guy Boudin (France), Frank Majore, Robert MAPPLETHORPE, Helmut Newton (Great Britain), Irving Penn, Herb Ritts, Deborah Turbeville, Chris Van Wangenheim, Bruce Weber

WHEN Since the late 1960s

WHERE Primarily the United States and Western Europe

WHAT The *fashion aesthetic* (or *fashion sensibility*) refers not to fashion photography—commercial work commissioned for advertisements—but to the use of fashion photography's glamorizing style in "art" photographs intended for gallery walls. The fashion photograph—and now the fashion-aesthetic portrait or figure study—relies on bold and simple design flavored with a dash of class and sexiness. Many of its most suggestive qualities have been pirated from AVANT-GARDE art and photography, usually long after the fact. Cubism, which had emerged before World War I, was "borrowed" by Irving Penn and Horst during the 1940s for fashion photo-layouts. Richard Avedon's fascination with physical movement in fashion pictures was rooted in art photography made thirty years earlier by Henri Cartier-Bresson and André Kertesz.

Most photographers producing fashion-aesthetic pictures are also fashion photographers. Art photographers have supported themselves with their fashion shots since fashion photography's inception in the work of early twentieth-century figures such as Baron Adolphe de Meyer, Edward Steichen, Louise Dahl Wolfe, and Cecil Beaton. Despite this crossover, the distinction between a photographer's art photography and his or her fashion photography was strictly delineated. Then, in 1978, the prestigious Metropolitan Museum of Art in

New York eroded this distinction by mounting a major exhibition integrating Avedon's fashion, art, and journalistic pictures.

The situation has grown increasingly confused ever since. Throughout the 1970s Irving Penn straightforwardly applied the fashion aesthetic to garbage and cigarette butts, endowing such gritty subjects with elegance. During the 1980s most photographers utilized the fashion aesthetic to comment on itself. Celebrated photographers like Robert Mapplethorpe and Bruce Weber have synthesized a homoerotic sensibility that virtually merges fashion and art—only the context of who commissioned the pictures and where they were intended to be seen distinguishes the two types of their photographs. All of this work has, incidentally, helped to fuel a market for current and historic fashion-advertising photography comparable to that for film stills and publicity shots.

FEMINIST ART

▷ **WHO** Eleanor Antin, Judith Barry, Lynda Benglis, Helen Chadwick (Great Britain), Judy CHICAGO, Judy Dater, Mary Beth Edelson, Rose English (Great Britain), Feminist Art Workers, Karen Finley, Harmony Hammond, Lynn Hirshman, Rebecca Horn (Germany), Joan Jonas, Mary KELLY (Great Britain), Silvia Kolbowski, Barbara Kruger, Leslie Labowitz, Suzanne LACY, Sherrie Levine, Ana Mendieta, Meredith Monk, Linda Montano, Anne Noggle, Donna-Lee Phillips, Yvonne Rainer, Martha Rosler, Faith Ringgold, Ulrike Rosenbach (Germany), Miriam SCHAPIRO, Carolee Schneemann, Cindy Sherman, Barbara Smith, Nancy Spero, May STEVENS, Rosemarie Trockel (Germany), Hannah Wilke, Sylvia Ziranek (Great Britain)

▷ **WHEN** Since the late 1960s

▷ **WHERE** Primarily Great Britain and the United States

▷ **WHAT** Women artists such as Helen Frankenthaler, Grace Hartigan, and Bridget Riley gained considerable reputations during the 1950s and early 1960s. Although they were female, the CONTENT of their work was not, by design, feminist: that is, it neither addressed the historical condition of women nor could it be identified as woman-made on the basis of appearance alone. Until the end of the 1960s most women artists sought to "de-gender" art in order to compete in the male-dominated, mainstream art world.

The counterculture of the 1960s inspired new and progressive social analyses. The mainstream was no longer regarded as ideologically neutral. Feminist analysis suggested that the art "system"—and even art history itself—had institutionalized sexism, just as the patriarchal society-at-large had done. Feminists employed the classic strategy of the disenfranchised, as did racial minorities, lesbians, and gays: they restudied and reinterpreted history. Of special concern to feminist theorists was the historical bias against crafts vis-à-vis HIGH ART. This new interest in art forms that had traditionally been relegated to the bottom of the status hierarchy (quilts, Persian rugs, Navajo blankets) eventually led to the emergence of PATTERN AND DECORATION in the mid-1970s.

By 1969 overtly feminist artworks were being made and feminist issues raised. That year saw the creation of both WAR (Women Artists in Revolution), an offshoot of the New York–based Art Workers' Coalition, and the Feminist Art Program, led by Judy Chicago at California State University in Fresno. (It soon recruited Miriam Schapiro as codirector and moved to the California Institute of the Arts in Valencia.) Fledgling feminist institutions quickly arose in New York, Los Angeles, San Francisco, and London, including galleries (A.I.R., SoHo 20, the Women's Building, Womanspace); publications (*Women and Art, Feminist Art Journal, Heresies*); and exhibitions (*Womanhouse, Womanpower*). Throughout the 1970s the meaning of feminist art and the roles that politics and spirituality play within it (the latter sometimes in the form of the "Great Goddess") were articulated by thoughtful critics such as Lucy Lippard and Moira Roth. By the end of the decade the position of the essentialists—that there was a biologically determined female identity that should be expressed in women's creations—was challenged by feminist artists and writers who regard that identity as culturally determined or "socially constructed."

Feminist artworks have varied greatly. Predominating in the 1970s were auto-biographical works in many media and cathartic, ritualized PERFORMANCES—including Mary Beth Edelson's *Memorials to the 9,000,000 Women Burned as Witches in the Christian Era* and Suzanne Lacy's and Leslie Labowitz's *In Mourning and in Rage*, a series of events featuring black-hooded figures that was designed to attract the attention of the news media and disseminate information about violence against women at the time of the Hillside Strangler rape-murders in Los Angeles.

The return in the 1980s to traditional media encouraged feminist artists to create works with a CONCEPTUAL—and critical—bent. The notion of the patriarchal "male gaze" directed at the objectified female OTHER has been explored by

artists including Yvonne Rainer, Silvia Kolbowski, and the British artist Victor Burgin. Two examples of recent feminist art that have received widespread attention are Cindy Sherman's photographic investigations of the self in a culture of role playing and Barbara Kruger's evocations of cultural domination through the graphic vocabulary of advertising.

If such works seem less overtly feminist than their predecessors, it is largely because feminist principles have been so widely accepted—despite the brouhaha frequently surrounding the term itself. In opposition to the purity and exclusivity of MODERNISM, feminism called for an expansive approach to art. The feminist use of NARRATIVE, autobiography, decoration, ritual, CRAFTS-AS-ART, and POPULAR CULTURE helped catalyze the development of POSTMODERNISM.

FIGURATIVE

Figurative is a word that is used in two sometimes contradictory ways. Traditionally it has been applied to artworks that are REPRESENTATIONAL rather than completely ABSTRACT. Grounded in nature, such images encompass everything from nudes and portraits to still lifes and landscapes.

According to Webster's dictionary, *figurative* also means "having to do with figure drawing, painting, etc." This sense of the term is gaining popularity. To many speakers, *figurative painting* means paintings of the human figure. You are likely to hear it used both ways.

"FINISH FETISH"—*see* LOS ANGELES "LOOK"

FLUXUS

▷ **WHO** Joseph Beuys (Germany), George BRECHT (Germany), Robert Filiou (France), Ken Friedman, Dick HIGGINS, Ray Johnson, Alison Knowles, George MACIUNAS, Jackson MacLow, Charlotte Moorman, Yoko Ono, Nam June Paik, Daniel Spoerri (Switzerland), Ben Vautier (France), Wolf Vostell (Germany), Robert Watts, Lamonte Young

▷ **WHEN** 1960s

▷ **WHERE** International, having begun in Germany and quickly spread to New York and the northern European capitals. Similar activities were taking place independently in Japan and California.

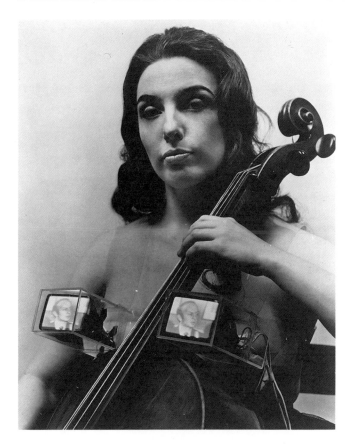

NAM JUNE PAIK (b. 1932).
TV Bra for Living Sculpture, 1969. Television sets and cello (worn by cellist Charlotte Moorman). Photograph © Peter Moore, 1969.

▷ **WHAT** The term *Fluxus* was first used by George Maciunas on an invitation to a 1961 lecture series at the Gallery A/G in New York. Implying *flow* or *change* in several languages, Fluxus is more a state of mind than a STYLE.

With Fluxus artists, social goals often assumed primacy over aesthetic ones. The main aim was to upset the bourgeois routines of art and life. Early Fluxus events—guerrilla theater, street spectacles, concerts of electronic music—were aggressive demonstrations of the libidinal energy and anarchy generally associated with the 1960s. Rather than an alliance with POPULAR CULTURE, Fluxus artists sought a new culture, to be fashioned by AVANT-GARDE artists, musicians, and poets. Mixed media was the typical Fluxus format. Numerous art forms were simultaneously and cacophonously deployed at events that sometimes resembled contemporaneous ACTIONS or later HAPPENINGS, though they tended to be more humorous and open-ended.

Such events ranged from group readings of Haiku-length poems that pre-scribed simple activities like taking a stroll or burning a Christmas tree to attention-getting events such as the Charlotte Moorman–Nam June Paik col-laboration featuring Moorman playing her cello while wearing little more than a brassiere fashioned from miniature television sets.

Fluxus activity was not limited to live events. Mail (or correspondence) art—postcardlike collages or other small-scale works that utilized the mail as a distribution system—were pioneered by Fluxus artists, especially Ray Johnson. Another Fluxus innovation was rubber-stamp art, sometimes in tandem with mail art. Fluxus artworks can sound eccentric and inconsequential, but their underlying iconoclastic attitudes made them influential precursors of CONCEPTUAL and PERFORMANCE art.

FOLK ART—*see* NAIVE ART

FORMAL/FORMALISM

Formalism derives from *form.* A work's "formal" qualities are those visual elements that give it form—its shape, size, structure, scale, composition, color, etc. *Formalism* is generally believed to imply an artistic or interpretive emphasis on form, rather than CONTENT, but form and content are, in fact, complementary aspects in any work.

Although philosophical debates about form were initiated in ancient Greece, the concept of formalism is generally associated with MODERN art and especially with the thinking of three influential theorists: the critics Clive Bell, Roger Fry, and Clement Greenberg. At the beginning of the twentieth century the British writers Bell and Fry sought to create a quasi-scientific system based on visual analysis of an artwork's formal qualities rather than its creator's intentions or its social function. Developed in response to the early modern interest in artworks foreign to the Western tradition—especially Japanese prints and African sculpture—their method was intended to permit the cross-cultural evaluation of art from any place or time.

The formalist approach dominated art criticism and modernist thought after World War II. Its best-known exemplar is the American Clement Greenberg, whose influence rose along with that of American art—chiefly ABSTRACT EXPRESSIONISM and later manifestations of NEW YORK SCHOOL painting and sculpture.

A new generation of articulate formalist critics such as Michael Fried and Rosalind Krauss emerged in the 1960s, but so did the limits of the formalist approach. POP ART, in particular, defied meaningful formal analysis. How could Roy Lichtenstein's images taken from comic books be understood without investigating their social and cultural meanings? Pop art proved to be a precursor of POSTMODERNISM, and since the mid-1970s formalist interpretation has been yielding to more expansive critical approaches based in FEMINISM, SEMIOTICS, and DECONSTRUCTION.

FOUND OBJECT

A found object is an existing object—often a mundane manufactured product—given a new identity as an artwork or part of an artwork. The artist credited with the concept of the found object is Marcel Duchamp. (Georges Braque and Pablo Picasso had already begun to inject bits of non-art material into their pioneering COLLAGES and ASSEMBLAGES of 1912–15, but they significantly altered those materials.) In 1913 Duchamp began to experiment with what he dubbed the *Readymade*. After adding a title to an unaltered, mass-produced object—a urinal or a shovel, for example—he would exhibit it, thereby transforming it into a readymade sculpture. His intention was to emphasize art's intellectual basis and, in the process, to shift attention away from the physical act or craft involved in its creation. Other DADA and SURREALIST artists mined the nostalgic potential of found objects in works less cerebral than Duchamp's.

Post—World War II artists put found objects to a variety of different purposes. They range from Edward Kienholz's chilling tableaux assembled from man-nequins and discarded furniture to Haim Steinbach's more theoretical ensem-bles of domestic objects intended to question whether artworks made of mass-produced components can be simultaneously functional, decorative, and expressive. Joseph Beuys's dog-sled sculpture invokes his personal history, and even painters such as Jasper Johns have utilized found objects (in Johns's case, a broom, a chair, ball bearings) by affixing them to their paintings. Whether old or new, a found object infuses an artwork with meanings associ-ated with its past use or intended function.

See NEO-DADA

FUNK ART

▷ **WHO** Robert Arneson, Clayton Bailey, Bruce Conner, Roy DE FOREST, Mel Henderson, Robert HUDSON, Richard Shaw, William WILEY

▷ **WHEN** Mid-1960s to mid-1970s

▷ **WHERE** San Francisco Bay Area

▷ **WHAT** *Funk* derives from *funky,* a musical term that was applied to numer-ous visual artists in Northern California starting in the early 1960s. Peter Selz, then director of the University Art Museum in Berkeley, officially christened the movement with the 1967 exhibition *Funk.*

Funk art is offbeat, sensuous, and direct. Humor, vulgarity, and autobiograph-ical narrative are typical elements, although funk art imagery ranges far and wide, from Roy De Forest's paintings of anthropomorphic animals to Robert Hudson's brightly painted sculptural abstractions. Funk artists frequently delighted in the manipulation of unusual materials and FOUND OBJECTS. Their unconventional use of materials not only obscured the division between painting and sculpture but also helped transform clay from a crafts material to a sculptural one.

Funk art was heavily influenced by earlier anti-art movements, especially the playful absurdity of DADA and NEO-DADA. (William Wiley's punning work has been aptly dubbed "Dude Ranch Dada.") Reacting against the seriousness of New York— and Los Angeles—centered abstraction, funk artists have looked to POPULAR CULTURE rather than the history of art for inspiration.

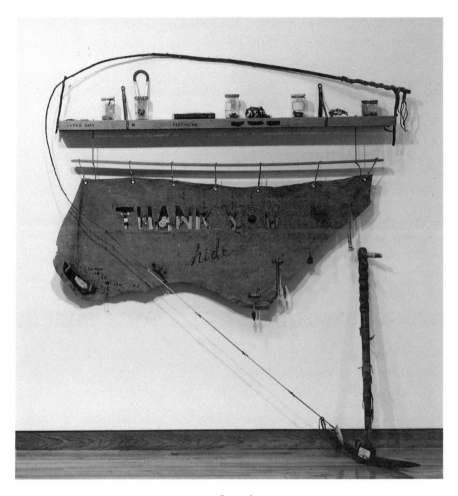

WILLIAM T. WILEY (b. 1937).
Thank You Hide, 1970–71. Wood, leather, pick, found objects, and ink and charcoal on cowhide, 74 x 160 1/2 in. Des Moines Art Center; Coffin Fine Arts Trust Fund, 1970–71.

In 1969 the Chicago artists James Nutt and Gladys Nilsson were guest teachers at the University of California at Davis, an hour's drive north of San Francisco. While working in this bastion of funk art they helped cement the strong bonds between CHICAGO IMAGIST and Bay Area artists.

GESTURE/GESTURALISM

Gesturalism refers to paintings or drawings that emphasize the artist's expressive brushwork. By calling attention to his or her "handwriting," an artist evokes the subjectivity of painting itself.

The expression of artistic personality through gestural brushwork dates back at least as far as the seventeenth-century paintings of Frans Hals and Diego Velázquez and in modern art to the canvases of Edouard Manet. Gesturalism became a vehicle for EXPRESSIONISM starting with the work of Vincent van Gogh, and the two have been linked ever since, most recently in the gestural output of NEO-EXPRESSIONIST artists.

GRAFFITI ART

▷ **WHO** Crash, Daze, Dondi, Fab Five Freddie (also known as Freddie Brathwaite), Futura 2000, Keith HARING, Lady Pink, Lee Quinones, Ramellzee, Samo (aka Jean-Michel Basquiat), Alex Vallauri (Brazil), Zephyr (aka Andrew Witten)

▷ **WHEN** Mid-1970s to mid-1980s

▷ **WHERE** Primarily New York

▷ **WHAT** *Graffito* means "scratch" in Italian, and graffiti (the plural form) are drawings or images scratched into the surfaces of walls. Illicit graffiti (of the "Kilroy was here" variety) dates back to ancient Egypt. Graffiti slipped into the studio as a subject after World War II. Artists such as Cy Twombly and Jackson Pollock were interested in the way it looked, the Frenchman Jean Dubuffet was interested in what it meant as a kind of OUTSIDER ART, and the Spaniard Antoni Tàpies was interested in the ways it could be incorporated into his imagery of urban walls.

During the early 1970s—soon after aerosol spray paint in cans became readily available—New York subway trains were subjected to an onslaught of exuber-

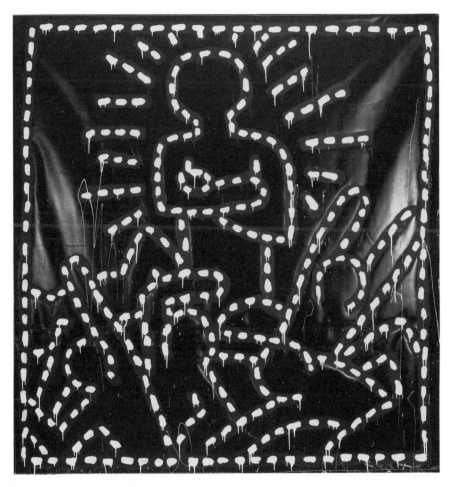

KEITH HARING (b. 1958).
Untitled, 1982. Vinyl ink on tarpaulin, 84 x 84 in. Dannheisser
Foundation.

antly colored graffiti. The words and "tags" (graffiti writers' names) were soon augmented with elaborate cartoon-inspired images. Most graffitists were neither professional artists nor art students but streetwise teenagers from the Bronx and Brooklyn.

Several milestones marked graffiti's move from the street to the gallery: the United Graffiti Artists' 1975 exhibition at New York's Artists Space; Fab Five Freddie's widely discussed spray-painted homage to Andy Warhol's Campbell's soup cans in 1980; the *Times Square Show*, also in 1980, which galvanized the attention of the New York art world; the ongoing support in the form of exhibition opportunities and career counseling provided by Fashion Moda, an ALTERNATIVE SPACE in the Bronx; and, ultimately, the development of a graffiti STYLE by professionally trained artists such as Keith Haring. The year 1983 saw the zenith of graffiti art, with its first major museum exhibition at the Boymans-van Beuningen Museum in Rotterdam and the *Post-Graffiti* exhibition at Sidney Janis's blue-chip gallery.

The popularization of graffiti raised questions of unusual aesthetic and sociological import. Was graffiti vandalism? Or urban FOLK ART? The writer Norman Mailer romanticized it as the anarchic manifestation of social freedom, while critics such as Suzi Gablik charged that ghetto youths were being exploited by a novelty-crazed art market.

Graffiti's move to the galleries proved fatal: by the mid-1980s it already seemed outmoded. Underground "tags" and images designed to be rapidly painted on metal and seen in motion had been transformed into self-parody. Like the latest trend in fashion, graffiti was imported from the streets, commercialized, and then quickly pushed aside.

See EAST VILLAGE

GUTAI—*see* HAPPENING

HAIRY WHO—*see* CHICAGO IMAGISM

HAPPENING

▷ **WHO** Jim Dine, Red Grooms, Al Hansen, Allan KAPROW, Claes Oldenburg, Carolee Schneemann, Robert Whitman

▷ **WHERE** Primarily New York

▷ **WHEN** Early to mid-1960s

▷ **WHAT** The name *Happening* comes from Allan Kaprow's first show at New York's Reuben Gallery in 1959, called *18 Happenings in 6 Parts*. Within three rooms a carefully rehearsed multimedia event unfolded. Performers coolly read fragmented texts (a sample: "I was about to speak yesterday on a subject most dear to you all—art . . . but I was unable to begin"); assumed mimelike poses; painted on canvas; played the violin, flute, and ukelele. Meanwhile, the audience moved from room to room on cue, "becom[ing] part of the happenings" as the invitation had promised. It also became the audience's task to decipher the disconnected events. Kaprow offered little help, having cautioned those attending that "the action will mean nothing clearly formulable so far as the artist is concerned."

Kaprow defined a Happening as an "assemblage of events performed or perceived in more than one time and place"—that is, as an environmental artwork activated by performers and viewers. The artists who made Happenings never issued a group manifesto defining their art form, and that may help account for its variety. Red Grooms's *Burning Building* (1962) was a vaudeville-style evocation of a fire that had performers tumbling out of the set's windows. Claes Oldenburg's eerie *Autobodys* (1963), staged in a Los Angeles drive-in movie theater, was populated primarily by figures on roller skates and black-and-white cars inspired by the limousines prominent in the television coverage of President Kennedy's then-recent funeral.

Some have cited the Happening-like spectacles created by the Japanese Gutai group as precedents for Happenings, but neither the Gutai artists nor their work was known in New York until the early 1960s. (The experimental art group was founded in Osaka in 1954 under the influence of the master-artist Jiro Yoshihara and included the artists Akira Kanayama, Saburo Mirakami, and Kazuo Shiraga.) Precursors closer to home were the various DADA events, with their chance-derived arrangements or compositions. The composer John Cage spread the word about them, first at Black Mountain College in North Carolina and later at the New School for Social Research in New York, where most of the Happening artists attended his classes during the

mid-1950s. The mixing of media and the concern for everyday life in Happenings is part of the larger POP ART phenomenon.

See ACTION/ACTIONISM, FLUXUS, PERFORMANCE ART

HARD-EDGE PAINTING

▷ **WHO** Karl Benjamin, Lorser Feitelson, Frederick Hammersley, Al Held, Ellsworth KELLY, John McLaughlin, Kenneth NOLAND, Jack Youngerman

▷ **WHEN** Late 1950s through 1960s

▷ **WHERE** United States

▷ **WHAT** The term *hard-edge painting* was first used in 1958 by the Los Angeles critic Jules Langsner to describe the ABSTRACT canvases of West Coast painters uninterested in the brushy GESTURALISM of ABSTRACT EXPRESSIONISM. The following year the critic Lawrence Alloway applied the term to American paintings with surfaces treated as a single flat unit. The distinction between figure and background was eliminated in favor of the allover approach pioneered by Jackson Pollock a decade earlier. Unlike Pollock's free-form compositions, hard-edge paintings are typically geometric, symmetrical, and limited in palette. Other precursors from the 1950s include Ad Reinhardt, Leon Polk Smith, and Alexander Liberman.

Hard-edge paintings vary from Kenneth Noland's chevron-patterned compositions to Ellsworth Kelly's oddly shaped monochrome paintings on canvas or metal. The machine-made look of such works pointed ahead to the three-dimensional "primary structures" of MINIMALISM. Although the precision and impersonality of hard-edge painting distinguish it from the spontaneous-looking compositions of COLOR-FIELD PAINTING, the two styles overlapped, and artists such as Noland worked in both modes.

HIGH ART—*see* POPULAR CULTURE

HIGH-TECH ART

▷ **WHO** Artn, Nancy Burson, Harold Cohen (Great Britain), Douglas Davis, Peter D'Agostino, Paul Earls, Ed Emshwiller, Perry Hoberman, Jenny Holzer, Milton Komisar, Bernd Kracke (Germany), Bruce Nauman, Nam June Paik, Sonya

Rapoport, Alan Rath, Bryan Rogers, James Seawright, Sonia Sheridan, Eric Staller, Wen-ying Tsai, Stan Vanderbeek, Woody Vasulka, Ted Victoria

▷ **WHEN** Since the 1970s

▷ **WHERE** Primarily the United States

▷ **WHAT** High-tech art is not a movement; it is contemporary art made with sophisticated technology, including computers, lasers, holograms, photo-copiers, facsimile machines, satellite transmissions, and the like. The range of such work is broad, from sensuous copy-machine prints by Sonia Sheridan to computer-driven drawing-and-painting machines by Milton Komisar. The most effective high-tech art transcends its hardware. It can explore themes related to technology (as in Alan Rath's *Voyeur*, a humanoid construction with video monitors for eyes) or simply employ a particular technology to help con-vey meaning, just as a painter might select acrylic over oil paints for a desired effect. CONCEPTUAL ART encouraged artists to use any materials necessary for the communication of their ideas.

In many instances, the hardware and expertise required for high-tech artworks is difficult to obtain and utilize. It has frequently been provided by corpora-tions or by institutions such as the Massachusetts Institute of Technology's Center for Advanced Visual Studies, which sprang from the ART-AND-TECHNOLOGY movement. That movement of the 1960s mirrored the profound optimism about technology embodied in MODERNISM, but more recent art is likely to express the ambivalence toward it shared by many denizens of POSTMODERN society.

HOLOGRAPHY—*see* HIGH-TECH ART

HYPER-REALISM—*see* PHOTO-REALISM

IDEA ART—*see* CONCEPTUAL ART

INSTALLATION

▷ **WHO** Terry Allen, Joseph BEUYS (Germany), Christian Boltanski (France), Jonathan Borofsky, Marcel Broodthaers (Belgium), Daniel BUREN (France), Chris Burden, Bruce Charlesworth, Terry Fox, Howard Fried, GENERAL IDEA (Canada), Frank Gillette, Group Material, Hans HAACKE, Helen and Newton HARRISON, Lynn Hirshman, David Ireland, Patrick Ireland, Robert IRWIN, Irwin (Yugoslavia), Ilya Kabakov (USSR), Joseph Kosuth, Sol LeWitt, Donald Lipski, Walter De Maria, Tom Marioni, Michael McMillen, Mario Merz (Italy), Antonio Muntadas (Spain), Maria Nordman, Nam June Paik, Judy PFAFF, Michelangelo PISTOLETTO (Italy), Sandy Skoglund, Alexis Smith, James Turrell, Bill Viola

▷ **WHEN** Since the 1970s

▷ **WHERE** United States, primarily, and Europe

▷ **WHAT** The everyday meaning of *installation* refers to the hanging of pictures or the arrangement of objects in an exhibition. The less generic, more recent meaning of *installation* is a site-specific artwork. In this sense, the installation is created especially for a particular gallery space or outdoor site, and it comprises not just a group of discrete art objects to be viewed as individual works but an entire ensemble or environment. Installations provide viewers with the experience of being surrounded by art, as in a mural-decorated public space or an art-enriched cathedral.

Precedents for installations date mainly from the POP ART—era of the late 1950s and 1960s. The most notable are Allan Kaprow's "sets" for HAPPENINGS, Edward Kienholz's tableaux, Red Grooms's theatrical environments such as *Ruckus Manhattan*, Claes Oldenburg's *Store* filled with his plaster renditions of consumer objects, and Andy Warhol's enormous prints in the form of wallpaper.

Unlike many of the works mentioned above, most installations are unsalable. Some examples: Judy Pfaff creates dramatic environments comprising thousands of throwaway elements that evoke undersea gardens or dreamlike fantasy worlds. Daniel Buren makes installations of stripes applied to structures that comment by their placement on the physical or social character of the site. Donald Lipski brings together hundreds of manufactured objects to create witty, three-dimensional variants of allover painting.

Installations generally are exhibited for a relatively brief period and then dismantled, leaving only DOCUMENTATION. Their unsalability and their labor-

intensiveness proved an unsatisfying combination in the increasingly market-attuned art world of the early 1980s. Today the term *installation* is sometimes applied to permanent, site-specific, sculptural ensembles created for corporate or public settings.

See LIGHT-AND-SPACE ART, PATTERN AND DECORATION, PUBLIC ART

JUNK SCULPTURE

▷ **WHO** Arman (France), Lee Bontecou, CESAR (France), John CHAMBERLAIN, Eduardo Paolozzi (Great Britain), Robert Rauschenberg, Richard Stankiewicz, Jean Tinguely (Switzerland)

▷ **WHEN** Primarily the 1950s

▷ **WHERE** Europe and the United States

▷ **WHAT** Junk sculptures are ASSEMBLAGES fashioned from industrial debris. Their roots can be traced to the Cubist COLLAGES and constructions by Pablo Picasso and Georges Braque. The real originator of junk sculpture, however, is the German DADA artist Kurt Schwitters, who began to create assemblages and collages from trash gathered in the streets after World War I.

By World War II the Western nations—especially the United States—had inad-vertently pioneered the production of industrial refuse on a grand scale. Dumps and automobile graveyards became a favorite haunt of artists who gathered auto parts and other manufactured cast-offs. They welded them into art or sometimes presented them as FOUND OBJECTS relocated from the trash heap to the gallery.

The range of effects created with these materials is striking. César had entire cars compressed into squat and strangely beautiful columns that clearly reveal their origins as vehicular junk. Lee Bontecou combines steel machine parts with fabric to produce ABSTRACT reliefs that typically suggest a face-vagina with horrific zipper-teeth. The use of discarded materials in such works eloquently comments on the "throwaway" mentality of postwar consumerism. It also implies that welded iron and steel are more appropriate sculptural materials for the machine age than carved marble or cast bronze.

KINETIC SCULPTURE

▷ **WHO** Yaacov Agam (Israel), Pol Bury (France), George Rickey, Nicolas Schöffer (France), Jesus Rafael Soto (Venezuela), Jean Tinguely (Switzerland)

▷ **WHEN** Late 1950s through 1960s

▷ **WHERE** International, but primarily of interest to Europeans

▷ **WHAT** "Kinetic sculpture" is sculpture that contains moving parts, powered by hand or air or motor. It began when the DADA artist Marcel Duchamp mounted a spinnable bicycle wheel on a stool in 1913. In the 1920s the Eastern European artists Naum Gabo and László Moholy-Nagy started to experiment with kinetic sculpture that resembled machines. Shortly thereafter the American Alexander Calder invented the mobile, a delicately balanced wire armature from which sculptural elements are suspended.

Kinetic sculptures are not limited to any one STYLE, but they do share a germinal source of inspiration: the twentieth-century infatuation with technology. The term encompasses a wide variety of approaches. The metal rods of George Rickey's constructions sway in the wind, responsive to the natural elements. Jean Tinguely's kinetic JUNK SCULPTURE *Homage to New York* (1960) destroyed itself in the Museum of Modern Art's garden and demonstrated a darkly satirical view of the industrial era.

The use of modern machinery in kinetic sculpture made it a precursor of—and inspiration for—artists' experiments with more advanced hardware such as lasers and computers. Although these HIGH-TECH works are technically kinetic sculptures, they are more often considered in conjunction with the movement known as ART AND TECHNOLOGY.

A few younger artists create kinetic sculpture today, most notably Mark Pauline and Survival Research Laboratory. This San Francisco—based group orchestrates cacophonous spectacles in which horrific, essentially low-tech machines do battle with one another, evoking the militarization of technology and the gritty realities of life in the urban jungle.

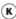
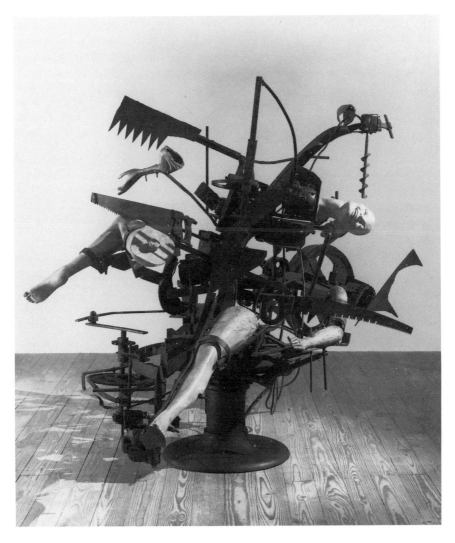

JEAN TINGUELY (b. 1925).
Dissecting Machine, 1965. Motorized assemblage: painted cast iron
and welded-steel machine parts with mannequin parts, 72 7/8 x 74 x
83 7/8 in. The Menil Collection, Houston.

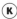

KITSCH

Kitsch refers to the LOW-ART artifacts of everyday life. It encompasses lamps in the shape of the Eiffel Tower, paintings of Elvis Presley on velvet, and lurid illustrations on the covers of romance novels. The term comes from the German verb *verkitschen* (to make cheap). Kitsch is a by-product of the industrial age's astonishing capacity for mass production and its creation of disposable income.

The critic Clement Greenberg characterized kitsch as "rear-guard" art—in opposition to AVANT-GARDE art. Kitsch, he observed (in "Avant-Garde and Kitsch," published in *Partisan Review* in fall 1939), "operates by formulas . . . it is vicarious experience and faked sensation. It changes according to style, but remains always the same. Kitsch is the epitome of all that is spurious in the life of our time." He defined kitsch broadly to include jazz, advertising, Hollywood movies, commercial illustration—all of which are generally regarded now as POPULAR CULTURE rather than kitsch. Although Greenberg's definition of kitsch is overly expansive, his analysis of how it operates remains apt. Today *kitsch* is most often used to denigrate objects considered to be in bad taste.

Attitudes toward kitsch became more complicated with the advent of POP ART in the early 1960s. What had been dismissed as vulgar was now championed by individuals who were fully aware of the reviled status of the "low-art" objects of their affections. This ironic attitude toward kitsch came to be known as "camp," following the publication of the essay "Notes on 'Camp'" by the cultural commentator Susan Sontag in *Partisan Review* in fall 1964.

Obscuring the distinctions between low and HIGH ART was key to the repudiation of MODERNISM and the emergence of POSTMODERNISM. Beginning in the late 1970s kitsch became a favorite subject for such artists as Kenny Scharf, who depicts characters from Saturday-morning cartoons, and Julie Wachtel, who APPROPRIATES figures from goofy greeting cards.

See SIMULATION

LIGHT-AND-SPACE ART

▷ **WHO** Michael Asher, Robert IRWIN, Maria Nordman, Eric Orr, James TURRELL, Doug Wheeler

▷ **WHEN** Late 1960s through 1970s

▷ **WHERE** Southern California

▷ **WHAT** The use of radically new art-making materials and the dematerialization of the art object characterize light-and-space art. It can be considered a descendant of the earlier LOS ANGELES "LOOK," whose practitioners experimented with unusual materials such as cast resin and fiberglass.

As immaterial as CONCEPTUAL ART, light-and-space art focuses less on ideas than on sensory perceptions. Robert Irwin has created numerous INSTALLATIONS in which constantly changing natural light—often filtered through transparent scrims—is used to redefine a space. For viewers, his mysterious light-shot environments intensify sensory awareness and heighten the experience of nature itself in the form of light.

Works of light-and-space art have frequently—and aptly—inspired either scientific or metaphysical interpretations. Irwin and James Turrell, for instance, investigated the phenomenon of sensory deprivation (which influenced the development of their similarly spare light-works) as part of the ART-AND-TECHNOLOGY program initiated by the Los Angeles County Museum of Art in 1967. For his series of works on the theme of alchemy, Eric Orr has used natural light as well as blood and fire.

LOS ANGELES "LOOK"

▷ **WHO** Peter Alexander, Larry BELL, Billy Al Bengston, Joe Goode, Robert IRWIN, Craig KAUFFMAN, John McCRACKEN, Kenneth Price, DeWain Valentine

▷ **WHEN** Mid- to late 1960s

▷ **WHERE** Los Angeles and environs

▷ **WHAT** The *Los Angeles "look"*—a more neutral phrase than the slangily pejorative *Finish Fetish* or *L.A. Slick*—refers to two- and three-dimensional ABSTRACTIONS, usually crafted from fiberglass or resins. Glossy and impersonal, with slick finishes suggestive of the machine-made, they have often been compared to automobiles and surfboards, two iconic staples of life in Southern California.

In their simplicity and abstraction, such works are certainly an offshoot of then-contemporary MINIMALISM. But unlike rigorously theoretical Minimalist art, these works are upbeat and accessible. Their often bright colors and man-ufactured appearance recall POP ART's evocation of commercial products.

The work itself ranges from the simple standing or leaning slabs by John McCracken and Peter Alexander to objects that incorporate light, such as Larry Bell's glass boxes and Robert Irwin's white disks. (Such works paved the way for the LIGHT-AND-SPACE-ART of the 1970s.) For some, the Los Angeles "look" constitutes Southern California's most substantive contribution to the history of postwar art. In the mid-1980s artists such as McCracken were rediscovered by NEO-GEO artists in New York interested in abstraction and the look of every-day domestic objects.

LOW ART—*see* POPULAR CULTURE

LYRICAL ABSTRACTION—*see* COLOR-FIELD PAINTING

MAIL ART—*see* FLUXUS

MANIPULATED PHOTOGRAPHY

▷ **WHO** Ellen Carey, Walter Dahn (Germany), Joan Fontcuberta (Spain), Benno Friedman, Jack Fulton, Paolo Gioli (Italy), Judith Golden, Susan Hiller (Great Britain), Astrid Klein (Germany), Jerry McMillan, Arnulf RAINER (Austria), Lucas SAMARAS, Deborah Turbeville, Lynton Wells, Joel-Peter WITKIN

▷ **WHEN** Since the mid-1970s

▷ **WHERE** Europe and the United States

▷ **WHAT** A manipulated photograph has been altered, embellished, or assaulted. A variety of GESTURAL "manipulating" techniques have been utilized by photographers during the past two decades. Arnulf Rainer draws on his prints, producing EXPRESSIONISTIC self-portraits. Lucas Samaras treats the still-wet emulsions of his Polaroid prints like finger paints, creating a tumult of pat-tern. Joel-Peter Witkin scribbles on his negatives, yielding disturbingly surreal compositions.

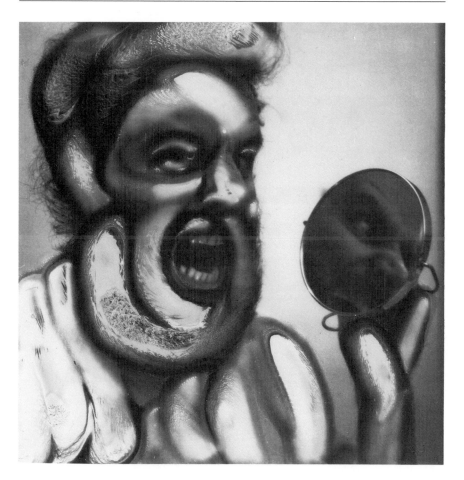

LUCAS SAMARAS (b. 1936).
Photo-Transformation, November 12, 1973, 1973. SX Polaroid print
on paper, image: 3 x 3 1/8 in. High Museum of Art, Atlanta; Gift of
Lucinda W. Bunnen

At the turn of the century some photographers marked or hand colored their photographs in order to emulate more prestigious print media such as etching. The techniques of today's manipulators are inspired less by history than by the desire to subvert STRAIGHT PHOTOGRAPHERS' concern only for the medium's documentary capabilities ("FABRICATING" photographers are similarly motivated to create fictional subjects) and to make expressive pictures that may resemble paintings as much as photographs.

MALE GAZE—see FEMINIST ART

MEDIA ART

▷ **WHO** Ant Farm, Joseph BEUYS (Germany), Border Art Workshop, Chris Burden, Lowell Darling, Gran Fury, Group Material, Guerrilla Girls, Jenny Holzer, Leslie Labowitz and Suzanne Lacy, Les LEVINE, Mike Mandel and Larry Sultan, Antonio MUNTADAS (Spain), Marshall Reese, Martha Rosler, Krzysztof Wodiczko

▷ **WHEN** Since the 1970s

▷ **WHERE** Primarily the United States

▷ **WHAT** *Media*, in this case, refers not to the physical constituents of art, such as acrylic paint or bronze, but to the mass media. Art of this type assumes the form of such far-flung means of communication as newspapers, television, advertising posters, and billboards. Media art is a subset of CONCEPTUAL ART, and its chief precursor is POP ART, with its attraction to POPULAR CULTURE. Former advertising illustrator Andy Warhol used tabloid photographs as the sources for his silkscreened images of movie stars and disasters. Unlike Warhol, most media artists have been highly critical of the mass media and their methods of manipulating public opinion.

Some have attempted to reveal the ideological biases of the mass media. Chris Burden, in the widely broadcast satirical videotape *Chris Burden Promo* (1976), targeted the media's cult of personality by putting his name at the end of a list of revered artists that begins with Michelangelo. Others, such as the Guerrilla Girls and Gran Fury, have functioned as muckraking journalists by providing the public with little-known information about sexism and the AIDS crisis in the form of posters that they paste on New York walls. Challenging the notion that only the rich and powerful have access to the media,

Les Levine purchased billboard space in Great Britain during the early 1980s to reactivate dialogue about Northern Ireland's civil war through such oblique messages as "Block God." Such approaches reveal that the extensive influence of art on the media is now reciprocated in the form of media art.

MEDIATION—*see* VIDEO ART

MINIMALISM

▷ **WHO** Carl ANDRE, Ronald Bladen, Dan FLAVIN, Mathias Goeritz (Mexico), Donald JUDD, Sol LEWITT, Robert Mangold, Brice Marden, Agnes Martin, John McCracken, Robert Morris, Dorothea Rockburne, Robert Ryman, Nobuo Sekie (Japan), Richard SERRA, Tony Smith, Frank Stella, Kishio Sugo (Japan), Katsuo Yoshida (Japan)

▷ **WHEN** 1960s to mid-1970s

▷ **WHERE** Primarily the United States

▷ **WHAT** The term *Minimalism* emerged in the writings of the critic Barbara Rose during the mid-1960s. "ABC Art," the title of an influential article she wrote for the October 1965 issue of *Art in America*, did not catch on as a name for the movement, but in that article she referred to art pared down to the "minimum," and by the late 1960s *Minimalism* was commonly being used. It aptly implies the movement's MODERNIST goal of reducing painting and sculpture to essentials, in this case the bare-bones essentials of geometric abstraction. Primarily descended from early twentieth-century CONSTRUCTIVISM, Minimalism was heavily influenced by the clarity and severity of works by the postwar artists Barnett Newman, Ad Reinhardt, and David Smith. Minimalism is the first art movement of international significance pioneered exclusively by American-born artists.

Minimalist painting eliminated REPRESENTATIONAL imagery and illusionistic pictorial space in favor of a single unified image, often composed of smaller parts arranged according to a grid. Despite this tendency toward mathematically regular compositions, Minimalist painting varies widely—from the evocation of the sublime in the nearly monochrome canvases by Agnes Martin or Robert Ryman to the spare and rigorous essays in geometry by Robert Mangold or Brice Marden.

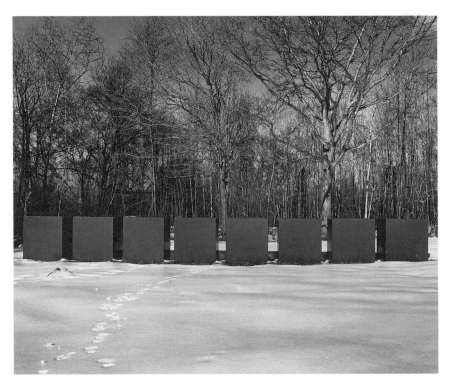

DONALD JUDD (b. 1928).
Untitled, 1967. Rolled steel with auto lacquer; 48 x 48 x 48 in. each.
Collection Philip Johnson.

Minimalism was more frequently associated with sculpture than painting. Minimalist sculpture also eliminated representational imagery, pedestals (human scale predominated), and sometimes even the artist's touch. Typically produced by industrial fabricators, such elemental geometric forms came to be known as *primary structures*, after an influential show of the same name organized by Kynaston McShine at New York's Jewish Museum in 1966.

Committed to the ideal of creating new forms rather than recycling old ones, Minimalist sculptors hoped to transcend the production of mere art objects by producing three-dimensional works that straddled the boundary between art and the everyday world. Robert Morris's boxlike cubes and Donald Judd's shelflike slabs resembled the similarly geometric forms of then-contemporary International Style architecture and late-modern interior design. Despite the artists' interest in infiltrating the urban environment, the public generally found their works inaccessible. Ironically, Minimalism became the sculptural STYLE of choice for corporate collections during the 1970s, at the same time that the sleek glass boxes of International Style architecture came to symbolize corporate power.

Minimalism dominated the art of the late 1960s just as ABSTRACT EXPRESSIONISM had dominated the art of the 1950s—and as no single style would do in the 1970s. International variants arose in Mexico and in Japan, where an important school of Minimalist sculpture, called *Mono-ha*, was centered in Tokyo between 1968 and 1970.

The term *Post-Minimalism* was coined by the critic Robert Pincus-Witten and appeared first in "Eva Hesse: Post-Minimalism into Sublime," in the November 1971 *Artforum*. Pincus-Witten used it to distinguish the more embellished and pictorial approach of Richard Serra's cast-lead works and Eva Hesse's pliable hangings from the stripped-down, prefabricated look of pre-1969 Minimalist works by Judd and Morris. The late 1980s saw the return of the sleek, machined look of Minimalism in the work of young sculptors who rejected the high-pitched emotionalism of NEO-EXPRESSIONISM.

See NEO-GEO

MOBILE—*see* KINETIC SCULPTURE

MODERNISM

Generically, *modern* refers to the contemporaneous. All art is modern to those who make it, whether they are the inhabitants of Renaissance Florence or twentieth-century New York. Even paintings being made today in a fifteenth-century STYLE are still modern in this sense.

As an art historical term, *modern* refers to a period dating from roughly the 1860s through the 1970s and is used to describe the style and the ideology of art produced during that era. It is this more specific use of *modern* that is intended when people speak of modern art or MODERNISM—that is, the philosophy of modern art.

What characterizes modern art and modernism? Chiefly, a radically new attitude toward both the past and the present. Mid-nineteenth-century Parisian painters, notably Gustave Courbet and Edouard Manet, rejected the depiction of historical events in favor of portraying contemporary life. Their allegiance to the new was embodied in the concept of the *avant-garde*, a military term meaning "advance guard." Avant-garde artists began to be regarded as ahead of their time. Although popularly accepted, this idea of someone's being able to act "outside history," apart from the constraints of a particular era, is rejected by art historians.

Crucial to the development of modernism was the breakdown of traditional sources of financial support from the church, the state, and the aristocratic elite. The old style of patronage had mandated artworks that glorified the institutions or individuals who had commissioned them. Newly independent artists were now free to determine the appearance and CONTENT of their art but also free to starve in the emerging capitalist art market. The scant likelihood of sales encouraged artists to experiment. The term "art for art's sake"—which had been coined in the early nineteenth century—was now widely used to describe experimental art that needed no social or religious justification for its existence.

Modern art arose as part of Western society's attempt to come to terms with the urban, industrial, and secular society that began to emerge in the mid-nineteenth century. Modern artists have challenged middle-class values

by depicting new SUBJECTS in dislocating new styles that seemed to change at a dizzying pace. Certain types of content—the celebration of technology, the investigation of spirituality, and the expression of PRIMITIVISM—have recurred in works of different styles. The celebration of technology and science took the form of the glorification of speed and movement seen in Futurism, and the use of scientific models of thinking by artists linked with CONSTRUCTIVISM, CONCRETE ART, and the ART-AND-TECHNOLOGY movement. The investigation of spirituality embodied in early ABSTRACTION, LIGHT-AND-SPACE ART, and the shamanistic rituals by ACTION and FEMINIST artists was a reaction against the secularism and materialism of the modern era. Expressions of primitivism in Post-Impressionism, Cubism, and German EXPRESSIONISM simultaneously reflected new contacts with Asian, African, and Oceanic cultures "discovered" through imperialism and a romantic longing to discard the trappings of civilization in favor of a mythical Golden Age.

Modern art, especially abstract art, was thought by FORMALIST critics to progress toward purity; in the case of painting, this meant a refinement of the medium's essential qualities of color and flatness. (The flattened treatment of pictorial space and concern for the "integrity" of the PICTURE PLANE culminated in the monochrome paintings of the 1950s and 1960s.) This progressive reading of modern art posited a direct line of influence running from Impressionism to Post-Impressionism and on to Cubism, Constructivism, expressionism, DADA, SURREALISM, ABSTRACT EXPRESSIONISM, POP ART, and MINIMALISM, virtually ignoring the contribution of artists working outside Paris or New York.

This idea of progress was especially popular during the late modern era, the twenty-five years or so after World War II. In retrospect that linear view seems to mirror the frenetic output of products, and their instant obsolescence, in the modern industrial age. A booming market for contemporary art emerged in the 1960s with a flurry of stylistic paroxysms that seemed exhilarating to some observers but struck others as a parody of fashion's constantly moving hemlines. Many artists reacted by attempting to create unsalable works.

Modernism's apotheosis of avant-garde novelty—what the American critic Harold Rosenberg called the "tradition of the new" in his 1959 book of that name—encouraged artists to innovate. One aspect of that innovation was the use of odd new art-making materials (including FOUND OBJECTS, debris, natural

103

light, HIGH-TECH equipment, and the earth itself); new processes and media (COLLAGE, ASSEMBLAGE, VIDEO, and COMPUTER ART); and new forms (abstraction, APPROPRIATION, CRAFTS-AS-ART, INSTALLATIONS, and PERFORMANCE ART).

See POSTMODERNISM

MONO-HA—*see* MINIMALISM

MONSTER ROSTER—*see* CHICAGO IMAGISM

MULTICULTURALISM

Multiculturalism is the opposite of ethnocentricity. In terms of the visual arts, it describes the increasingly widespread opposition among curators, critics, and artists to the elevation of the European cultural tradition over those of Asia, Africa, and the indigenous or nonwhite populations of the Americas. The concept gained currency in the United States and Europe during the late 1980s partly because of the dramatic influx of nonwhite immigrants and the often racist responses triggered by such migrations. The instant transmission of information and ideas across national borders made possible by contemporary technology has also encouraged multiculturalism.

Multiculturalism rejects the vestiges of colonialism embodied in tendencies to regard art from other cultures either as "primitive" or as the exotic products of cultural OTHERS. It demands that works of art from non-European cultures be considered on their own terms. The Centre Georges Pompidou in Paris mounted the controversial exhibition *Les Magiciens de la terre* in 1989. Its coupling of works by well-known Western artists and works by third-world artists unknown to the art world frequently revealed radically different ideas about the nature of art itself. In the United States during the late 1980s several exhibitions of Hispanic and Chicano art were aptly criticized for their blanket interpretation of such art as NEO-EXPRESSIONISM—a designation that ignores the cultural roots from which the work springs.

MULTIPLE

▷ **WHO** Yaacov Agam (Israel), Jonathan Borofsky, Alexander Calder, John Chamberlain, Mark di Suvero, Marcel Duchamp, Ellsworth Kelly, Edward

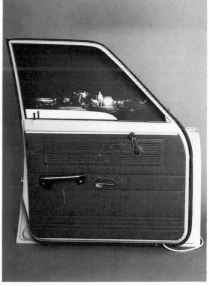

EDWARD KIENHOLZ (b. 1927).
Sawdy, 1971. Car door, mirrored window, automotive lacquer,
polyester resin, silkscreen fluorescent light, galvanized sheet metal,
39 1/2 x 36 x 7 in. National Gallery of Art, Washington, D.C.; Gift of
Gemini G.E.L., 1981.

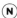

Kienholz, Isamu Noguchi, Claes Oldenburg, Robert Rauschenberg, Man Ray, Daniel Spoerri (Switzerland), Joe Tilson (Great Britain), Jean Tinguely (Switzerland), Victor Vasarely (Hungary)

▷ **WHEN** Since about 1960

▷ **WHERE** Europe and the United States

▷ **WHAT** A multiple is a three-dimensional artwork produced in quantity. Multiples have rarely been made in large numbers, despite a considerable amount of rhetoric about making art affordable through mass production. They are part of a long tradition. Since the Renaissance, prints (etchings and lithographs) and statuary (in bronze and china) have been fabricated by workshops or factories in limited numbers or "editions" that made them cheaper than unique artworks but still desirable as originals. Multiples are now distributed by print publishers or art dealers who invariably discuss them in terms of editions.

In 1955 the artists Yaacov Agam and Jean Tinguely suggested the idea of doing multiples to the Parisian art dealer Denise René. Four years later the artist Daniel Spoerri founded Editions M.A.T. (Multiplication Arts Transformable) in Paris, which produced reasonably priced multiples in editions of one hundred by Alexander Calder, Marcel Duchamp, Man Ray, Tinguely, Victor Vasarely, and others. Developments in the early 1960s such as the PRINT REVIVAL and POP ART's interest in the mass-produced object made the idea seem especially promising. That promise was realized in the late 1960s with the emergence of collectors attracted to the investment potential of these relatively low-priced works of contemporary art.

NAIVE ART

Naive art is produced by artists who lack formal training but are often obsessively committed to their art making. It may appear to be innocent, childlike, and spontaneous, but this is usually deceptive. Naive artists frequently borrow conventional compositions and techniques from the history of art, and many maintain a remarkably consistent level of quality. Grandma Moses is probably the best-known naive artist of our era.

There is a general naive STYLE. In painting this tends toward bright colors, abundant detail, and flat space. In sculpture (or architectural constructions), it often involves assembling junk or cast-off materials in exuberant constructions such as Simon Rodia's Watts Towers in Los Angeles.

The modern interest in naive art stems from MODERNISM's fascination with "primitive" cultures and unconscious states of mind. The development of ABSTRACTION has made the distortions of naive art seem part of the mainstream. The first evidence of this phenomenon may be the popularity of Henri Rousseau, a former Sunday painter whose charmingly abstracted fantasies seemed appealingly AVANT-GARDE to Pablo Picasso and his circle in early twentieth-century Paris.

Naive art should not be confused with folk art. Folk art features traditional decoration and functional forms specific to a culture. (Folk art has been generally corrupted by the demands of tourism.) Naive art is a product of individual psyches rather than communal history, and it tends to be decorative and nonfunctional. A virtual synonym for *naive art* is *Outsider art*, although the latter is sometimes regarded more narrowly as the work of those actually outside mainstream society, such as prisoners and psychotics.

See ART BRUT, PRIMITIVISM

NARRATIVE ART

▷ **WHO** Jo Harvey Allen, Terry Allen, Eleanor Antin, Ida Applebroog, John Baldessari, Jonathan Borofsky, Joan Brown, Colin Campbell (Canada), Bruce Charlesworth, Sue Coe, Robert Colescott, Robert Cumming, Oyvind Fahlström (Sweden), Eric Fischl, Vernon Fisher, Leon Golub, Jörg Immendorff (Germany), Jean Le Gac (France), Alfred Leslie, Duane Michals, Grégoire Mueller (Switzerland), Odd Nerdrum (Norway), Dennis Oppenheim, Faith Ringgold, Allen Ruppersberg, Alexis Smith, Earl Staley, Mark Tansey, Hervé Télémaque (France), William Wegman, Bruce and Norman Yonemoto

▷ **WHEN** Since the mid-1960s

▷ **WHERE** Europe and the United States

▷ **WHAT** Narrative—or story—art represents events taking place over time. These events may, however, be compressed into a single image that implies something that has already happened or is about to take place.

Painting, of course, has told stories since at least the time of the ancient Egyptians. Starting in the Renaissance, "history painting"—paintings of events from biblical or classical history—acquired the highest status. Nineteenth-century painting and sculpture depicted not only great moments in history

but also domestic dramas of a decidedly sentimental nature. Such subjects were rejected by MODERN painters during the late nineteenth century in favor of scenes from contemporary life. Later modern artists sought to purge painting and sculpture of narrative. Story telling was thought best pursued by writers rather than visual artists, and *literary* became an insult in the argot of modern art.

By the 1960s the modernist insistence on abstraction and the taboo against narrative had made telling tales irresistible to many artists. POP ART, NEW REALIST painting and sculpture, and NOUVEAU REALISME all provided FIGURATIVE imagery into which narratives could be read—whether or not they were intended by the artist.

The most popular form of visual narrative now is painting, with PERFORMANCE, INSTALLATIONS, and VIDEO ART the runners-up. Narrative artwork ranges from Bruce Charlesworth's amusing "who done it" installations suggestive of B novels to Faith Ringgold's affecting autobiographical stories written and painted on quilts. (Words are a frequent element in narrative art.) The narrative approach seems especially suited to psychological self-examination and the investigation of the role-playing that is so conspicuous an element of late twentieth-century social interaction.

See ALLEGORY

NATURALISM—*see* REALISM

NEO—*see* POST-

NEO-DADA

▷ **WHO** Wallace Berman, Bruce Conner, Edward Kienholz, Jasper JOHNS, Robert RAUSCHENBERG

▷ **WHEN** Mid-1950s to mid-1960s

▷ **WHERE** United States

▷ **WHAT** The term NEO-DADA was first applied to the work of Jasper Johns, Allan Kaprow, Robert Rauschenberg, and Cy Twombly in an unattributed comment in the January 1958 issue of *Artnews* magazine. It has come to be associated

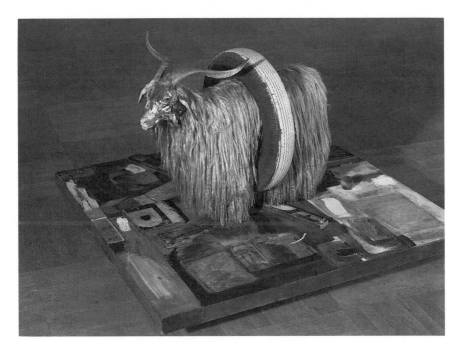

ROBERT RAUSCHENBERG (b. 1925).
Monogram, 1955–59. Mixed-media construction, 48 x 72 x 72 in.
Moderna Museet, Stockholm.

primarily with the work of Johns and Rauschenberg rather than that of Kaprow and Twombly, but it is also appropriate to apply it to the slightly later ASSEMBLAGES by Wallace Berman, Bruce Conner, and Edward Kienholz.

The *Artnews* evocation of DADA referred to two aspects of the early twentieth-century movement. First, there was a Dada-like sense of paradox and ambiguity embodied in Johns's paintings of targets, numbers, and maps that filled the entire surface of the canvas. Second, there was a connection to Marcel Duchamp, Kurt Schwitters, and other Dada artists in Rauschenberg's use of junk and FOUND OBJECTS to create "combines"—hybrid painting-sculptures. (For one of them, the artist used his own mattress and quilt as his "canvas.")

Neo-Dada provided a bridge between ABSTRACT EXPRESSIONISM and POP ART. Johns and Rauschenberg shared the former's predilection for GESTURAL brushwork and grand scale but rejected the sublimity of Abstract Expressionism in favor of everyday imagery. In this regard they influenced the development of Pop art. Neo-Dada's counterpart in Europe was NOUVEAU REALISME.

NEO-EXPRESSIONISM

▷ **WHO** Luis Cruz Azaceta, Georg Baselitz (Germany), Jean-Michel Basquiat, Jonathan BOROFSKY, Sandro Chia (Italy), Francesco CLEMENTE (Italy), Chema Cobo (Spain), Robert Colescott, Sue Coe, Enzo Cucchi (Italy), Rainer Fetting (Germany), Eric Fischl, Gérard Garouste (France), Nancy Graves, Jörg IMMENDORFF (Germany), Oliver Jackson, Roberto Juarez, Anselm KIEFER (Germany), Per Kirkeby (Denmark), Christopher LeBrun (Great Britain), Robert Longo, Markus Lupertz (Germany), Helmut Middendorf (Germany), Malcolm Morley, Robert MORRIS, Mike Parr (Australia), A. R. Penck (Germany), Mimmo Paladino (Italy), Ed Paschke, David Salle, Salome (Germany), Julian SCHNABEL, José María Sicilia (Spain), Earl Staley

▷ **WHEN** Late 1970s to mid-1980s

▷ **WHERE** International

▷ **WHAT** The first use of the term *Neo-Expressionism* is undocumented, but by 1982 it was being widely used to describe new German and Italian art. An extremely broad label, it is disliked—as are so many media-derived tags—by many of the artists to whose work it has been applied.

Neo-Expressionism (often shortened to *Neo-Ex*) was a reaction against both

CONCEPTUAL ART and the MODERNIST rejection of imagery culled from art history. Turning their backs on the Conceptual art modes in which they had been trained, the Neo-Expressionists adopted the traditional formats of easel painting and cast and carved sculpture. Turning to modern and premodern art for inspiration, they abandoned MINIMALIST restraint and Conceptual coolness. Instead their art offered violent feeling expressed through previously taboo means—including GESTURAL paint handling and ALLEGORY. Because it was so widespread and so profound a change, Neo-Expressionism represented both a generational changing of the guard and an epochal transition from modernism to POSTMODERNISM.

It is difficult to generalize about the appearance or CONTENT of Neo-Expressionist art. Its imagery came from a variety of sources, ranging from newspaper headlines and SURREALIST dreams to classical mythology and the covers of trashy novels. The German artists have invoked early twentieth-century EXPRESSIONISM to deal with the repression of German cultural history following World War II. Some American painters, such as Julian Schnabel, use eclectic historical images to create highly personal and allusive works. Others, such as Sue Coe, refer to contemporary events to create pointed social commentary.

Neo-Expressionism's return to brash and emotive artworks in traditional and accessible formats helped fuel the booming art market of the 1980s and marked the end of American dominance of international art.

See EAST VILLAGE, TRANSAVANTGARDE

NEO-GEO

▷ **WHO** Ashley Bickerton, Peter Halley, Jeff Koons, Meyer Vaisman

▷ **WHEN** Mid-1980s

▷ **WHERE** New York

▷ **WHAT** *Neo-Geo* is short for "neo-geometric CONCEPTUALISM." It is used, confusingly, to refer to the art of the four very different artists noted above. It probably limits the confusion to apply *Neo-Geo* only to the work of those four artists, although the evocative use of domestic objects as sculptural material by Haim Steinbach and Swiss artist John Armleder does seem closely related.

Jeff Koons's stainless-steel replicas of KITSCH consumer objects, including whiskey decanters in the form of celebrity portraits, are far from geometric

and certainly better understood as APPROPRIATION art. They have little in common with Peter Halley's paintings of linked rectangles (or "cells") inspired by Jean Baudrillard's SIMULATION theory. Both Ashley Bickerton and Meyer Vaisman made "wall sculptures"—thick paintings that extend from the wall and can be viewed from three sides. Vaisman coupled photographic blowups of canvas weave with fragmented images of faces or figures; Bickerton produced paint-encrusted ABSTRACTIONS that evoke household objects or even surfboards. What this disparate work does share is an interest in the cool ironies of POP ART and the use of Conceptual art to address issues related to the nature of the art market during New York's economic boom of the 1980s.

Many regard the term *Neo-Geo* as nothing more than a marketing device, important as an emblem of art-world careerism (Vaisman was also an EAST VILLAGE dealer who showed the work of Koons and Halley) and of the art market's insatiable appetite for the new, rather than as an aesthetic signpost. It has come to be associated with an October 1986 show at the prestigious Sonnabend Gallery in New York that certified the meteoric rise of the four young artists. A poorly received 1987 exhibition of work from the Saatchi Collection in London called *New York Art Now* dampened international enthusiasm for the "movement." By 1989 the term itself was rarely heard, although the artists associated with it continue to receive widespread attention.

NEW IMAGE

▷ **WHO** Nicholas Africano, Jennifer Bartlett, Jonathan BOROFSKY, Neil JENNEY, Robert MOSKOWITZ, Susan Rothenberg, Joel Shapiro, Pat Steir, Donald Sultan, Joe Zucker

▷ **WHEN** Mid-1970s to early 1980s

▷ **WHERE** United States

▷ **WHAT** The name *New Image* derives from the Whitney Museum of American Art's 1978 show *New Image Painting*, curated by Richard Marshall. Although the exhibition was derided as a grab bag of disparate styles—it showcased paintings by many of the artists listed above—it did point to two crucially important phenomena: the return of recognizable FIGURATIVE imagery after a decade of MINIMALISM; and the return of the familiar paint-on-canvas format after a decade of the non-objects of CONCEPTUAL ART.

The progenitor of New Image painting is former ABSTRACT EXPRESSIONIST Philip

Guston. By 1970 he had abandoned the shimmering abstractions for which he was known in favor of idiosyncratic cartoonlike scenes of the tragic human comedy. None of the New Image painters mimicked Guston's highly personal style; it was his gutsy eccentricity that proved catalytic.

Each of the New Image painters charted a highly individual course, but many of their works do create the effect of a figure tentatively emerging from an ABSTRACT background. Consider, for example, Susan Rothenberg's sketchy horses, Nicholas Africano's tiny characters, and Robert Moskowitz's silhouetted objects—all seen against essentially abstract and PAINTERLY backgrounds. Other artists identified as New Image painters applied more Conceptual approaches. Neil Jenney coupled painted images with punning, explanatory titles limned on frames; Jennifer Bartlett produced paintings on steel plates that systematically explored painting's language of abstraction and REPRESENTA-TION through dozens of differently handled versions of the same subject; and Jonathan Borofsky created large INSTALLATIONS composed of paintings, mechanical sculptures, FOUND OBJECTS, and texts, all intended to evoke a dreamy *faux-naïf* consciousness.

Although it is difficult to generalize about so varied a group of artists, New Image painting anticipated the postmodern interest in figurative imagery and even, in the case of Pat Steir, the APPROPRIATION of historical painting as a source of SUBJECTS. During the late 1970s New Image was sometimes regarded in tandem with PATTERN AND DECORATION—two nearly diametrically opposed routes back to traditional-format painting after an era in which it had been abandoned.

NEW REALISM

▷ **WHO** William Bailey, Jack Beal, William Beckman, Martha Erlebacher, Janet Fish, Lucian FREUD (Great Britain), Gregory Gillespie, Neil Jenney, Alex KATZ, Alfred LESLIE, Sylvia Mangold, Alice NEEL, Philip Pearlstein, Fairfield Porter, Joseph Raffael, Neil Welliver

▷ **WHEN** 1960s through 1970s

▷ **WHERE** Primarily the United States

▷ **WHAT** By 1962 the term *New Realism* was being used in the United States and France (where it was called *NOUVEAU REALISME*) as a name for POP ART. That use never caught on in the United States, and the term began to signify instead a

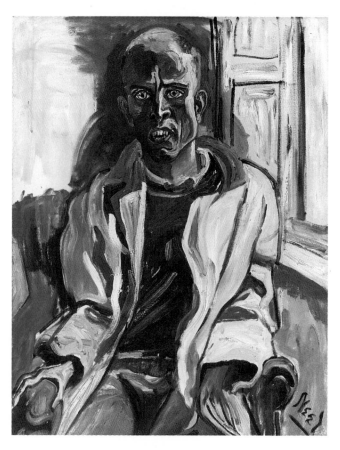

ALICE NEEL (1900–1984).
Randall in Extremis, 1960. Oil on canvas, 36 x 28 in. Robert Miller Gallery, New York.

new breed of REALISM. The traditional variety had linked humanistic CONTENT with the illusionistic REPRESENTATION of observed reality and the rejection of flattened pictorial space derived from ABSTRACTION.

By contrast, New Realism—although a radical departure from the ABSTRACT EXPRESSIONISM that dominated the 1950s—incorporated the flattened space, large scale, and simplified color of MODERNIST painting. Some New Realist artists like Alfred Leslie had, in fact, switched from abstract to representational painting.

New Realism is too broad a term to have much meaning except as a shorthand for a FIGURATIVE alternative to the abstraction of Abstract Expressionism or MINIMALISM. It has taken many forms, from Fairfield Porter's serene land-scapes to Alice Neel's slyly psychological portraits, and from the abstracted nudes by Philip Pearlstein to the cerebral self-portraits by William Beckman. The term also tends to imply a nongestural or nonexpressionistic handling of paint that suggests fidelity to appearances. The belief that New Realist artists are primarily motivated by an interest in the way things look is belied by the psychic probing of Lucian Freud's work or the radically simplified stylizations of Alex Katz—two artists associated with New Realism.

NEW WAVE

New Wave was a journalistic tag initially—and pejoratively—applied to new French filmmakers of the late 1950s, including François Truffaut and Jean-Luc Godard. (It is still used to refer to contemporary filmmakers such as the German director Wim Wenders.) During the mid- to late 1970s it began to be applied to a new generation of pop musicians in the United States, some of whom were art-school graduates. The increasingly theatrical and eclectic nature of PERFORMANCE ART had encouraged many art students to form bands such as Romeo Void and the spectacularly successful Talking Heads. California art-school graduates from institutions like the San Francisco Art Institute opened storefront ALTERNATIVE SPACES that showcased music and performance as well as exhibitions. An EXPRESSIONISTIC type of advertising poster developed that would influence NEO-EXPRESSIONIST painting.

Soon *new wave* began to be applied, imprecisely, to the visual arts. Two large-scale exhibitions in New York thrust the new-wave aesthetic into the media. The first was the *Times Square Show* of 1980, organized by Collaborative Projects, Inc., and the alternative space Fashion Moda. A decaying former massage parlor was transformed into an illegal, multistory exhibition space. For the first time, GRAFFITI artists were brought together with a new generation

of painters and sculptors (including John Ahearn and Tom Otterness) who were reacting against the antiobject orientation of CONCEPTUAL art. Offering an alternative to the austerity of all-white galleries, the circuslike show created an appealing amalgam of the gallery, the club, and the streets. By the time the second exhibition extravaganza, *New York New Wave* (curated by René Ricard), opened at P.S. 1 in September 1981, the term *new wave* simply referred to the mix of graffiti, Neo-Expressionist, and EAST VILLAGE art that would dominate the first half of the 1980s. Now—as with film—it is merely a synonym for the new and the abrasive.

NEW YORK SCHOOL—*see* SCHOOL OF PARIS

NONOBJECTIVE—*see* ABSTRACT/ABSTRACTION

NONREPRESENTATIONAL—*see* ABSTRACT/ABSTRACTION

NOUVEAU REALISME

▷ **WHO** (from France unless otherwise noted) Arman, César, Christo (Bulgaria), Yves KLEIN, Mimmo Rotella, Niki de Saint Phalle, Daniel Spoerri (Switzerland), Jean TINGUELY (Switzerland)

▷ **WHEN** Late 1950s to mid-1960s

▷ **WHERE** France

▷ **WHAT** The term *Nouveau Réalisme* was coined by the French critic Pierre Restany and appeared on a manifesto signed by many of the artists noted above on October 27, 1960. It translates as "NEW REALISM," but in English that name has come to stand for a more conventional sort of realist painting. To complicate matters further, POP ART, too, was once called *New Realism*, and it is Pop art to which Nouveau Réalisme is closely related.

The Nouveaux Réalistes favored the grittiness of everyday life over the elegantly imaginative and introspective products of 1950s-style ABSTRACTION. Their individual approaches to making art, though varied, all constituted a reaction against the international dominance of ABSTRACT EXPRESSIONISM, ART INFORMEL, and TACHISME. They shared this attitude with that of their American

contemporaries the NEO-DADAISTS Jasper Johns and Robert Rauschenberg and the HAPPENING artist Allan Kaprow.

The manifesto that the Nouveaux Réalistes signed in Yves Klein's apartment in 1960 called only for "new approaches to the perception of the real." Its vagueness well suited the diversity of their art. As a group they are best known for their use of junk and FOUND OBJECTS: Arman creates witty ASSEMBLAGES of musical instruments or domestic appliances and Daniel Spoerri affixed the remains of meals to wooden panels.

OP ART

▷ **WHO** Yaacov Agam (Israel), Richard Anuszkiewicz, Lawrence Poons, Bridget RILEY (Great Britain), Victor VASARELY (Hungary)

▷ **WHEN** Mid-1960s

▷ **WHERE** Europe and the United States

▷ **WHAT** *Op art* is short for *optical art;* other names for this STYLE are *retinal art* and *perceptual abstraction.* The sculptor George Rickey coined the term in 1964, in conversation with Peter Selz and William Seitz, two curators at the Museum of Modern Art. Op art, actually Op painting, is always abstract, and the *optical* refers to "optical illusion": Op paintings create the illusion of movement. Parallel wavy black lines set against a white background, for instance, convincingly suggest movement and depth in Bridget Riley's vibrant works.

Op's antecedents date back at least as far as Josef Albers's courses on color theory and optical experimentation at the Bauhaus school of art in Germany during the late 1920s. Op art's moment of greatest celebrity came in 1965 with the Museum of Modern Art's exhibition *The Responsive Eye.* But soon after that Op art was recycled as a motif in fabric and interior design, and having come to symbolize stylistic change for its own sake, it quickly faded from the scene. Because it epitomized trendy stylistic turnover it was picked up in the late 1980s by APPROPRIATION artists such as Philip Taaffe and Ross Bleckner, who were investigating MODERN art's succession of styles.

ORGANIC ABSTRACTION—*see* ABSTRACT/ABSTRACTION

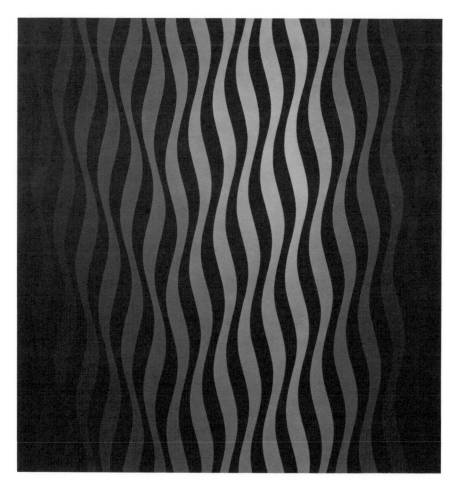

BRIDGET RILEY (b. 1931).
Drift No. 2, 1966. Acrylic on canvas, 91 1/2 x 89 1/2 in. Albright-Knox Art Gallery, Buffalo; Gift of Seymour H. Knox, 1967.

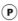

THE OTHER

The concept of "the Other" refers to women, people of color, inhabitants of the so-called Third World, lesbians, and gays—that is, all groups that have traditionally been denied economic and political power. Its origins have sometimes been traced to the French theorist Simone de Beauvoir's *Second Sex*, a pioneering work of existentialism-suffused feminism written in 1949.

To regard people as Others is to see them as objects rather than as subjects driven by psychological needs and desires similar to the viewer's. (Adherents of the influential French psychoanalytic theorist Jacques Lacan tend to view the first Other as the mother.) This is, of course, the foundation of prejudice and a psychic defense against understanding people different from oneself.

The Other entered the discourse of artists and critics in the late 1970s and began to be frequently heard in the mid-1980s. The cultural historian Edward Said ably utilized this concept in his investigations of "Orientalism," nineteenth- and twentieth-century depictions of Asians and Africans by Western artists that failed to accord them the psychological complexity and humanity with which Europeans were depicted. The 1984 traveling exhibition *Difference: On Representation and Sexuality*, organized by the critic Kate Linker for the New Museum of Contemporary Art in New York, examined the social construction of gender and sexuality in both film and the visual arts. The late 1980s saw a growing number of visual artists in the United States and Great Britain addressing issues of "Otherness."

See MULTICULTURALISM

OUTSIDER ART—*see* NAIVE ART

PAINTERLY

The Swiss art historian Heinrich Wölfflin coined this term in 1915 in order to distinguish the optical qualities of Baroque painting from Neoclassical painting. As he saw it, the loose and GESTURAL paint handling, or "painterly" quality, of the former focuses the viewer's attention on dazzling visual effects, whereas the sculptural linearity of the latter invites touch. The opposite of *painterly* is not *sculptural* but linear. The term *linearity* is only rarely heard anymore, but *painterly* is often used to describe paint handling that is loose, rapid, irregular, gestural, dense, uneven, bravura, EXPRESSIONIST, or that calls attention to itself in any other way.

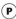

FORMALIST critics after World War II adopted Wölfflin's dualism as a strategy for championing ABSTRACT painting. Although the idea of "painterly painting" may seem redundant, it corresponds with MODERN notions of an art form's progressing toward its "essence"—in painting's case, an emphasis on flatness, color, and tactile paint surfaces.

The critic Clement Greenberg suggested calling ABSTRACT EXPRESSIONISM *painterly abstraction*, and in 1964 he curated an influential show of COLOR-FIELD and HARD-EDGE painting at the Los Angeles County Museum called *Post-Painterly Abstraction*.

PAPIER COLLE—see COLLAGE

PARALLEL GALLERY—*see* ALTERNATIVE SPACE

PATTERN AND DECORATION

▷ **WHO** Brad Davis, Tina Girouard, Valerie Jaudon, Joyce Kozloff, Robert KUSHNER, Kim MacCONNEL, Rodney Ripps, Miriam SCHAPIRO, Ned Smyth, Robert Zakanitch

▷ **WHEN** Mid-1970s to early 1980s

▷ **WHERE** United States

▷ **WHAT** By the mid-twentieth century the adjective *decorative* was firmly established as an insult in contemporary art parlance. The prevailing critical view of decoration as trivial has rarely been shared by non-Western cultures, as is evident from the complex and sophisticated patterning of Islamic, Byzantine, and Celtic art. Inspired by such sources—as well as by carpets, quilts, fabrics, mosaics and other crafts, both Eastern and Western—a group of artists in the mid-1970s began to create works that challenged the taboo against decorative art.

Unlike so many other "isms," Pattern and Decoration (or *P and D*) actually *was* a movement. Feeling alienated from the concerns of the mainstream art world, the Pattern-and-Decoration artists—many of them from Southern California—gathered in a series of meetings in Robert Zakanitch's New York studio during the fall of 1974. They met to discuss the nature of decoration and their attraction to it. Some had been influenced by the feminist concern for womanmade crafts such as quilts and Navajo blankets. Others, including

the critic Amy Goldin, were fascinated with non-Western art forms. Their desire to raise the status of decoration in contemporary art resulted in a number of panel discussions and public presentations during 1975. Many of the Pattern-and-Decoration artists would soon begin to show with the then-fledgling New York art dealer Holly Solomon.

Although they were reacting against MINIMALISM, Pattern-and-Decoration artists often started with the same flattening grid frequently employed by Minimalist painters. The effects they achieved, however, are precisely the opposite of the rigorously theoretical Minimalist canvases. They produced large, boldly colored paintings or sewn works on unstretched fabric that suggest flower-patterned wallpaper (in the case of Robert Zakanitch), Japanese fans (by Miriam Schapiro), and Celtic-inspired interlaces (by Valerie Jaudon). Proceeding from an understanding of decoration's role not just in art but in domestic and public places, Pattern-and-Decoration artists also create functional objects and INSTALLATIONS—Ned Smyth and Joyce Kozloff in tile, Tina Girouard in linoleum, Kim MacConnel by painting on 1950s furniture.

PERFORMANCE ART

▷ **WHO** Vito ACCONCI, Laurie ANDERSON, Eleanor Antin, Anna Banana (Canada), Bob and Bob, Eric Bogosian, Stuart Brisley (Great Britain), Nancy Buchanan, Chris BURDEN, Scott Burton, Theresa Hak Kyung Cha, Ping Chong, George Coates, Colette, Papo Colo, Paul Cotton, Ethyl Eichelberger, Karen Finley, Terry Fox, General Idea (Canada), Jan Fabre (Belgium), Gilbert and George (Great Britain), Guillermo Gómez-Peña, Rebecca Horn (Germany), Joan Jonas, Leslie Labowitz, Suzanne Lacy, Tom Marioni, Tim Miller, Meredith MONK, Linda Montano, Nice Style—the World's First Pose Band (Great Britain), Luigi Ontani (Italy), Gina Pane (Italy), Mike Parr (Australia), Ulrike Rosenbach (Germany), Rachel Rosenthal, Carolee Schneemann, Jill Scott (Australia), Stelarc (Australia), the Waitresses, Robert WILSON

▷ **WHEN** Since the late 1960s

▷ **WHERE** International

▷ **WHAT** The term *performance art* is extraordinarily open-ended. Since the late 1970s it has emerged as the most popular name for art activities that are presented before a live audience and that encompass elements of music, dance, poetry, theater, and video. The term is also retroactively applied to earlier live-art forms—such as BODY ART, HAPPENINGS, ACTIONS, and some FLUXUS and

FEMINIST ART activities. This diffusion in meaning has made the term far less precise and useful.

Starting in the late 1960s many artists wanted to communicate more directly with viewers than painting or sculpture allowed, and their ways of doing so were inspired by a variety of visual art sources. These ranged from early twentieth-century DADA events (composer John Cage helped spread the word about them in postwar New York) to Jackson Pollock's painting for a film camera in 1950. Until the late 1970s artists specifically rejected the term *performance* for its theatrical implications.

The type of performance art that began in the late 1960s was primarily a CONCEPTUAL activity, and such events bore little resemblance to theater or dance. Instead, they took place in galleries or outdoor sites, lasted anywhere from a few minutes to a few days, and were rarely intended to be repeated. A few examples suggest the variety of approaches to performance during this era. Starting in 1969 the British duo Gilbert and George dubbed themselves "living sculpture" and appeared as robotic art objects in their exhibitions or on the streets of London. For *Seedbed*, part of his January 1972 show at New York's Sonnabend Gallery, Vito Acconci masturbated under a ramp on which audience members walked while listening to his microphone-amplified responses to their presence. *Duet on Ice* (1975) found Laurie Anderson on a Bologna street corner teetering on ice skates and playing classical and original compositions on the violin until the blocks of ice encasing the skate's blades melted. And in 1977 Leslie Labowitz created *Record Companies Drag Their Feet*, a performance designed to focus attention on the use of exploitative images of women on album covers and in society at large. Many artists of this generation (Scott Burton, Gilbert and George, and Vito Acconci among them) have since moved from making performances to making art objects.

A second generation of performance artists emerged in the late 1970s. Rejecting the austerity of Conceptual art and its traditionally critical approach to POPULAR CULTURE, the first generation of artists raised on TV moved performance out of the galleries. Performance can now be seen in theaters, clubs—as music or stand-up comedy—on videotape or film. Performance, usually with striking visual elements, often seems synonymous with AVANT-GARDE dance, drama, or music. The 1980s has produced numerous "cross-over" talents whose roots can be traced to performance and the visual arts. They

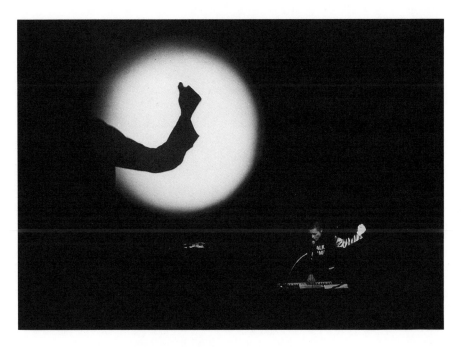

LAURIE ANDERSON (b. 1947).
United States Part II, 1980. Photograph by Paula Court, New York.

include the musicians Laurie Anderson and David Byrne, the actors Ann Magnuson and Spalding Gray, the comics Whoopi Goldberg and Eric Bogosian, the new vaudevillian Bill Irwin, and the opera designer Robert Wilson.

PHOTOMONTAGE—*see* COLLAGE

PHOTO-REALISM

▷ **WHO** Robert BECHTLE, Claudio Bravo (Chile), John Clem Clarke, Chuck CLOSE, Robert Cottingham, Rackstraw Downes, Don Eddy, Richard ESTES, Janet Fish, Audrey Flack, Ralph Goings, Richard McLean, Malcolm MORLEY

▷ **WHEN** Mid-1960s to mid-1970s

▷ **WHERE** Primarily the United States

▷ **WHAT** The New York art dealer Louis Meisel is generally credited with originating the term *Photo-Realism*. (It prevailed over *Realism, Sharp-Focus Realism*, and, in Europe, *Hyper-Realism*.) Photo-Realism is just what the name implies: a type of REALIST painting whose subject is the photograph, or the photographic vision of reality. In his painting of a family posed in front of its late 1950s car, Robert Bechtle, for instance, was more concerned with the flattening effect of the camera on the image than with the nostalgic depiction of suburban family life. Put another way, it is the photographic effect that interests many Photo-Realist painters as much as their subjects.

Most Photo-Realists specialize in a certain type of subject: Richard Estes in photographs of highly reflective windows; Audrey Flack in photographs of symbolic still lifes seen from above; and Malcolm Morley in photographs of travelers on glamorous cruise ships. The polyvinyl sculptures of Duane Hanson and John De Andrea—who work from casts of clothed or unclothed models—can be considered the three-dimensional equivalent of Photo-Realism.

When Photo-Realist paintings appeared in large numbers at Documenta 5—the 1972 version of the important German mega-exhibition—most critics derided it as intolerably backward looking. In fact, the banality of the images, the technique of painting from slides projected onto the canvas, the shallow pictorial space, and the use of thinly applied acrylic paint link many Photo-Realist paintings with POP ART.

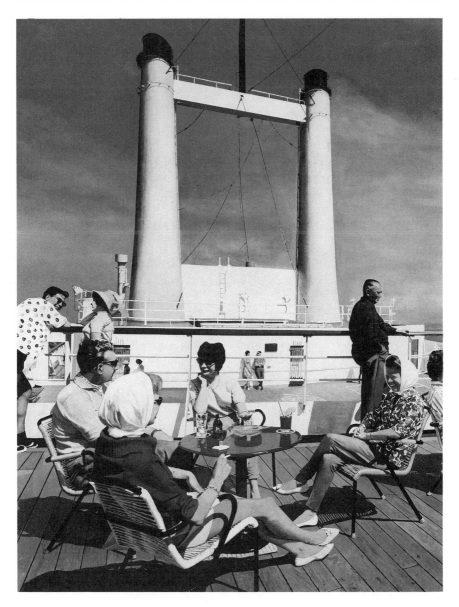

MALCOLM MORLEY (b. 1931).
On Deck, 1966. Magnacolor on liquitex ground on canvas, 83 3/4 x 63
3/4 in. The Metropolitan Museum of Art, New York; Gift of Mr. and
Mrs. S. Brooks Barron, 1980.

PICTURE PLANE

The concept of a picture plane originated during the Renaissance and spurred the development of the principles of perspective. It is not the physical surface of a painting but an imaginary one, which theorists and critics have traditionally equated with a window separating viewers from the image. The picture plane can be "punctured" in a variety of ways: by the depiction of an out-of-scale object in the foreground that appears to occupy the space between the forward limits of the pictorial space and the viewer; or—in the case of an ABSTRACTION—by the inclusion of an illusionistic rendering of, say, an X painted with its shadow so it appears to leap off the surface of an otherwise flat composition. FORMALIST critics of the 1950s and the '60s inveighed against violations of the "integrity of the picture place" (a common phrase) in pursuit of absolute flatness.

PLURALISM

Pluralism is the opposite of a clearly defined mainstream. It refers to the coexistence of multiple STYLES in which no single approach commands the lion's share of support or attention. Although all kinds of art—from REALIST to ABSTRACT and impressionist to EXPRESSIONIST—were produced simultaneously throughout the MODERN period, in the 1920s modern art began to be regarded as a tidy succession of styles originating in the late nineteenth century. During the 1950s ABSTRACT EXPRESSIONISM was seen as the culmination of that development, and critical interest was focused on it to the exclusion of other approaches.

By the mid-1960s a more variegated tapestry of contemporary art was being woven: POP ART, COLOR-FIELD PAINTING, and MINIMALISM were all receiving critical and commercial attention. The 1970s were pluralist with a vengeance. New styles and new media included ARTE POVERA, CONCEPTUAL ART, CRAFTS-AS-ART, EARTH ART, FEMINIST ART, MEDIA ART, PATTERN AND DECORATION, PERFORMANCE, and VIDEO, among many others. The pluralism of the 1970s clearly sprang from the political and cultural upheavals of the late 1960s. Women, for instance, achieved quantitatively larger representation in the art world than at any previous period in history.

The complexity of the pluralist art scene of the 1970s—the decade most associated with pluralism—alienated some observers. Critics hostile to pluralism decried the emphasis on forms other than painting and sculpture, which

demanded radically new criteria of evaluation. Others viewed the situation as open rather than chaotic and maintained that it more accurately reflected the diversity of contemporary society. The subsequent decline of NEO-EXPRESSIONISM in the mid-1980s has been followed by a pluralist situation in which virtually all forms of work are exhibited and written about.

POLITICAL ART

Every artwork is political in the sense that it offers a perspective—direct or indirect—on social relations. Andy Warhol's images of Campbell's soup cans, for instance, celebrate consumer culture rather than criticize it. Jackson Pollock's ABSTRACTIONS proclaim the role of the artist as a free agent unencumbered by the demands of creating recognizable images. The politics are almost invariably easier to spot in pre-MODERN works, such as portraits of kings or popes that frankly announce themselves as emblems of social power.

Milestones of twentieth-century political art include Soviet AVANT-GARDE art from about 1920, Mexican mural paintings and the United States' WPA projects of the 1930s, and Pablo Picasso's *Guernica* (1937). Many of these works take leftist positions supporting the distribution of art to mass audiences or criticizing official policies. Right-wing views were expressed in the art and architecture of the Nazi and Fascist regimes. Paintings of Aryan youths promoted Hitler's genocidal dreams, and ambitious architectural programs linked the Italian and German governments with the authority of classical Greece and Rome. During the 1930s and '40s debate raged among American artists such as Stuart Davis and Arshile Gorky over whether an artist should make straightforwardly political art by using recognizable imagery or create abstractions free of overt politics. The latter viewpoint eventually prevailed, largely due to the Hitler-Stalin Pact of 1939, which many artists and intellectuals regarded as a betrayal.

In current usage *political art* refers to works with overtly political subjects made to express criticism of the status quo. Political artists include Rudolf Baranik, Victor Burgin, Sue Coe, Leon Golub, Felix González-Torres, Hans Haacke, Jerry Kearns, Suzanne Lacy, Martha Rosler, May Stevens, and collective groups such as the Border Art Workshop, Feminist Art Workers, Gran Fury, Group Material, and the Guerrilla Girls. The efficacy of political art becomes a thornier matter when questions of distribution, context, and audience are considered. Can a painting sold for $100,000 to a bank or a multinational cor-

poration function critically? Some politically inclined artists have turned to CONCEPTUAL ART or to making posters for the street in order to control not only the production of their art but also its distribution and context.

POP ART

▷ **WHO** Robert Arneson, Jim Dine, Oyvind Fahlström, Richard HAMILTON (Great Britain), David Hockney (Great Britain), Robert Indiana, Ron Kitaj (Great Britain), Roy LICHTENSTEIN, Claes OLDENBURG, Eduardo Paolozzi (Great Britain), Sigmar Polke (Germany), Mel Ramos, James Rosenquist, Ed Ruscha, Wayne Thiebaud, Andy WARHOL, Tom Wesselmann

▷ **WHEN** Late 1950s through 1960s

▷ **WHERE** Primarily Great Britain and the United States

▷ **WHAT** *Pop* stands for *popular* art. The term *Pop art* first appeared in print in an article by the British critic Lawrence Alloway, "The Arts and the Mass Media," which was published in the February 1958 issue of *Architectural Design*. Although Pop art is usually associated with the early 1960s (*Time*, *Life*, and *Newsweek* magazines all ran cover stories on it in 1962), its roots are buried in the 1950s. The first Pop work is thought to be Richard Hamilton's witty COLLAGE of a house inhabited by fugitives from the ad pages called *Just What Is It That Makes Today's Home So Different, So Appealing?* (1956). That work was first seen at *This Is Tomorrow*, an exhibition devoted to POPULAR CULTURE, by the Independent Group of the Institute of Contemporary Arts in London. The show that thrust Pop art into America's consciousness was *The New Realists*, held at New York's Sidney Janis Gallery in November 1962.

Precedents for Pop art include DADA, with its interest in consumer objects and urban debris, and the paintings and collages of Stuart Davis, an American MODERNIST who used Lucky Strike cigarette packaging as a subject in the 1920s. Chronologically closer at hand, Jasper Johns's NEO-DADA paintings of everyday symbols like the flag were crucially important to American Pop artists. Some observers regard NOUVEAU REALISME as the precursor of Pop. In fact, the rapprochement with popular culture that was epitomized by Pop art seems to have been part of the ZEITGEIST of the 1950s in England, France, and the United States.

Popular culture—including advertising and the media—provided subjects for Pop artists. Andy Warhol mined the media for his iconic paintings and

silkscreened prints of celebrities such as Marilyn Monroe, and Roy Lichtenstein borrowed the imagery and look of comic strips for his drawings and paintings. Claes Oldenburg transformed commonplace objects like clothespins and ice bags into subjects for his witty large-scale monuments.

Pop art was simultaneously a celebration of postwar consumerism and a reaction against ABSTRACT EXPRESSIONISM. Rejecting the Abstract Expressionist artist's heroic personal stance and the spiritual or psychological content of his work, Pop artists took a more playful and ironic approach to art and life. Pop painting did not, however, eschew the spatial flatness that had come to characterize twentieth-century AVANT-GARDE painting.

POSTMODERNISM, NEO-GEO, and APPROPRIATION art—grounded in popular culture, the mass media, and SEMIOTIC interpretation—could never have happened without the precedent of Pop art.

POPULAR CULTURE

Popular culture used to be called *mass culture*, which is now an outmoded term. Made up of a multitude of forms of cultural communication—illustrated newspapers, movies, jazz, pop music, radio, cabaret, advertising, comics, detective novels, television—it is a distinctly MODERN phenomenon that was born in urban Western Europe during the nineteenth century. A nascent working class with a bit of leisure time on its hands created a demand for new art forms that were more accessible than opera, classical music, ACADEMIC painting, traditional theater, and literature. Those elite art forms, developed for aristocratic audiences, required education to be understood. They are known as *high art;* popular (or pop) culture is often referred to as *low art.* The competition between high and low culture peaked in the 1950s and '60s with debates over whether intellectuals (and children) should watch television, whether POP ART *was* art, and other cultural controversies.

For the first half of the twentieth century, the gulf separating high art and popular culture was cavernous. Modern art regarded itself as revolutionary and critical of bourgeois, or middle-class, culture. Uncompromisingly idealistic and frequently hard to sell, it stood apart from commerce. Popular culture, on the other hand, was defined by its commercial success or failure. Although many modern artists were fascinated with jazz or the movies of Charlie Chaplin, their fascination surfaced only indirectly in their art. The popular entertainments offered at music halls and cabarets, for instance, were

frequently portrayed by early modern painters. But for the most part they made paintings of these nightspots, rather than inexpensive prints or advertising posters. The high-art status of their works was never in doubt.

With the advent of Pop art about 1960, this changed. Art was no longer insulated from the consumer-oriented imagery that had become so distinctive a feature of mid-twentieth-century life. The seeds of the symbiotic relationship between art and popular culture that were planted in the Pop art of the 1960s blossomed in the CONCEPTUAL ART of the 1970s. PERFORMANCE, MEDIA, and VIDEO artists of the second half of that decade frequently took as their subjects pop-cultural forms, including soap operas, B novels, and advertisements. Ironically, this reconciliation between popular culture and high art signaled the success of the modernist demand for the portrayal of contemporary experience. Artists could no longer see themselves as beleaguered outsiders confronting a backward-looking bourgeois establishment. (Many began to appear in liquor advertisements beginning in the mid-1980s.) In POSTMODERN art, hostility toward popular culture has been replaced by direct engagement with it. NEO-EXPRESSIONIST painters, for example, were just as likely to take their motifs from Saturday-morning cartoons as from art historical depictions of Marie Antoinette frolicking in milkmaid's attire.

See KITSCH

POST-

Post- is a prefix attached to another term to signify *after*. POST-MINIMALISM means "after MINIMALISM"; POSTMODERNISM means "after MODERNISM," and so on. The use of the term is a modern development. It was first applied to the Post-Impressionists—Paul Cézanne, Paul Gauguin, Georges Seurat, Vincent van Gogh, and others—the major French painters who followed the Impressionists.

That these painters shared little besides their excellence and their historical moment points to the problematic nature of *post*—save in such objective terms as *postwar*. Its use is likely to mislead or mask the real meaning of movements or artworks by implying that they are primarily reactions to what preceded them rather than independent phenomena. (The term *neo*—meaning "new," as in NEO-EXPRESSIONISM—is similarly problematic.) Ultimately, this rush to judgment—we usually think of new work in terms of what we already

know—results in a linear but not necessarily accurate vision of history. Such terms frequently obscure, rather than enhance, the understanding of art.

POST-MINIMALISM—*see* MINIMALISM

POSTMODERNISM

The term *postmodernism* probably first appeared in print in Daniel Bell's *End of Sociology* (1960). Charles Jencks began to apply it to architecture a decade later, when it was also widely invoked in connection with Judson-style dance, which was named after the Judson Memorial Church in Greenwich Village and championed everyday or "vernacular" movement. It was not until the late 1970s that the term began to be routinely used by art critics. Its definition was so vague then that it meant little more than "after MODERNISM" and typically implied "against modernism."

Many theorists believe that the transition from modernism to postmodernism signified an epochal shift in consciousness corresponding to momentous changes in the contemporary social and economic order. Multinational corporations now control a proliferating system of information technology and mass media that renders national boundaries obsolete. (Images of artworks that appear in the art magazines, for example, are instantly accessible to an international audience.) Postmodern or postindustrial capitalism has successfully promoted a consumerist vision that is causing a rapid redrawing of the East-West boundaries established after World War II. The ecological revolt that dawned during the 1960s—as did most of the changes that distinguish postmodernism from modernism—signaled a loss of modern faith in technological progress that was replaced by postmodern ambivalence about the effects of that "progress" on the environment. Just as modern culture was driven by the need to come to terms with the industrial age, so postmodernism has been fueled by the desire for accommodation with the electronic age.

Following World War II, modern art making and art theory grew more reductive, more prescriptive, more oriented toward a single, generally abstract mainstream. (Many other kinds of art were being produced, but that kind of art and theory received the bulk of support from the art establishment.) With MINIMALISM, artists of the 1960s reached ground zero—creating forms stripped down almost to invisibility—and the historical pendulum was set back in

motion. Modernism's unyielding optimism and idealism gave way to the broader, albeit darker, emotional range of postmodernism.

Building directly on the POP, CONCEPTUAL, and FEMINIST ART innovations of the 1960s and '70s, postmodernists have revived various genres, subjects, and effects that had been scorned by modernists. The architect Robert Venturi succinctly expressed this reactive aspect of postmodernism by noting, in his influential treatise *Complexity and Contradiction in Architecture* (1966), a preference for "elements which are hybrid rather than 'pure,' compromising rather than 'clean,' ambiguous rather than 'articulated,' perverse as well as 'interesting.'..."

It is important to distinguish what is new about postmodernism from what is a reaction against modernism. In the latter category is the widespread return to traditional genres such as landscape and history painting, which had been rejected by many modernists in favor of abstraction, and a turning away from experimental formats such as PERFORMANCE ART and INSTALLATIONS. APPROPRIATION artists challenge the cherished modern notion of AVANT-GARDE originality by borrowing images from the media or the history of art and re-presenting them in new juxtapositions or arrangements that paradoxically function in the art world as celebrated examples of innovation or a new avant-garde. Such practices are one source of the difficulty in defining this open-ended term—many observers speak of *postmodernisms.*

One distinctly new aspect of postmodernism is the dissolution of traditional categories. The divisions between art, POPULAR CULTURE, and even the media have been eroded by many artists. Hybrid art forms such as furniture-sculpture are now common. In terms of theorizing about art, earlier distinctions between art criticism, sociology, anthropology, and journalism have become nonexistent in the work of such renowned postmodern theorists as Michel Foucault, Jean Baudrillard, and Fredric Jameson.

Perhaps the clearest distinction between modern and postmodern art involves the sociology of the art world. The booming art market of the 1980s fatally undermined the modern, romantic image of the artist as an impoverished and alienated outsider. What many term the Vincent van Gogh model of the tormented artist has been replaced by the premodern ideal of the artist as a (wo)man of the world, à la Peter Paul Rubens, the wealthy Flemish artist and diplomat who traveled widely throughout European society during the seven-

teenth century. The postmodern phenomenon of retrospective exhibitions for acclaimed artists in their thirties puts heavy pressure on artists to succeed at an early age and frequently results in compromises between career concerns and artistic goals, a problem unknown to the generations of modern artists who preceded them.

POST-PAINTERLY ABSTRACTION—*see* COLOR-FIELD PAINTING

PRIMARY STRUCTURE—*see* MINIMALISM

PRIMITIVISM

There are several kinds of primitivism. There is art by prehistoric or non-Western peoples. (In this case the terms *primitive* and *primitivism* frequently appear in quotes to suggest the inaccuracy and ethnocentricity of such characterizations.) There are subjects or forms borrowed from non-Western sources, including Gauguin's renderings of Tahitian motifs and Picasso's use of forms derived from African sculpture. There is also work by artists who are self-taught, but *primitivism* is rarely used that way anymore.

The idea of primitivism stems in large part from the sentimental notion of the "Noble Savage" as a superior being untainted by civilization, which was popularized by the eighteenth-century French philosopher Jean-Jacques Rousseau. Imperial conquests in Asia, Africa, and Oceania brought exotic foreign cultures to the attention of Europeans. Showcased in the spectacular expositions and fairs of the nineteenth century, the arts and crafts of non-Western peoples offered artists expressive, non-NATURALISTIC alternatives to the illusionistic tradition that had prevailed in Western art since the Renaissance.

The desire to express a truth that transcended mere fidelity to appearance was a fundamental tenet of MODERNISM. Although non-Western art provided many European artists with a model for emotive and sometimes antirational art, they frequently misinterpreted it. Fierce-looking West African masks, for instance, were seen as representations of the mask maker's own inflamed feelings, when they were actually produced as talismans to insure a tribe's good fortune in battle.

The compelling desire to invest art with emotional or spiritual authenticity distinguishes modern from Victorian art, which tried to instruct or divert viewers. To communicate genuine feeling, modern artists turned to a multitude of primitivizing forms and approaches. The motif of the shaman in FEMINIST, ACTION, and PERFORMANCE ART alludes to the prehistoric connection between art, religion, and magic. EARTH ART may evoke prehistoric places of worship. The abundance of childlike imagery in modern art, epitomized in paintings by Paul Klee, embodies the related yearning to escape adulthood and "civilized" social responsibilities. The GRAFFITI or ART BRUT artist's role as a social outsider implies the rejection of an over-civilized world. In Western culture, romantic myths of primitivism are among the most enduring ideas of the last two hundred years..

See THE OTHER

PRINT REVIVAL

▷ **WHO** The foremost printer-publishers are Cirrus Editions Limited (Los Angeles); Crown Point Press (San Francisco); Experimental Workshop (San Francisco); Gemini G.E.L. (Graphics Editions Limited) (Los Angeles); Landfall Press (Chicago); Parasol Press Ltd. (New York); Tamarind Lithography Workshop (Albuquerque); Tyler Graphics, Ltd. (Mount Kisco, New York); Universal Limited Art Editions (ULAE) (West Islip, New York).

▷ **WHEN** Since the late 1950s

▷ **WHERE** United States

▷ **WHAT** *Print revival* is actually a misnomer, because the European tradition of fine prints by artists had never really caught on in the United States in the first place. A few pre–World War II American MODERNISTS, such as John Marin and Edward Hopper, did make prints, but their output was irregular, and the small art-buying public here was uncomfortable with the idea of more than a single "original" inherent in printmaking.

The distance separating American artists and printmakers began to shrink in the late 1930s as European artists fleeing Hitler arrived in New York. Along with them came Stanley William Hayter, the renowned English printer who moved his printmaking studio, Atelier 17, from Paris to New York in 1941. He collaborated with such artists as Mark Rothko and Willem de Kooning, instructing them in numerous lithographic and etching techniques. In 1950 he returned to Paris, although New York's Atelier 17 remained open until 1955.

The print revival began in earnest when Tatyana Grosman opened Universal Limited Art Editions in West Islip on Long Island in 1957, followed by the artist June Wayne's establishment of Tamarind Lithography Workshop in 1960 in Los Angeles. Grosman and Wayne are widely credited with initiating unprecedented interest in American lithography; Kathan Brown would soon do the same for etching at Crown Point Press in the San Francisco Bay Area. All three enabled the most critically acclaimed contemporary artists to experiment with printmaking in collaboration with master printers.

A milestone in the history of American printmaking was the production of Robert Rauschenberg's six-foot-high *Booster* (1967) at Gemini G.E.L. At that time the largest lithograph ever created, it mixed lithographic and screenprinting techniques to achieve the effects that Rauschenberg desired. CONCEPTUAL artists' emphasis on finding the appropriate means to realize an idea stimulated printers and artists to experiment. This spirit of innovation and eclecticism has been America's major contribution to printmaking. Similar approaches are now common in Europe, having been pioneered at the Kelpra Studio in London, where founder Chris Prater began working with artists in 1961. Today there are few contemporary artists of note throughout Europe, Latin America, and the United States who do not include printmaking in their repertoire.

See MULTIPLES

PROCESS ART

▷ **WHO** Lynda Benglis, Joseph Beuys (Germany), Agnes Denes, Sam Gilliam, Hans HAACKE, Eva HESSE, Jannis Kounellis (Italy), Robert Morris, Richard Serra, Keith Sonnier

▷ **WHEN** Mid-1960s to early 1970s

▷ **WHERE** -United States and Western Europe

▷ **WHAT** In process art the means count for more than the ends. The artist sets a process in motion and awaits the results. Eva Hesse used malleable materials like fiberglass and latex to create ABSTRACT forms that seem to spring from the interactions of her unstable materials and that are slowly decomposing over time. In Hans Haacke's plexiglass cubes, or "weather boxes," water

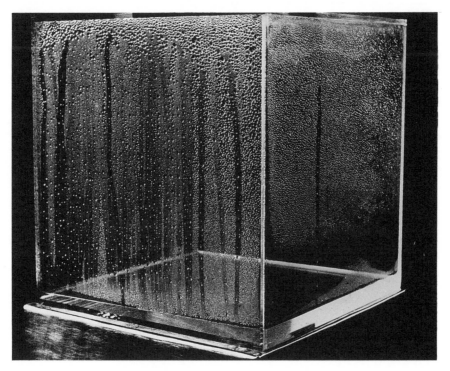

HANS HAACKE (b. 1936).
Condensation Cube, 1963–65. Acrylic, plastic, water, and the climate
in the area of the display, 11 3/4 x 11 3/4 x 11 3/4 in. John Weber Gallery,
New York.

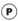

condenses and evaporates in response to the changing levels of light and temperature in the gallery.

Process art was "certified" by two important museum exhibitions in 1969: *When Attitudes Become Form*, curated by Harold Szeeman for the Berne Kunsthalle, and *Procedures/Materials*, curated by James Monte and Marcia Tucker for the Whitney Museum of American Art in New York. Antecedents of process art include Jackson Pollock's ABSTRACT EXPRESSIONIST poured paintings and the slightly later stain paintings by COLOR-FIELD artists such as Helen Frankenthaler. For Pollock and Frankenthaler, the appearance of their work depended partly on chancy processes and the viscosity of specific paints.

MINIMALISM was a crucial catalyst, for process artists reacted against its impersonality and FORMALISM. They sought to imbue their work with the impermanence of life by using materials such as ice, water, grass, wax, and felt. Instead of platonic, abstract forms that would be at home anywhere in the Western world, they made their works "site specific," sometimes by scattering components across a studio floor or outdoor setting.

Process artists' commitment to the creative process over the immutable art object reflects the 1960s interest in experience for its own sake. Also, they hoped to create nonprecious works with little allure for the newly booming art market. Process art should be considered alongside other anti-Minimalist trends of that day such as ARTE POVERA, CONCEPTUAL ART, EARTH ART, and PERFORMANCE ART.

PUBLIC ART

▷ **WHO** Dennis Adams, Stephen Antonakos, Siah ARMAJANI, Alice Aycock, Judy Baca, Scott BURTON, Mark di Suvero, Jackie Ferrara, R.M. Fischer, Dan Flavin, Richard Fleischner, Richard HAAS, Lloyd Hamrol, Michael Heizer, Doug Hollis, Nancy Holt, Robert IRWIN, Valerie Jaudon, Luis Jiminez, Joyce Kozloff, Roy Lichtenstein, Mary Miss, Robert Morris, Max Neuhaus, Isamu NÒGUCHI, Claes Oldenburg, Albert Paley, Richard Serra, Tony Smith, Ned Smyth, Alan Sonfist, Athena Tacha

▷ **WHEN** Since the late 1960s

▷ **WHERE** United States

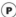

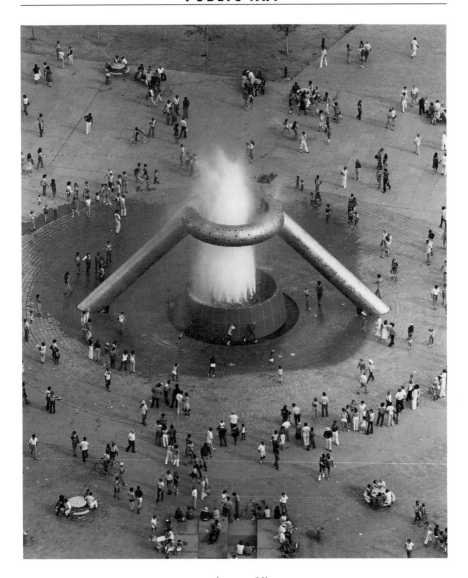

ISAMU NOGUCHI (1904–1988).
Horace E. Dodge and Son Memorial Fountain, 1978. Stainless steel, with granite base, height: 24 ft. Philip A. Hart Plaza, Detroit.

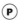

▷ **WHAT** In the most general sense, *public art* is simply art produced for—and owned by—the community. This notion of art is as old as art itself, dating back to prehistoric cave-painting and idol-carving. The history of art encompasses far more examples of public than private art, ranging from the frescoes and sculpture of temples and cathedrals to the commemorative statuary created for public squares.

Radical changes came with MODERN art. The AVANT-GARDE search for the new was incompatible with the aim of reaching a wide public. So, too, was the modernist emphasis on the purity of individual art forms, which mandated that the traditional relationship of sculpture and architecture, for instance, be dissolved. By the late 1950s this had led to the construction of myriad unembellished buildings with ABSTRACT sculptures—what today's architects and public artists jokingly call "plop art"—placed on their sterile plazas.

Public art is related to a couple of government initiatives of the late 1960s: the percent-for-art programs and the National Endowment for the Art's Art in Public Places program. The percent-for-art programs now operating in about half of the states and many cities and counties set aside for art a certain percentage (usually one percent) of the construction budget for a public project. The Art in Public Places program assists communities with funding and expertise in commissioning and acquiring artworks for public sites.

Changes in thinking about the nature of art itself in the late 1960s dovetailed with such official encouragement. Many artists were leaving their studios to create EARTHWORKS and other environmental forms that demanded an architectural rather than a studio scale. The challenges of realizing such complex projects provided artists with not merely the necessary skills but also the willingness to collaborate and hence abandon the complete control that comes from working in a studio.

Hostility to a small number of public artworks that some observers found inappropriate led to heated controversies in the 1980s. Maya Lin's abstract Vietnam War Memorial in Washington, D.C., was augmented with Frederick Hart's more conventional FIGURATIVE sculpture, and Richard Serra's SITE-SPECIFIC *Tilted Arc* sculpture was removed from its lower Manhattan site in 1989 after years of legal and administrative wrangling. One outcome of such disputes has been the widespread adoption of procedures that encourage greater community input and bring artists into the design process at an earlier stage.

Public artworks range from Joyce Kozloff's tiled murals in subway stations to Max Neuhaus's SOUND SCULPTURES for similar sites; from Isamu Noguchi's multi-

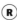

acre parks and plazas to Richard Haas's trompe-l'oeil murals that transform
drab walls into architectural fantasies, and from Dennis Adams's politically
probing bus-shelter images to Judy Baca's murals of the history of Los Angeles
and its Hispanic communities painted on the concrete walls of the Los Angeles
River. Artists are even designing what were once anonymous architectural
elements, such as seating, lighting, and ornamental pavements.

READYMADE—*see* FOUND OBJECT

REALISM

Realist art—like realist literature—originated in mid-nineteenth-century
France. It was pioneered by the painter Gustave Courbet, who announced
that never having seen an angel, he could certainly never paint one. His
resolve to be truthful to his own experience made him a forebear of
MODERNISM.

In its original, nineteenth-century sense, *realism* implied not just the accurate
depiction of nature, but an interest in down-to-earth everyday subjects.
Naturalism referred only to an artist's fidelity to appearances. Carried to its
illusionistic extreme, naturalism results in *trompe-l'oeil*—literally "fool-the-
eye"—painting. By the mid-twentieth century the distinction between the two
had largely disappeared, and today *realism* and *naturalism* are used inter-
changeably.

Apart from the SURREALISTS, who invented a naturalistic style of portraying their
often unnatural dreams, and the German artists of the *Neue Sachlichkeit* (or
New Objectivity) movement, who laced their realist portraits with biting psy-
chological insights, AVANT-GARDE artists rejected realism in favor of ABSTRACTION.
(*Neue Sachlichkeit* and Surrealist artists were roundly criticized for their use of
recognizable figurative imagery.) During the 1950s realism disappeared from
critical consideration, only to emerge at the end of the decade with POP ART
and NEW REALISM. The scope of today's realism is capacious, most of it falling
into the loose category of New Realism. Effective realist art, such as Eric
Fischl's psychologically charged renderings of domestic drama, recalls the
nineteenth-century sense of the term as a powerful means of commenting
on—and illuminating—contemporary experience.

REGIONALISM

Regionalism has two meanings—one that predates World War II and one that follows it. The earlier use, which gained currency in the mid-1930s, applies to American artists of that day who rejected MODERNISM in favor of developing independent styles. The Regionalists—also known as the American Scene painters—included Thomas Hart Benton, Grant Wood, and John Steuart Curry. Although they were usually regarded as conservative defenders of family and flag, this view is oversimplified. Benton, for instance, held unorthodox views that were evident in his satirical paintings of midwestern life.

A second meaning of regionalism has emerged since World War II and New York's apotheosis as international art capital. As New York claimed center stage, artists in other centers of art-making activity, such as Los Angeles, San Francisco, and Chicago, were relegated to marginal status. (Artists who worked in NEW YORK SCHOOL—derived modes were considered mainstream no matter where they lived.)

Regionalism tends to be used pejoratively, with the connotation of provincialism. Unlike the prewar Regionalist "school," latter-day regionalism is largely a function of geography rather than philosophy. New York remains the center of the international art world, but its dominance is being challenged. Decentralization has been fueled by real-estate costs that make New York a prohibitively expensive place for artists and critics to live, by the emergence of regional art publications such as the *New Art Examiner* that provide alternative viewpoints, and by the emergence of art schools such as the California Institute of the Arts, which educated many of the most eminent American artists of the 1980s. The virtually instant communication available today suggests that the notion of a physical center and outlying regions may soon be irrelevant.

See BAY AREA FIGURATIVE STYLE, CHICAGO IMAGISM, LOS ANGELES "LOOK"

REPRESENTATION

A representation is a depiction of a person, place, or thing. *Representational* refers to artworks with a recognizable subject, as opposed to works that are termed ABSTRACT.

The interpretation of representations is nearly synonymous with the study of images and symbols known as *iconography.* The study of representations may, however, range further afield than those of iconography, to address the

mass media or aspects of POPULAR CULTURE such as advertising, which had previously been outside the art historian's scope. Such analyses are often interdisciplinary. The study of representations of the elderly, for example, might encompass images and texts found in the news media, film, advertising, and art of various cultures.

RUBBER-STAMP ART—*see* FLUXUS

SALON—*see* ACADEMIC ART

SCHOOL OF PARIS

School of Paris is a rather vague term for numerous movements in MODERN art that emanated from Paris during the first half of the twentieth century. Chief among them were Fauvism, Cubism, and SURREALISM.

The term also refers to Paris's pre-eminent position as the center of modern art from its inception until World War II. Following the war the United States came to dominate art making among the Western allies, just as it dominated the group's political and economic life. *The New York School*—beginning with ABSTRACT EXPRESSIONISM and including, according to some observers, COLOR-FIELD PAINTING and MINIMALISM—is invariably invoked in triumphant opposition to the School of Paris it "dethroned."

SEMIOTICS

All communication requires the use of signs, language itself being the most universal system of signs. Semiotics is the science of those signs. Although the term is several hundred years old, semiotics is largely a twentieth-century phenomenon. Semiotic analysis has been trained on numerous subjects, ranging from snapshots and comic strips to body language and the barking of dogs. Artists and critics became interested in it during the 1960s following the emergence of POP ART, which rejected the language of art in favor of that of advertising. CONCEPTUAL artists used the languagelike codes of the mass media, structural anthropology, and other disciplines previously outside the scope of art and impervious to FORMALIST criticism.

Semiotics is rooted in separate investigations by the Austrian philosopher Ludwig Wittgenstein and the Swiss linguist Ferdinand de Saussure early in this century. Instead of analyzing classical philosophical propositions or concepts involving ethics or aesthetics, they analyzed the language in which they were couched in search of their underlying nature and biases. Their work foretold the increasingly important role of communications and the packaging and promotion of ideas in MODERN culture. They noted that language provides the chief metaphor for organizing meaning, used to describe phenomena as dissimilar as the "genetic code" and the "fashion vocabulary."

Semiotics has provided an analytical tool for writers: Roland Barthes used it to analyze photography, and Umberto Eco applied it to architecture. Some artists—including the Conceptual and FEMINIST artists Judith Barry, Victor Burgin, Hans Haacke, and Mary Kelly—*deconstruct* social stereotypes, myths, and clichés about gender and power that are communicated and reinforced by mass-media sign systems. *Deconstruction* is a semiotics-derived analysis that reveals the multiplicity of potential meanings generated by the discrepancy between the ostensible CONTENT of a "text"—which may be a work of art—and the system of visual, cultural, or linguistic limits from which it springs.

One and Three Chairs (1965), by the Conceptual artist Joseph Kosuth, exemplifies a semiotic approach to the nature of meaning. It comprises a wooden folding chair, a full-scale photograph of that chair, and the dictionary definition of *chair*. In the vocabulary of semiotics the wooden chair is a "signifier," the definition of *chair* is the "signified"; and together they equal the "sign." Kosuth augmented this simple equation by providing the photograph of the chair as a substitute for the viewer's perception of the real chair, thereby suggesting that art—unlike semiotics—may not be reducible to scientific principles.

SET-UP PHOTOGRAPHY—*see* FABRICATED PHOTOGRAPHY

SHAPED CANVAS

▷ **WHO** Lucio Fontana (Italy), Ellsworth KELLY, Kenneth Noland, Leon Polk Smith, Richard Smith (England), Frank STELLA

▷ **WHEN** 1960s

▷ **WHERE** United States and Europe

SHAPED CANVAS

FRANK STELLA (b. 1936).
Darabjerd III, 1967. Synthetic polymer on canvas, 120 x 180 in.
Hirshhorn Museum and Sculpture Garden, Smithsonian Institution,
Washington D.C.; Gift of Joseph H. Hirshhorn, 1972.

▷ **WHAT** Paintings are usually rectangular, but circular pictures, or tondos, were popular in Europe during the Renaissance and there are examples of oval- and diamond-shaped canvases in early twentieth-century art. The term *shaped canvas* gained currency as more than a neutral descriptor with the exhibition of Frank Stella's "notched" paintings at the Leo Castelli Gallery in September 1960. These were MINIMALIST paintings in which symmetrically arranged pinstripes echoed the unconventional shape of the stretched canvas. The imagery and the underlying canvas were integrated; the painting became less an illusionistic rendering than an independent object, the two-dimensional counterpart of Minimalism's three-dimensional PRIMARY STRUCTURES.

Although such works sometimes seemed to synthesize painting and sculpture, the intention was precisely the opposite. A single, extremely flat surface was maintained, in contrast to later multilevel three-dimensional ASSEMBLAGES and reliefs, most notably by Stella himself, that did obliterate the distinction between painting and sculpture. Contemporary painters have put the non-rectangular format to a variety of different purposes, ranging from the fragmented imagery spread across Elizabeth Murray's brash multicanvas works to the spirituality of Ron Janowich's ABSTRACTIONS.

SIMULACRUM—*see* SIMULATION

SIMULATION

A simulation is a replica, something false or counterfeit. The terms *simulation* and *simulacrum* (the plural is *simulacra*) are virtual synonyms in current art parlance. Although *simulation* can accurately be used to describe a forgery or the reenactment of a newsworthy event, in the art world it usually refers to the POSTMODERN outlook of Jean Baudrillard and other French thinkers whose beliefs became influential in the late 1970s.

Baudrillard asserts that we can no longer distinguish reality from our image of it, that images have replaced what they once described. Or, in the SEMIOTIC language of "The Precession of Simulacra," published first in the September 1983 issue of *Art & Text*, "It is no longer a question of imitation, nor of reduplication . . . [but] of substituting signs of the real for the real itself." Responding to the new technology that facilitates the endless reproduction or cloning of information and images—television, facsimile machines, even genetic engineering—Baudrillard suggests that the notion of authenticity is essentially meaningless. His work poses the questions: What is an original? And where

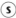

do public events leave off and the flow of images representing and interpreting them begin?

Baudrillard's line of reasoning dovetailed with some artists' concerns about the meaning of originality at the end of the MODERN era, an epoch that had placed so high a premium on AVANT-GARDE originality. Artists such as Sarah Charlesworth, Clegg and Guttmann, Peter Halley, Barbara Kruger, Sherrie Levine, Allan McCollum, and Richard Prince—and critics writing about them— often referred to Baudrillard's notion of the simulacrum. Many of these artists are associated with APPROPRIATION, the self-conscious use of images culled from art history or POPULAR CULTURE. During the mid-1980s the term *simulationism* was briefly popular.

SITE SPECIFIC—*see* INSTALLATION

SITUATIONISM

▷ **WHO** André Bertrand (France), Benjamin Constant (Netherlands), Guy DEBORD (France), Asger JORN (Denmark), Giuseppe Pinot Gallizio (Italy), Spur Group (Germany)

▷ **WHEN** 1957 to 1972

▷ **WHERE** Western Europe

▷ **WHAT** The Situationist International was founded in 1957 when two earlier AVANT-GARDE groups—the Lettrist International and the Movement for an Imaginist Bauhaus—formally merged. Highly theoretical, Situationism emerged from an analysis of Western society that indicted capitalism for its transformation of citizens into passive consumers of the depoliticized media spectacle that had replaced active participation in public life. (This viewpoint is best articulated in Guy Debord's influential 1967 book, *Society of the Spectacle.*)

Situationism's roots can be traced back to the SURREALIST mission of radically disrupting conventional, bourgeois life. It can, in fact, be considered a post-war form of Surrealism, in which the emphasis on the psychological unconscious was replaced by an interest in the concepts of *détournement* (diversion or displacement), *dérive* (drift), and *urbanisme unitaire* (integrated city life). *Urbanisme unitaire* necessitated the creation of artworks that crossed the boundaries separating art forms—paintings larger than buildings, for

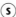

instance—and of urban environments as locales for *Situations*, or meaningful social interactions.

These theoretical concerns were translated into a variety of artistic approaches with a shared intellectual foundation but no common STYLE. Asger Jorn exhibited "détourned" works painted over partially obliterated cheap reproductions of art, calling into question the value of originality and authorship. Giuseppe Pinot Gallizio created 145-meter-long, city-scaled "industrial" paintings satirizing automation, which he sold by the meter. Magazines, posters, and films were also produced, primarily by the Spur Group and Debord.

By the mid-1960s Situationist art making had largely given way to theoretical writing and political organizing. The French general strike of May 1968 owed much to Situationist ideas and was immortalized in the Situationist posters and cartoons that embodied the goals of the student Left. The Situationist International was dissolved in 1972. A major Situationist exhibition, *On the Passage of a Few People through a Rather Brief Moment in Time*, was mounted by the Centre Georges Pompidou in 1989 and proved controversial in its attempt to present this highly politicized movement through art objects and historical artifacts.

Situationism vitally influenced the development of British punk art, inspired some European CONCEPTUAL and ARTE POVERA artists, and presaged the strategies of POSTMODERNISTS like Barbara Kruger and Richard Prince, who subvert the visual idioms of advertising.

SNAPSHOT AESTHETIC

▷ **WHO** Larry Clark, Bruce Davidson, Robert FRANK, Lee FRIEDLANDER, Joel Meyerowitz, Garry WINOGRAND

▷ **WHEN** Late 1950s through 1970s

▷ **WHERE** Primarily the United States

▷ **WHAT** The vast majority of twentieth-century photographs have been either photojournalistic images or snapshots taken by amateurs. The least self-conscious or sophisticated of photographic approaches, amateur snapshots follow certain conventions determined by the camera itself and by popular ideas about what a photograph should look like.

Snapshots are almost invariably views of people or the landscape, made at eye

LEE FRIEDLANDER (b. 1934).
Mount Rushmore, South Dakota, 1969. Gelatin-silver print,
7 7/16 x 11 1/8 in. Philadelphia Museum of Art; Purchased with a grant
from the National Endowment for the Arts and matching funds con-
tributed by Lynne and Harold Honickman, the J. J. Medveckis
Foundation, Harvey S. Shipley Miller and J. Randall Plummer, and
D. Robert Yarnall, Jr.

level, with the subject in middle distance and in natural light. The central placement of the subject often allows random bits of reality to sneak into the edges of the picture. It is this unplanned "marginalia" that endows some snapshots with a complexity and humanity otherwise achieved only by the most skilled professional photographers.

During the 1960s and 1970s this naive but powerful approach exerted a tremendous influence on art photography. The originator of this aesthetic was Robert Frank, who in 1959 published a book of black-and-white photographs called *The Americans*. This Beat-era, on-the-road vision of America as an amalgam of parking lots, gas stations, backyards, and small-town politicians and their constituents was simultaneously a compelling and a damning look at the frequently romanticized small-town American scene. Frank's project was revolutionary not merely for his sometimes mundane subjects but also for the relatively straightforward STYLE of his pictures. Although it rejected the ennobling, even mystical aims of Ansel Adams, Alfred Stieglitz, Edward Weston, and other pioneers of STRAIGHT PHOTOGRAPHY, the camera-derived, unembellished snapshot aesthetic is a tributary of the straight photographic mainstream.

The irony and detachment inherent in the snapshot aesthetic aligned it with POP ART, which was developing at the same time. Both took as their point of departure the world as it is, rather than as it ought to be. Garry Winogrand and Lee Friedlander, for example, produced pictures about American rites, foibles, and obsessions previously unexplored by photographers. Their often random-looking compositions attempted to embody the flux and flow of rapidly changing contemporary lifestyles, usually with tongue-in-cheek humor. The apparent artlessness of such work masked its own conventions, including the production of relatively small prints and virtually exclusive use of black-and-white—rather than color—film.

SOCIAL REALISM

Social Realism is a term with two meanings, one coined prior to World War II, the other after. The original meaning refers to leftist political art produced during the 1920s and 1930s, primarily in the United States, Mexico, Germany, and the Soviet Union. It was not originally used to mean any particular STYLE, and Social Realist works range from the ambitious Mexican mural cycles by Diego Rivera and José Clemente Orozco to the paintings on topical themes of class struggle by the American Ben Shahn. The bias of Social Realism against

ABSTRACTION and toward the didactic illustration of political subjects gave it a pronounced anti-MODERNIST flavor.

Today, *Social Realism* (often mistakenly called *Socialist Realism*) has become a pejorative term for banal, REALIST images of the working class meant to be accessible to every viewer, of any age or IQ. It is frequently, though not exclusively, identified with communist countries, including the Soviet Union, China, and North Korea. Such propagandistic works have been produced by the thousands, but Social Realism is no longer the officially sanctioned art-making approach anywhere.

SOTS ART

▷ **WHO** (all Soviet born) Eric BULATOV, Valeriy Gerlovin and Rimma Gerlovina, Ilya Kabakov, Kazimir Passion Group, KOMAR and MELAMID, Alexander Koslapov, Leonid Lamm, Leonid Sokov, Alexander Yulikov

▷ **WHEN** Since the early 1970s

▷ **WHERE** Europe, United States, and USSR

▷ **WHAT** The term *Sots art* was coined by Komar and Melamid in 1972 in Moscow, where the now American-based collaborators were then living. A friend had likened the mass-cultural imagery they were using to Western POP ART, which inspired their ironic wordplay on Socialist art.

Socialist stood for the SOCIAL REALIST view of art that had dominated Soviet culture since the time of Stalin. A Soviet doctrine promulgated in 1934 demanded artworks "national in form and Socialist in content." By the end of the 1960s official artistic production had degenerated into hackneyed ACADEMIC images of Revolutionary heroes and heroines, assembly lines, and workers on tractors.

Artists began to APPROPRIATE and subvert these clichéd images of nationalism, gender, and power. To do this, they utilized parody, ironic juxtapositions, and dislocating backdrops against which they set their subjects. Komar and Melamid, for instance, painted a 1972 double self-portrait of themselves in the manner of countless state portraits of Lenin and Stalin; Leonid Sokov created viciously satirical sculptures of Soviet leaders.

These "unofficial"—as opposed to government-supported—artists found it impossible to exhibit their work in the USSR. The Sots art group issued a

manifesto and tried to participate in an open-air exhibition of 1974, which was dubbed the "Bulldozer" show after officials mowed it down. In the wake of the ensuing international criticism a follow-up show was mounted two weeks later, but the Sots artists were never permitted to hold a group exhibition exclusively devoted to their work.

During the 1970s many of the Sots artists were allowed to emigrate, primarily to New York. (Not until the inception of Gorbachev's *glasnost* in the late 1980s would the line separating "official" and "unofficial" art begin to dissolve.) The first major New York exhibition offering Sots art was Komar and Melamid's 1976 show (smuggled out of Moscow) at Ronald Feldman Fine Arts; the most important was the traveling group show *Sots Art*, mounted by the New Museum of Contemporary Art in 1986.

Sots art is the first AVANT-GARDE art movement within the USSR since the 1930s. The Pop art–like irreverence of Sots art, its interest in mass communication and cultural signs (or SEMIOTICS), and its appropriation-based method all link it with the international rise of POSTMODERNISM in the late 1970s.

SOUND ART

▷ **WHO** Laurie Anderson, John Anderton (Great Britain), Chris Apology, Rosland Bandt (Australia), Connie Beckley, Charles and Mary Buchner, Phil Dadson (New Zealand), Paul Earls, Brian Eno, Terry FOX, Doug HOLLIS, Paul Kos, Alvin Lucier, Tom Marioni, Max NEUHAUS, Bruce Nauman, Pauline Oliveiros, Dennis Oppenheim, Nam June Paik, Jill Scott (Australia), Wen-ying Tsai (China), Yoshi Wada

▷ **WHEN** 1970s

▷ **WHERE** International

▷ **WHAT** The *art* half of the term *sound art* announces that such works, composed primarily of sound, are made by visual artists (or by crossover PERFORMANCE artists). Sound art is usually presented in visual-art venues—galleries, museums, environments, and PUBLIC ART and performance sites—or on audio-cassette "magazines."

Luigi Russolo first assailed the division between art and music with his 1913 Futurist manifesto *The Art of Noise* and with his orchestras of strange instru-

ments (gurglers, shatterers, buzzers, and the like) used to suggest the auditory ambience of the street. What would become the CONCEPTUAL ART aspect of this art-music fusion was initiated when a screw was allegedly dropped into DADA artist Marcel Duchamp's READYMADE, *A Bruit secret (With Hidden Noise)* (1916). After World War II, Duchamp's disciple John Cage continued in this spirit with his silent compositions designed to focus attention on ambient sound. They were predicated on Cage's assertion that "Music never stops, only listening." HAPPENINGS and FLUXUS events frequently included sound or music.

Sound sculpture took off as a Conceptual art form beginning in the late 1960s and, like so many other Conceptual art forms, peaked in the 1970s. Many Conceptual artists, including Bruce Nauman and Jill Scott, created sound works while simultaneously working in other media such as INSTALLATIONS and video. Two 1970 shows—at New York's Museum of Contemporary Crafts and San Francisco's Museum of Conceptual Art—suggested how widespread the use of sound by artists was becoming.

Today artists are using sound to chart a variety of courses. Some, including Laurie Anderson, incorporate pop music within their theatrical performances. Others, such as Brian Eno, Doug Hollis, and Max Neuhaus, create subtly textured sound environments. Hollis's outdoor works, for instance, are sometimes triggered by natural phenomena such as the wind. It is environments such as these, which focus almost entirely on the aural, that are most often considered "sound art." Chris Apology puts sound to highly conceptual purposes in the *Apology Line*, an interactive phone service in New York in which callers may apologize and hear confessions by others.

STAGED PHOTOGRAPHY—*see* FABRICATED PHOTOGRAPHY

STAIN PAINTING—*see* COLOR-FIELD PAINTING

STORY ART—*see* NARRATIVE ART

STRAIGHT PHOTOGRAPHY

▷ **WHO** Ansel ADAMS, Berenice Abbott, Diane ARBUS, Eugène Atget (France), Bill Brandt (England), Henri CARTIER-BRESSON (France), Imogen Cunningham, Walker EVANS, Robert FRANK (Switzerland), Lee Friedlander, Lewis Hine, Dorothea Lange, Albert Renger-Patzsch (Germany), Alfred STIEGLITZ, Paul Strand, Edward Weston, Garry Winogrand

▷ **WHEN** 1900 through 1970s

▷ **WHERE** Europe and the United States

▷ **WHAT** The term *straight photography* probably originated in a 1904 exhibition review in *Camera Work* by the critic Sadakichi Hartmann, in which he called on photographers "to work straight." He urged them to produce pictures that looked like photographs rather than paintings—a late nineteenth-century approach known as *Pictorialism*. To do so meant rejecting the tricky darkroom procedures that were favored at the time, including gum printing, the glycerine process, and scratching and drawing on negatives and prints. The alternative demanded concentrating on the basic properties of the camera and the printing process.

The great MODERNIST tradition of straight photography resulted from the thinking of Hartmann and many others. It featured vivid black-and-white photographs ranging from Eugène Atget's luminous images of a rapidly disappearing Parisian cityscape to Imogen Cunningham's striking nudes of her husband on Mount Rainier. It was often considered equivalent, especially during the first half of the century, to documentary photography—loosely, the pictorial equivalent of investigative reporting. Documentary photography was epitomized by Lewis Hine's turn-of-the-century images of slum dwellers and the government-sponsored portraits of the Depression-era poor by Walker Evans and Dorothea Lange.

Straight photography is so familiar that it is easy to forget that it is an aesthetic, no less artificial than any other. The fact that black-and-white pictures may look more "truthful" than color prints, for instance, points to just one of straight photography's highly influential conventions. After World War II the orthodoxies of straight photography began to be challenged. Unconventional approaches emerged, including an interest in eccentric lighting, blurred images of motion, and tilting of the frame for expressive effect. So, too, was there widespread interest in the SNAPSHOT AESTHETIC, and finally, even the use of color.

DIANE ARBUS (1923–1971).
Identical Twins, Roselle, New Jersey, 1966. Gelatin-silver print,
14 3/4 x 14 1/4 in. Collection, The Museum of Modern Art, New York;
Richard Avedon Fund.

The debate over whether photography is an art raged for nearly a century. The early twentieth-century photographer, publisher, critic, and gallery owner Alfred Stieglitz linked straight photography's destiny to modernism by simultaneously championing it along with modern painting and sculpture. While straight photographs have been exhibited in museums and galleries since 1909, a market for them did not really develop until the 1970s, when painting and sculpture in traditional formats were in unusually short supply.

Straight photography has lost much of its prestige as POSTMODERN photographers have rejected its once-dominant tenets. They now produce works that counter the purist emphasis on straight photographic process (MANIPULATED PHOTOGRAPHY), on documentary veracity (FABRICATED and MANIPULATED PHOTOGRAPHY), and on maintaining the distinction between art and POPULAR CULTURE (FASHION AESTHETIC).

STYLE

There is no such thing as a work of art without a style. The idea of style as defined by art history is rooted in the belief that artworks from a particular era (the T'ang Dynasty, the Italian Renaissance, the 1960s) share certain distinctive visual characteristics. These include not only size, material, color, and other FORMAL elements, but also subject and CONTENT.

Artists cannot transcend the limits of their era. (Forgeries of Jan Vermeer's seventeenth-century works that were painted by the notorious forger Hans van Meegeren fifty years ago seemed authentic then but now loudly announce themselves as works of the 1930s and '40s.) Without the twentieth-century tradition of spatially flattened abstraction behind them, it's difficult to imagine that the PATTERN-AND-DECORATION artists of the 1970s would have turned to Middle Eastern rugs and tiles for inspiration. If consumer society had not mushroomed after World War II, POP ART could not have come into being.

Other factors such as locale, training, and perhaps even gender—this has been the subject of heated debate among feminists and nonfeminists—affect the styles of individual artists. A multitude of personal styles contribute to the stylistic currents of a given era. No artist's style is likely to completely embody any one particular style; it is, after all, individuality and personality that contemporary Westerners value in art.

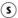

SURREALISM

▷ **WHO** Jean (Hans) Arp (Germany), Joseph Cornell, Salvador Dali (Spain), Max ERNST (Germany), Frida Kahlo (Mexico), René Magritte (Belgium), André MASSON (France), Matta (Chile), Joan MIRO (Spain), Meret Oppenheim (Switzerland), Pablo Picasso (Spain), Man Ray, Yves Tanguy (France), Remedios Varo (Mexico)

▷ **WHEN** 1924 to 1945

▷ **WHERE** Primarily in Europe, but also in Latin America and the United States

▷ **WHAT** Surrealism, the movement that dominated the arts and literature during the second quarter of the twentieth century, is included here because it is central to MODERN art. Its enduring importance derives from both its innovative subjects and its influence on postwar ABSTRACT painting.

The term *Surrealism* is now used too indiscriminately. It was coined by the French poet Guillaume Apollinaire in 1917 to refer to his freshly minted drama *Les Mamelles de Tirésias* and to Pablo Picasso's set designs for the ballet *Parade.* Its meaning was articulated by the French poet André Breton in the first "Manifesto of Surrealism" (1924), which is Surrealism's birth certificate. Breton defined it as "pure psychic automatism by which it is intended to express . . . the true function of thought. Thought dictated in the absence of all control exerted by reason, and outside all aesthetic or moral preoccupations."

Surrealism is a direct outgrowth of DADA; the two are often considered in tandem, and the Dada artists Max Ernst and Jean Arp were bridges to Surrealism. Dada contributed such essentials as experimentation with chance and accident, interest in FOUND OBJECTS, BIOMORPHISM, and automatism (pictorial free association). The Surrealists gave these Dada concerns a psychological twist, helping to popularize the Freudian fascination with sex, dreams, and the unconscious.

During the 1920s two styles of Surrealist painting developed. The first is exemplified by the bizarre, hallucinatory dream images of Salvador Dali and others, which are rendered in a precise, REALIST style. To many observers, that return to illusionistic FIGURATION marked a regressive step in the course of increasingly abstract modern art. This sort of dream imagery entered the popular imagination not only through art but also via film, fashion, and advertising.

The second, actually earlier, Surrealist approach was the automatism favored by Joan Miró and André Masson. Lyrical and highly abstract, their composi-

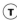

tions present loosely drawn figures or forms in shallow space that evoke Native American pictographs and other forms of non-European art.

The Paris-based Surrealists remained an organized cadre of writers and artists throughout the 1930s. Hitler's rise to power and the prospect of war sent many of them to New York. There they provided the role models for Arshile Gorky, the last of the official Surrealist painters, and the artist who helped point the way from the automatic variety of Surrealism to ABSTRACT EXPRESSIONISM.

SYNESTHESIA—*see* ABSTRACT/ABSTRACTION

SYSTEMIC PAINTING—*see* COLOR-FIELD PAINTING

TACHISME—*see* ART INFORMEL

TRANSAVANTGARDE

▷ **WHO** (all Italian) Sandro Chia, Francesco Clemente, Enzo Cucchi, Nicola De Maria, Mimmo Paladino, Remo Salvadori

▷ **WHEN** Late 1970s to mid-1980s

▷ **WHERE** Italy

▷ **WHAT** The term *Transavantgarde* is the invention of the Italian critic Achille Bonito Oliva. He has defined Transavantgarde art as traditional in format (that is, mostly painting or sculpture); apolitical; and, above all else, eclectic. The Transavantgarde artists APPROPRIATE images from history, POPULAR CULTURE, and non-Western art.

Oliva's characterization of the Transavantgarde is essentially a definition of NEO-EXPRESSIONISM, coined before that term caught on. Although he intended his description to apply to the international Neo-Expressionist mainstream that emerged in the early 1980s, it has become identified only with Italian artists of that sensibility.

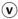

VIDEO ART

▷ **WHO** Vito Acconci, Max Almy, Laurie Anderson, ANT FARM, Robert Ashley, Stephen Beck, Dara Birnbaum, Colin Campbell (Canada), Peter D'Agostino, Douglas Davis, Juan Downey, Ed Emshwiller, Terry Fox, Howard Fried, Gilbert and George (Great Britain), Frank Gillette, Dan Graham, John Greyson (Canada), Doug Hall, Julia Heyward, Gary Hill, Rebecca Horn (Germany), Joan Jonas, Michael Klier (Germany), Paul KOS, Richard Kriesche (Austria), Shigeko Kubota, Marie Jo Lafontaine (Belgium), Les Levine, Joan Logue, Chip Lord, Mary Lucier, Stuart Marshall (Great Britain), Robert Morris, Antonio Muntadas (Spain), Bruce NAUMAN, Tony Oursler, Nam June PAIK, Adrian Piper, Klaus Rinke (Germany), Ulrike Rosenbach (Germany), Martha Rosler, Jill Scott (Australia), Richard Serra, Michael Snow (Canada), Keith Sonnier, John Sturgeon, Skip Sweeney and Joanne Kelly, Target Video, Top Value Television, T. R. Uthco, Stan Vanderbeek, Woody and Steina Vasulka, Edin Velez, Bill Viola, Bruce and Norman Yonemoto

▷ **WHEN** Since the mid-1960s

▷ **WHERE** International

▷ **WHAT** Video art is video made by visual artists. It originated in 1965, when the Korean-born FLUXUS artist Nam June Paik made his first tapes on the new portable Sony camera and showed them a few hours later at Cafe à Go Go in New York's Greenwich Village.

Video is a medium, not a STYLE. Artists use video technology in remarkably varied ways. Some (including Paul Kos, Mary Lucier, Jill Scott, and Bill Viola) make videotapes to be used in PERFORMANCE ART or in INSTALLATIONS. Others (such as Les Levine, Martha Rosler, and the Vasulkas) create videotapes to be screened on video monitors in art museums or galleries. Still others (including Skip Sweeney and Joanne Kelly, Edin Velez, and the Yonemotos) prefer to broadcast or cablecast their videotapes on television, a modus operandi that requires conforming to the costly technical standards and corporate values of the networks and independent channels. For many video artists, the unresolved relationship of art video and television remains a perennial issue.

The best way to suggest the astonishing variety of video art is to cite a few examples. Frank Gillette's six-monitor video installation *Aransas* (1978) created a portrait of the swampy Aransas landscape that literally surrounded viewers. The German artist Michael Klier's *Der Riese* (*The Giant*, 1983) is a collage of "found" video footage from surveillance cameras. Joan Jonas's *Organic*

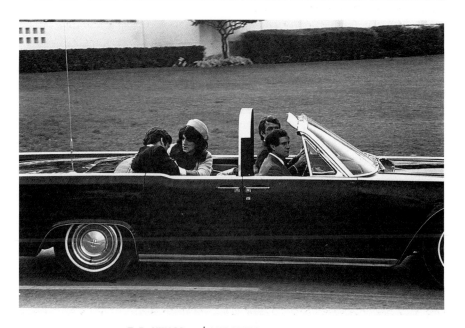

T. R. UTHCO and **ANT FARM.**
The Eternal Frame, 1976. Production still by Diane Andrews Hall.
Collection of the artist..

Honey's Vertical Roll (1973) used the rolling images of poorly adjusted video monitors as an expressive distortion. Ant Farm and T. R. Uthco's *Eternal Frame* (1976), re-creates John Kennedy's assassination in Dallas and raises disturbing questions about our increasingly mediated—or indirect, media-derived experience—of reality. For *Leaving the Twentieth Century* (1982), Max Almy utilized the latest computer-based technology to create special effects rarely seen before in artists' video.

As in performance art, video's CONCEPTUAL ART–oriented first generation has given way to a second, POSTMODERN generation. Almy is typical of that generation, creating works attuned to POPULAR CULTURE rather than critical of it. *Leaving the Twentieth Century*'s high-tech imagery synched to rock music seemed to anticipate the MTV style of music videos, which appeared soon after the release of her tape.

XEROGRAPHY—*see* HIGH-TECH ART

ZEITGEIST

This German word (pronounced tsīt-gīst) has entered the English language untranslated. It literally means "spirit of the time" and suggests the mood and thinking of a given era or, colloquially, "what's in the air." In art terms Zeitgeist refers to certain characteristics of a period or moment: the melancholic introspection of the *fin de siècle* (1890s); the optimism and experimentation of the 1960s; POSTMODERNISM's ironic embrace of tradition and history.

Page numbers in **boldface** refer to main entries for art movements, art forms, and critical terms.
Page numbers in *italics* refer to illustrations.

164

PRACTICE AND RESEARCH IN LITERACY

Edited by

ADITI MUKHERJEE

AND

DUGGIRALA VASANTA

Research in Applied Linguistics Vol. 5

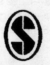

SAGE Publications

New Delhi • Thousand Oaks • London

First published in 2002 by

Sage Publications India Pvt Ltd
M-32 Market, Greater Kailash I
New Delhi 110 048

Sage Publications Inc
2455 Teller Road
Thousand Oaks, California 91320

Sage Publications Ltd
6 Bonhill Street
London EC2A 4PU

In collaboration with the Centre of Advanced Study in Linguistics, Osmania University, Hyderabad.

Published by Tejeshwar Singh for Sage Publications India Pvt Ltd, typeset by Microtech Data Processors, Delhi and Printed at Chaman Enterprises, Delhi.

Library of Congress Cataloging-in-Publication Data

National Symposium on Literacy (1998: Centre of Advanced Study in Linguistics, Osmania University)
 Practice and research in literacy / editors, Aditi Mukherjee and Duggirala Vasanta.
 p. cm. — (Research in applied linguistics; v. 5)
Papers and other material from the National Symposium on Literacy, held at the Centre of Advanced Study in Linguistics at Osmania University, Feb. 16–17, 1998.
Includes bibliographical references and index.
 1. Literacy programs—India—Case studies—Congresses. 2. Literacy —Social aspects—India—Congresses. I. Mukherjee, Aditi. II. Vasanta, Duggirala, 1955–III. Title. IV. Series.

LC157.I5 N39 302.2'244—dc21 2002 2002022691

ISBN: 0-7619-9597-8 (US-Hb) 81-7829-123-1 (India-Hb)
 0-7619-9693-1 (US-Pb) 81-7829-161-4 (India-Pb)

Sage Production Team: K.E. Priyamvada, Sushanta Gayen and Santosh Rawat

CONTENTS

LIST OF ABBREVIATIONS

AFLP	Adult Farmers Literacy Programme
AIPSN	All India People's Science Movement
APJVV	Andhra Pradesh Jana Vignana Vedika
BGVS	Bharat Gyan Vigyan Samiti
BGVJ	Bharat Gyan Vigyan Jatha
CABE	Central Advisory Board of Education
CE	Continuing Education
CORO	Committee of Resource Organisation
DFID	Department for International Development
DIET	District Institute for Educational Training
DLS	District Literacy Society
DPEP	District Primary Education Programme
ETS	Education Testing Service
HSTP	Hoshangabad Science Teaching Programme
IPCL	Improved Pace and Content Learning
JCK	Jana Chaitanya Kendra
JVV	Jana Vignana Vedika
KSSP	Kerala Sastra Sahitya Parishad
MHRD	Ministry of Human Resource Development
MLA	Member of the Legislative Assembly
MLL	Minimum Levels of Learning
MRO	Mandal Revenue Officer
NAEP	National Adult Education Programme
NFE	Non Formal Education
NIAE	National Institute of Adult Education
NLM	National Literacy Mission
NLMA	National Literacy Mission Authority
NSSO	National Sample Survey Organisation
OBC	Other Backward Classes
OBCM	Ongoing Beneficiary Contact Monitoring
PDS	Public Distribution System
PL	Post Literacy
PLC	Post Literacy Campaign
POA	Programme of Action
PRA	Participatory Rural Appraisal
PRI	Panchayat Raj Institution
PROBE	Public Report on Basic Education
PSF	Pondicherry Science Forum
PSM	People's Science Movement
REFLECT	Regenerated Freirean Literacy through Empowering Community Techniques
SAEP	State Adult Education Programme
SCERT	State Council for Education Research and Training
SRC	State Resource Centre
ST	Scheduled Tribe
TLC	Total Literacy Campaign
WMT	Word Method of Teaching
ZSS	Zilla Saksharata Samiti

ACKNOWLEDGEMENTS

The papers in this volume emerged out of a National Symposium on Literacy organized by the Centre of Advanced Study in Linguistics, Osmania University during February 16–18, 1998. At the time of the symposium, many institutions and individuals helped us with academic, organizational, financial and other administrative matters. By contributing both published as well as unpublished books and articles, Government reports, visual material and ideas on literacy, several people helped us in bringing out a select bibliography and souvenir at the time of the symposium. Some of our colleagues, friends and family shared our excitement about the symposium. They participated in bringing out the souvenir and put up with many inconveniences while we spent many hours editing the manuscript for publication. With the exception of one or two papers which we are sorry to have missed, we were able to get all the participants to revise and resubmit their papers. We thank them for their cooperation. For their help in getting the manuscript to go to press, we are grateful to Prof. Rama Kant Agnihotri and Prof. A.L. Khanna, series editors for the Sage series in Applied Linguistics. Omita Goyal and K.E. Priyamvada of Sage Publications, New Delhi have been very helpful in ensuring that the volume got to where it is today. Since we cannot thank each organization/individual for their specific contribution to this volume, we are listing their names to express our gratitude. We apologize for any omissions we may have made.

Anthra, Yakshi and Girijana Deepika; A.P. Jana Vignana Vedika; Anveshi research centre for women's studies; Centre of Advanced Study in Linguistics, Osmania University (colleagues, research scholars and office staff); Central Institute of English & Foreign Languages (Library staff); National Literacy Mission, New Delhi Research and Practice in Adult Literacy (RaPAL) group, UK; Sandip Bandyopadhyay; Purushottam Bharadwaj; David Barton; P. Devi; Sonya Gupta; Prathibha Karanth; Kasturi; L.M. Khubchandani; K.K. Krishna Kumar; K. Shiv Kumar; V. Swarajya Lakshmi; Usha Lakshmi; Kamal Mahendroo; Priti Manuel; Lakshmidhar Mishra; Madhusudan; Rekha Pappu; M.P. Parameswaran; P.K. Ravindran; Sadhana Saxena; Ilina Sen; J.L. Sachdeva; Rajesh Sachdeva; S.R. Sankaran; J. Venkateswara Sastry; R. Srivatsan; D. Subba Rao; Brian V. Street; Jacob Tharu; Susie Tharu; B.S. Vasudeva Rao.

INTRODUCTION

'What would happen if the world were to become
literate. Answer: Not so very much, for the world is by
and large structured in such a way that it is capable of
absorbing the impact. But if the world consisted of
literate, autonomous, critical, constructive people,
capable of translating ideas into action, individually or
collectively—the world would change' (Galtung,
1976: 93).

The last decade of the twentieth century in India was eventful in
many ways. It was a decade of conflicting voices. On the one
hand, dominant voices representing a mainstream ideology made
claims about integration and a homogeneous identity and promoted
their common agenda across the length and breadth of the country.
On the other hand, numerous alternative voices sought to assert
their rights as independent groups with distinct identities which
did not necessarily fit under a homogenizing ideological umbrella.
This decade saw many regroupings and realignments as
manoeuvres on the political chessboard led to frequent changes in
the government both at the central and the state level. This was
also a decade of considerable opening up of the economy to global
market forces, as part of economic 'development' programmes.
This resulted in instability necessitating massive readjustments
among various sections of society.

Somewhere in this state of flux, mass literacy programmes were
initiated on a large scale. Conflicting voices and aspirations found

their way into this domain too. There were claims and counter-claims in terms of goals and levels of achievement. It was an era of euphoria and cynicism; anticipation and disappointment. New theories and methodologies emerged. Large scale literacy campaigns were undertaken, both by the State and Non Government Organisations. (NGOs). But by and large, the theoreticians, policy formulators and literacy workers worked in isolation from one another.

Wherever mass literacy campaigns have been undertaken in the world, they have been initiated with the purpose of bringing about major structural transformations in the economic, social and political lives of the people in question. Sometimes it is the State which has a strong political and ideological commitment to transformations in favour of the oppressed, that initiates the movement—as happened in the former USSR, China, Vietnam, and Cuba. In other cases, the movement constitutes a part of the struggle to free a nation from dictatorial or foreign rule. For instance, in Nicaragua, the campaign for literacy formed a crucial aspect of the Sandinista Liberation Front's struggle against the dictatorship of Anastasio Somoza García and his National Guard. Similarly, during the freedom movement in India, mass literacy/education were embedded in the context of the struggle to free the nation from foreign rule. In mobilizing the masses to participate in the freedom movement, education was deemed to be of paramount importance by the leaders of pre-independence India. Several political figures and social reformers such as Mahatma Gandhi, Rabindranath Tagore, B.R. Ambedkar, Ishwarchandra Vidyasagar, Jyotiba and Savitri Phule, and Pandita Ramabai, among others, had not only stressed the need for education but also initiated several educational programmes (including the preparation of primers and textbooks) to further the cause of educating the common man. Significantly, during this period, literacy was neither seen as being distinct from education nor was it an end in itself. In fact, Gandhi had very explicitly argued that education had to go beyond literacy and not end with it. As Agnihotri (in this volume) has pointed out, 'the period... is marked by intense literacy and political awareness programmes implemented through summer schools for political education, literacy classes and literacy campaigns, library movements, extension lectures and a variety of other socially relevant activities'. The literacy movement was clearly situated in a social

context and was geared towards a long-term socially transformational goal.

In today's context, the conditions of dictatorial or foreign rule do not exist in India. Nor does the country seem to have a government driven by any ideological commitment, as in socialist countries, to bringing about radical structural transformations to benefit the masses. The present campaign for mass literacy and education, therefore, must be seen as part of the modernization process. Although since independence, India has achieved creditable success in many areas, such as industrial growth, the emergence of a large scientific community, the green revolution etc., it has fared rather poorly in the areas of literacy and elementary education. It is true that literacy rates have gone up since independence, but it is equally true that the absolute number of illiterate people has also gone up during the period 1981–91. Dreze and Sen (1995) have pointed out how other countries in different stages of development—whether driven by market oriented capitalism (South Korea, Taiwan, Thailand) or communist-party-led socialism (Cuba, Vietnam, China) and other mixed systems of economic planning (Costa Rica, Jamaica, Sri Lanka)—have left India far behind in the areas of adult literacy and elementary education. After more than half a century of independence, the adult literacy rate in India hovers somewhere around 60 per cent which is far below the average of even the least economically developed countries in the world. The comparative literacy statistics provided by Dreze and Sen are revealing. Citing the case of Kerala and accounting for its achievements in most socio-cultural areas they point out the existence of a '...dialectical relationship between educational progress and social change: the spread of education helps to overcome the traditional inequalities of caste, class and gender, just as the removal of these inequalities contributes to the spread of education' (1995: 109). It is in this context that one would like to examine the literacy programmes undertaken on a large scale by the government in the last two decades.

In 1978 (just after the Emergency) the National Adult Education Programme (NAEP) was launched with a view to bringing about a radical change in the socio-economic developmental process. Inspired by Paolo Freire's philosophy, the programme sought to draw the poor to the centre of development activity as participants, rather than letting them remain passive spectators.

Maintaining the interlinked relationship between illiteracy and poverty, the NAEP viewed literacy practice as a political act. However, despite the enthusiasm of the early years, and significant work done by some committed groups along Freire's notion of participatory learning in small pockets, the NAEP had to be wound up within a decade leaving the Education Commission's (1964–66) call for 'liquidating illiteracy' unfulfilled. Bordia and Kaul (1992), Banerjee (1993) and Ramachandran (1999) have attributed the unfortunate termination of the programme to, among other things, corruption, mismanagement of funds and excessive bureaucratization. Ravindran (in this volume) has gone to the extreme of claiming that since the spirit of the programme was too radical to be comfortable for those in power, the 'dangerous ideological content was removed and the campaign spirit was killed by the government'.

In 1984–85, several 'Technology Missions' were launched by the government to tackle certain welfare measures on a war footing, such as supply of clean potable water, containing infant mortality through immunization, attaining self-reliance in oil seeds, setting up a rapid network of rural tele-communications systems, and *eradication of illiteracy*. It is interesting that literacy should have figured on the agenda of the Technology Missions. Clubbing literacy with other technologically geared programmes would lead to the suspicion that literacy may have been perceived as a technological advancement in the sense of merely imparting literacy 'skills', and not as a social movement that would relate to ideological and socio-political questions such as the dynamics of inequality, injustice and power-resource imbalance. It is significant that by now the NAEP's original goal of 'education' (which was in keeping with the pre-independence ethos) of initiating a movement for lifelong learning, had shifted to a 'quick-fix' campaign for 'literacy' with no long-term vision or commitment (as admitted by L. Mishra, the former Director General of the National literacy Mission, in this volume). The 'illegitimate distinction between literacy and education' (Agnihotri in this volume) appears to have been covertly granted official legitimacy.

When the National Literacy Mission (NLM) came into being in 1988, as part of the Ministry of Human Resource Development, the goals it formally chalked out for itself were very impressive. The aim was to impart 'functional literacy' to about 80 million

adults in the age group of 15–35 years by the year 1995. It was expected that 'functional literacy' would enable the neo-literates not only to achieve self-reliance in literacy but also become aware of the causes of their deprivation and move towards amelioration of their condition through organization and participation in the process of development. It was envisaged that they would also acquire skills to improve their economic status and imbibe certain values like national integration, conservation of the environment, women's equality and the benefits of family planning etc. The logistics for achieving these goals were carefully worked out. It was decided to adopt a campaign mode which was to be a 'compromise between a centre-based hierarchical approach and a revolutionary approach in which literacy is inevitably embedded in a struggle for socio-political and economic change' (Agnihotri, 1994). The programme came to be popularly known as the Total Literacy Campaign (TLC). Some of the salient features of the programme were:

(a) The district was to be the basic unit of operation,

(b) The District Collector was to be incharge of the programme,

(c) Like NAEP, the TLC was to bring together motivated people from diverse walks of life—the administration, voluntary groups, locally elected bodies, semi governmental agencies like Bharat Gyan Vigyan Samiti (BGVS) and other activists participating individually—in order to carry out a well orchestrated campaign,

(d) The literacy classes were to be preceded by a long campaign to motivate the potential learner and to recruit volunteers to teach them. This was to be through environment building programmes including mobile cultural performances that came to be known as *Jathas* and *Kalajathas,*

(e) The performance/achievement of the TLC in each district was to be evaluated internally as well as externally by institutions of social science research, universities, and voluntary organizations.

The entire programme gave the impression of tight planning with a time bound framework that made it seem quite achievable. The literacy centres had started functioning in most of the

selected districts by 1990. By 1998, it is reported that 447 districts were covered by TLC under various phases: 215 under the literacy campaign phase; 173 under the post-literacy phase; and 59 under the continuing education phase.

Kerala has often been cited as the state in which the 'campaign' mode worked. In February 1990, the Ernakulam district of Kerala was declared the first 'totally' literate district in India. The campaign mode was soon adopted in the other districts of Kerala. In April 1991, i.e., in a little over a year's time, Kerala achieved total literacy with a literacy rate of 90 per cent. The resulting euphoria is understandable. Kerala Sastra Sahitya Parishad (KSSP), the activist group that had been working closely with the People's Science Movement (PSM) in Kerala, played the lead role in the planning and execution of the campaign. Significantly, the District Collector who was in charge of the campaign had himself been a senior and committed member òf the KSSP. The campaign mode in Kerala very soon became the 'model' that the rest of the country was expected to follow. However, there were reservations about attributing the success of Kerala entirely to the TLC (Dreze and Sen, 1995; Agnihotri, 1994; Ramachandran, 1996). It has been pointed out that several historical, geographical, cultural, social and political factors may have provided the material bases for the positive reception of the campaign at this point of time. To begin with, Kerala already had a very high rate of literacy when the TLC was initiated in the state. As Saldanha (1999: 2023) has pointed out, 'regions of high literacy do have the human and cultural resources to address their literacy issues. This is demonstrated by the intervention of the Committee of Resource Organisation (CORO), a voluntary organisation in the city of Bombay' where between the years 1989 and 1993, a substantial number of learners 'were taught by instructors who were school students resident in the same slum communities as the learners and often related to them'. Kerala also had a history of strong progressive and radical political movements. Social voluntarism has a traditional base here. Jeffrey (1992) has indicated how the relatively favourable position of women in society and their informed agency had contributed substantially to major social achievements. Most of the primary school teachers in Kerala are women and much of the success in the areas of literacy and elementary education may be attributed to the active participation

of the women. Kerala has also been much ahead of other states in 'the scope and quality of a wide range of public services such as schooling facilities, basic health care, child immunization, social security arrangements, and public food distribution' (Dreze and Sen, 1995: 54). Besides, as Ramachandran (1996) has pointed out, a relatively long history of achievement in mass literacy has facilitated 'informed political activism' contributing to many social reforms, especially in the areas of class, caste and gender based inequalities.

Ravindran (in this volume) claims that despite the favourable factors mentioned above, the TLC in Kerala would not have succeeded without certain crucial features that characterized the campaign. He, however, does not take cognizance of the fact that the current literacy campaign could acquire the crucial features cited by him, precisely because of the pre-existing material and cultural bases built over a long period of time. The volunteers undertaking the work almost with a missionary zeal, without expectation of payment, the de-bureaucratization of the government personnel and machinery (by his own admission, many of the '"NGO Lieutenants" were government servants who were taken on deputation to the KSSP and had temporarily become "free citizens" and therefore were not hierarchically controlled by the Collector'); or in other words, 'giving a people's face to the bureaucracy'; and, the 'house to house visits a number of times', etc.,may not have been feasible if historically, the social and political conditions had not built up an atmosphere over time which was conducive to this kind of commitment. What was probably needed was a catalyst and the NLM seems to have provided this through theTLC.

Dreze and Sen (1995: 55), after recognizing Kerala's 'special cultural and historical characteristics which may have helped its social transformation' have argued that 'the *political process* (emphasis added) itself has played an extremely important role in Kerala's development experience, supplementing or supplanting these inherent characteristics'. They, therefore, believe that Kerala's achievement can be 'emulated' in other states of India, including Uttar Pradesh, where basic deprivations remain endemic, with the help of 'determined and reasoned political activism'. Whether such political activism can take place abruptly in a vacuum, ignoring the material base, is a moot point.

Kerala, then, became the 'model' for literacy campaigns in the rest of the country. In the early 1990s the Pondicherry Science Forum (PSF), a reputed NGO in Pondicherry, engaged itself in mass mobilization—quite similar to what KSSP had done in Kerala—with spectacular success, like Kerala. Nellore in Andhra Pradesh is another district where the political fallout of the TLC made national news, and generated a debate of significance comparable to the one about the Ernakulam success. It had far reaching implications for the women's movement which gained enough strength to influence sensitive policies of the state government on liquor, leading to total prohibition (Vasanta et al., in this volume; Shatrugna, 1998; Anveshi Report, 1993; BGVS, 1994; Ilaiah, 1992). In fact, the movement became so powerful that it threatened the nexus between the government and the liquor lobby sufficiently to make the State move its entire machinery to contain the movement. This included withdrawal of the 'offensive' literacy primers, transfer of the committed teachers/leaders to far off places, and even efforts to bribe and intimidate the women. Ironically, when the people became 'aware of the causes of their deprivation' and were struggling to move towards 'amelioration of their condition' the State had too much at stake to allow the movement to continue. It makes one wonder whether the logic of governance can permit the State to implement a radical agenda for literacy which would make the masses question the very basis of the exploitative structures on which it rests.

Ernakulam, Nellore, Pudukkottai and Pondicherry where grassroots mobilization of the people for a long time before the initiation of TLC had ensured its great success, were probably a few exceptions to the generally dismal performance of the programme. Many districts like Bijapur and Narsinghpur, where NGOs committed to political activism did not exist prior to the campaign, achieved very little by 'emulating' the Kerala model. The campaign mode did not seem to be viable in the absence of a politically activated, grassroots level, people's organization. The government machinery neither had the skill nor the political will to prepare suitable grounds for the 'implementation' of the campaign. Transplanting the model without the prerequisite groundwork failed to inspire both the volunteers and the potential learners, as the 'campaign' operated totally outside their specific social context. Saldanha (1999: 2019), while arguing that the 'strategy is sound

and anyhow is all that exists, without a large scale alternative in sight', also makes note of the fact that,'the struggle was implemented across the board, throughout the country, in generally an undifferentiated manner and without much care for contextualization. Even certain basic preconditions during the preparatory phase of the campaigns, such as the generation of widespread voluntarism ... came to be neglected as the campaigns gradually came to be both finance-driven and drawn by the needs of low literacy states.'

In 1998, an independent survey, (i.e., not 'officially' through the NLM's evaluation channel) of the post-literacy scenario in three districts of Madhya Pradesh—Narsinghpur, Raipur and Bilaspur, was conducted. It indicated that in Raipur and Bilaspur where Rupantar (an NGO) and BGVS respectively, were engaged in mobilization of the people around contextually embedded social issues there was far greater success in imparting and sustaining literacy than in Narsinghpur where the literacy activity was undertaken in total isolation from any social or developmental activities (Mukherjee, 1999). In fact, the performance in Narsinghpur was extremely discouraging although, quite ironically, it had been declared a 'totally literate' district in 1992 and proclaimed the 'Ernakulam of the Hindi belt'. Why is it that the awareness generating *jathas* and *kalajathas* as part of the TLC had not succeeded in motivating the learners to become and remain literate in most of the districts? The question is, can sporadic and sudden awareness campaigns generate and sustain sufficient motivation among the learners? Can these campaigns substitute politically informed and sustained activism around contextually rooted issues at the grassroots level?

Experiences elsewhere have shown that literacy drives have better chances of survival and success when they are linked with social/political movements from 'below'. It may be recalled that even Frank Laubach's innovative 'each one teach one' approach became effective in the Philippines only after he had been able to overcome the Moro resistance by initiating a movement among the youth to address basic local problems like water scarcity and other issues like health, hygiene, agriculture and animal husbandry. The programme became so relevant that when it was wound up for extraneous reasons, '... the Moro leaders wanted to keep it alive and they issued the instruction that anyone becoming literate

should in turn make another literate or would be killed' (Ghosh, 1998: 405). Burdwan (another moderately successful TLC district in West Bengal) had experienced a long phase of peasant movement. Pudukkottai in Tamil Nadu, where there had been a substantial amount of political mobilization of the women quarry workers before the TLC was launched is another successful TLC district. Literacy was built into the watershed development and land literacy programmes in Kerala and in West Bengal the total operation was deeply rooted in local problems and developed with community participation. The reason for Jyotiba and Savitri Phule's phenomenal success in their literacy/education drive in Maharashtra in the nineteenth century may to a great extent be attributed to the fact that the entire movement was clearly linked to fighting social injustices such as the exploitation of women and the lower castes. Literacy was not dealt with in the abstract and was therefore, not meaningless. The attempt to artificially instill motivation from 'above' which the TLCs have been trying to do, becomes not only irrelevant but also self-defeating in the final analysis. If the NLM seriously means to link literacy with radical transformations in the socio-economic lives of the people and their general well-being, the least it can do is to provide institutional support wherever sites for context-specific social/political movements are created rather than buckle under the slightest perception of threat, as it did in Nellore. But, once again, such radical action may be contradictory to the logic of governance.

The most positive fallout of the TLC, as reports from many districts indicate, is that it had apparently succeeded in inspiring the rural poor to educate their children (Banerjee, 1993; Public Report on Basic Education [PROBE], 1999). There seems to be an increased demand from the people for better schooling facilities and greater accountability. It is also reported that the resistance to immunization programmes has been contained to a great extent. And, above all, the participation of those from the disadvantaged groups—like the members of the scheduled tribes, scheduled and other backward castes, and women (especially Muslim women)—in literacy classes and their achievement level have been quite encouraging. This is also borne out by our experience in Madhya Pradesh (Mukherjee, 1999) and reports from other areas such as Kerala, Nellore, and Pudukkottai. These are not small achievements by any means.

But clearly, this is not *all* that the NLM had set out to achieve. It had expected to 'eradicate illiteracy' from the country in the foreseeable future. Based on provisional data and the figures indicating an increase in literacy between 1981 and 1991, the projected estimate of literacy growth given by the Census Commissioner of India in 1991, has not been very encouraging. It was argued that in the normal course it would take the country about another 56 years to achieve total literacy (Nanda, 1991). However, the data from the 1998 report of the National Sample Survey Organisation (NSSO) would make us believe that India has finally made a major breakthrough in the attempt to achieve total literacy. In a period of a mere six years (1991–97) the literacy rate has shot up by 10 per cent i.e., from 52 per cent to 62 per cent. This can, by any standards, be considered a quantum leap. The total number of illiterate people is said to have fallen from 329 million in 1991 to 294 million in 1997, despite the considerable growth in population. It indicates a growth rate of 10 per cent in six years as against 8.7 per cent in the preceding decade. It is also projected that in the next five or six years, the literacy rate will cross 75 per cent. The NSSO claims that 'India would reach a level of between 66 and 68 per cent by the time of the Decennial Census of 2001. Assuming as literacy experts hold, that total literacy for India means reaching the sustainable threshold of 75 per cent, then India could expect to reach this level sometime between 2004 and 2005. This would be earlier than the previous expectation of around 2011' (p. 7). Further, stressing the spectacular achievement in this regard, the NSSO also claims that 'In sum, it can now be said with conviction that the battle against illiteracy has been well and truly joined' (p. 8). The report concludes with the faith that 'the NSSO figures will provide great encouragement to literacy workers, activists, volunteers, NGOs, practitioners and; of course, the Mission and the Government'. It would, indeed, be worth nurturing this faith if it were possible to take these figures at face value. However, it is difficult to do so in view of the fact that many districts had not gone through external evaluation (Narsinghpur, for instance), the number of people declared literate in many cases were inflated for extraneous reasons, the criteria for evaluation were loose in several cases, and a very large number of neo-literates had reverted to illiteracy due to delay, or total absence of follow up work. The validity of the

official statistics indicating stupendous success may be suspect. It may be educative to go back to Ernakulam and Pudukkottai, our two showpieces of 'success', and evaluate afresh how many neo-literates have sustained their literacy skills after the areas were declared totally literate and how this literacy actually translated into empowerment in their day-to-day lives.

One of the main aims of this book is to challenge the dominant discourse of literacy — that literacy is a neutral and a purely skill-based enterprise; that the basic literacy skills of reading, writing and numeracy can be imparted to the masses provided that sufficient number of volunteer-teachers came forward to work in the night schools; that once these skills are imparted and care is taken to assess that they have in fact learnt the skills, the learners will automatically acquire the necessary knowledge to improve their economic status; that the method used in one area can successfully be transplanted to the others as a 'model', and so on. Above all, the book hopes to challenge the argument that mass literacy campaigns have come to occupy pride of place in the agenda of national action and that they are an important barometer of the nation's development and progress.

These (dominant) discourses have been drowning out a whole lot of weaker discourses — that teaching people to merely decode letters (with a total disregard to their social and economic background and the uses they would like to put literacy to constructively) is meaningless; that while mass literacy programmes are important for any society, the content, organization, methodology and political objectives of these programmes must be allowed to be scrutinized (without being labelled as 'anti-literacy') and for that to happen, it is necessary to identify and sustain local literacies; that the literacy pedagogy will not contribute to an effective dialogical process unless it is sensitive to the variety of language that the learners are familiar with; that unless the curriculum is negotiated, 'literacy instruction' will not lead to greater awareness about the rights of the learners and hence such knowledge will not translate into action for social transformation. A place has been provided in this book for both these voices — the dominant and the alternate discourses on literacy and education in the Indian context.

Having noticed a wide gap between the theoretical writing on literacy and school education on the one hand, and the ground level

experiences that some of us had (during the mid-90s) while work-
ing with the underprivileged and out of school children, we de-
cided to organize a National Symposium on Literacy at the
Centre of Advanced Study in Linguistics at Osmania University,
Hyderabad on February 16 and 17, 1998. We invited both literacy
theorists and practitioners to come together for a dialogue. The
two-day symposium was attended by over 100 participants in-
cluding noted literacy theorists, Government officials associated
with the National Literacy Mission, activists associated with NGOs
working in the areas of literacy and education such as the BGVS,
Eklavya, Jana Vignana Vedika (JVV), KSSP, Yakshi, representa-
tives from women's organizations, university teachers and research
scholars. The meeting proved to be very productive. At the end of
the symposium, there were suggestions for establishing a forum
for literacy at Osmania University so that people interested in the
issues of literacy and education could continue to interact. While
we could not start such a forum, we decided to bring out the
papers presented at the symposium in the form of a book.

With the firm belief that all the voices must co-exist and be
heard, we have tried to minimize our editorial efforts to bring about
uniformity, especially in the content. In other words, we do not
necessarily agree with the views expressed by all the contributors
to this volume nor are we happy with the way some of them have
sought to study the issue and report the results. However, we
realized that the alternative discourses gain 'meaning' only when
the taken-for-granted dominant discourse is also made visible. In a
few cases when we could not get hold of the full-fledged papers,
we have transcribed the gist of the oral presentations by listening
to the audio-tapes of the presentations. Despite our sincere
efforts, we could not include all the papers presented at the sym-
posium. We regret losing some very important contributions from
the field, in particular the Hoshangabad Science Teaching
Programme (HSTP) of Eklavya (an NGO in Madhya Pradesh) and
the post-literacy programmes in Pondicherry. We have included a
paper that was scheduled for presentation but could not be
presented due to some unforeseen circumstances. The paper
authored by the three NGOs, viz., Girijana Deepika, Yakshi and
Anthra, working with the tribal population in the East Godavari
Districts of Andhra Pradesh, was not presented at the sympo-
sium, although an earlier version of it was submitted to us at the

time of the symposium, for circulation. This book then is not strictly a record of the proceedings of the symposium. Instead, it is a collection of articles carrying disparate views on how literacy is perceived in the current context.

The contents of this book have been organized into two sections. The first section titled Theoretical Perspectives features papers by Rama Kant Agnihotri, Brian Street, Sadhna Saxena, Aditi Mukherjee, and Lachman Khubchandani. Drawing on his experiences of working with literacy and primary education programmes in India, Agnihotri calls for an elimination of the illegitimate distinction between the concepts of literacy and education. His paper provides a detailed description of the changing socio-political scenario in which literacy programmes were planned, implemented, and institutionalized in India. Brian Street's paper emphasizes the need to draw on theoretical debates to fight the dominant and simplistic notions of literacy typically used in the developmental discourses around the world. In particular, he illustrates the distinction between literacy practices and literacy events in relation to a literacy project in South Africa and one in Banda District in Uttar Pradesh. In her paper, Sadhna Saxena places the anti-*arrack* agitation that took place in Nellore, in its historical context. She discusses how the entire movement was subverted by the government which succeeded in depoliticizing the women through the introduction of credit and thrift societies. Aditi Mukherjee's paper focuses on the question of code in literacy practice. Arguing that the selection of a given code (standard vs dialect) in literacy practice, particularly in the primers, cannot be a socially or politically neutral and ideologically innocent act, she suggests the possibility of using the dialect as part of a conscious effort towards a minoritarian project that would make communication without domination possible. Lachman Khubchandani takes issue with the prevailing practice of ignoring speech variation across dialects in school education and literacy programmes. He argues that spoken language must be given more importance since it is the spoken and not the written language that plays a major role in learning and communication.

The second section titled Literacy Practice: Pedagogy and Evaluation has 10, papers by Rajesh Sachdeva, Sandip Bandyopadhyay, Ilina Sen, D. Vasanta, Sonya Gupta and P. Devi, Lakshmidhar Mishra, P.K. Ravindran, K.K. Krishna Kumar and

S.R. Sankaran, D. Subba Rao and B.S. Vasudeva Rao, V. Swarajya Lakshmi and a joint paper by three NGOs, viz., Girijana Deepika, Yakshi and Anthra. Rajesh Sachdeva's paper draws on everyday experiences to show how literacy is a socially constructed phenomenon, besides outlining the problems involved in implementing non-mainstream methodologies in offering literacy training to the rural poor in a school setup. Sandip Bandyopadhyay's paper raises many important issues pertaining to the designing of literacy primers for people from marginalized sections of society in the context of West Bengal. Ilina Sen discusses her experiences with an NGO called Rupantar (based in Raipur) which was involved in literacy activity in Chhattisgarh. The major issue addressed by this paper is the use of the Chhattisgarhi dialect instead of standard Hindi in the primers designed by Rupantar and the ensuing problems during the literacy and post-literacy phases. In the next paper Vasanta, Sonya, and Devi discuss the problems pertaining to NLM's definition of 'functional literacy' and its guidelines for evaluation. They argue for the need to reconceptualize the terms 'literacy' and 'evaluation' by drawing on some theoretical debates in the field of literacy studies. They illustrate their point using the mass literacy campaign and the anti-liquor agitation that took place in the Nellore district of Andhra Pradesh during the early 1990s. The last paper in this section is a report of the collaborative efforts of three different NGOs involved in literacy work with the *adivasis* in the East Godavari District of Andhra Pradesh. Girijana Deepika, an independent *adivasi* people's organization joined hands with two Hyderabad based organizations, Yakshi and Anthra in imparting literacy training to the adult *adivasis*. They describe the REFLECT (Regenerated Freirean Literacy through Empowering Community Techniques) approach which has been reconceptualized by making use of certain practices of the *adivasi* community, such as the *gotti*, and how it has successfully drawn the neo-literates into discussions about local issues central to their lives.

Several of the contributors focus on specific issues in their articles. Lakshmidhar Mishra, the former Director-General of the NLM, in an exhaustive account, analyzes mass literacy campaigns (NLM in this case) from the official perspective of the planners. P.K. Ravindran describes the role of the KSSP in the literacy campaign in Kerala. K.K. Krishna Kumar and S.R. Sankaran discuss the role of the BGVS in the implementation of the TLC

and the problems encountered. D. Subba Rao and B.S. Vasudeva Rao, provide an evaluation of the TLC in the Nellore district of Andhra Pradesh, and V. Swarajya Lakshmi discusses the pedagogical problems related to transaction of literacy primers, in the Mahaboobnagar district of Andhra Pradesh.

We hope that in this book we have been able to provide a comprehensive view of the different issues related to 'literacy' and 'literacy drives' in today's context, and that the volume will be of interest to both literacy theorists and literacy practioners.

REFERENCES

Agnihotri, Rama Kant. 1994. 'Campaign-based literacy programmes: the case of the Ambedkar Nagar experiment in Delhi'. *Language and Education*. Vol. 8, Nos. 1 and 2, pp. 47–56.

Anveshi Report. 1993. 'Reworking gender relations, redefining politics: Nellore village women against arrack'. *Economic and Political Weekly* (EPW). Jan. 16–23, pp. 87–90

Banerjee, Sumanta. 1993. 'Revisiting the National Literacy Mission'. *EPW*. June 19–26, pp. 1274–78

Bharatiya Gyan Vigyan Samiti (BGVS). 1994. *Gyan Vigyan Sandesh*. Vol. 1, Nos. 1–3.

Bordia, Anil and R. Kaul. 1992. 'Literacy efforts in India'. *Annal: World Literacy 2000*.

Dreze, Jean and Amartya Sen. 1995. *Economic Development and Social Opportunity*. Oxford: Oxford University Press. Reprinted in India in 1996 by Oxford India Paperbacks (Fifth impression, 1998).

Galtung, J. 1976. 'Literacy, education, and schooling–for what?' In Leon Bataille (ed), *A Turning Point for Literacy*. New York & Oxford: Pergamon Press, pp. 93–105.

Ghosh, Suresh Chandra. 1998. 'Frank C. Laubach as the father of the adult literacy movement in India'. In Martha Friedenthal-Haase (ed) *Personality and Biography: Proceedings of the Sixth International conference of the History of Adult Education,* Europaischer Verlag der Wissenchaften: Peter Lang, pp. 401–08.

Ilaiah, Kancha. 1992. 'Andhra Pradesh and anti-liquor movement'. *EPW*. Nov. 7–14, pp. 2406–08.

Jeffrey, Robin. 1992. *Politics, Women and Well-Being: How Kerala Became 'A Model'*. Cambridge: Cambridge University Press.

Mukherjee, Aditi. 1999. *Literacy: the Indian Context*. Project report submitted to the Indian Institute of Advanced Study, Shimla.

Nanda, A.R. 1991. 'Literacy trends and prospects'. *Literacy mission*. Vol. 14, No. 10.

National Sample Survey Organisation. 1998 Report.

PROBE. 1999. New Delhi: Oxford University Press.

Ramachandran, V.K. 1996. 'On Kerala's development achievements'. In Jean Dreze and Amartya Sen (eds) *Indian Development: Selected Perspectives.* New Delhi: Oxford India Paperbacks.

Ramachandran, Vimala. 1999. 'Adult education: a tale of empowerment denied'. *EPW.* Vol. XXXIV, No. 15, pp. 3492–93.

Saldanha, Denzil. 1999. 'Residual illiteracy and uneven development' In three parts in *EPW.* July 3, pp. 1773–84, July 10, pp.1907–21, July 17, pp. 2019–33.

Shatrugna, M. 1998. 'Literacy as liberation: the Nellore experience'. In S. Shukla and R. Kaul (eds) *Education, Development and Underdevelopment.* New Delhi: Sage Publications, pp. 241–64.

Section I

Theoretical Perspectives on Literacy, Society,

Language, and Education

1

A FARCE CALLED LITERACY

Rama Kant Agnihotri

INTRODUCTION

It is with a sense of utter despair that I present this paper before you. Over two decades ago when I seriously became interested in literacy and education, there was hope. Not just hope; in fact, one witnessed significant educational initiatives all over the world which made one feel that the world of poverty, destitution, and ignorance would look different after a quarter of a century. There was hope in Kerala and West Bengal; all of us were overwhelmed by the quality and pace of change in Castro's Cuba and Sandinistan Nicaragua; significant literacy movements were underway in Senegal, Cameroon, Nigeria and Tanzania; human dignity with language as one of its defining features, was being celebrated in the Caribbean islands of Belize and Honduras and there was hope in the lofty declarations of agencies such as the UNESCO and the UNICEF. Today I have no hope and with Ghalib, say

koi ummeed bar nahin aati
koi surat nazar nahin aati

i.e., 'all my hopes stand belied/no prospect is in sight' (tr. Kanda, 1992: 153). We need a paradigm change; a breath of fresh air. I have no doubt that Athreya and Chunkath (1996: 274) will accuse me of creating an ambience of overwhelming cynicism, but I don't think that a handful of committed activists with government support can bring about any significant change. We need to think

of socio-political models and structures in which literacy and education are no longer add-on appendages; these models must build social and political institutions around literacy and education rather than the other way round. Le Page (1997: 80) with contributions from literacy experts from all over the world concludes his survey of the literacy scene across the continents saying:

> Under warlords, education of all kinds whether for self-realization or social good is a casualty; in time of drought and famine and forced migrations there are relatively few Josephs. Former President Bush's new world order, and the authority and potential of the UN, have disintegrated in a general despair. Television and radio are the nursemaids of this despair; people do not need to be able to read to experience it. Illiterates do not need to be able to read to operate Kalashnikov rifles, though the gun makers may need to.

It is not my purpose to discuss the new paradigm; I don't even feel competent to do so. But collectively I think we should at least make a move towards that agenda. Whether we agree with him or not, Gandhi did show us that such a model was possible in principle. I will try to clear some ground to enable us to think afresh; I will also try to examine why some of the most outstanding literacy and educational projects I have been associated with, have failed to reach their expected targets and what we can learn from those experiences.

LITERACY AND EDUCATION

You may have noticed that I have consistently been saying literacy and education; it is my firm conviction that considerable damage to the cause of literacy and all the allied changes it was expected to bring about in society has been done because of this illegitimate distinction between literacy and education. A moment's reflection on the agenda of literacy will show that we do not think of education when we talk of literacy. Literacy is generally defined in terms of elementary skills of reading, writing and numeracy and in more fashionable functional models it includes survival skills of being able to read bills, price tags, advertisements, street and traffic signs, bus and house

numbers, cartoons, greeting cards, railway reservation forms etc. How far are we justified in calling this literacy? Isn't the whole enterprise an insult to human intelligence right from the beginning? Even if we regard these skills of some value, it should be clear that they are of no direct relevance to the lives of the poor people. These skills only make them serve their masters better. There is now a fresh dimension added to literacy: the dimension of local literacies. It is now being suggested that the whole literacy enterprise should be turned inwards since there is a lot that the participants in a literacy programme can learn from their own community. The agenda is the same: keep them as far away as possible from places of power. There are images that literacy evokes in the minds of scholars and laymen alike: images of poverty, naked and starved children, overworked sleepy labourers (males and females), sometimes shy housewives—all of them struggling hard to learn the alphabet, some numbers, and be able to write their names, read bus numbers or perhaps fill in a form; and once six or eight weeks are over, it is felt that their 'education' is over and they may go back to their work, more frustrated than ever before. The whole exercise only helps the establishment to inflate its literacy rates. On the other hand, the images that education evokes are quite different: these are not images of impoverished, overworked adults though quite often the children we see in our images look rather malnourished; here we do not talk in terms of weeks and months but 10 to 12 years; the project of education does not simply stop at learning the basic alphabet and acquiring numeracy; there is a curriculum, a set of books, a peer-group of classmates and in quite a large number of cases, a teacher per class as well; in fact, when we talk of education, the implicit understanding is that the child undergoing that process can become anything: a poet, a doctor, an engineer, a research scientist etc. It is of course true that anyone who does anything original does so not because of but in spite of his or her education. In fact, the political agenda of education is only a shade different from the political agenda of literacy. It says: if you can't keep them away from places of power, let them become the tools of sustaining the existing power relations in society. My first submission is that we stop making this distinction between literacy and education and redefine the goals of education in our new socio-economic dispensation. Every citizen of this world is entitled to education in

all its glory and a socio-economic and political structure which fails to provide this facility must be rejected.

We may also note that for social, historical, and political reasons that we need to seriously unpack, all discussion centering around literacy has remained firmly associated with poverty. The implicit understanding seems to be that the poor need literacy and the rich and the middle class need education. Since this assumption is neither clearly articulated nor carefully examined, all our current programmes and future planning gets conditioned by this understanding. Historically, only a few privileged elite were allowed access to education; in feudal societies, an agricultural labourer or a carpenter or a mason or a housewife may have needed some skills, informally acquired in the family, but nobody thought there was any necessity for formal education for these sections of society. A class of industrial labour has been added to the deprived sections in capitalistic and/or democratic societies. From a sociological perspective, the social class which appropriated the exclusive right to education consisted of 'Brahmins', the likes of whom existed all over the world in one form or the other. The kind of physical, ritualistic, religious and social barriers that these sections of society constructed between themselves and the deprived ensured that no educational facilities would reach the latter for centuries. Politically, it suited those in power to keep the deprived out of the ambit of education. That was the surest way of sustaining the status quo. Even today, once you train yourself to read what is there in the margins of the educational discourse, it becomes clear that the primary purpose is to sustain the status quo, be it in literacy or in education.

Once this illegitimate distinction between literacy and education is demolished, we need to clarify what every citizen is entitled to in the context of a miniscule elite exploiting millions of people. Sites of education in this context will by definition become spaces for active subversion. As Lankshear (1987: 216) argues, it is imperative for us to make a distinction between proper and improper literacies: Proper literacy comprises practices of reading and writing which enhance people's control over their lives and their capacity for making rational judgements and decisions by enabling them to identify, understand and act to transform social relations and practices in which power is structured unequally. Education, as I see it, must rise above practices of reading and

writing; it must engage all the participants in a collective dialogue that examines all the present and past oral and written discourses in an attempt to create a better future. Literacy, according to Street (1993: 9), is saturated with ideology involving fundamental aspects of epistemology, power, and politics.

THE LEGEND

Even if we accept the minimalist definitions of literacy given by the establishment all over the world, we notice that the picture is not particularly heartening. Take the case of India. According to the 1991 census, the total population of India is 846.30 million. In order to calculate literacy rates, only the population aged seven years and above is taken into account. In the 1961, 1971, and 1981 census, the population aged five and above was considered, for calculating literacy rates. This obviously raises serious problems for any cross-census examination of increase in literacy rates. In any case, according to the 1991 census, the literacy rate in the seven plus age group is 52.21 per cent. The literacy rate among females is 39.29 per cent; the rural literacy rate is 44.69 per cent; the drop-out rate from Class I to V is estimated to approximately 50 per cent at the primary school stage. All this ensures that literacy rates will change if at all at an extremely slow pace and the condition of women and rural sectors will always be worse than men and urban sectors. During 1981 and 1991, a growth rate of 8.64 per cent is reported; however, what's interesting is that in 1981, even when the population between five and seven years was excluded for calculating literacy rates only an increase of 2.14 per cent was recorded. (For all the above details, see *Statistical Database for Literacy*, National Institute of Adult Education, New Delhi, 1993.) After 50 years of independence, this indeed is a dismal picture. And if we think of literacy in the sense in which I have suggested above, perhaps the number of educated will fall dramatically. In fact, many celebrated as highly educated may have to be classified as illiterate.

If we briefly examine the history of literacy in India, we notice that it was very rarely that literacy projects were taken up with any seriousness and long term social planning. The results were rewarding whenever literacy efforts constituted a part of resistance or subversion. In ancient India, the typical mode of knowledge transaction was oral; the Vedic tradition showed that

logical thinking, empirical analysis, reflective introspection and democratic elements need not necessarily be associated with the Greek's invention of script literacy in spite of the claims made among others by Ong (1967), Goody (1968) and Oxenham (1980). And yet the Vedic times were characterized by Sanskritic domination not very different from the domination of Persian in the Mughal times, English in the British times, and Hindi in contemporary India. The defining feature of education in all these periods was that it was asocial in character and was restricted ruthlessly to a select few. Some of the earliest notable attempts at mass literacy were associated with social reform movements of the Christian missionaries though we know today that the motivations behind these projects were not entirely innocent. For example, the Andhra Evangelical Church, Guntur, was founded in 1848 and it organized, in addition to its primary task of spreading Christianity, several educational and literacy related activities. Almost as a defensive reaction to the activities of the missionaries, Brahmo Samaj (1857), Prarthana Samaj (1867), Arya Samaj (1875), Indian Social Conference (1887) and Ramakrishna Mission (1897) and several other organizations launched social reform movements of which literacy and education became an integral part. The library movement also picked up, as people such as T. Madhav Rao supported the rural libraries in Baroda and the movement gradually spread to Bombay and Madras. There was a context for literacy here. Learners were highly motivated and engaged in reformist activities. They wanted to learn to read and write with understanding and to be able to communicate their ideas to other people. Yet for all these movements, literacy in the sense we have defined it was a peripheral issue and there was no long-term agenda for sociopolitical change.

It was as a part of the struggle for independence that India witnessed meaningful literacy related activities. It soon became clear to the leaders of the national movement that non-cooperation with British rule could not succeed without a solid foundation of grassroots reconstruction. The period 1920–40 was marked by intense literacy and political awareness related programmes implemented through summer schools for political education, literacy classes and literacy campaigns, library movements, extension lectures and a variety of other socially relevant activities. For example, the school started by Lala Lajpat Rai in

1920 in Lahore focused not only on reading and writing but also on political education and social awareness. Several state governments including those of Punjab, Bengal, Bombay and Uttar Pradesh took a keen interest in literacy programmes and set aside budgets for adult education. A large number of NGOs sprang up in almost every major city of the country and night schools, literacy classes, mobile libraries, and extension lectures became a common phenomenon. Both Tagore and Gandhi noticed the immense importance of literacy for the freedom struggle and national reconstruction. Both also noticed that literacy, as it is generally understood, could only be the beginning and not the end of education. For Tagore, all education had to be rooted in nature; for Gandhi it had to be rooted in a definite socio-economic order. Gandhi believed that students must pay for their education; they should learn a craft e.g., spinning, weaving, sandal-making etc., and produce goods that the government would willingly buy. In a series of articles written in 1937–38 in *The Harijan*, Gandhi elaborated his concept of Basic Education in considerable detail. In *The Harijan* of Oct. 9, 1937 (see Bose, 1950) he said,

> I am a firm believer in the principle of free and compulsory primary education for India. I also hold that we shall realize this only by teaching the children a useful vocation for cultivating their mental, physical and spiritual faculties. Let no one consider these economic calculations in connection with education as sordid or out of place. There is nothing essentially sordid about economic calculations. True economics never militates against the highest ethical standard, just as true ethics to be worth its name must, at the same time, be also good economics. (p. 292)

As I said earlier, what is striking about Gandhi's formulation is that he thought of an overall socio-economic structure to which education was central. He had such faith in basic human goodness and dignity that he almost ignored the inherent contradictions of the class struggle in which the surplus produced by the labour was shamelessly appropriated by the oppressors. Also notice that Gandhi talks only of primary education. Tagore was convinced that national unity and international harmony could not be achieved without universal education. In his 'Talks in China', Tagore (1934)

said, 'our endeavour has been to include this ideal of unity in all the activities in our institution, some educational, some that comprise different kinds of artistic expression, some in the shape of service to our neighbours by way of helping the reconstruction of village life' (see Das 1996: 612–13). For Tagore, all education must be located in a harmonious interaction between the learner, community and nature. Once again, class struggle does not constitute the basis of Tagore's pedagogy, though primers produced by Tagore and his colleagues are far better than what we see today in our literacy campaigns.

The 1940s and 50s were a period of consolidation and institutionalization of literacy efforts in India; it was also a period during which the limitations of enthusiastic small scale campaigns and 'Each one, Teach one' like approaches became increasingly evident. The Jamia Institute of Adult Education was established in the 1920s. It was in 1939 that the Indian Adult Education Association was created and in its 1942 meeting it recommended the formation of an Adult Education Department. This association also launched several literacy programmes and did some pioneering work in the areas of material production, teacher training and field-level surveys. Not only were these programmes short-lived, they did not even remotely approximate the success achieved during the struggle for freedom. Since the kind of zeal that originates from a Tagore, a Gandhi, or a desire to free oneself from slavery was missing, the time and money invested in materials and eliciting pledges produced limited results. As the meta-narratives such as that of the struggle for national independence became scarce, the literacy agenda assumed a minimalist version. The teaching materials were no longer informed by issues of national importance and consisted largely of meaningless, boring and unnatural texts which aimed at teaching the alphabet and a small set of words in a linear and additive fashion. Such an enterprise could hardly prove to be a fertile ground for innovative teaching materials. It was functionalism at its worst: a limited amount of curriculum and materials to be transacted in a few weeks to produce quantifiable results. You were generally declared literate, if you could write your name and address, read a few sentences and count upto 10.

A variety of literacy programmes were launched in recent times e.g., the Farmers Functional Literacy Project (1967), the National

Adult Education Programme (NAEP, 1978) and the National Literacy Mission (NLM, 1988). The Constitution of India (Art. 45) stipulated in 1950 that within a period of 10 years, free and compulsory education for all until they attain the age of 14 would be provided. The country should have been fully literate by 1960. Since that target has not been achieved and does not seem achievable, almost every decade the government announces a new national literacy programme often accompanied only by cosmetic changes. Though both NAEP and NLM had promising starts, particularly in terms of environment building, community participation and some innovations in the development of learning materials and teaching methods, these programmes failed to have any lasting impact because of inherent structural drawbacks, rigid implementation strategies, inflexible and boring curricula, minimization and instrumentalization of literacy goals, the desire to declare villages and districts literate in a short period, inadequate financial resources and most of all, the absence of a driving force and a vision. It is only in some small-scale voluntary efforts which focused simultaneously on education and development that we notice seeds of change. Mohsini (1993: 50–53) examines some of them including the ones in Madras (1946), Etawah (1948), Nilokheri (1949), Kanpur (1945) and Rasulia (1951).

The intervention of national and international agencies even in collaboration with the local NGOs to juxtapose vocational training, rural development and literacy has not produced any significant results because these efforts have often been motivated only by pseudo-Freirean adult education programmes (Kidd and Kumar, 1981; Ramabrahmam, 1988, 1989). Long-term programmes of literacy cannot be created without a vision of social change; further, these programmes must elicit active participation of all sections of society. In order to decide the nature of curriculum for a set of learners, we cannot take shelter in the received principles of curriculum development. We need to engage in an active social dialogue in which teachers, learners and their community, and not just academics and pedagogues, are fully respected participants (Kumar, 1987).

CAMPAIGN-BASED MODELS

One hoped that the campaign-based literacy programmes would produce better results. They may be regarded as a compromise

between centre-based programmes and local initiatives. The three most important ingredients of a campaign-based approach are: mass participation, voluntary workers and environment building through a variety of community based socio-cultural activities. This model was really thrown up in Kerala (Athreya, 1991), in particular in the Ernakulam total literacy project, where the Kerala Sastra Sahitya Parishad (KSSP) has been engaged for years in bringing about a social change among the rural people. It was also tried out with some success in Pudukkottai, Tamil Nadu (Athreya and Chunkath, 1996). The campaign-based Kerala model should be seen in the context in which it emerged. As Agnihotri (1994) argues, it is built on the solid base of a tradition of voluntary social work, ability to generate and mobilize local resources and effective networking with governmental and voluntary agencies. It should also be seen in the context of Kerala already having the highest literacy rate and the lowest infant mortality rate among Indian states and a long tradition of socially sensitive political work. It is also important to keep in mind Kerala's strategic geographical location on the ocean facing the Middle East, largely matrilinear structure in some parts assuring economic security to women, the role of Christian missionaries, timely rainfalls, the role of the left governments and most of all the role of KSSP. It is thus a convergence of social, political, historical, geographical, and cultural factors that made the campaign-based approach succeed in Ernakulam. The dangers of transplanting such a model without appreciating the context in which it is likely to flourish and without ascertaining a certain level of disturbing awareness among the intelligentsia are becoming increasingly apparent. Social voluntarism is not created overnight or in a couple of weeks through organizing street plays or poetry or painting competitions; social voluntarism is difficult to sustain without a minimal level of economic security, particularly when the context is not one of political revolt. One is therefore not surprised that Athreya and Chunkath (1996) conclude the success story of Pudukkottai with guarded enthusiasm.

Campaigns are by definition transient and can hardly provide solutions to a country of 900 million people, of whom approximately half wait to be initiated into the dynamics of written language to be able to appropriate it as a tool in their struggle against corruption and oppression. The situation deteriorates as international funding accelerates the speed of these campaigns

and co-opts whatever little talent was hitherto engaging itself with critical literacy. An example of a typical popular report of such campaigns may be seen in a recent issue of the *Hindustan Times* (Feb. 4, 1998): 'Female Literacy Lamp Burns Bright in Bageechi, in the Bharatpur district of Rajasthan—it bore the ignominy of having not one girl child in school... now with volunteers and workers of Lok Jumbish...funded on a 3:2:1 basis by the Swiss International Development Agency (SIDA), Government of India, and Government of Rajasthan...Bageechi boasts of a 100 per cent count for girls...'etc., and all this is generally achieved in less than a year in most cases. It is fashionable in all such literacy drives to celebrate the support received from the local community in terms of infrastructure etc. I think this only helps the organizers to overlook the fact that nothing is really happening. Let us not mock the helplessness of the poor by celebrating their magnanimity; they suffer from starvation and disadvantage and those are the real issues that are consistently hedged. The limitations of campaign-based programmes are discussed in some detail in Agnihotri (1994) and Saxena (1992). Saxena (1997) brings out clearly the limitations of all formal and non-formal interventions when they are not informed by a policy of incorporating resistance offered by the people to educational practices into their new programmes.

Prashika and DPEP

Though I have actively participated in a variety of educational programmes, I would like to mention briefly only two here: *Prashika* (acronym for *praathmik shikshaa kaaryakram*), the primary education programme (see Agnihotri et al., 1995) of a well-known voluntary group called Eklavya, which is engaged in innovative educational and developmental projects in rural areas of Madhya Pradesh, and DPEP, the District Primary Education Programme of the Government of India. DPEP is a macro-level programme funded by a large number of international funding agencies including the IMF, World Bank, ODA, UNICEF, SIDA etc.

Though there is enormous amount of activity in DPEP in terms of travelling, text-book production and teacher-training, the programme is not informed by any serious academic or social perspective. Since I do not see DPEP bringing about any significant changes, I will not say much about it here. It caters largely to the needs of children who are already going to school; the

programmes for alternative schooling and special focus groups have hardly started yet. The programme congratulates itself in being socio-politically neutral; it only wants results in terms of the number of children reached, books produced, and teachers trained. Speed is the key word; DPEP protagonists actually believe that change is taking place at the speed of the aircraft in which they travel. Any academic intervention is carefully discouraged. It is felt that it does not contribute anything significant to the programme; on the contrary, it is claimed that it slows down the speed at which the programme is expected to produce 'results'.

Far more painful are the failures of Eklavya's *Prashika.* Eklavya had everything one could ask for: a group of highly intelligent activists, state support, active collaboration with colleges and universities and most importantly, rich experience in launching innovative programmes in schools in the form of HSTP (Hoshangabad Science Teaching Programme), a programme it inherited from another celebrated organization in the field of social and educational intervention, Kishore Bharati. I do not wish to belittle the achievements of *Prashika*; in fact, all subsequent primary education programmes have leaned heavily on it. In the mid-1980s, there was great hope in *Prashika*; the first few years saw considerable innovations and intense activity: large-scale sociolinguistic surveys were conducted; enormous amount of effort was spent in identifying texts, preparing classroom activities and trying out different classroom transaction techniques in collaboration with teachers on the one hand and experts from the universities on the other. We seemed to know what we were doing. We wanted children to overcome their inhibitions and speak, draw, and play in the class freely. We did succeed to a certain extent. The teacher-training camps were intense and questioned some of the basic stereotypes shared by the teachers; we also tried to understand children and their community through the eyes of these teachers. The character of some schools seemed to be changing: children became active participants in the processes of learning; their inhibitions were to a large extent gone; drawing nonsense pictures acquired meaning; the language of the children acquired some respectability in the classroom; deep-seated stereotypes about the purity and correctness of language were beginning to be questioned. However, the initial euphoria gradually petered away as we moved from the micro to the macro levels

and noticed the increasingly diluting nature of the programme and we wondered whether innovation was just another name for an island. But that was not all. There was more frustration in store for us. As we moved from Classes 1 and 2 to higher classes, we noticed that we were carrying on the programme largely because we wished to bring it to its logical end i.e., Class 5. We did not for example have answers to the following questions: What should be the content? How will it be relevant to the lives of these children? Since most of them will leave school after Class 5, what knowledge schema and skills should we focus on. Can we assure that there will be a teacher, that he or she will not be transferred and that he or she will not be asked to do a variety of non-academic jobs during his or her teaching hours? Can we make sure drinking water, toilets, blackboards etc., in the school? Most of all, can we make efforts to address some of the issues that were central to the lives of teachers? The answer from both Eklavya and the State was an unambiguous 'No'. We also did not know how to accommodate the resistance the teachers and the community at large offered to our innovative practices. In this context, exercises such as collaborative material production with teachers and children, community participation and field-trial of materials lost their meaning and were predictably never undertaken seriously. *Prashika* is active even today and is certainly making significant contributions in the field of primary education. But there is no way it can participate in social transformation; that agenda has consciously been kept outside the ambit of Eklavya's constitution.

We could not do anything even close to Nicaragua where, as Lankshear shows us, in spite of the near elimination of its native people by the Spaniards and subsequent American contra war and support to terrorists, the Nicaraguan literacy crusade created conditions for the development of proper literacy. The goals were not defined in a minimalist fashion and literacy skills were located in political awareness, critical thinking, research in health and agriculture, economic and political participation and most of all in an active interest in local literacies including local history, art and culture. Second, a major part of the theory and practice of the literacy agenda was predicated on the history of the Nicaraguan revolution. Third, literacy materials consisted of meaningful dialogues and pictures rather than isolated letters and words.

Fourth, considerable preparations were made before (and not after) the crusade was launched in training teachers and preparing primers and teachers' guides. Fifth, serious preparations for post-literacy work were made before the crusade ended. Sixth, primary education, adult education, special education for the disadvantaged and the handicapped, and the literacy crusade were all examined and fine-tuned collectively. In fact, once the revolutionaries were ready to launch the crusade, all educational institutions were closed for a period of six months to involve school and college students, and teachers in the crusade. Finally, foreign financial inputs were neither available nor sought after. Once the revolutionary context of the literacy crusade was made explicit, voluntary help was readily forthcoming. The success of the Nicaraguan literacy crusade is well-attested (Lankshear 1987:196–202). Even if there are serious questions or cynicism about the experiment, it is clear that this is the minimum that is required. A more comprehensive dream is required before we can expect more.

TEACHERS, MATERIALS, AND METHODS

It is interesting how decisions about teacher-training, materials, and methods are made in the absence of a socio-political perspective. After the famous Kothari Commission Report of 1964 what seems to have influenced our educational policy most is a tiny little document called the 'Minimum Levels of Learning' (MLL). Compared to MLL, the Kothari Commission Report must be considered a masterpiece, though it obviously had serious limitations. MLL is indeed a behaviourist document par excellence. It assumes that learning takes place in a linear and additive fashion and knowledge is accumulated brick by brick before the wall is built. I have worked with hundreds of primary school teachers and literacy workers and I have always found it extremely difficult to pull them out of the spell of MLL. For them, it is the Bible, sacred and beyond any rational enquiry. It bears the stamp not only of the Ministry of Human Resource Development, NCERT (which I hear is now beginning to question it), SCERTs and DIETs but also some of the most notable scholars in education. I have often asked the teachers I have worked with, the following question: was the Taj Mahal built before it was built or after it was built? That has always set teachers thinking. After some initial hesitation, they realize that the Taj Mahal must have been fully

conceived before it was actually built. The fact of learning taking place in a non-linear holistic manner becomes apparent to them. But the social forces and the burden of tradition pushes them back to a defence and implementation of MLL inspite of this transitory experience of how a learner may try to understand and internalize the universe around her. Except a few minor innovations here and there, I don't think there has been any major breakthrough in material production, teaching techniques or teacher training. They have been essentially behaviourist and asocial.

PROCESSES OF LEARNING

One positive outcome of *Prashika* was that it sharpened our understanding of the processes of learning. It was clear that any initiative that is not embedded in the social reality of the lives of people among whom it is launched is bound to have limited success whatever be its other assets. It was also clear that unless a programme finds ways of addressing the resistance a community offers to innovative practices, it cannot be sustained for long. We also realized that there will be significant variation from one setting to another where the setting includes all the relevant social and psychological variables. Yet we felt there is a core grammar of learning as it were, a set of basic strategies on which every human being irrespective of his or her age or environment creates his or her systems of knowledge. A critical understanding of the work of researchers such as Chomsky, Piaget, Vygotsky, and Freire among others enabled us to form some idea of the extremely mysterious ways of learning and understand what we may wish to call the core grammar of learning. Some aspects of this core grammar are beginning to be accepted fairly widely now because of some of the recent advances in cognitive sciences. I think most scholars would accept the position that we are born with some innate abilities; that there is a kind of biological programming which enables humans to do what other animals just cannot. It is a very difficult idea to put across to teachers and teacher trainers; it is often difficult for them to accept that humans learn not so much because there are teachers, teaching and books but just because they are human. Language often turns out to be a good example here. Once the complex nature of the structure of language is appreciated and once it is understood that almost all normal children are linguistic adults by the age of three

or four irrespective of the culture into which they are born, people begin to see Chomsky's point about genetic linguistic endowment. In spite of some fundamental differences one notices between Chomsky and Piaget, a rich cognitive disposition among human beings is never denied. It is generally very fruitful to ask teachers and teacher trainers to recollect instances of watching children doing something remarkable, reflect over the whole situation and analyze it, trying to isolate achievements that in no way could be even remotely associated with what the child may have been taught at home or school. It is this critical reconstruction of the familiar that most forcefully brings out the innate cognitive endowment. What is the nature of this cognitive endowment? Without any outside help, we store and process our observations, analyze them and draw inferences from them. We not only create the schema to structure our existing world in a variety of different ways but also to negotiate any unforeseen situation. A child or an adult always finds a way out, right or wrong, whenever confronted with a new situation. As Vygotsky (see Cole et al., 1978) has so effectively argued, a child is actually writing even when she has not learnt the alphabet. She has her own script and her own written language. Once the innate cognitive endowment of human beings is recognized, we need to be clear that the remaining development of mind takes place in a social setting.

LOCAL LITERACIES

Since knowledge is defined from the vantage point of the elite, the social milieu of the poor is generally associated with a cognitive deficit. There is considerable evidence now to show that the so-called illiterate societies nourish several important local oral and written literacies and forms of knowledge that compare favourably with any modern written mode of discourse. The variety and richness of local literacies has very few parallels in contemporary models of education which are essentially behaviourist in their orientation and homogenizing in their results. In fact, in our systems of education, poor children will in principle have no access to the discourse of power. The individual and societal multilingualism which defines a child's ethnicity will not receive any recognition in pedagogy. It is only now that people are beginning to think of multilingualism as a resource (see e.g., papers in Heugh et al., 1995); monolingual modes of teaching insult the

languages and cultures of the underprivileged sections of society. But we must not romanticize local literacies and cultures. According to Heath (1986: 18), literacy acquisition is often a function of society-specific tasks, which are sometimes far removed from those of formal schooling, and are not conceived of as resulting from effort expended by 'teacher' and 'learners'. Several studies e.g., those of Scribner and Cole (1981) among the Vais of north western Liberia, Cohen (1958, as quoted in Heath, 1986) of the Saharan Tuareg society, Walker (1981) of the Cherokee Indians among others, clearly bring out the fact that the meaning of literacy may show significant variation between one setting and another. But we must exercise great caution before romanticizing these forms of knowledge and focus on their revival as the main objective of our literacy agenda. In a typical Indian village, the Brahmin/astrologer transfers extremely complex systems of literacy skills to his son to enable him to read and prepare horoscopes; but these knowledge schema are extremely limiting as concepts or tools for any future meaningful enquiry. In the far north Mandi town of Himachal Pradesh, literacy in the Tankri script was extensively used for trade and commerce till about the beginning of the twentieth century. Nobody uses it any longer. But people, academics more than the common people, remember it with great fondness and talk of its revival. Illich (1981: 30) warned us, 'we first shamelessly spend enormous amounts of money to standardize languages at the cost of ethnic languages telling our children and students how to speak and then spend token amounts to teach the counterfeits of ethnic languages as academic subjects'.

Given the economic and political pull associated with each language in a given setting, it is not always easy to implement and sustain the academically sound but socio-politically neutral concepts of literacy and education through the mother tongue notwithstanding the ad infinitum repetition of the 1953 UNESCO declaration in support of education through the mother tongue. Stories of whole communities claiming languages of power as their native languages and of those who tell the census officer that the language said to be associated with their speech community is spoken only in the next village are far too well known to be recounted here in any great detail. We also know once again of whole elite groups which for political mileage construct extremely attractive rhetoric of patriotism and nationalism around the mother

tongues of the community to which they belong but send their own children to schools that use languages of power right from the kindergarten. The only times when the vernaculars of the people receive any serious attention in peace times is when a linguist frustratingly tries to initiate literacy primers in the vernacular which in most cases is hitherto unwritten or when a greedy sales executive hunts for a vernacular copy-line that would boost the sale of his product. The history of literacy across time and space makes it clear that literacy in general is conducted through the standard language and that the learners will never be allowed to gain any mastery over the standard language or the knowledge that it encodes. It is this paradox which makes the literacy project so frustrating. The feudal lord will never allow his slaves to learn an idiom that may enable them to question his illegitimate power; the industrialist will open free schools for his labour but will allow them and their children only minimal levels of education—they need only as much education as is required for participating in the assembly line; the political democrat will go only as far as permitting the production of efficient clerks.

CONCLUSION

A literacy programme around which we do not weave a vision of global social transformation is not likely to survive long. Education is far too important an issue to be left to the vagaries of free market forces. It is the very basis of what being human means and what it means to live in human groups with dignity and solidarity. Second, just learning to read and write should satisfy neither the learner not the instructor or the evaluator. One must be able to read with understanding and one must be familiar with the whole dynamics of the written mode of communication. Collectively produced texts are potential sites for resistance and subversion. Third, all activities associated with the literacy programmes must involve some degree of reflective and critical behaviour. Finally, the relationship between literacy and empowerment should be clearly spelt out without any romanticization. Local literacies are not to be preserved as objects of wonder; and mainstream literacy goals are not to be stated in such a minimalist format that they constitute an insult to human intelligence.

It is imperative that mainstream literacies be acquired to fight forces of oppression and authoritarianism; it is equally imperative

that local literacies be sustained to make that struggle possible. The manpower, methods and materials required for such an enterprise will not be imposed from above in hierarchically organized structures but will be generated in close collaboration with the community in question. The pedagogical and research questions are not to be decided in advance; they are to be raised and resolved in active collaboration with the community. And all this cannot be done in a hurry.

REFERENCES

Agnihotri, R.K. 1994. 'Campaign-based literacy programmes: The case of the Ambedkar Nagar experiment in Delhi'. *Language and Education.* 8.1 & 2, pp. 47–56.

Agnihotri, R.K., A.L. Khanna, and S. Shukla. 1995. *Prashika: Eklavya's Innovative Experiment in Primary Education.* New Delhi: Ratna Sagar.

Athreya, V. 1991. 'The Kerala model: How to extend the literacy drive'. *Frontline* V (May 25–June 7), pp. 97–98.

Athreya, V.B. and S.R. Chunkath. 1996. *Literacy and Empowerment.* New Delhi: Sage Publications.

Bose, N.K. (ed) 1950. *Selections from Gandhi.* Ahmedabad: Navajivan Publishing House.

Cole, M., V. John-Steiner, S. Scribner, and E. Souberman (eds). 1978. *L.S. Vygotsky, Mind in Society: The Development of Higher Psychological Processes.* Cambridge: Harvard University Press.

Cohen, M. 1958. *La grande invention de l'escriture et son evolution.* Paris: Imprimerie Nationale.

Das, S.K. (ed) 1996. *The English Writings of Rabindra Nath Tagore.* Vol. II. New Delhi: Sahitya Akademi.

Goody, J. (ed) 1968. *Literacy in Traditional Societies.* Cambridge: Cambridge University Press.

Heath, S.B. 1986. 'The functions and uses of literacy', In Castell, S. De, A. Luke, and K. Egan (eds) *Literacy, Society and Schooling.* Cambridge: Cambridge University Press.

Heugh, K., A. Siegruhn, and P. Pluddemann (eds). 1995. *Multilingual Education for South Africa.* Johannesburgh: Heinemann.

Illich, I. 1981. 'Taught mother tongue language and vernacular tongue', In Pattanayak, D.P. *Multilingualism and Mother Tongue Education.* Delhi: Oxford University Press, pp. 1–39.

Kanda, K.C. 1992. *Masterpieces of Urdu Ghazal from 17th to 20th Century.* New Delhi: Sterling Press.

Kidd, R. and K. Kumar. 1981. 'Co-opting Freire: a critical analysis of pseudo-Freirean adult education'. *Economic and Political Weekly.* 16.1, pp. 27–36.

Kothari Commission Report. 1964–1966. *Education and National Development.* Ministry of Education, Government of India.

Kumar, K. 1987. 'Curriculum, psychology and society'. *EPW.* 22.12, pp. 507–12.

Lankshear, C. 1987. *Literacy, Schooling and Revolution.* New York: The Falmer Press.

Le Page, R.B. et al. 1997. 'Political and economic aspects of vernacular literacy'. In Tabouret-Keller, A. et al. (ed) *Vernacular Literacy: A Re-Evaluation.* Oxford: Clarendon Press, pp. 23–81.

Mohsini, S.R. 1993. *History of Adult Education in India.* New Delhi: Anmol Publication.

Ong. W.J. 1967. *Orality and Literacy.* Methuen.

Oxenham, J. 1980. *Literacy: Writing, Reading and Social Organization.* Routledge and Kegan Paul.

Ramabrahmam, I. 1988. *Adult Education: Policy and Performance.* Delhi: Gian Publishing House.

————.1989. 'Literacy Mission: receding horizons'. *EPW.* 24.17, pp. 2301–03.

Saxena, S. 1992. 'Myth of total literacy in Narsingpur'. *EPW.* 27.45, pp. 2408–10.

————.1997. *A Study of Formal and Non-formal Education Programmes.* Ph.D thesis submitted to the University of Delhi, Delhi.

Scribner, S. and N. Cole, 1981. *The Psychology of Literacy.* Cambridge: Harvard University Press.

Street, B. (ed) 1993. *Cross-cultural Approaches to Literacy.* Cambridge: Cambridge University Press.

Walker, W. 1981. 'Native American writing systems'. In Ferguson, C.A. and S.B. Heath, (eds) *Language in the USA.* Cambridge: Cambridge University Press.

2

LITERACY AND DEVELOPMENT: CHALLENGES TO THE DOMINANT PARADIGM*

Brian V. Street

INTRODUCTION

I would like to put some current work on literacy in development in a broader perspective, with respect to recent theoretical developments and to cross-cultural studies of literacy derived from them. I will consider some of the underpinning ideas on which new approaches to work in literacy rests — in particular ideas derived from the New Literacy Studies. I argue that a major problem in literacy and development has been that literacy has remained under-theorized. The dominant view has been that literacy in itself was a 'good', so that little debate was necessary. At the same time, literacy in itself was conceived of as simply a set of technical skills, the same everywhere, to be imparted through direct 'delivery' systems. There appeared to be no need for theory and the complex disputes and contentions over meaning that have marked the last decade of literacy theory in the disciplines of anthropology, linguistics, and education have, until recently, been ignored by literacy agencies, concerned simply to 'improve' the statistics for levels of literacy. Against this empiricist and simplistic tradition, I will explore the different meanings of 'literacies' in the

* Parts of this article have already appeared in B. Street (ed.), *Literacy and Development: Ethnographic Perspectives*. London, Routledge, 2001.

plural—multiple literacies; multi-literacies; new literacies—and I will explicate key terms in the field such as *literacy events* and *literacy practices*. I will then look at some case studies where new approaches to literacy in development have been applied: the Social Uses of Literacy Project in South Africa and The Banda Project in India. Finally I suggest the implications of these new approaches for policy and programmes.

REFLECTING ON LITERACY: MY OWN EXPERIENCE

In keeping with the concern for contemporary reflexive understandings, derived from my own discipline of anthropology but also apparent now in many sectors, I begin with an account of my own involvement in this field and what has led me to the ideas expressed here. I went to Iran during the 1970s to undertake anthropological field research (Street,1984). I had not gone specifically to study 'literacy' but found myself living in a mountain village where a great deal of literacy activity was going on. I was drawn to the conceptual and rhetorical issues involved in representing this variety and complexity of literacy activity at a time when my encounter with people outside of the village suggested the dominant representation was of 'illiterate', 'backward' villagers. For various reasons I found myself working in villages in the area of Mashhad on the border with Afghanistan. I had gone in fact to study migration patterns and the rural-urban movement, because that was the sort of thing anthropology students studied in those days, but I found myself drawn into looking at literacy activity in the village. I used to sit at a village table with the local school textbooks to help me learn Farsi, and people would ride past on their donkeys on their way up to orchards where they had fruits that they were selling to the city. As they rode by, they would stop and talk to this strange foreigner, help me learn the language and discuss the books I was using. Some interesting discussions began to emerge in which older men particularly would say, 'Isn't it terrible, the kids in the schools today aren't learning anything, standards are falling'—a familiar lament in my own country too. 'The teachers don't bother, this school is no use really, it's not like in our day.' So I explored this further, and the 'our day' turned out to be a reference to the fact that, before the State schools arrived in this village, there were Islamic schools, 'Qoranic schools—*Maktabs*. I explored this a bit further and discovered that what people thought

about reading and writing and what they did with it, and their identities associated with text, were quite different for those who had been in these *Maktab* schools than for others, working with literacy in other sectors of village society.

The experience in these villages challenged, I believed, many dominant stereotypes regarding Islamic learning as merely rote learning, mindless, uncritical, backward, as it is often represented. One of the interesting things in this village was the way in which local mullahs would go around to different men's houses for dinner parties, at which a number of men, who had learned their Islamic literacy in the *Maktab*, would gather to discuss a theme. They might discuss the *Sura* of *Maryam* in the Koran, partly generated by my presence I think because it has references to different interpretations as between Islam and Christianity regarding Mary and virgin birth. Having been brought up as a Catholic I got quite interested in these theological debates and we had some interesting discussions. But this is quite different from the dominant Western stereotype of Islamic schooling as mindless rote learning, a myth still perpetuated in many development programmes.

The other thing that I learned from these encounters was that the kind of literacy that people were learning from these texts was different from that represented in the dominant image of literacy in development. The literacy of the 'Qoranic school was actually deployable in other contexts. Whilst development stereotypes suggest 'Qoranic literacy was not proper literacy because the pupils were 'simply' memorizing the words, a closer look at some of the texts indicates more complex and interesting ways in which they were being used. For instance, the texts did not necessarily employ the conventions familiar in dominant academic discourse (such as the book in which this chapter appears), with neat, straight lines on the page all the way down, empty margins etc. (Street, 1996) Instead, books of Islamic commentary used at the 'Qoranic school, would have texts at an angle across the page with bullet points and little inserts and commentaries down the side of the page at different angles: the whole text was juggled around much more. I began to realize that what people were learning implicitly if not explicitly was the nature of text, the nature of meaning being constructed not only semantically in the actual units, the words, the grammatical structures, but actually through the text type; the layout and the positioning of words and sentences

was actually part of meaning, and pupils were learning this semiotic and on occasions transferring it to other contexts.

One such context was the selling of fruit to the cities. This was the time of the Shah and the early 1970s oil boom in the cities, that led to great demand for products. This village was well-known as a rich village and was cashing in very well. In selling the fruit down to the nearby city of Mashhad, it was necessary to develop various forms of organization which involved literacy: individual farmers would bring the fruit down from the orchards and sell it to a *tajer*, a middleman, who would then put it into a store and send it off later at an appropriate time for sale at the urban markets. In order for that transaction to take place, as farmers sold their fruit to the *tajer*, people had to fill in bills of sale, names had to be written, quantities, accounts, places, times, dates recorded and cheques written—there was a branch of a bank in the village. So there was a lot of literacy going on. The *tajer* would send the crates down to the city and write, 'Mohammed Amini' on the crate and the driver had to know where he was taking it, who it belonged to. So I began to recognize a different literacy than that going on in the *Maktab*, and yet one that built on this traditional literacy, to provide a new form relevant to the needs of modern commerce. For it was the older men who had been trained in the *Maktab* who were acting as *tajers*. I have suggested elsewhere (Street, 1984) that it was their social authority and knowledge, linked with their 'Qoranic literacy, that facilitated this new literacy. Children trained in the *Dabastan* or the State school may at first seem to be the most likely people to develop this commercial literacy, but in practice the form of literacy they learned at school and their lack of authority in social circles in the village, countered this possibility. It was the social practices of literacy not simply the decoding skills that mattered.

There are number of reasons why the State school did not provide the basis for such social literacy practices. The teachers who taught there often came from urban areas and were not very interested in the village: as in many such contexts, they focused upon an urban hierarchy and career progress, and they saw the village as a backward place they had to put up with for a short while: so they were not really interested in the lessons. On the other hand there was an ambivalence; the parents wanted to send at least one child to the city, because then they could get out of

the village and into the white collar urban work of the cities. In order to achieve this they had to send their sons to the village school—but at the same time they did not really respect it: therein lay the ambivalence. What was happening in schools was not, then, providing pupils with the kind of literacy that would be useful in the village: it did not give them the social authority or the skills to actually do the *tajer* work of buying and selling; the school pupils were looking outside, not inside. So gradually I began to do my own classification of the literacy going on in the village, and developed the notion that there were three literacies, not one: *Maktab* literacy learned in the 'Qoranic schools, commercial literacy, as I call the work of buying and selling, and *Dabastan* or school literacy.

But this ran counter to the dominant classification of those working in education and in literacy programmes. For instance, the *Sepayeh Danesh*, the Shah's army of knowledge, was founded on the principle of sending people into the rural areas to overcome illiteracy: the soldiers for education would come into the village and say, 'Isn't it sad, all these mindless villagers living in the dark as illiterates?' This appeared in direct contrast with the complex literacies with which I found myself surrounded in such villages. It was, indeed, true that few of the villagers would have probably passed the various tests and exams set by agencies and educational institutions. Most of them, for instance, had not been through the third or fourth grade of the *Dabastan*, and very often these are the bases for the figures on literacy that countries send to UNESCO about the number of years of schooling (Wagner, 1990).

So I thought, if this is the case here, maybe it is the case elsewhere; these international conceptions of illiteracy may not correspond to what is actually happening on the ground. I was living in a place with a variety of intellectual, social, and material processes going on, with three different kinds of literacy, yet the villagers were all being dismissed at the centre, both in Tehran and in international agencies, as being illiterate. This disparity probably had broader implications: might this dismissal of local practices also be the case in other situations too? I have kept this image in mind as I have observed and investigated literacy in other parts of the world—urban Philadelphia, South Africa, Ghana, the UK etc. In all of these cases I hear dominant voices characterizing local people as 'illiterate' (currently the media in the UK are full of such accounts,

cf. Street, 1997) whilst on the ground ethnographic and literacy-sensitive observation indicates a rich variety of 'practices' (Heath, 1983; Barton and Hamilton, 1998). When literacy campaigns are set up to bring literacy to the illiterate, I find myself asking first what local literacy practices already exist and how do they relate to the literacy practices of the campaigners? In many cases the latter fail to 'take' — few people attend classes and those who do drop out (Abadzi, 1996), precisely, I would argue, because they are the literacy practices of an outside and often alien group. Even though in the long run many local people do want to change their literacy practices and take on board some of those associated with Western or urban society, a crude imposition of the latter that marginalizes and denies local experience is likely to alienate even those who were initially motivated.

Development discourse about illiteracy has traditionally associated it with living in darkness, with mindlessness, lack of cognitive skills, lack of progress, and an inability to think in a modern way. Colin Lankshear (1987) in *Literacy, Schooling, and Revolution*, sums up some of these issues well:

> The association of literacy with a modernization syndrome, the conception of modern man[sic], and the development of attitudes and dispositions of flexibility, adaptability, empathy, willingness to accept change, proneness to adopt innovations, all of these were guiding assumptions behind the trend to literacy campaigns in the Third World. (Lankshear, 1987: 42)

He quotes Hagerstand, for instance, as claiming that 'The demand for education is at times an innovation which must be introduced to a society in order to open it to further innovation. Literacy and other new skills eventually transform social communication and resistance into patterns more susceptible to innovation and the progress that comes with it' (ibid.). The word 'progress', familiar from ninth century colonial discourse, recurs here unselfconsciously. The belief is that culture and the culture of illiteracy are holding people back; their cognitive processes are not as developed as those of Western educated people. 'Illiterate' people are presumed to come from 'backward' cultures — indeed their illiteracy is a distinguishing mark of backwardness. Their culture is a barrier to progress and to literacy. 'Culture' in a

fixed sense is then linked with what I have come to call the 'autonomous' model of literacy (Street, 1984): a similar reification of literacy and reduction of its dynamic, varied and contested nature to a single 'thing'.

All of this seemed quite at variance with my experience in this and other villages. So I then turned to the academic literature to see what it had to say about literacy. And there I discovered a similar adherence to the autonomous model of literacy: here too literacy was being conceptualized as a single thing, that is the same everywhere, and it was assumed that without it people were in cognitive, social and cultural deficit (Goody, 1968). Literacy in this view is the same right across the world, with a big L, little y, a singular noun. Yet, I had already come across three different sets of literacies in one village. The argument from this autonomous model suggests that the acquisition of literacy has consequences for social progress, cognitive development, democracy, and economic take-off. Anderson and Bowman (1966), for instance, suggest a 40 per cent literacy level is necessary for economic take-off. This threshold figure still appears occasionally in the development discourse. Illiteracy and literacy are treated as two terms in a complete binary system, you are either one or you are the other.

The people in the Iranian villages where I was living, on the other hand, might well not pass the tests for literacy and yet were using reading and writing all the time. So the dominant assumptions about literacy, both in development circles and in academic discourse, did not seem to me to work: the conceptions involved reification, treating literacy as both unitary, in the sense of being a single thing, and binary, in the sense that you either had it and were literate or did not and were illiterate; these ideas were probably ethnocentric as well because they were actually derived from developers' and academics' own society and its uses and meanings of literacy.

Against these dominant discourses, research, then, has a task to do in making visible the complexity of local, everyday, community literacy practices and challenging the stereotypes and myopia. This indeed has become a major drive in my own research, teaching and writing, both in the research community and in the public arena. Following through its implications for programme design, including pre-programme research of local literacy

practices; of curriculum, pedagogy and assessment/evaluation are major tasks that require first a more developed conceptualization of the theoretical and methodological issues involved in understanding and representing 'local literacy practices'. I turn, then, first to recent conceptualization of the field.

RESEARCH AND THEORY IN LITERACY

Autonomous and Ideological Models of Literacy

Engaging with the theoretical debates that I am outlining here is, I would argue, as important for work in literacy and development as it is for literacy work in so called developed societies: it is not a 'luxury' to be left to those who are 'better off' (Oppenheim, 1995). In development contexts the issue of literacy is often represented as simply a technical one: that people need to be taught how to decode letters and they can do what they like with the literacy after that. The argument about social literacies challenges this simplification by suggesting that engaging with literacy is always a social act even from the outset: the ways in which teachers or facilitators and their students interact is already a social practice that affects the nature of the literacy being learned and the ideas about literacy held by the participants, especially the new learners and their position in relations of power.

It is therefore important that those working in the field of literacy and development engage equally in the theoretical and conceptual debates being described here and challenge the dominant conception of literacy work which sees it as simply applied, obvious and not in need of such theory. It is precisely the lack of such explicit attention to theory, I would argue, that has led to so many failures in development of literacy programmes; behind the naturalization of teaching and learning have lurked ideological pressures and political dogmas, often colonial but also urban/rural, or based on local ethnic conflicts and hierarchies. Making explicit our theoretical apparatus enables us to 'see' such biases and decide for ourselves whether we wish to accommodate or challenge them.

Academics, researchers, and practitioners working in literacy in different parts of the world are beginning to come to the conclusion that the autonomous model of literacy on which much of the practice and programmes have been based, was not an

appropriate intellectual tool for understanding the diversity of read-
ing and writing around the world, and the practical programmes
this required (Heath, 1983). So they have developed what I have
come to call an ideological model of literacy (Street, 1984). This
model starts from different premises than the autonomous model —
it posits instead that literacy is a social practice, not simply a tech-
nical and neutral skill; that it is always embedded in socially
constructed epistemological principles. It is about knowledge: the
ways in which people address reading and writing are themselves
rooted in conceptions of knowledge, identity, and being. Literacy,
in this sense, is always contested, both its meanings and its prac-
tices, hence particular versions of it are always 'ideological', they
are always rooted in a particular world view and a desire for that
view of literacy to dominate and to marginalize the other
(Gee, 1991).

One example, to bring home the significance of this
argument concretely, comes from an article in *Cross-Cultural
Approaches to Literacy* — a collection of articles by anthropolo-
gists who have worked in literacy around the world and have
attempted to apply dynamic models of culture to dynamic models
of literacy (Street, 1995). Kulick and Stroud conducted anthropo-
logical research in villages in New Guinea and began with the ques-
tion that developers ask, 'What is the impact of literacy?' How-
ever, they soon noticed that literacy was being added to the
communicative repertoire in more complex ways than the
concept of 'impact' conveyed. They noted that the things that
people did with that literacy were rather different than the people
who had brought it had imagined. Missionaries had brought it and
wanted to use it for conversion and for control and discipline; this
is similar in many contexts where missionary groups have taught
reading but not writing for precisely the same purpose — if people
can write, they actually can write their own things down, if they
can read they can only read what you provide them (Clammer,
1976). They can still reinterpret it but they are rather more under
the control of the teachers. Kulick and Stroud, being sociolinguists
as well as anthropologists were interested in what happens to the
communicative repertoire when such missionary literacy arrives:
they argued that instead of talking about the 'impact' of literacy,
we should ask the question, how do people 'take hold of literacy?'
What they saw happening was that people were using literacy in

the way that they had used oral interaction. There were precise conventions for making a speech, the dominant one being that you must not appear to put anyone else down when you make it. It is both inappropriate to put someone down and inappropriate to speak in a braggardly way about yourself, and yet at the same time you want to get your own way. So a variety of clever political discourses and conventions emerged. Kulick and Stroud discovered when they looked at the texts people were writing, that they were using the same sociolinguistic conventions, the same discourse strategies as in the speech making. They were inserting the written into their oral. So instead of talking about impact, the researchers talk about taking hold, they talk about the way people have made use of literacy (Kulick and Stroud, 1993). There are now many such examples from around the world which indicate how the communicative repertoire varies, from people simply taking literacy and doing with it what they had already done, to people discovering new functions to do with it which may be quite different from what the school teachers or the missionaries had in mind.

I call this alternative approach an 'ideological' and not a cultural model because I want to ensure that we attend to the power dimension of these reading and writing processes. The example of the missionaries and of the teachers makes that clear. The concept of 'impact' then is not just a neutral developmental index, to be measured, but is already part of a power relationship. These are issues about power, assumptions about one particular set of ideas, conceptions, and cultural groups being in some way taken on by another group. What is the power relation between them, what are the resources, where are people going if they take on one literacy rather than another literacy, how do you challenge the dominant conceptions of literacy? It seems to me quite impossible to address the issue of literacy without also addressing these issues of power (Street, 1996). A cultural model of literacy, particularly the reified view of culture rather than culture as process, leads one to fall back into the old reifications: a particular group of people become associated with a particular literacy; another group of people are associated with another literacy. The contestation over what counts as literacy and whose literacy is dominant gets lost. So it is called an ideological model of literacy in order to highlight the power dimension of literacy.

Multiple Literacies

There have, however, been problems with the conceptualization of multiple literacies which the ideological model of literacy employed, to challenge the autonomous model. In characterizing literacy as multiple it is very easy to slip into the assumption that there is a single literacy associated with a single culture, and so there are multiple literacies just as there are, supposedly, multiple cultures. So when we find Gujarati culture and Gujarati 'literacy' in Leicester or in Pakistan, Hindi literacy and Hindu 'culture' in India, the two get put together in fixed lists. If we start instead from a plural conception of culture (see 'Culture is a Verb', Street, 1993) then we recognize that culture is a process that is contested, not a given inventory of characteristics and such easy links of culture and literacy are not helpful. A *claim* to culture is itself a part of the process rather than a given. So in that sense one cannot use the concept of 'multiple literacies', to simply line up a single literacy with a single culture.

Another phrase that emerged more recently, which I think also is problematic, in this larger context is the concept of *multi-literacies*. A group of researchers calling themselves the 'New London Group' (NLG) have put forward the notion of multi-literacy to refer not to multiple literacies, associated with different cultures, but multiple forms of literacy associated with channels or modes, such as computer literacy, visual literacy (NLG, 1996). NLG is more interested in channels and modes of communication that can be referred to as 'literacies'. Kress in particular is interested in the notion of visual literacy, so for him multi-literacy signals a new world in which the reading and writing practices of literacy are only one part of what people are going to have to learn in order to be 'literate'. They are going to have to learn to handle software packages with all their combinations of signs, symbols, boundaries, pictures, words, texts, images, et cetera. The extreme version of this position is the notion of 'the end of language' — that somehow we are no longer talking about language in its rather traditional notion of grammar, lexicon et cetera, but rather we are now talking about semiotic systems that cut across reading, writing, speech, into all these other semiotic forms of communication. This, then, is what is signalled by the term 'multi-literacies' a rather different approach from that entailed by the 'multiple literacies' view outlined earlier.

Despite their differences, the problem with both positions is the same problem of reification, and also that of determination, or *determinism*. If you identify a literacy with a mode or channel — visual literacy, computer literacy — then you are slipping into the danger of reifying it according to form: you are failing to take into account the social practices that go into the construction, uses and meanings of literacy in these contexts. The multi-literacies view, then, implies a kind of determinism of channel or technology in which it would appear that visual literacy, in itself, has certain effects which may be different from computer literacy. The focus is on the mode, on the visual and the computer, rather than on the social practices in which computers, visual and other kinds of channels are actually given meaning. It is the social practices, I would want to argue, that give meaning and lead to effects, not the channel itself.

Literacy Events and Literacy Practices

I would like to briefly indicate two further concepts in the field of New Literacy Studies that enhance this social conception of literacy, the concept of *literacy events* and that of *literacy practices*. Barton (1994) notes that the term literacy events is derived from the sociolinguistic idea of speech events. It was first used in relation to literacy by Anderson et al. (1980) who defined it as an occasion during which a person 'attempts to comprehend graphic signs' (1980: 59–65). Heath, further characterized a 'literacy event' as 'any occasion in which a piece of writing is integral to the nature of the participants' interactions and their interpretative processes' (Heath, 1982: 93). I have employed the phrase 'literacy practices' (Street, 1984:1) as a means of focusing upon 'the social practices and conceptions of reading and writing', although I later elaborated the term to take account both of 'events' in Heath's sense and give greater emphasis to the social models of literacy that participants bring to bear upon those events and those that give meaning to them (Street, 1993). Barton and Ivanic (1991) set up their study of everyday literacies in Lancaster, England by attempting to clarify what has been meant by literacy events and literacy practices. Baynham (1995) entitled his recent book, which includes detailed accounts of the relations between oral and written language use amongst Moroccans in London, *Literacy Practices*. Similarly Prinsloo and Breier's *The Social Uses of*

Literacy (1996), which is a series of case studies of literacy in South Africa and which I describe in more detail below, used the concept of events but then extended it to practices. My own recent book *Social Literacies* (Street, 1996: cf. also Street forthcoming) tries to develop the concepts and clarify the different uses. So a literature is emerging that directly addresses the issue of the relation between *literacy events* and *literacy practices*. I would like to outline here my own view of these relations and their significance for the field of literacy and development.

Literacy events is a helpful concept, I think, because it enables researchers, and also practitioners, to focus on a particular situation where things are happening and you can see them— this is the classic literacy event in which we are able to observe an event that involves reading and/or writing and can begin to draw out its characteristics: here we might observe one kind of event, an academic literacy event, and there another which is quite different—catching the bus, sitting in the barber's shop, negotiating the road—the Lancaster research projects have made good use of this concept (Barton and Ivanic, 1991; Barton and Hamilton, 1998). But there is also a problem, I think: if we use the concept of *literacy event* on its own, it remains descriptive and—from an anthropological point of view—it does not tell us how the meanings are constructed. If you were to observe this literacy event as a non-participant who was not trained in its conventions and rules you would have difficulty following what is going on, such as how to work with the text and to talk around it. There are clearly underlying conventions and assumptions around the literacy event that make it work.

So I now come to *literacy practices*, which seems to me at the moment the most robust of the various concepts that researchers have been developing. The concept of *literacy practices* both attempts to handle the events and the patterns around literacy and to *link* them to something broader, of a cultural and social kind. And part of that broadening is that we bring to a literacy event, concepts and social models regarding what the nature of the event is, that make it work and give it meaning. We cannot get at those models simply by sitting on the wall with a video and watching what is happening. There is an ethnographic issue here: we have to start talking to people, listening to them and linking their immediate experience out to other

things that they do as well. And that is why it is often meaningless to just ask people about literacy, as in many recent surveys (Basic Skills Agency, 1997; OECD, 1995) or even about reading and writing because what might give *meaning* to this event may actually be something that is not in the first instance thought of in terms of literacy at all. It may be about religion (as Yates, 1994, shows with respect to the literacy programmes in Ghana), or about status (as in the Kulick and Stroud example above), or the social relations of the workplace (Gee et al., 1996). Heath found in discussing newspaper reading with urban adolescents in the US that much of their activity did not count in their minds as literacy at all. So a superficial survey would have missed the significance of their actual literacy practices and perhaps labelled them non-readers, or more insultingly 'illiterate' as in much press coverage of this area (Heath and McLaughlin, 1995). So one cannot predict beforehand what will give meaning to a literacy event and what will link a set of literacy events to literacy practices. Literacy practices, then, refer to this broader cultural conception of particular ways of thinking about and doing reading and writing in cultural contexts. It is on the basis of the above theoretical debates and in particular the development of the concept of literacy practices, that I now put forward some case studies to exemplify the new ways of thinking about literacy and of developing practical programmes associated with them.

CASE STUDIES

1. The Social Uses of Literacy Project (South Africa)

I begin with a project in South Africa called the Social Uses of Literacy, that rejects the autonomous approach and attempts to build a new conception of culture and development in the field of literacy (Prinsloo and Breier, 1996). This project was based at the Universities of Cape Town, and of the Western Cape, which came together to research the actual meanings and uses of literacy on the ground prior to the development of policy. As an anthropologist this seems to me a truism but I keep being naively astonished to discover that development is often done the other way round; the policy on say adult education and literacy is developed first, without reference to research on what people are actually doing with literacy in their everyday lives.

The literacy programme in South Africa at present is a very challenging one in the context of the needs for redress, reconstruction and redevelopment following the inequalities of the Apartheid era. There are large numbers of people without any schooling: the Apartheid State marginalized and ignored them, and the new government needs to get things in place quickly to help them. It needs to develop an adult literacy policy and adult education policy. It is doing so very often on the basis of models derived from European countries. A lot of NGOs on the ground are concerned that the local nature of literacy teaching, literacy learning and literacy practice may get lost in this centralizing process. The research project reported in the *Social uses of Literacy* book has to be seen in terms of that current tension. The project involves a dozen or so researchers going into different sectors or domains of South Africa—in Namaqualand; in rural areas; in Marconi Been; in a settlement in Cape Town; amongst Taxi drivers in Cape Town; in Belleville South, a coloured settlement; and Site 5 where people had been forcefully uprooted and settled, and then tried to make a kind of living and develop resources. The researchers also did some study on the ways in which a mass electoral process could be successfully implemented for a population without majority literacy.

Different sites were chosen for the research on the premise, contradicting that of dominant educational and development discourse, that literacy means different things in different contexts, and that if you are designing literacy programmes you may have to design different kinds of programmes according to where people are. I will give one example of what this might mean. A Xhosa speaking woman called Elizabeth on Site 5, has been working for the last decade to create resources in the settlement: paved roads, running water etc. In her house she had lots of different documents; she worked with and across and around documents, she went to meetings all the time. Some of those documents were in English, some in Xhosa. It is probably doubtful whether she would pass many exams in literacy in either of those languages or literacies, but she used them effectively in political action for the last decade with meetings and pressure groups to get these things done in the settlement. In the new dispensation, there is a new bureaucratized hierarchy of relationship between local people and the local State, involving different literacies and

different discourses than those of the Apartheid period. The ANC
is setting up classes for local people to give them literacy, to
enable them to deal with these new needs. In this context
Elizabeth has now become marginalized; with respect to educa-
tional institutions, she is told she is illiterate, her children laugh at
her and say, 'You're illiterate, you must go to classes.' She goes to
classes, and the classes employ neo-Freirean discourse which
involves not contestation but rote repetition of syllables—bah-be-
bo. In the class all pupils sit and chant these sounds. But Elizabeth
sits there finding it not much help in relation to her political prac-
tice. Likewise, with respect to the new political institutions, meet-
ings have now been taken over by besuited men who are speaking
in English, and Elizabeth sits at the back in silence. So she is being
marginalized and silenced in both domains, written and oral. Ironi-
cally, she is being made illiterate by the arrival of the literacy class
and silenced by the arrival of democracy.

So the question the researchers are posing to the ANC and to
the organizers of adult literacy practices in South Africa (and else-
where) is, what kind of literacy support, not just necessarily classes,
might one provide for someone like Elizabeth, to enable her to
enhance the skills she has already got, to build on what she is
doing, and what she has done for the last ten years and not to
marginalize her and treat her as nothing. Good pedagogy, accord-
ing to these researchers and practitioners, builds upon where people
are and acknowledges the contestation involved in change both
for the learners and the facilitators. There are an increasing
number of examples like this that are currently being documented
in different parts of the world (Street, 1995; Hornberger, 1997).

2. The Banda Project (India)

A classic example of a project that relates to local literacy
practices rather than providing centrally determined curriculum
and teaching, is the participatory material production activity in
Banda, Uttar Pradesh in Northern India. A group of women had
been trained by government agents in hand pump maintenance
and were managing the village pumps in the region. Having
successfully improved local water supply and sanitation, the women
involved wanted to spread their knowledge and bring about further
social and economic changes in the region and one route for achiev-
ing this was that they learn to read and write. Working through the

local action plan, Education for Women's Equality that became known as the *Mahila Samakhya Project*, they applied some of the same organizational features employed in learning hand pump maintenance to the learning of literacy. This included setting up residential literacy camps to which women would go for ten-day periods, enabling them to focus on literacy work and not be distracted by their usual everyday responsibilities. In this context, too, the women themselves had much more control over the nature of the literacy they were learning and how they learned it.

The women hand pump mechanics needed literacy for very specific purposes: to maintain records of spare parts, other repairs, depths of the bore, read the instruction manual and so on. They felt humiliated about having to get their log books updated by the government mechanics. In addition, the demand for literacy was enhanced as incidents of women being cheated and exploited by the economically and socially dominant class came to light. In this context, then, literacy was linked to both a political and a skills agenda. There had been no need to spell out the uses of literacy to these women or to 'motivate' them to attend, as in many programmes where lack of motivation is seen as the major barrier to successful classes. Here the women hand pump mechanics demanded that they be included in the literacy camps and already had immediate uses for the literacy they were learning—to develop posters, charts and other material, helping water committee members keep their records in order, writing applications and other reports. The programme, then, had to be designed as an integrated one, technical skills reinforcing empowerment.

Despite their growing confidence in other areas, these women, like Elizabeth in the South African context, feared formal literacy, partly because of its associations with authority and control. They overcame these fears by working in the same collective atmosphere as they had in developing their engineering skills and indeed, the trainers themselves were also learning on the job as they had not encountered a situation like this before. A creative aspect of this development was the production of materials, what in other contexts is referred to as 'Learner Generated Materials' (LGM) (Rogers, 1992). This ranged from producing a primer or literacy text book, to creating wall newspapers, writing stories and recording the day's experiences. After

the camps, various measures were adopted to enable the learners to keep in touch with each other. For instance, the women were called upon to prepare charts and posters that were displayed during functions related to the hand pump project. They were encouraged by government agents to write reports, applications and other petitions and to use their literacy to express their ideas and views on current affairs through writing and illustrations.

Nirantar, an NGO that works with women, acted as a resource group for these projects and has been active in providing training programmes, developing materials and documenting and evaluating the activities in Banda (I am indebted to Dipta Bhog of Nirantar for much of the information that follows, although the interpretations are my own). The activists in Nirantar have been involved in helping the women develop a newsletter which would enable the contacts and experience to be maintained and would spread the news about these activities. Again the residential workshop model was used, a group of women from the project coming together for three days for a writing workshop at the end of which the first edition of the newsletter *Mahila Dakiya* (or woman 'postman') was produced. The women themselves wrote, designed and created the newsletter, the trainers being concerned to go beyond the more technical aspects of literacy work and allow the participants the space and time to discuss and reflect on their work collectively. This shared voice was transformed into text when the actual work of writing, illustrating, reading and editing was taken up. Further issues of the newsletter have been produced and as problems arise, they are dealt with on the same collective and negotiated basis.

Most recently there has been the issue of what language, dialect and register to use for the newsletter. At first everyone agreed unanimously that writing should be in the local dialect, Bundeli as it is more accessible for most readers. However, the language of power in the area is Hindi and there was pressure to write in the standard in order to give the newsletter and the project more prestige and authority. But writing in Hindi made it harder to incorporate local idioms and styles of representation and of course made the newsletter less accessible to many local people. In keeping with its participatory and problem-solving approach, Nirantar opened up this problem to discussion rather

than simply attempting to make central decisions as many agencies still do. One proposed solution was to write the newsletter in Hindi but to incorporate local dialects where appropriate, thereby mixing the codes in ways that some commentators have suggested is already familiar to many participants (Rao, 1994). Another solution was for the writers to develop their own new mixed language form—a sort of Creole—that they understood, for instance writing in Bundeli, but replacing some local vocabulary and phraseology with standardized items from Hindi. A problem with this creolized version, of course, was that it would only be comprehensible to those in the know.

The decision-making process is continuing and there is no clear 'solution'; each choice creating its own problems as, of course everyday language situations generally do. For Nirantar the key issue was being open and reflexive about these issues and facilitating genuine discussion and decision making, rather than imposing solutions. There were also register issues: whereas in speaking, the form of language was negotiated and interactive, in writing the women had a more formal model and tended to use prescriptive terms 'take the water', 'do this' etc. Stories likewise turned out not to be innocent of underlying ideology, an account of using bicycles having implicit in it issues about violence to women but also messages about coping with humour: purity contradictions lay behind accounts of the real dirt of everyday life versus an idealized account of purity: whichever emphasis was agreed upon, it would create conflict and risk stereotyping. Readers too turned out to be different literacy subjects: whilst the women had become accustomed to reading and writing collectively and to sharing their interpretations and pleasures, the newsletter writers had to remind themselves that men tended to read individually and silently, and for information rather than to share experiences. The writing for the newsletter, then, had to take account of these differences even whilst also being politically committed to perhaps helping to change the gender stereotypes on which they appeared to rest.

Even Nirantar with its participatory philosophy and focus on women's own perceptions had at first seen writing and the language issue in more functional terms. They had conceptualized rural women as development subjects. Experience however, soon

moved them towards a more sensitive understanding of the womens' subjectivity as cultural beings and of the power issues that these language choices raised. They became very conscious of how the literacy activity in writing a newsletter was much more than simply a technical one and of how unconsciously develop-ment discourse imposes decisions that are culturally biased even behind apparent neutrality. The project continues and further research on this and others like it are necessary to enable us to understand the complexities both of everyday literacy prac-tices and of specific literacy practices that become associated with development interventions. For both the research and the practice, the traditional models of literacy with which we have worked are no longer adequate: in the case of the Banda women water pump engineers and of the people in post-Apartheid South Africa described above, as in others around the world, an ideologi-cal model of literacy can enable us to see practices that are other-wise invisible and to thereby build culturally sensitive programmes for intervention.

IMPLICATIONS FOR POLICY AND PROGRAMMES

If one looks closely at contemporary literacy programmes in the light of the conceptual tools I have been putting forward here, I would argue that the majority would be found to subscribe to the autonomous model of literacy and to the fixed, 'model of culture'. Just a few here and there are beginning to talk about local cultural processes and local literacies, as with the case studies described here. The practical implications of a shift to the new conceptions of literacy and of culture are immense, ranging from the need for educators to take account of local meanings *before* designing programmes and curricula, to the importance of developers noting local variation in beliefs and practices before introducing Western-oriented health, agriculture and economic programmes.

A number of literacy projects in recent years (Prinsloo and Breier, 1996; Yates, 1994; EDDEV, 1998) have begun to include an ethnographic research component in order to investigate local lit-eracy practices from the earliest stage in such projects, as we saw in the example of the Social Uses of Literacy Project. Ethno-graphic researchers are trained in field work methods and sensitized to ways of discovering and observing literacy practices on the ground and their findings are then fed into the campaign

design and development. People living in poverty and women (two groups specifically targeted in many projects) may have 'needs' for literacy—varied reading needs and varied writing needs—that are different from those envisaged by programme designers at the centre, whose knowledge may be relatively restricted without the benefit of this kind of research. These 'needs' may also vary from one region to another. Apart from the actual *uses* of literacy by different groups at different times and places, the *perceptions* that local people hold of literacy may also crucially affect the take-up and effectiveness of literacy programmes. As part of ethnographic inquiry, researchers are trained to elicit people's perceptions— through interviews—formal and informal, observations and everyday conversations.

The findings of such research, regarding existing literacy practices, perceptions of literacy and further literacy 'needs' can play a significant role at different stages of a literacy project. In terms of curriculum design, for instance, they can provide information on those uses of literacy which local people are familiar with, where they want help in upgrading or changing their literacy practices and what they are likely to use literacy for after the programme, so that what they have learnt is sustainable.

Perceptions of literacy and of classes can also, of course, play a major role in resistance to a literacy project, as a recent survey of work with Women and Literacy (McCaffery and Williams, 1993) demonstrates. Finding out about these perceptions can help prevent the large drop out rates classically found in many literacy projects that lack such a research component. The findings of such research are also useful in developing materials for the literacy classes. As a recent DFID research project on 'Post-Literacy' (Rogers, 1994) has demonstrated, it is often more cost-effective and efficient to work with materials that already exist in the environment than to design new ones specifically for literacy classes. Once research has found what materials are part of the local literacy environment, the campaign input can then involve providing further copies of such materials (such as that produced by health and agriculture agencies etc.); assisting those agencies to make their materials more user-friendly to beginning readers; and training teachers in the uses of such materials as learning aids.

Having set out to argue the importance of including theoretical analysis in the approach to literacy programmes, I would like to conclude by setting out a list of some of the practical inputs that current theory suggests are necessary for the success of literacy programmes. I start with the development of a framework for literacy research whose findings can be made available to the project team prior to extensive development work on the literacy programme itself and continuing throughout the programme. In order to make most effective use of such research, a number of inputs are necessary:

- Training of researchers through workshops etc., in qualitative research methods (liaising with and perhaps providing some staff development for local research capacities).
- Providing resources for a number of small research projects using these methods and personnel, and facilitating liaison and support amongst the researchers themselves.
- Facilities for presentation of findings at various stages of the Literacy project to interested parties, from the Project Steering Committee, to funding agencies and through guidance to tutor trainers on the ground.
- Setting up of a 'support group' with access to agency and other literacy materials, and to those who produce and distribute them, to assist their use in the literacy programme.

Such a programme (currently being attempted in a DFID funded literacy project in Nepal, cf. EDDEV, 1998) can help to link the theoretical work described in this paper with the practical work on which agencies and activists mostly focus. To allow these aspects of literacy work—theory and practice—to remain separate will be to open ourselves to the failures and missed opportunities that have weakened literacy programmes in the past. To put them together is to open up new paths for positive development in literacy work.

REFERENCES

Abdazi, H. 1996. *Adult Literacy: A Problem Ridden Area*. Washington: World Bank.

Anderson, C.A. and M. Bowman (eds) 1966. *Education and Economic Development*. London: Frank Cass.

Anderson, A. B., W. H. Teale and E. Estrada. 1980. 'Low-income children's pre-school literacy experiences: some naturalistic observations'. *Quarterly Newsletter of the Laboratory of Comparative Human Cognition* 2, pp. 59–65.

Barton, D. 1994. *Literacy: An Introduction to the Ecology of Written Language*. London: Routledge.

Barton, D. and R. Ivanic (eds) 1991. *Writing in the Community*. London: Sage.

Barton, D. and M. Hamilton. 1998. *Local Literacies*. London: Routledge.

Basic Skills Agency. 1997. *International Numeracy Survey*. London: Basic Skills Agency (BSA).

Baynham, M. 1995. *Literacy Practices: Investigating Literacy in Social Contexts*. London: Longman.

Clammer, J. 1976. *Literacy and Social Change: a Case Study of Fiji*. Brill: Leiden.

EDDEV. 1998. 'Community Literacies Project'. Nepal/London: DFID/CfBT.

Freire, P. 1985. *The Politics of Education: Culture, Power and Liberation*. Massachusetts: Bergin & Garvey.

Gee, J. 1991. *Social Linguistics: Ideology in Discourses*. London: Falmer Press.

Gee, J., G. Hull and C. Lankshear. 1996. *The New Work Order: Behind the Language of the New Capitalism*. London: Allen & Unwin.

Goody, J. 1968. *Literacy in Traditional Societies*. Cambridge: (hereafter CUP).

Heath, S.B. 1982. 'Protean shapes in literacy events: ever-shifting oral and literate traditions'. In D. Tannen (ed) *Written language: Exploring Orality and Literacy*. Norwood: Ablex.

————. 1983. *Ways with Words*. Cambridge: CUP.

Heath, S.B. and M.W. McLaughlin. 1995. *Identity and Inner-City Youth*. New York: Teachers College Press.

Hornberger, N. (ed) 1997. *Language Planning from the Bottom up: Indigenous Literacies in the Americas*. Berlin: Mouton de Gruyter.

Kulick, D. and C. Stroud. 1993. 'Conceptions and uses of literacy in a Papua New Guinean village'. In B. Street (ed) *Cross-Cultural Approaches to Literacy*. Cambridge: CUP.

Lankshear, C. 1987. *Literacy, Schooling, and Revolution*. New York, Philadelphia and London: The Falmer Press.

McCaffery, J. and D. Williams. 1993. *Gender and Literacy*. London: ODA Technical Report.

New London Group. 1996. 'A Pedagogy of multiliteracies: designing social futures'. *Harvard Educational Review*. Vol. 66, No. 1, pp. 60–92.

OECD. 1995. *Literacy, Economy and Society: Results of the First International Adult Literacy Survey* (IALS). Ottowa, Canada: OECD/ Statistics.

Oppenheim, L. (ed) 1995. *Adult Literacy: An International Urban Perspective.* New York: UNESCO.

Prinsloo, M. and M. Breier (eds) 1996. *The Social Uses of Literacy: Theory and Practice in Contemporary South Africa.* Amsterdam/SACHED Books, Johannesburg: Benjamins.

Rao, N. 1994. 'Mahila Samakhya Project—a case study of Banda', in *BALID Newsletter.*

Rogers, A. 1992. *Adults Learning for Development.* London: Cassell Educational Ltd.

Rogers, A. 1994. *Using Literacy: A New Approach to Post Literacy Materials.* London: DFID.

Street, B. 1984. *Literacy in Theory and Practice.* Cambridge: CUP.

————. (ed) 1993. *Cross-Cultural Approaches to Literacy.* Cambridge: CUP.

————. 1995. *Social Literacies: Critical Perspectives on Literacy in Development, Ethnography and Education.* London: Longman.

————. 1996. 'Literacy and power?' *Open Letter.* Vol. 6, No. 2, UTS, Sydney, pp. 7–16.

————. 1997. 'The implications of the new literacy studies in literacy education'. *English in Education.* NATE, Vol. 31, No. 3, Autumn, pp. 26–39.

————. (Forthcoming) 'Literacy events and literacy practices'. In K. Jones and M. Martin-Jones (eds), *Multilingual Literacies: Comparative Perspectives on Research and Practices.* Amsterdam: John Benjamins.

Wagner, D. 1990. 'Literacy assessment in the Third World: an overview and proposed scheme for survey use'. *Comparative Education Review.* 33, pp. 112–38.

Yates, R. 1994. Gender and Literacy in Ghana. Ph.D. Dissertation, University of Sussex.

3

NELLORE REVISITED: LOCATING THE ANTI-*ARRACK* AGITATION IN ITS HISTORICAL CONTEXT

Sadhna Saxena

The National Literacy Mission is a Government of India sponsored programme. It follows a campaign-based approach for creating awareness about and interest in literacy. M.P. Parameswaran of the Kerala Sastra Sahitya Parishad and Bharat Gyan Vigyan Samiti, who envisaged the campaign-based model of total literacy, stated in one interview that the biggest achievement of this approach has been that it has put literacy on the national agenda (Hashangabad Vigyan,1991). Indeed it has, but at what cost in terms of ideas and policy has to be investigated. The hype and euphoria, which accompanied the launch of literacy campaigns pushed many other crucial issues related to poverty out of the education discourse, that could otherwise have been on the national agenda.

Adult education and literacy has a long history in India. However, never before in the history of education in India has there been a government programme that has been so widely covered by the media, that has generated so much curiosity and interest and earned the good will of the people, as the Total Literacy Campaigns launched by NLM. Also, probably never before were so many members of civil society—NGOs, journalists, social scientists, teachers, activists, and independent philanthropists—engaged as observers, evaluators, trainers or reporters as in this programme. The roots of unevenness of the

consequences such interventions have to be located in the social context and history of movements in the area as well as in the nature of intervention. An analysis of the Nellore experience provides wonderful insights on all these accounts. Here, an effort has been made to understand the anti-*arrack* agitation of Nellore district by taking into account the historical events not only in this district but in the immediate neighbourhood as well. Interestingly, what emerges is different from what has been claimed by the NLM.

Undoubtedly, mass education and mass literacy are important issues for any society. However, since education is neither an uncontested terrain nor can a universal notion of adult education be claimed, therefore the content, organization, methodology, and political objectives of mass education merit some scrutiny. Also, claims of empowering potentials have to be judged against the inevitable process of disempowerment of the powerful elite. Power to the underprivileged presupposes the struggle for power sharing, a concept understandably not entertained in any of the government sponsored empowerment programmes be it literacy, women's empowerment, or elementary education.

Emergence of State Sponsored 'Empowerment' Campaigns

The 1980s was the decade of campaigns, mobilization and empowerment of the non-literate population and women by the state. This created an environment of false hope and confusion for the intelligentsia and educationists started talking about the space given by the state and focused attention on the utilization of this space, presumably for raising more urgent social issues. This optimism among intellectuals and some women's groups initiated a new kind of debate, centred around the 'space' theory. It criticized the 'cynics' for their endless suspicion about the role of the state. So, during this decade of the 1980s, after a very turbulent preceding decade, the government launched programmes for the empowerment of the poor and the disadvantaged, especially women, with renewed credibility. The intelligentsia, however, quite conveniently, overlooked or ignored the underlying ideological shift—the state abdicating its responsibility for development, assertive action, and resource redistribution and talking about empowerment.

Women's Resource Centre, Saheli's comments, made in the context of women's development programmes, and applicable in the context of literacy programmes as well, summed up the situation thus:

> In contrast to development plans for other sections of the population, government's emphasis with respect to women is not on policy measures, resource allocation or redefining development, but on 'awareness building' and 'mobilization' or, in other words struggle as opposed to development. With such a definition of development, a bizarre situation has been created where the fight is no longer against the establishment, but is state-sponsored struggle. The State has consciously used progressive jargon to blur the contradictions between its own interests and those of the people. The class question thus gets subsumed under gender concerns, and it is attempted to direct energies from major structural contradictions in the society (Saheli, 1995: 3).

The Significance of the People's Response

Hope, in such a situation lies only in the action of the people, women or men. For example, the Sathins who jolted the officials of the Women's Development Programme out of their complacency in Rajasthan (Dube,1996). In Andhra Pradesh women did the same with the literacy officials in Nellore, the State government in Hyderabad, and subsequently the Central government in Delhi.

This potential of the people to resist or oppose the state's agenda, specifically discussed in the case of the women of Nellore in this section, demonstrates the capability of the people to reject and demand forms of education necessary for them.

Social and political change is an extremely complex process. The intention here is neither to simplify it nor to celebrate the small movements at the cost of obliterating the larger structural issues, but to identify and focus attention on glimpses of protest by the people.

While discussing the theory of resistance, Henry Giroux poses the question whether all oppositional behaviour could be termed as resistance? And he himself clarified that oppositional behaviour which could be termed as resistance should have some of the following characteristics, at least:

- potential for generating radical consciousness;
- raising an element of critique, collective critical action, emancipatory potential;
- all such oppositional behaviour rooted in a reaction to authority and domination (Giroux, 1983).

While discussing the limitations of resistance theory he points out that even these theories have failed to address certain crucial questions, e.g., patriarchy (Giroux, 1983: 104). But, can patriarchy be discussed without taking into account class oppression? The Nellore struggle encompassed both— women resisted patriarchy in the domestic arena, and both patriarchy and class oppression in the public arena, by struggling against the state-liquor baron nexus. On the surface it seems, (as publicized by the NLM literacy experts and various reports, such as Athreya (1992), Shatrugna (1992), and Ramachandran (1995), as if it was due to the literacy campaign that the anti-*arrack* agitation erupted and its transformation into the credit and thrift societies of women was the most logical outcome. It would seem so unless the role of various state agencies, their agendas and vested interests are clearly identified and debated.

The Anti-*Arrack* Agitation

The Nellore anti-*arrack* agitation was a local women's response to the education programme initiated for them by the State. Their forthright response was actually a rejection of the government's assumption, identifying illiteracy as one of the important causes of their backwardness and poverty. The mood is apparent in the following clearly articulated statement of one of the women activists, 'No, [the] literacy drive did not have much impact on us. We don't care about literacy. We want better wages, more employment and to live without fear' (Ramnarayan, 1992: 57). Of course, the spread of the spontaneous agitation in the Nellore district and further, in the whole of Andhra Pradesh (AP), was due to the literacy infrastructure which facilitated it, though inadvertently. But Nellore is not an isolated case where such an agitation started. There is a history of such agitations in AP which remain unreported because most of the earlier agitations were led by CPI (ML) groups. In this context Balagopal writes:

But any honest narration of the story cannot participate in the deception, which is not to say that the present anti-*arrack* agitation is a continuation of the CPI (ML) groups' efforts or that the women who started the fight against *arrack* in the villages of Nellore district were aware of and inspired by the previous efforts of the CPI (ML) groups (Balagopal, 1992: 2459).

Nellore is one of the Southern Coastal districts of AP and there was prohibition on liquor here until 1969. Hence the situation here was different from the Telangana area where there was no ban on liquor during the Nizam's rule and also later when it was integrated with AP in 1956. Prohibition was introduced in 1949 in the Old Madras Presidency and since coastal districts were part of the Madras Presidency the ban continued here and in the Rayalaseema area until 1969. The ban was then lifted by Kasu Brahmananda Reddy on the ground that it was encouraging the sale of adulterated liquor.

The contribution of the literacy programme in Nellore, has been discussed in isolation, not in the continuum of the existing socio-political reality. The role of the state has not been pro-people as it is made out to be by this interpretation of the upsurge. The literacy programmes, their impact, the emergence of a political movement, all these aspects have to be seen in the context of the recent history of the region, otherwise a very distorted picture emerges.

The Telangana districts have a history of anti-*arrack* agitation and struggle that is more than a decade old. The movement against the sale of *arrack* started in North Telangana districts like Warangal, Karimnagar and Adilabad at the behest of the CPI (ML), the People's War Group in particular, and also other groups but attempts were made to suppress the movement by police intervention that went to the extent of selling *arrack* not only under police protection but even from police stations.

Notwithstanding the repression, there is a widespread people's ban on *arrack* sales in these districts and no auctions could be held for as many as 1,739 *arrack* shops in 1990–91 in Warangal, Karimnagar and Mahboobnagar districts (Reddy and Patnaik, 1993: 1059).

Reddy and Patnaik further said:

> While the CPI (ML)-sponsored ban on *arrack* sales was met by the state with brutal attacks on agitating women, apparently the movement started spontaneously but in fact as a result of [a] combination of social, economic, and political factors, was initially responded [to] by the state with a kind of indifference under [the] cynical hope that it would fizzle out (Reddy and Patnaik, 1993: 1059).

And according to Balagopal, the government and police would go to any extent to defeat the CPI (ML)'s political programmes. He writes:

> And so far, in the last two years Warangal and Karim-nagar witnessed the obnoxious sight of police stations being converted into *arrack* shops and policemen armed with self-loading rifles guarding crates of *arrack* packets and vending them. It even went to the ridiculous extent of policemen identifying villages where poor people had stopped drinking and beating up the villagers, abusing them for their naxalite sympathies (Balagopal, 1992: 2459).

Further, Prasad reported in *Frontline*:

> About two years ago, the PWG, a naxalite outfit, enforced prohibition in the Singareni coal belt, encom-passing the towns at Bellampalli and Ramagundam and in Karimnagar and Warangal. PWG enforced the 'ban' by blasting liquor shops. A bar owner who took police help to run his business was shot. The PWG ban, which was for a year, had a salutary effect on the incomes of the coal miners and other poor people in the districts of Karimnagar, Adilabad and Warangal. After the PWG was banned in May this year, liquor shops were thriving once again (Prasad, 1992: 52).

Therefore it is ahistorical to present the anti-*arrack* agitation in Nellore and other districts during 1992–93 as a totally autono-mous struggle which had no historical continuity or context. In fact, by all accounts, it is obvious that the discontent was brewing

for quite a number of years. And in the recent past there is a history of small, village level protests which included the passing of a resolution by the village level panchayats against the sale of *arrack* and stopping its entry into the villages.

When this researcher visited Nellore in 1996, women in the villages recounted their small village level struggles. In fact, Dr Ankaiah Reddy who runs a hospital in Kanigiri mandal narrated an incident which took place almost ten years ago. During this incident women got together at the village level and stopped the entry of *arrack* into their village. The first reaction of the village males was hostility and disdain. However, when the women raised this issue at the panchayat meeting, the panchayat was pressurized to support them. Dr Reddy, who belongs to Dubagunta village, was of the opinion that the history of that area must be replete with such protests but they failed to influence government policy as they remained scattered.

So, while in the Telangana area the organized struggle against *arrack* has been happening for the last one and a half decades, in Nellore and other coastal districts the struggle remained confined to sporadic incidents till 1992.

Political Economy of *Arrack*

Let us now look at some of the startling facts related to the *arrack* business in the state of AP and the role of various ruling parties in deliberately promoting this business. The *arrack* business flourishes and expands with the patronage and support of the ruling elite.

Though prohibition forms part of the Directive Principles of the Constitution, *arrack* was one of the major sources of revenue for the Government. The revenue that the AP government got from the excise on *arrack* and Indian made foreign liquor increased from Rs 39 crores in 1970–71 to Rs 812 crores in 1990–91. Budget estimates of total revenue from the sale of liquor for the year 1991–92 was Rs 839 crores. This is not an innocent change caused by changing lifestyles and habits but the consequence of the deliberate policy pursued by the government. Unwilling to collect the taxes it imposes on the urban rich and entirely unwilling to tax the rural rich who are substantial in number in the state, the AP government has increasingly turned to liquor sales as a major source of revenue. And as 70 to 80 per cent (about Rs 656 crores) of the

growing excise was accounted for by the revenue from *arrack*, the poor people's drink, *arrack* policy basically boils down to taxing the poor (Reddy, 1993: 1063; Balagopal, 1993: 2457).

From the early 1970s, the liquor contractors started supporting elections in a big way and a lot of this liquor money was used during electioneering. They got political protection in return. However, soon came a stage when the liquor contractors also decided to join politics and the politicians decided to engage in the lucrative liquor business. 'The two modes of public life thus coalesced, and the modern breed of Andhra politicians was born' (Balagopal, 1992: 2458). That is, politicians turned into liquor contractors and liquor contractors turned into politicians.

The excise taxes constituted as much as 8 per cent of all state taxes for 1991–92. 'Moreover, since excise only makes upto one-third of the actual price of *arrack*—with the rest going into the coffers of the liquor contractors—almost Rs 2,000 crores were drained last year from the most disenfranchised of Andhra's citizens on this score only' (Anveshi, 1993: 87). And According to Kancha Ilaiah, 'For every 25 paise that the state gets, the contractors get 75 paise' (Ilaiah, 1992: 2408). 'With 23 per cent of the population being *arrack* addicts, Nellore district netted Rs 21 crores in *arrack* auctions last year, and this would have gone up to Rs 25–30 crores this year but for the agitation' (Ramnarayan, 1992: 58).

The government is the sole authorized producer of *arrack* and the production cost comes to roughly Re 1/litre. Poor people buy this in polythene sachets of 45 ml and 90 ml. The price at which the state issued *arrack* to the contractor in 1991–92 was Rs 10.50/litre. And the contractors used to sell it to the consumer roughly at the rate of about Rs 50–60/litre. If overheads such as packing, transporting, excise duty and the cost of hiring goonda gangs (necessary to run this business) is included then it seems the liquor contractors are actually losers. However, their real and massive income is from illegal sale and production to which the government turns a blind eye. 'Everybody knows that the official statistics on *arrack* is a mockery of truth. Obviously the consumption of *arrack* is much higher and this is accounted for by the illicit distilling and packaging parallel to the government *arrack*' (Reddy, 1993: 1063).

The government makes every effort to auction selling rights at higher price. The contractor in turn gets the freedom to decide how and at what price he sells the liquor.

One District Collector who conducts auction tempts the bidder by telling them that so many lakhs of rupees are being disbursed under rural development, tribal development or Rozgar schemes in such and such areas and therefore the contractors are guaranteed a sizable market without much risk (Balagopal, 1992: 2458).

A revenue officer disclosed 'we spend Rs 50 crores for development activities of the weaker sections. We make Rs 62 crores through their purchase of *arrack*' (Ramnarayan, 1992: 58).

And Prasad writes:

Arrack and liquor shops have been proliferating in towns and villages in Andhra Pradesh since 1978, during Dr Chenna Reddy's first term as the Chief Minister. Today Hyderabad has about 700 liquor shops compared to 1,000 fair price shops selling essential commodities (1992: 54).

Effect on Women's Life

The importance of *arrack* increased steadily in the state during the 1970s and the 1980s, right through the tenure of N.T. Ramarao (who became the most vocal supporter of the anti-*arrack* agitation during 1991–92) and the tenures of the Congress Chief Ministers who followed him.

The *arrack* business, promoted vigorously by the State, increased and so did the number of *arrack* shops. The number of shops however declined in 1990–91 due to the innovations started by none other than N.T. Ramarao. That was the phase when the *arrack* contractors devised a new strategy and started selling *arrack* in polythene packets which the vendors started delivering at the door steps of the customers. From the complaints of the women, one could guess the damage it caused through increased drinking with little regard to place or time, day or night.

The vulgarity of this government-sponsored venture could be gauged by the fact that women in Ranga Reddy district used to be paid wages in terms of sachets of *arrack*. Even men were paid

wages in *arrack* in some of the districts. In Mahaboobnagar district the children who worked on cotton fields, were paid wages in cash and kind, kind being a bottle of toddy to sooth their nerves, the girls at the Mahila Shikshan Kendra told this researcher in 1996. And according to Anveshi's report:

> The resulting 'flood' (due to aggressive sale of liquor at the village level to earn maximum profit) of liquor has breached village life at too many points. To mention just one, it is a practice for landlords to pay their labourers' wages in the form of tokens or coupons, to be exchanged for packets of *arrack* at the village shop. Thus, in return for a day's work a family receives no money, only drunken men (Anveshi, 1993: 87).

Women suffering physical abuse by their husbands was just one of their many causes of suffering. Children were starved and their family life was full of endless abuses and bickering. The social fabric of the family and community life was torn apart. No peace, no sleep for women. Anveshi's report mentions that numerous women, in the past, were driven to the point where they committed suicide. On the quality of life Reddy and Patnaik comment:

> The suffering of the women, the very state of wife and husband speaking [with] hate, the absence of love and affection within the household, the neglect of children and daily drunken brawls and the destruction of the very [fabric of] family life are adequate social indicators of the degenerating quality of life (Reddy, 1993: 1065).

The Literacy Campaign and the Anti-*arrack* Movement

The literacy programme in Nellore district has to be seen in the context of this socio-economic and historical backdrop. The literacy programme was officially launched in Nellore district on October 2, 1990 and was implemented from January 1991 after intensive preparations (Shatrugna, 1992).

According to the 1991 Census the State's literacy rate was 45.11 per cent against the national average of 52.11 per cent (M.M. Rao, 1992). The literacy percentage of Nellore was 49.06 per cent. The literacy programme's aim was to make 4.5 lakh people in the age group of 9–35 years, from 45 mandals and 2,000

villages, literate. The programme was launched jointly by the BGVS and the District administration through the Zilla Saksharata Samiti (ZSS). For conducting literacy classes village level volunteer teachers were identified during the campaign in the preparatory phase. According to Shatrugna the estimated requirement was 40,000 volunteers but 55,000 volunteers came forward to run the classes. An important fact is that most of the volunteers from rural areas were from backward castes and were landless labourers. The resource persons for training these volunteers were a large number of school teachers. About 100 such school teachers were freed from their school responsibilities and deputed to the district committees (ZSS) for conducting training and follow up work.

The primers for the literacy classes were prepared by the district level committee constituted for this purpose, consisting school and college teachers, language experts, and BGVS representatives. The manuscript of the primers was duly examined and approved by the Improved Pace and Content Learning (IPCL) Committee of the NLM.

Within four to five months of the beginning of the literacy classes, trouble started. The story, widely reported in newspapers, magazines and confirmed during interviews conducted with the district level BGVS activists, is that women in Dubagunta village of Kanigiri mandal protested when some drunken men tried to disrupt their literacy meeting. One story on the *arrack* problem in the literacy primer, 'Seethamma Katha', in which a woman, who was unable to reform her drunkard husband, commits suicide, affected the women in a few villages a great deal. Moved by this story the Dubagunta village women got together and started an organized struggle against *arrack*. They were able to stop the entry of *arrack* into their village. 'Seethamma Katha' was not based on any actual incident but was written for the primer by the Andhra Mahila Sabha as the *arrack* problem and suicide by women is a social reality in Nellore district. The Dubagunta story, 'If Women Unite' based on a real incident found its way into the post-literacy primers. This post-literacy primer was also approved by the IPCL Committee. By the time post-literacy primers were published the anti-*arrack* agitation had already spread in many villages of Nellore and the neighbouring Kurnool and Chittoor districts.

The literacy classes were stopped after a few months. Literacy volunteers and BGVS volunteers actively participated in the

anti-*arrack* agitation. Literacy infrastructure, the volunteers and the places where classes were supposed to be held, facilitated the spread of the agitation. The BGVS functionaries admit that the literacy process suffered, but clearly it was not the issue which could have motivated the women. For BGVS district and State level functionaries it was a *fait accompli* as the village level volunteers and women were in the forefront of the agitation and they demanded that people who came for the literacy campaign, support them. The spread and success which was being talked about in those days was not of the literacy process but of the anti-liquor agitation. From the interviews, which this researcher conducted with several village women, volunteers and BGVS functionaries, it emerged very clearly that in those extreme conditions, women who probably gathered for a literacy meeting or class discussed the *arrack* issue and got involved in action to change the situation thus making the literacy initiative a secondary priority.

Repercussions

While the NLM officials were taking credit for the empowerment of women through the literacy programme, the State government showed its unhappiness by confiscating all the post-literacy primers (which were released after a gap of more than two years) and taking many other repressive measures.

During our visit to Nellore district, BGVS leaders told us that although the anti-*arrack* agitation was a spontaneous movement which touched upon a burning issue for the people, however, due to this the post-literacy work had suffered enormously. Obviously, it was the major agenda for the BGVS but not for the struggling women. The Nellore TLC was evaluated recently by a team of external evaluators from Hyderabad University and their findings reveal that Nellore district's achievements are of C grade, the literacy rate achieved is 34 per cent. Activists said that the *arrack* agitation consumed people totally and once the movement took off there was no time or space left for literacy work. They also said that the agitation was against the policies of the State government while literacy was a programme of the Central government — probably implying that there was a contradiction between the two governments and the agitators got the benefit of this for a little while. However, this could not be carried on for too long as the State government reacted very sharply.

The repressive steps which the State government took were as follows:

(1) A virtual ban was imposed on the post-literacy primers which had the Dubagunta story in it. However, by the time the State government woke up to impose the ban about 6,000 copies had already been distributed. The NLM executive was approached by some researchers and journalists and the NIAE faculty members to register their protest against this as the post-literacy primers were approved by the IPCL committee set up to do this job. However, the NLM committee chose not to take a stand in this matter and by not doing anything the Department of Education gave a free hand to the State government.

(2) Most of the teachers who were deputed to the Zilla Saksharata Samitis (ZSSs) were sent back to their schools before the end of their term and a few teachers were suspended for participating in the agitation. The order of the Collector clearly warned the teachers and the other BGVS activists that the anti-*arrack* agitation is an anti-government activity and people participating in it will not be spared. They were asked not to participate in the *padyatras* also. This was told to us by the BGVS activists.

This was an important government document which seemed to have changed the course of the literacy programme in Nellore district. After this order the BGVS activists were in a real dilemma. The village women, who were agitating, expected BGVS activists to support them wholeheartedly and the government was pressurizing them to withdraw their support. Some of the motivated and committed activists resolved this by changing their names and supporting the agitation. The most befitting statement came from a young BGVS volunteer. She said that the real threat was from the poor women and their militancy whom the government could not send back with a stroke of a pen!

In this context it is worth noting what was published in the EPW,

As anti-*arrack* agitation is spreading fast in the state, addressing a meeting of district Collectors

> in Hyderabad on November 26, Chief Minister
> Kotla Vijayabhaskar Reddy has expressed his
> 'anger' at the manner in which certain district
> Collectors, while implementing the literacy
> programme, had 'raised' anti-government senti-
> ments among the learners through the text-
> books. Taking a 'serious' note of the role of the
> 'erring' district Collectors, he warned them to
> be 'careful' in future' (Shatrugna, 1992: 2584).

(3) The Collector of the district who took special interest in
the literacy programme was transferred some time in 1992.
It is said that this was done under pressure from the liquor
contractors as this collector, who himself was from the
backward community and sympathetic towards the move-
ment, could not get the auction done. It is during his tenure
that the auction was postponed 32 times (Anveshi,
1993: 88).

(4) The collector was also warned that 'anti-social' elements
from BGVS should not be allowed to publish primers. After
this, all the material had to be scrutinized by the State
Resource Centre before publication.

(5) Police was used by the district administration for stopping
dharnas and picketing and beating up women activists who
managed to stall the auctioning of contracts. Apart from
this it appeared to have adopted more underhand methods
also to break the women's morale by floating the rumour in
a number of villages that if women succeed in stopping the
arrack sales, the procurement price of rice will promptly
be hiked up. The liquor baron, through their goondas also
spread this rumour that the supply of cheap rice would be
stopped in villages where women are stopping the arrack
supply. This was reported to me by the village level literacy
volunteers and the BGVS activists.

Epilogue

It is very clear that the governments, state or central, were not
prepared for this kind of an upsurge. Such an outcome of
literacy was neither intended nor predicted. It is wrong to give the
credit for this upsurge to the literacy programme in isolation. The
literacy programme is a government programme which is imposed

from above whereas the *arrack* agitation started from below. However, it cannot be denied that the literacy programme did provide a crucial opportunity (physical space) to women to meet regularly and discuss their problems. The important role played by the village level literacy volunteers has also to be emphasized. They had first hand experience of the havoc which *arrack* had caused in the lives of the poor people.

It is also very important to understand how the Dubagunta story found its way into the post-literacy primers within a short period of less than 10 months. It is crucial to acknowledge the fact that the social context influences the content. This shows the level of awareness of the victims, the textbook writers, the volunteers, all of whom are situated in the context where *arrack* is dehumanizing the lives of the poor, especially the women. In the village of Dubagunta, the initiative to stop the sale of *arrack* was taken by a widow, Rosamma, who was not a student, and whose husband had died of cirrhosis of liver caused due to excessive drinking. After this, the inclusion of the Dubagunta story in the post-literacy primer was a conscious decision of the writers committee. They included this story after a lot of debate and discussion amongst themselves.

Another incidental gain of the literacy programme was that some of the student volunteers reached the interior villages and saw the extent of rural deprivation with their own eyes. It is very clear from the other people's experience also that the poor people of the villages, educated or uneducated, residing in the remote corners of the country, without much scope for any kind of sympathetic interaction, do welcome such opportunities and try to make the best use of them. However, in most of the places, for the lack of a common identifiable issue and a history of any kind of organized protest, nothing much really happens and the government tries to implement its own agenda. At best there is passive resistance in terms of high drop-out rates or ignoring of the educational programme. In this respect Nellore was different. There was a burning issue which was wrecking the family and social lives of the poor people. An equally important factor was a history of movement against 'saara' (the local term for *arrack*) in the adjoining region. In Nellore, we were told, of late, the women were alarmed to see their young children drinking diluted *arrack* by filling water in the empty *arrack* polythene bags.

In my view, the shamelessness and impunity with which *arrack* was promoted in AP had left most sane people in a state of shock and the kind of support it gets from the powers that be, had generated a feeling of helplessness also. So this initiative by the victims, the wretched of the earth, the poor women, was in a way a welcome break for all types of social and political activists. However, the illusion it has created is that the production and sale of *arrack* can probably be controlled by peaceful means — and not by resorting to the violent tactics of the CPI (ML) groups that include threatening the *arrack* contractors.

And a last concluding remark. The production and sale of *arrack* was banned in Andhra Pradesh in 1994. The village level women's groups could have raised a demand for land or equal wages as we heard in Salla village of Venkatachalam Mandal. But before that itself, on the suggestion of the Collector Sambasiva Rao (on whose suggestion the Chief Minister later launched the 'taking government to the people' programme), credit and thrift societies of women were started at the village level. The credit and thrift societies depoliticized the women's groups. Women started fighting amongst themselves for loans and there were charges of favouritism. The group leaders spent most of their time at the mandal headquarters and not in the villages trying to please the visiting officers in order to get special favours for themselves. This deep concern about the new developments was expressed to me by the field level activists and the district level leaders of the BGVS. The point, which I am trying to raise is not whether the societies are running well or not. It is the depoliticization of the active women, who shook the State for almost a year, that is the cause for concern. In 1996 the government again partially lifted the ban on the plea of loss of revenue. The credit and thrift societies had taken their toll, for after the lifting of the ban on *arrack* there were no widespread protests.

References

Anveshi. 1993. 'Reworking gender relations'. *Economic and Political Weekly* (EPW) 28. Nos. 3 and 4, pp. 87–90.

Athreya, Venkatesh. 1992. 'Lessons from Nellore'. *Frontline*. 4.12.1992: pp. 52–53.

Balagopal, K. 1992. 'Slaying of a spirituous demon'. *EPW* 27. No. 46, pp. 2457–61.

Hoshangabad Vigyan. 1991. Eklavya. Hoshangabad, M.P.

Giroux, Henry. 1983. *Theory of Resistance in Education.* Massachusetts: Bergin & Garvey.

Ilaiah, K. 1992. 'Andhra Pradesh's anti-liquor movement'. *EPW* 27. No. 45, pp. 2406–07.

Prasad, R.J. Rajendra. 1992a. 'A spirited battle—anti-liquor awakening in A.P.' *Frontline*. 4.12.1992: pp. 51–53.

————. 1992b. 'Fighting on—women against liquor in AP'. *Frontline*. 18.12.1992: pp. 93–94.

Ramachandran, Vimala. 1995. 'Empowering Women to Access Resources—Converging Through Social Mobilization'. Report. New Delhi: UNICEF.

Ramnarayan, Gowri. 1992. 'A sobering struggle: AP women lead anti-liquor crack-down'. *Frontline*. 4.12.1992: pp. 55–61.

Reddy, D.N. and Arun Patnaik. 1993. 'Anti-*arrack* agitation of women of AP'. *EPW* 28. No 21, pp. 1059–66.

Saheli. 1995. *In Solidarity*. New Delhi: Saheli, Women's Resource Centre.

Shatrugna, M. 1992. 'Literacy and *arrack* in Andhra'. *EPW* 27. No. 48, pp. 2583–84.

LANGUAGE, DIALECT, AND LITERACY

Aditi Mukherjee

The significance of language in literacy activity cannot be overstated.* Its role as a linguistic 'skill' and, more importantly, as a medium for social negotiation among groups situated differently in the hierarchical power structure in a given society merits due consideration. Since literacy primers form the mainstay of most mainstream literacy programmes, the 'language' used in the primers is an ideological issue which must be seriously debated.

The question of 'which' variety of a language should be adopted in the development of literacy primers, is tricky. Typically, it often gets relegated to the background in favour of either certain' mainstream' assumptions or pragmatic considerations. The most prevalent attitude is that of indifference or a refusal to acknowledge dialect variations as an issue worthy of consideration or debate. Even when the problem is recognized, it is generally brushed aside with practical arguments, such as, since there are many 'dialects' of a language, and it is not possible to develop primers in so many dialects, the 'standard' variety is the natural choice. The mainstream assumptions are well captured by the following statement of a renowned and committed academic who has not

* I am thankful to the Indian Institute of Advanced Study at Shimla for offering me a fellowship from 1997–1999. Most of the work for this paper was done during this time.

only evaluated some TLCs, but also written Telugu primers for Non-Formal Education:

'The best way to go about in preparing a literacy primer is to select a few words which do not belong to any dialect.'

The statement more or less sums up the implicit guiding principles underlying most literacy primers:

(a) That, there exists a variety in a language which is not a dialect;

(b) That, there will be 'a primer' and the best way to prepare it is already known to some of us;

(c) That, the code to be selected for the primer would not be a 'dialect' and therefore, by implication, would be the 'neutral' standard variety of the 'language';

(d) That, because the code selected is neutral and constant, the primer will be useful for teaching learners of heterogeneous backgrounds speaking 'dialects' or variants of the constant 'language'. It is assumed that the standard does not belong to any particular region or class and is, therefore, nationally uniform leading to national intelligibility; and

(e) That the 'words' will be selected by the primer-writer, and therefore, the appropriateness of the contents of the primer will be left entirely to the discretion of the (primer) writer.

In other words, the decision to select the code and content of the primers will rest entirely with some centralized authority with no input whatsoever from the learners at any stage.

This approach, instead of problematizing language, conforms to a superficial (though a widely accepted) understanding of language as an apolitical and neutral entity.[1] It ties up well with the most simplistic definition of literacy as 'being able to read and write' and not essentially as a political activity. The literacy activity is thus reduced to merely imparting a skill, i.e., the task is to acquaint the learner with the orthographic system (literally,

[1] Ironically, the mainstream linguists (whose business it is to analyze language) typically uphold a socially and politically agnostic approach to language. They are unable to handle a dynamic system like language without first decontextualizing and then freezing it for analytical purposes. Anything but the speech of Chomsky's 'ideal speaker-hearer' continues to fall outside the purview of linguistic inquiry.

saaksharata/aksharagyaan or alphabetization) and thereby enabling them to grasp the correspondence between orthography and phonology. This reductionist approach, though seriously challenged and rejected by many literacy theorists and practitioners in the past several decades, unfortunately governs most of our current literacy programmes.

To begin with, we must seriously contest the notion of language as *pure form* with 'power to reflect pre-existing meanings passively without playing an active part in the creation and maintenance of that which it reflects' (Hasan, 1996: 390). Language has to be seen not as a mere static and disembodied unit used to perform mere pragmatic functions, but as a dynamic process of constantly constructing our reality, creating fresh meanings, and establishing our social identities. Thus, to separate the code (in the reductionist sense) from these inherent characteristics and treat it as an asocial, apolitical, de-contextualized entity, a mere 'skill' to be imparted in the name of literacy is not only unrealistic but somewhat self-defeating in the larger enterprise. Selection of a code for literacy primers cannot be a socially/ politically 'neutral' and ideologically innocent act.

In our faith in the Standard language as the constant, we overlook the fact that the 'unity of language is fundamentally political... The scientific enterprise of extracting constants and constant relations is always coupled with the political enterprise of imposing them on speakers and transmitting order-words.'[2] The foregone conclusion to privilege the standard variety of a language as the most suitable for literacy primers is obviously not founded on any linguistic reality of its inherent superiority over the other variants that are dismissed as dialects. The language/dialect distinction is not a linguistic one. Here I risk repeating the cliché — 'language is a variety with its own Army and Navy', to question the very notion of dialect. The enterprise of standardizing a variety of any language is closely linked with the power equations that exist among the speakers of different variants. The powerful group's variety assumes the prestigious position of the, 'standard', whereas the other groups' varieties (though more numerous than the former, but dwelling in the margins of the power structure)

[2] Deleuze (in Constantin V. Boundas 1993. *The Deleuze Reader*), pp. 145–46.

remain dialects, or 'minor', to be treated as mere deviations from the norm.

The process of standardization involves an act of exclusion arising out of an intolerance of heterogeneity. It is imbued with the tendency to totalize and draw neat and exclusive boundaries around tightly knit norms, effecting a closure. Like any other totalizing act, whether it is social, political, theoretical, religious, or philosophical, it is characterized by violence. The violence is directed against those who fall outside the defined boundary— in their being 'considered minoritarian, by nature and regardless of number, in other words, a subsystem or an outsystem'.[3] In interaction with the 'minor', therefore, the effort is mainly directed towards achieving homogeneity, mainstreaming and conformity in favour of the dominant mode of functioning particularly in communication. It is one of the many ways in which the 'major' sets out to define, profile, and describe what is 'proper' and what is not proper, or, what constitutes a 'corruption' of the dominant discourse. As the protagonist of Toni Morrison's *Beloved* aptly put it, 'definitions belong(ed) to the definers and not the defined'. The 'minor' or the dialect speakers fall in the category of the 'defined' with negative stereotypes like poor, rustic, uneducated, unsophisticated etc., attributed to them. It has to be more than a mere coincidence that the same attributes seem to characterize the illiterates.[4] The 'definers' who privilege the standard language take it upon themselves to educate the 'defined' in terms of the code that seems most appropriate in their paradigm.

The act of defining 'language' as opposed to 'dialect' is not an isolated act. It belongs to a larger set of definitions that embrace questions of nationality, history, culture, education, and a projected vision of development. Code selection, in favour of the 'standard' then, is but a token of a larger world view that pervades the consciousness of the dominant group. In this world view, homogeneity is the desired norm that is supposedly linked with development, educational advancement, political modernity/enculturation, ideological tranquillity and stability, and economic growth. The

[3.] Ibid. p. 150.
[4.] The most common abuse in Hindi, to run down a person is *anpadh ganwar* —literally, 'illiterate rustic'.

argument assumes that development requires communication, and that is facilitated by linguistic homogeneity. This is a legacy we have inherited from the 'developed' world which seems to be convinced that 'a country that is linguistically highly heterogeneous is always underdeveloped or semi-developed, and a country that is highly developed *always* has considerable linguistic uniformity (Pool, 1972: 222, emphasis mine).[5] Are we to understand from this claim that Canada and Switzerland, the two 'officially' multilingual countries are 'underdeveloped', and Bhutan and Nepal which may be said to be linguistically uniform, are more economically ' developed'? Fishman, who as a reputed scholar of sociology of language is very influential in matters relating to language planning, has been advocating a definite link between linguistic homogeneity and economic development for a long time. He and his followers perceive heterogeneity as a hindrance to progress because it generates 'conflict'. Linguistic homogeneity is also supposed to help in keeping 'primordial ties and passions... under control' so that 'smooth governance' may be facilitated (Fishman, 1968). The word 'control' is charged with a political ideology reflected in the efforts to homogenize in order to consolidate the powers of the dominant group.

The prerequisite condition of marginalizing, if not eliminating, linguistic heterogeneity ensures that the minor lacks 'the power to determine their own destiny' (Williams, 1992). Arguments in favour of homogenization are not restricted to linguists and sociologists alone, but are amply manifest in the world of commerce. For instance, the media mogul Rupert Murdoch has candidly stated that homogenization of language is a force for global harmony and economic efficiency which, apart from catching prosperity in their networks, will also bring about 'order—and, ultimately, peace'.[6]

The hegemonic nature of such argumentation has not only gained legitimacy in the Western world but has also left its legacy in the

5. Pool makes this observation on the basis of an empirical survey of language use in 133 countries!
6. Cited in Vines 1996. Interestingly, when 'dialects' of Hindi like Bhojpuri, or, 'Hinglish' are used in several programmes telecast on Murdoch's channels they are there for sheer entertainment value. These are invariably spoken by characters who are meant to be laughed at and not to be taken seriously.

'developing'[7] countries that were mostly erstwhile colonies in the third world. The assumption is that countries that were rendered underdeveloped as a result of colonial rule, also have under developed languages which need to be modernized and standardized in order to 'develop'. It is a target modelled after the prevailing philosophy in the 'developed' world. 'The exuberant readiness of large numbers of scholars from ex-colonial countries simply to apply intact and confirm these ideas and the accompanying methodologies in their work has only strengthened the assumption' (Kandiah, 1995: xx). Unfortunately, there has been no critical appraisal of this position to ascertain the validity of establishing a causal relationship between linguistic homogeneity and overall development. Thus, one has to deal with the double injustice of being left not only with a crippled economy as a result of colonization but also a negative mindset in reacting to our own reality of linguistic heterogeneity. It is time to 'decolonize our minds' (Wa Thiongo, 1986) and break free from the self-defeating obsession that the standard language would be a panacea for all our problems.

Despite the presence of several studies indicating multilingualism as an asset for social and cognitive development, the balance is often tilted in favour of 'uniformity'. The logic of 'uniformity as desirable' is extended from multilingualism to multidialectalism. Variation continues to be perceived as deviation and, therefore, as dysfunctional.

In the context of literacy, it is often claimed that the use of the standard language is necessary because it gives a sense of identity to the dialect speakers and brings them under one umbrella. (The assumption, of course, is that the dialect speaker lacks any identity.) In other words, it is meant to unite the people. The argument is very close to the 'Hindutva' model of integration where all undefined sections of the society are sought to be brought within the 'common' fold of Hinduism. The fact that many sections of society, particularly from the scheduled castes and scheduled tribes are totally alienated from the mainstream and seek a different identity, an identity of their own, is paid very little attention.[8] For 'dialect' speakers not identifying with the dominant 'standard language', the Maithili movement in Bihar striving to break away

7. In this context, Venuti (1998) aptly describes 'developing' as 'no more than a backward relation to world capitalism'.
8. See Ilaiah (1996) for a detailed elaboration of the theme.

from the generic 'Hindi',[9] and the Sylhetis settled in England identifying themselves as speakers of Sylheti rather than of Bangla (Mukherjee, 1986), are only a few examples from the contemporary scene.

The notion that a standard language unites the diverse groups of dialects under one head must be seriously contested. In fact the tendency to highly Sanskritize the Indian languages in the process of standardization is leading to the creation of diglossic situations where they did not exist before.[10] The gap between the day to day language and the 'standardized' form of the language is increasingly causing a hindrance to communication among groups, rather than facilitating it. The trend to Sanskritize, despite arguments upholding its legitimacy in purely 'neutral' linguistic terms, is not innocent of an underlying political ideology. Its roots go back several decades in the post-independence history of the country.[11] The unintelligibility of the newly developed Sanskritized versions of Indian languages was commented upon by Lohia way back in 1966, who complained that the orthodox pundits with their high-flown Sanskritized Hindi and Bangla were doing great harm to the cause of their languages. He was quite critical of the way the languages of our newspapers, particularly those in Hindi, were becoming more and more unintelligible. More than three decades since then, the situation cannot be said to have improved.[12] The currently emerging standard Indian languages continue to ratify and further

[9.] See Brass (1974).

[10.] See Kachru (1991) and Mukherjee, 1992. De Silva (1976) has indicated that in diglossic situations as in Kannada, Tamil, and Sinhalese, mass literacy becomes a problem.

[11.] See Amrit Rai's (1991) *A House Divided*, for a historical perspective on the politics of Sanskritization and Persianization of a common tongue.

[12.] Mukherjee and Mishra (1988) and Mukherjee (1992) have empirically demonstrated that the so-called standard Hindi used in Doordarshan News, Question papers in Public Service Commission examinations, and the 'officialese' in NSS instruction books, are not intelligible to a majority of Hindi speakers including those who teach Hindi at different levels.

In the early years of this century, G.A. Grierson in his monumental work *Linguistic Survey of India* (published in 19 volumes between 1903 and 1928) had commented, 'Nine-tenths of the Sanskrit words which one meets in modern Hindi books are useless and unintelligible'(Vol. 1, Part 1, p.130).

deepen the gap between the speakers of 'prestige' and 'non-prestige' varieties of the language. Privileging these standards for literacy primers cannot but distance the minor further away from the major.

Bhokta (1998), commenting on the marginalization of the popular languages (in Bihar and North-Western Provinces in the late nineteenth century) that had for centuries met the cultural and occupational needs of an overwhelming majority, shows how 'the growing middle class tried to emphasize its separate cultural identity by developing a highly Sanskritized Hindi called Shisht Bhasha or sophisticated language.[13] Urdu Protagonists, too, began to borrow a large number of words from Persian and Arabic sources. Both groups completely ignored the *lok bhashas*, the languages of the common people, like Magahi, Maithili, Bhojpuri, Awadhi and Braj Bhasha.[14] The new languages, i.e., Sanskritized Hindi and Persianized Urdu, satisfied the cultural needs of the emerging middle class but failed to meet the cultural and occupational needs of the masses. Thus a rift was created that has not yet been bridged' (201–02). The movement for Shisht Bhasha denied the legitimacy lent to these dialects of Hindi by the vast storehouse of literature created in them including those by Kabir and Vidyapati. The Shisht or Standard Hindi got clearly identified with the upper and middle classes that did not do any 'manual work'. The dialects continued to be used by the 'peasants artisans and petty shopkeepers' for all their cultural and occupational functions. The adoption of 'Hindi' as the medium of instruction by the government, thus, 'denied educational opportunity to a large mass of rural population' (207). In the mid-nineteenth century, the traditional *pathshalas* used local languages and that had 'encouraged boys from the deprived sections of society and lower castes such as *kahar, kurmi, napti, teli, mahuri and gandhabanik* to attend them in large numbers. But the new language (Hindi) had no connection with their

13. Banerjee (1989) has pointed out how with the rise of the middle class in nineteenth century Bengal, the cultural expressions and language of the masses got systematically marginalized in favour of the norms evolved by the social elite.

14. Orsini (1999), talking about the place of language and literature in the politics of Nationalism, lends insight to 'why a certain form of Hindi came to be identified as the future national language' and 'how it became hegemonic' (p.409).

socio-cultural life, and undoubtedly discouraged them from further participation in the education system' (210-12).

Jha (1998) refers to a survey (1900-1901) of vernacular schools (where the local dialects were used) in the villages of Darbhanga district of Bihar and shows how the villagers somehow managed to secure local support for the schools because they found the vernacular education useful. Subsequently, when vernacular education lost support from the government as well as the local elite, the villagers 'virtually ceased to be part of any recognized educational system by the end of the last century'(225-26).

Similarly, in today's context, Aruna (1999) has pointed out how the insistence on the use of standard Tamil, which is closer to upper caste speech, in primary schools is tantamount to brutal 'linguistic disciplining' and alienates the children from lower castes and tribal community. 'Another dimension that is lost due to the rigid conception of "good" Tamil is the cultural capital accumulated in dialects. Speech communities in Tamil Nadu have well-developed production processes, and the speech of each of them is a rich repository of production-related terms and knowledge' (1013). By denying the children from such communities a right to use their 'dialect' in the process of being 'educated', they are dispossessed of their cultural capital. The 'public disavowal' of their own speech patterns contributes to the process of alienation. Ilaiah (1996) makes a similar point about Telugu where dialects which represent 'bahujan' speech forms, are systematically marginalized in favour of standardized Telugu so that the masses feel further alienated from the elite.

It has been pointed out (Pandit, 1972) that the reason for the high dropout rate[15] may be partly attributed to the enormous gap between the home language and the school language. This may account for a part of the truth as, in real terms, the dialect speaker has to virtually learn another code formally in order to have access to the primers. But given the long tradition of multilingualism in this country where it is a way of life rather than a product of conscious effort, it may be assumed that the learners are adept at handling more than one language at a time with no difficulty. Thus the

[15] In 1993, the National Institute of Adult Education had established the dropout rate at the Primary level at 50 per cent. It may be significantly higher in the case of Non-Formal Education and TLCs.

inter-dialectal linguistic differences should pose no insurmountable problem. My contention here is that one of the reasons for de-motivation leading to high dropout rates may well have something to do with socio-psychological as well as purely 'linguistic' factors. The literacy projects, the primers in particular, are fashioned in such a way that they indirectly tend to marginalize the learners' idiom as unsuitable for the literate discourse. That is, entry into this discourse is made possible or acceptable only in terms of the 'language' of the dominant group and not in the ' dialect' of the dominated.

Rejection of dialect would be tantamount to a rejection of certain ways of life because dialects are not mere embodiments of pure linguistic form but they also reflect and embody a set of values and a sense of shared experience. Because no two groups ever entirely coincide in their experience or belong to precisely the same set of social formations, every act of understanding involves an act of translation and a negotiation of values. It is essentially a phenomenon of interrelation and interaction. Unfortunately the onus for such translation in this particular context falls on the dominated groups. This happens as the common grounds for negotiation are denied to them because the only way a dialogue is made possible, if at all, is in terms of the dominant group's paradigm, i.e., the standard language. It certainly does not permit the learners to fall back upon their own idiom as the means of developing a positive sense of self worth. And this is a direct affront to the positive face needs[16] of the learners, non-recognition of which may well be the grounds for a breakdown in communication. In the absence of 'attunement to the attunement of the other'[17], the possibility of engaging in a dialogue, creating shared meanings, and thus, keeping the communication channel

[16]. Brown and Levinson (1978) have defined two aspects of 'face'—positive and negative. Positive face consists of the 'public self-image that every member (in a social interaction) wants to claim for himself', or, 'the positive consistent self-image or "personality" (crucially including the desire that this self-image be appreciated and approved of)...' Negative face is one's freedom to act, 'the basic claims to territories, personal preserves... i.e., freedom of action and freedom from imposition'.

[17]. This concept, introduced by Barwise and Perry in 1983, has become a key concept in the current dialogically based social-cognitive approach to language. See Wold (1992) for a comprehensive treatment.

operative, is eroded to begin with. The learners can be infused with the confidence derived out of an entry into the new universe of literate discourse only when they feel assured that they are no longer the 'inarticulate other', destined to be at the receiving end as objects, but the 'different other' with the potential to determine their own destiny, and, that difference does not necessarily mean deficiency. Nothing short of this restoration of subjecthood can energize the marginalized groups to negotiate with the dominant groups with any semblance of dignity and possibility of resistance.

The point is to pose a counter (however feeble and ineffective in the face of its might) to what Mohan (1995) has called a 'totalitarian' megasystem fashioned by global market forces. In this system, conflicts are reconciled 'not by compromise or consensus, but by choosing and backing the "strongest" of the existing options and seeking to absorb or eliminate the others... It is a simple social streamlining process and knocking out of "superficial" variation, manifested in a choice of one-and-only-one code that will be the "persona" of the new group', eliminating any possibility of 'participation from the interest groups that are soon to be losers...' (887).

Any attempt to resist an all pervasive megasystem like this may be but an act of foolhardy idealism. The State, which itself has chosen to conform to this new totalitarian world order, cannot be expected to overcome the all powerful constant—the standard language being one of its tokens—with its concomitant advantages. Instead, it is more natural to expect that the 'official' stance will be to have faith in the standard and push with determination the uncomfortable 'remainder'[18] under the rug. All this in the name of mainstreaming and 'developing' the unfortunate and illiterate masses!

Yet, there is scope for freedom to dream—to dream, as Freire visualizes it, of freedom from 'ideological determinism' and 'organized hopelessness' (Freire, 1998)—to dream of 'possible utopias'. Freire is clear about the role of language in this dream to seek freedom from the despondency of historical inevitability. Though the learners' own language is the means of developing a positive sense of self-worth, restricting them to their vernacular

18. Venuti (1998) uses Lecercle's term 'remainder' to elaborate the power dynamics in any language use at any historical moment when a major holds sway over minor variables.

should not be the goal. The relation of the vernacular or the dialect with language has to be confronted. While according due legitimacy to the learners' dialect as a means to their finding their voice so that they may speak or write their reading of the world, he cautions that the value of mastering the standard dominant language of the wider society cannot be overlooked. After all, 'it is through the full appropriation of the dominant standard language that students find themselves linguistically empowered to engage in dialogue with the wider sections of society' (Freire, 1987).

It is interesting that even Freire's radical pedagogy sees the possibility of dialogue only in terms of the dominant group's paradigm. It is the oppressed who must learn to speak the oppressor's tongue in order to be 'linguistically empowered' to negotiate and not the other way around. The danger inherent in this scheme goes beyond language. Mastering the oppressor's code does not stop with 'language' but is quite likely to entail other attitudes and social stances that serve as functions of language. The political tension between the major and the minor remains intact. Freire, in one of his earliest works (Freire, 1972), had cautioned that the oppressed sees the oppressor as the goal and, once liberated, steps into the latter's shoes. Mere appropriation of the standard language by the oppressed has the potential of leading to a cyclic predicament where the hierarchical social structures embedded in the language discourse are likely to be reproduced. The dialogical process, which essentially requires that an interaction would open up participants from both ends to change, and that has become the hallmark of Freirean pedagogy, must extend to the question of language. The principle of reciprocity in linguistic accommodation and readjustment cannot be ignored as they are intricately linked with other social and political adjustments.

How then, is one to engage with the question of standard language in terms of interaction rather than appropriation? Deleuze and Guattari (1987) offer a different possibility of facing up to the challenge of the overpowering dominance of the standard. Their argument verges on the ethical where the onus for change and adjustment is on the standard language and not the dialect. Restructuring of hierarchical relations is suggested through interaction and not appropriation. I quote them at length:

> We must distinguish between: the majoritarian as a constant and homogeneous system; minorities as

subsystems; and the minoritarian as the potential, creative and created, becoming. *The problem is never to acquire the majority, even in order to install a new constant.* There is no becoming-majoritarian; majority is never becoming. All becoming is minoritarian. Women, regardless of their numbers, are a minority, definable as a state or subset; but they create only by making possible a becoming over which they do not have ownership, into which they themselves must enter; this is a becoming-woman affecting all of humankind, men and women both. The same goes for minor languages: they are not simply sublanguages, idiolects or dialects, but potential agents of the major language's entering into a becoming-minoritarian of all its dimensions and elements. We should distinguish between minor languages, the major language, and the becoming-minor of the major language. Minorities, of course, are objectively definable states, states of language, ethnicity, or sex with their own ghetto territories, but they must also be thought of as seeds, crystals of becoming whose value is to trigger uncontrollable movements and deterritorializations of the mean or majority… There is a universal figure of minoritarian consciousness as the becoming of everybody, and that of becoming is creation. *One does not attain it by acquiring the majority.* The figure to which we are referring is continuous variation, as an amplitude that continually oversteps the representative threshold of the majoritarian standard, by excess or default… Continuous variation constitutes the becoming minoritarian of everybody, as opposed to the majoritarian Fact of Nobody. Becoming-minoritarian as the universal feature of consciousness is called autonomy. *It is certainly not by using a minor language as a dialect, by regionalizing or ghettoizing, that one becomes revolutionary*; rather, by using a number of minority elements, by connecting, conjugating them, one invents a specific, unforeseen, autonomous, becoming (105–06) (my emphasis).

The problem, according to Deleuze and Guattari, is 'not of reterritorializing oneself on a dialect or a patois but of deterritorializing the major language' (104). This can be achieved by *using* the

minor language 'to send the major language racing' i.e., not permitting the standard to remain ensconced in the comfortable boundaries of the constant, but subjecting it to a state of flux as a result of interaction with the dialects. That is the strength of authors termed 'minor', (such as the Czechoslovakian writer Kafka who submits German to creative treatment as a minor language) 'who are in fact the greatest, the only greats...' (105). Literary texts can be the site for increasing the 'radical heterogeneity by submitting the major language to constant variation, forcing it to become minor, deligitimizing, deterritorializing, alienating it' (Venuti, 1998: 10). Venuti extends this notion from creative production of texts to translation and claims that it is releasing the 'remainder' which characterizes 'good translation' as it cultivates a 'heterogeneous discourse, opening up the standard dialect and literary canons to what is foreign to themselves, to the substandard and marginal' (11). Selection of texts for translation as well as the choice of a particular idiom in the translated text, are not only a question of creativity but an ethical proposition. Good translation is, therefore, minoritizing.

Habermas points out how the 'technocratic consciousness' violates language, which is one of 'the two fundamental conditions of our cultural existence'. Language embodies 'the form of socialization and individuation determined by communication in *ordinary language*' and an engagement with it 'extends to the maintenance of intersubjectivity of mutual understanding as well as to the *creation of communication without domination*' (my emphasis) (1968: 113).

One has to engage with the hierarchical social structures embedded in the language-dialect relationship and think not in terms of 'appropriation' of one in favour of the other but 'creation of communication without domination'. Deleuze and Guattari's conceptualization in this regard and its adoption by Venuti for translation indicate alternative possibilities in this direction.

Language has remained a terrain for struggle. The struggle in Gramscian[19] terms is for 'reorganization of cultural hegemony'. One way to deal with the standard is to de-hegemonise it. This is precisely what Parakrama (1995) has argued about English in relation to '(post) Colonial Englishes'. His thesis strongly proposes

19. Antonio Gramsci cited in Giroux (1987: 1).

'active broadening of the standard to include the greatest variety possible' (xiii). He is, quite rightly, not satisfied with limiting the use of English 'dialects' in isolated scholarly experimental works that seek to 'legitimize certain group-interests, rather than as part of a project to broaden the standard itself' (vii). The use of the 'non-standard' has to be a conscious political act towards 'natural' resistance, and, therefore, one of the most sensitive indices of dehegemonization' (xii). What Parakrama is recommending in effect is, in Deleuze and Guattari's terms, to 'send the major language racing'—the so called standard English in this instance—by chipping away at its monopoly by 'paradoxically, adding stuff to it'. The attempt is to reverse the hitherto accepted direction of change and impact, i.e., instead of from centre to periphery, it is to be from the periphery to centre—from the non-standard to standard.

As in creative writing and translation, the ideological contestation over language in the domain of literacy cannot be overstated. Literacy is not just an isolated *act* of 'learning to read and write'. It is a *process* of 'becoming'. It does not merely involve jumping from one state of being (illiterate) to another (literate). Literacy is not an objective state or entity—something 'out there' which exists in its own right within the boundaries of its own functions and logistics. Being literate is not just a matter of 'achieving' this entity. Rather, it is a process—a process of finding a medium for negotiating with one's material and existential reality—deciphering it in all its complexity, questioning it, reshaping it. 'Appropriating' the received standard norm, including language with all its value-based package, or mere regionalizing the dialect, may appear to effect a transition from being minor to being major, but as Deleuze and Guattari would say, it will hardly be revolutionary. It will only serve to defeat the process of *minoritarian becoming* which entails the deterritorialization and decanonization of the major. It is the conscious *use* of the dialect, as a symbol of the minoritarian being, and forcing the standard to interact with it, that a truly dialogic process (where communication without domination is made possible) can be initiated. It is a dialogicality that requires the major, along with the minor, to be laid open to change and adjustment. The process of self-constitution by the minor must include the major—both subjected to reconstitution on grounds built on consensus that entails mutual respect. It is the defiance of the fixed

barriers between the 'constant' standard and the 'variable' dialects, between 'us' and 'them' that will lead to the minoritarian becoming. The process of literacy must involve both the minor and the major, the illiterate and the literate—ever in firmament, ever constituting and reconstituting themselves internally and in relation to each other.

As I have stated earlier, the mainstream literacy drives tend to ignore the power dynamics of literacy enterprise including those pertaining to language/dialect. They are characterized by an effort to centralize through homogenization and standardization of the language as well as the content of the literacy practice. The distinction between those who are to 'impart' literacy and those who are to 'acquire' it is clearly demarcated. It is also quite clear that it is the latter who are expected to 'change' through this exercise whereas the former remain unaffected. They are seen as belonging to two different worlds, two different categories of people whose interaction begins and ends with 'literacy transaction' in the most impersonal and mechanical fashion without either a felt need or a desire for dialogicality. The operation is undertaken with the fond belief that by 'transacting' literacy to the illiterates, the masses will be drawn into the mainstream (by beginning to acquire and conform to the mainstream norms), and this will subsequently ensure that all the social and economic advantages of literacy will automatically flow down to them. This is in keeping with what has been called the 'autonomous' approach to literacy (Street, 1984) that allows for total socio-political decontextualization. In this paradigm there is no problem in developing 'a primer' in 'a language/ code' for disbursement in neat packages for mass consumption. Thus, the assumptions underlying the statement (quoted in the beginning of the chapter), 'The best way to go about in preparing a literacy primer is to select a few words which do not belong to any dialect', hold good.

It is then outside the domain of the mainstream efforts (among the NGOs), where one may look for the possibility of an alternative approach that may be inclined to an 'ideological' (ibid) engagement with the enterprise of literacy. Obviously, *all* NGOs do not hold positions that in principle differ substantially from the dominantly autonomous paradigm. There are many NGOs that are content with being 'implementing agencies' to carry out the centrally designed and generally accepted scheme. Since there is

no major ideological disagreement, there is hardly any need felt for innovative methodologies.

But there are others who, inspired by the dream of 'possible utopias', attempt to confront the 'megasystem' on ideological grounds. Literacy for them is not a socio-politically neutral and isolated act independent of questions relating to power and inequality. Their approach theoretically requires that the activities be essentially situated in the immediate contexts of the learners. Since no two contexts are exactly identical, these programmes, instead of beginning with prefabricated methodology and primers, attempt to evolve context-specific methods and teaching materials in an interactive mode. To some extent, these projects are attempts at *minoritization*, in that they at least visualize a possibility of defying 'conform-to-the-norm' as a cherished goal and are therefore willing to try and validate the dialect by using it for literacy practice. In the following section I shall discuss some such experiments — their theoretical premises, methodology, achievements/failures and the inevitable problems they faced along the way.

Two groups — *Nirantar* at Banda in Uttar Pradesh and *Rupantar* in Chhattisgarh — confronted the question of language/dialect from an ideological standpoint. Their method being participatory, dialogues on this issue were initiated with the learners, and their opinions sought. Interestingly, and perhaps predictably, the understanding and expectations of the learners did not match the principled positions taken by the teachers. The teachers, acutely aware of the power dynamics between the language and dialect represented by 'us' and 'them', had thought that legitimizing the dialect in the literacy activity would not only empower the learners to negotiate in their own idiom, but also serve as a socially levelling force. The learners, on the other hand, equally aware of the power of the standard language and the social stigma attached to their respective dialects (inextricably related to their *inferior* gender, class, and caste positions in society), could not conceive the possibility of being 'educated' in anything but the standard language. To quote a teacher involved in the literacy programme in Madhya Pradesh, *'apni boli mein siikhaa hua padhaa likhaa nahin maanaa jaayegaa. Jab afsar aayegaa to hindii mein bolenge, tabhii padhaa likhaa maanaa jaayegaa'* (the one educated in the dialect will not be considered educated. It is only when we speak to the officer in

Hindi, we shall be considered educated).[20] This attitude was quite representative. The contradictions of the social world were apparent. The challenge was to confront the very concrete perception and assessment of education in terms of one's ability to interact with the 'officer', i.e., the representative of the powerful dominant group and that was possible only when the standard language had been mastered.

The programme co-ordinator at Raipur (Chhattisgarh) reports that their 'interaction with the village organizations, teacher training programmes, and learner interactions were all conducted in the Chhattisgarhi language' and not in the standard Hindi. 'The Chhattisgarhi language differs considerably from standard Hindi, and native speakers of Chhattisgarhi have considerable difficulty in managing to speak what is called standard Hindi, let alone read and write in it. There has also been an articulation of the Chhattisgarhi identity, a sense of being victims of uneven development in the state of Madhya Pradesh that has gathered strength throughout the decade of 1970s, 1980s and 1990s. The primacy given to Chhattisgarhi... touched a chord at a very basic level, and did a lot to secure the legitimacy of the programme' (Sen, in this volume). They were, thus, trying to make 'a dignity and social justice issue as much as a pedagogic point' through the use of the local dialect. Although the use of Chhattisgarhi had helped to break down the social barriers between the initiators and the beneficiaries of the programme to a great extent, when it came to literacy as a classroom practice, the proposal that the classes be conducted in Chhattisgarhi, met with the reaction of 'disbelief'. The learners and the local teachers 'equated education with learning the Hindi language, and did not think it was possible to be literate in Chhattisgarhi'. They echoed the commonly held stereotypical belief that a dialect (Chhattisgarhi in this case) cannot be written as it does not have a script. After subsequent discussions on what constitutes a language, and the arbitrary relationship between language and script, the learners seem to have been persuaded that it was after all possible to be literate in Chhattisgarhi. According to the programme co-ordinator, 'once the learning had begun, progress was excellent because the struggle to learn a new language was eliminated from the struggle to read, and people

[20] Cited in Saxena (1994).

really took the idea to heart'.[21] However, the actual process of developing the primers in Chhattisgarhi was problematic. The group had to contend with the absence of a written tradition in Chhattisgarhi and deal with the variant forms of words and sometimes, alternative syntactic structures. Besides, since the dialect had no written literature, only texts in standard Hindi could be provided to the learners at the post-literacy level. Though, having mastered the Devanagari script by now, it posed no technical problem to reading, 'it was taken by the teachers and students as a defeat of sorts'.

The experience of *Nirantar* at Banda presents some similarities. Like *Rupantar*, this group had a social justice agenda in introducing the dialect (Bundeli, in this case) in the literacy practice. The local teachers in the group were asked at the outset, 'In what language should your primer be?' Following were the responses:

'It should not be in the local language.
We speak our language, there is nothing new in it so why teach in Bundeli.
If we teach them in their language they will remain where they are.
How will they read other books if they are taught in Bundeli only?
We should teach only the pure and correct form—both in the written and oral mode.' (Nirantar: 8)

Like *Rupantar*, the *Nirantar* group initiated a dialogue on issues such as the 'notions of purity and correctness in language', 'the politics of language and the asymmetry of power that exists in the Indian context between the use of official standardized languages (Hindi) and regional languages and local dialects'. The group, apparently having made no headway through these dialogues, adopted another strategy. They undertook an exercise where they 'developed word lists in Bundeli in certain categories—items found in the house including architectural terms; kinship patterns;

21. This strategy must have been effective. In a field survey in Madhya Pradesh in 1998, we found that whatever little the learners in this region had retained was what they had learnt from the Chhattisgarhi primers, and not from the primers in standard Hindi that were given to them subsequently.

different idioms and qualities related to men, women and children; adjectives used for different types of personalities; jewellery items etc. The corresponding words in Hindi and English were written alongside'(9). This process, while 'inverting the power dynamics between the *Nirantar* members and the *Sahelis*'[22], also made the participants realize the indigenous cultural richness of the Bundeli language which had words/expressions that could far outstrip standard Hindi or English in capturing subtle nuances. Since these words/expressions did not constitute a part of the 'Hindi' vocabulary, were these to be treated as 'incorrect' and banished from the primers and actual classroom literacy practice? After extended discussions, the group decided to 'settle for a mix of Hindi and Bundeli'. It is true that the group had to finally make such compromises between language and dialect, but such exercises were valuable in that they contributed to the participants' (both teachers and learners) reinterpreting their own cultural experiences and language. 'Reversing women's feelings of inferiority about their language in literacy work—which was evident in their opening comments—is as much a part of empowerment processes as working for changing power relations at a macro level'(10).

Despite the initial ideological position regarding the power dynamics of standard and dialect, the Banda experience led the *Nirantar* group to finally come closer to the Freirean position that the importance of learning the standard cannot be denied. 'Validating the local language does not mean denying the importance of Hindi as this continues to be the language of "power" and the women in their new roles require access to this language of power'(10).

Whatever one's ideological stance, the pressures from the mainstream cannot be wished away. To construct an alternative that would substitute the mainstream would be socially unrealistic. The realistic goal would be to initiate a 'negotiation' between the two instead of substituting one with the other. The 'minoritization' process is precisely about such interactive negotiations that intend to deterritorialize the standard by drawing it into the firmament of reconstitution, instead of either being imposed as it is from the top or being substituted by the dialect. It is negotiations

[22.] *Sahelis* are the resource persons recruited from the local areas. Though not highly educated, most of them had completed primary education.

like these at micro levels that contribute their mite tcwards the decanonization of the dominant standard language and the socio-political values that are attached to it. Efforts like this can help us to move towards Habermas's notion of 'communication without domination'. Besides, if the literacy agenda is to be 'inclusive' (i.e., its benefits are genuinely geared towards including the masses, rather than being directly or indirectly instrumental to a goal that suits the already privileged sections of society), the language of literacy practice cannot remain 'exclusive'.

REFERENCES

Aruna, R. 1999. 'Learn thoroughly: primary schooling in Tamil Nadu'. *Economic and Political Weekly*. May 1, pp. 1011–14.

Banerjee, Sumanta. 1989. *The Parlour and the Streets: Elite and Popular Culture in Nineteenth Century Calcutta*. Calcutta: Seagull Books.

Barwise, J. and J. Perry. 1983. *Situations and Attitudes*. Cambridge, Mass: MIT Press.

Bhokta, Naresh Prasad. 1998. 'Marginalization of the popular languages and growth of sectarian education in colonial India'. In S. Bhattacharya (ed) *The Contested Terrain*. New Delhi: Orient Longman Limited, pp. 201–17.

Boundas, Constantin V. 1993. *The Deleuze Reader*. Columbia University Press.

Brass, Paul R. 1974. *Language, Religion and Politics in North India*. Cambridge: Cambridge University Press.

Brown, P. and S. Levinson. 1978. 'Universals in language usage: politeness phenomena'. In E. N. Goody (ed) *Questions and Politeness: Strategies in Social Interaction*. Cambridge: Cambridge University Press.

Deleuze, G. and F. Guattari. 1987. *A Thousand Plateaus: Capitalism and Schizophrenia* (trans. B. Massumi). Minneapolis: University of Minnesota Press.

De Silva, M. W. Saugathapala. 1976. *Diglossia and Literacy*. Mysore: CIIL.

Freire, Paulo, 1972. *Pedagogy of the Oppressed*. Penguin.

————. 1998. *Pedagogy of Freedom: Ethics, Democracy and Civic Courage*. Lanham: Rowman and Littlefield Publishers, Inc.

Freire, Paulo and Donaldo Macedo. 1987. *Literacy: Reading the Word and the World*. London: Routledge and Kegan Paul.

Fishman, Joshua A. 1968. 'Some contrasts between linguistically homogeneous and heterogeneous polities'. In J.A. Fishman, C.A. Ferguson and J. Dasgupta (eds) *Language Problems of Developing Nations*. New York: Wiley, pp. 53–68.

Giroux, Henry. 1987. 'Introduction: Literacy and the pedagogy of political empowerment'. In Paulo Freire and Donaldo Macedo, pp. 1–27.

Habermas, Jurgen. 1986. *Towards a Rational Society: Student Protest, Science and Politics* (trans. Jeremy J. Shapiro). London: Hienemann.

Hasan, Ruqaiya. 1996. 'Literacy, everyday talk and society'. In Ruqaiya Hasan and Geoff Williams (eds) *Literacy and Society*. London and New York: Longman, pp. 377–424.

Ilaiah, Kancha. 1996. *Why I am not a Hindu*. Calcutta: Samya Publications.

Jha, Hetukar. 1998. 'Decline of vernacular education in Bihar in the nineteenth century'. In S. Bhattacharya (ed) *The Contested Terrain*. New Delhi: Orient Longman Limited, pp. 218–28.

Kachru, Yamuna. 1991. 'Expanding domains and changing roles of a standard language: Hindi in multilingual India'. In B. Lakshmi Bai and B. Ramakrishna Reddy (eds) *Studies in Dravidian and General Linguistics*. Hyderabad: Osmania University Publications in linguistics, pp. 404–17.

Kandiah, Thiru. 1995. 'Centering the periphery of English: towards participatory communities of discourse', Foreword to Arjuna Parakrama's *De-Hegemonising Language Standards: Learning from (post) Colonial Englishes about English*. London: Macmillan Press Ltd, pp. xv–xxxvii.

Lohia, Rammanohar. 1966. *Language*. Hyderabad: Navakind.

Mohan, Peggy. 1995. 'Market forces and language in global India'. *EPW*. Vol. XXX No. 16, pp. 887–90.

Morrison, Toni. 1987. *Beloved*. New York: Knopf, p. 234.

Mukherjee, Aditi. 1986. Language Maintenance and Communication Networks among the Sylhetis in Leeds. Project Report submitted to the University of York, England.

————. 1992. 'Planning Hindi for mass communication'. *The Administrator*. Vol. XXXVII, pp. 73–80.

Mukherjee, Aditi and Dipti Mishra Sharma. 1988. 'Language planning in India: the need for empirical feedback'. Paper presented at the International Conference on Language and National Development, Hyderabad.

Nirantar. 1997. 'Literacy and power: exploring power relations within literacy programmes: a case study from Banda district, Uttar Pradesh'. Paper presented at a conference on literacy at Johannesburg.

Orsini, Francesca. 1999. 'What did they mean by "public"?: Language, literature and the politics of Nationalism'. *EPW*. Vol. XXXIV. Nov. 7, pp. 409–16.

Pandit, P.B. 1972. *India as a Sociolinguistic Area*. Poona: University of Poona.

Parakrama, Arjuna. 1995. *De-Hegemonising Language Standards: Learning from (Post) colonial Englishes about English*. London: Macmillan Press Ltd.

Pool, Jonathan. 1972. 'National development and language diversity'. In J. Fishman (ed) *Advances in the Sociology of Language*. Vol 2. The Hague: Mouton.

Rai, Amrit. 1991. *A House Divided*. Delhi: Oxford University Press.

Saxena, Sadhna. 1994. *Kis bhasha main padhein?* Mimeo.

Sen, Ilina. 'Experience with culture specific literacy work: the experience of Chhattisgarh'. In this volume.

Street, Brian. 1984. *Literacy in Theory and Practice*. Cambridge: Cambridge University Press.

Venuti, Lawrence. 1998. *The Scandals of Translation: Towards an Ethics of Difference*. London and New York: Routledge.

Vines, Gail. 1996. 'Death of a mother tongue'. *New Scientist*. Jan., pp. 24–27.

Wa Thiongo, Ngugi. 1986. *Decolonizing the Mind: The Politics of Language in African Literature*. Portsmouth, MH : Henneman (also James Currey, London).

Williams, Glyn. 1992. *Sociolinguistics: a Sociological Critique*. London and New York: Routledge.

Wold, Astri Heen (ed) 1992. *The Dialogical Alternative: Towards a Theory of Language and Mind*. Oslo: Scandinavian University Press.

UNIVERSAL LITERACY AND ORAL CULTURES: SOME DILEMMAS*

Lachman M. Khubchandani

In the contemporary world, the uncritical pursuits of modernization promulgate our current perceptions of literacy as the universal truth. Individuals and societies are dichotomized as 'literate' and 'illiterate', on somewhat similar lines to the aggressive theologicians professing a sharp division between believers and non-believers: *Momins* and *Kafirs*. The stigma of illiteracy is enormous. The word illiterate has now become synonymous not only with 'uneducated' but also with ignorant or backward. Illiteracy in the contemporary milieu has become 'an indivisible part of the general deprivation of employment, income, assets, social status, and political power' (Kamat, 1978). Against this backdrop, the onus of this paper is to focus upon the continuum between oral tradition and written culture, and to consider strategies of incorporating the characteristics of mass culture into the literate culture.

The functional relevance of many changes in the speech patterns of traditional societies for the 'oral-tilted' mass communication needs of the twentieth century has not been seriously attended to. One can envisage the possibility of the 'developing' nations passing directly into a Macluhanesque period where oral

* An expanded version of this paper was presented at the Grassroots Seminar on 'Education for All' held at the Centre for Research in Rural and Industrial Development, Chandigarh in 1992.

mass communication in the local traditional style would be made feasible by the electronic media.

According to the 1991 Census, the literacy rates in the country have increased to 52.1 per cent during the decade 1981–91, thus crossing the 50 per cent mark. (As per the 1981 Census, the literacy rate was 44 per cent.) Still the gap between the male and female literacy rates is enormous: males 64 per cent and females 39 per cent. At the same time, the total number of illiterate people in absolute terms has increased from 302 million in 1981 to 324 million in 1991 (Nanda, 1991).

The Indian Government is actively involved in a nationwide literacy mission through various schemes such as Operation Blackboard, to achieve the targets of universal literacy by the turn of the millennium. In these programmes, a greater emphasis is laid on providing adequate facilities in rural areas by erecting school buildings and arranging teacher-training programmes. One encounters many shortcomings in the academic planning of these programmes, such as: (1) There is poor enrollment and a high degree of absenteeism among rural children. Many tribal children fail to continue the schooling beyond initial classes; one of the primary reasons being the unintelligibility of the standard version of the language of the region in the primary manuals; (2) Current literacy programmes are totally disassociated with the rural culture. Tribal societies, by and large, find it difficult to relate the structure and the content of education to their ways of life. Evidently for them the difference between the school-language and home-language is very vast.

The Thane district in Maharashtra recorded a low rate of 14.4 per cent tribal literacy against the general literacy rate of 50.5 per cent, though there was a considerable increase in the number of educational institutions during 1961–1981. Primary schools have increased from 1,775 to 2,562 and secondary schools from 83 to 261. There is at least one educational institution in 95 per cent of the villages in the district. Special attention is on tribal education through 183 *baalwadis*, 76 *ashram* schools and 830 adult education centres in the district (Saldanha, 1989). But the benefits of literacy still continue to evade the tribals (Khubchandani, 1992).

In everyday life we use language 'to fit the external world into our own world. . . The symbolic representation of experience,

whether in children's play or our own gossip, is of the same order as that of the novel, the poem or the song; all of these modes enable the onlooker to contemplate the possibilities and consequences of the experience portrayed' (Grugeon, 1972). In this context we can appreciate the assets of oral tradition among illiterate communities transmitted from generation to generation through folklore, *Ramleela, Harikatha, Bhagat, Jatra* and many other modes of discourse still prevailing in our fairs and festivals, and in the regular ritual chanting of *mantras*.

How far do the differences in the language behaviour of oral and literate societies reflect differences in adequacy as opposed to acceptable variation? This inquiry raises certain issues of fundamental nature which need to be probed with an interdisciplinary perspective. How does language structure reality— both in a child's 'innocent' view of his universe, and in the adult's 'culturally determined' view of phenomena? So far our understanding about the correlation between thought processes and verbal expression is based more on inferences than on firm data. Wilkinson (1975: ii–iii) rightly expresses his concern: 'How far is the child's ability to think internally related to the external evidence of his thinking by words? A standard language use is often equated with good standard thoughts; but this may not be the case'. 'To elaborate is not necessarily to clarify, it is sometimes more likely to complicate and often to confuse' (Searle, 1973: 136).

Contemporary society seems to be circumscribed by the myth of treating language in everyday life as a 'crystallised entity' characterized by a distinct tradition, embodied in its literary heritage. The qualities of language used in a literary creation are quite different from those required in actual communication. In a sense, a literary creation comes closest to being regarded as an 'artifact' or an 'entity' utilizing speech as its raw material and crystalizing it within a language boundary—and is distinguished from an everyday life communication regarded as a 'fact'.

This myth is shared by many 'underdeveloped' speech communities too in their drive for modernization, just as they accept many other institutions and values from the 'developed' societies for transforming the economic and technological patterns of their societies.

Among traditional societies, in the East as well as in the West, the written text was conceived basically as an aid to spoken performance. In the Indian tradition it is well known that oral transmission of the Vedas and other Sanskrit literature has been practised from ancient times to the present. Burrow a prominent Indologist mentions that 'even when writing was introduced, this oral tradition persisted in the various departments of knowledge, and it continued as a basic feature of Indian education down to modern times... use of writing was only slowly adopted in the Brahmin schools, and in the early period its function lay primarily in business and administration' (1955: 64–65). According to Reneou, 'Dissemination by recitation was frequent, even for secular or semi-secular works, especially the Epics. Brahmanical teaching, including that of grammar, had been entirely oral till a previous date; Panini attests the existence of writing, but not its use in teaching. His grammar, with its supplements, gives reason to believe in a purely oral tradition' (1957: 32–34).

The Sanskrit term *smrti*, literally meaning 'remembered', is applied to post-Vedic literature known to have been transmitted orally from early times. 'From the Indian point of view a man can only be said to know what he knows by-heart; what he must go to a book to be reminded of, he merely knows of' (Garvin, 1973: 27).

According to Bright, the term *lipi* 'writing' is apparently a loanword into Sanskrit from old Persian *Dipi*. There is every likelihood that writing was known and used in South Asia from the pre-Mauryan times, 'but that it was probably restricted mainly to commercial and other practical purposes, and only adapted to sacred or secular literature in later times. This in turn suggests that the tradition of oral composition and of verbatim transmission was maintained in India well into the Classic period of Sanskrit literature' (1988: 32–39).

Pointing out the adverse effects of writing over the quality of communication, Plato warned that it would corrupt human memories, fostering both credulity and mistrust. In medieval England, written contracts were at first regarded with suspicion; a man's spoken word was his bond, it was felt, but a piece of paper was just a piece of paper (Clanchy, 1979).

Traditionally, non-formal education has drawn its strength from the mass appeal through the pursuits of folk arts and crafts,

missionary zeal, dissent movements and even subversive activities. 'Non-formal education is enmeshed in the cultural milieu of society as a part of lifelong education, pursued through literacy or without it... In such a society literacy, no doubt, forms an important asset and accomplishment of an individual, but not a necessary condition of his survival and dignity' (Khubchandani, 1981). Among the Oraon tribals before the advent of literacy, there were indigenous institutions, *jonkh erpa* for boys and *pel erpa* for girls, for transmitting the wisdom of the elders and their interpretations through story-telling, riddles, songs and dances (Jebasingh, 1990).

Formal education, on the other hand, has historically pitched itself through an elaborate mechanism of selection. It is initiated by literacy and is streamlined through certain time-bound stages in a credit-based system.

Education planners of modern India have committed themselves to the 'education for all' without seriously questioning the elitist framework of formal education. Many literacy drives in rural areas, though conducted under the banner of non-formal education, are in essence, charged with the mission of churning out 'certified' literates who could be sucked into the hegemonistic values of the neo-rich urban literates. A neo-literate from an oral culture not only acquires the rudiments of the three R's, but he/she aspires to speak, eat and dress like his/her counterparts in 'modern' society. This has developed into a paradoxical situation. On the one hand, it has given rise to skepticism and apathy among the masses in judging the high-sounding goals of education for development. The result is that a large proportion of those terminating their education at the primary level often relapse into illiteracy or semi-literacy. On the other hand, those who show successful results in their literacy achievements take pride in alienating themselves from their surroundings and their kith and kin, and in joining the stream of the urban proletariat. A report of the team of experts during the 1970s engaged in the Experimental World Literacy Program, sponsored by the UNESCO and UNDP have also pointed out the absence of absolute correlation between the ratio of success in conventional literacy and the rate of growth in rural occupations on a short-term basis such as, agriculture (UNDP, 1976).

In contemporary societies, many modernization processes undermine the multi-way interaction and participatory processes in human communication, so typical of rural cultures, grasping reality in its total ramifications, similar to understanding a painting or music. Literate cultures, in contrast, lay stress on comprehending the verbal discourse through segmental linearity. One cannot ignore the ecological imperatives of stratificational and situational multiplicity, so pervasive in the 'developing' nations, which stress more on oral cultures, than the new values being injected through the official development programmes.

Many of the present goals of language development in the country seem to be out of step with the Indian reality. The 'highbrow' values of speech—uniformity, precision, elegance, purity of form, allegiance to literary tradition, elaboration of language through coinage of new terms do not actually meet the demands of adequacy in everyday communication among rural and working-class children. At the same time, requirements of elegance in education (such as stress on urban idiom and sophistication) inhibit the introduction of literacy in an effective and economical manner. As stated above, a wide gap between the language(s) of home and that of school contributes to a significant extent to the large number of school dropouts in the country.

Literacy in the elitist framework has been put on a high pedestal similar to 'classical' skills, judged on the basis of a predetermined criterion of competence than on the spontaneous quality of participation. Societally, literacy in the modern ethos serves as a discriminating device of identifying 'advantaged' versus 'disadvantaged' classes in a society. These impediments undercut the universal goals of literacy.

The failure, or a slow growth, of many literacy drives is marked by a restricted entry for these who can afford the social costs, and are motivated enough to join the elitist 'advantaged' club. Problems of discontinuity for the rural and working-class entering the predominantly middle-class world of literacy, particularly their failure to articulate the 'urban' language, question the goals of universal literacy in removing inequalities in the social structure. Halliday et al. (1964) point out such an anomaly with some indignation: 'A speaker who is made ashamed of his own language habits suffers a basic injury as a human being; to make anyone,

especially a child, feel so ashamed is as indefensible as to make him feel ashamed of the colour of his own skin'.

A dispassionate understanding is required to prepare a sound basis for properly relating non-formal education as 'recurrent' life-long education with the formal education as 'preparatory' time-bound education.

People belonging to oral cultures, by and large, are not very conscious of the speech characteristics which bind them in one language or place them across the neighbouring boundary. Until recently one often noticed that in many Indian communities the urge of belonging to a particular language group was often relegated to somewhat less significant status in one's subjective evaluation of strata: 'so deep does bilingualism go in parts of Ganjam that from very infancy many grow up speaking both Oriya and Telugu, and are so much at home in both that they cannot tell which to write as their mother tongue' (Hutton, 1933).

Plural societies are generally endowed with an access to a wider verbal repertoire for inter-group and inter-cultural communications. Members in these societies generally interact in everyday life situations without fully committing themselves to learning the 'tradition-inspired' standardized nuances of another language or culture, such as the use of lingua franca—Hindustani in South Asia and Swahili in East Africa. Hindustani, though linguistically not very different from pedantic 'high' Hindi and 'high' Urdu, is a distinct communication system. Hindustani cannot be regarded as a language in the narrow technical sense; it is a communication amalgam. Individuals in such societies acquire more *synergy* (i.e., putting forth one's own efforts) and *serendipity* (i.e., accepting the other on his/her own terms, being open to the unexpected), develop positive attitudes to variations in speech (to the extent of even appropriating deviations as the norm in the lingua franca), in the process of 'coming out' of their own language/codes to a neutral ground. We get ample evidence of these processes on the Doordarshan when conducting live programmes in diverse cross-cultural settings. Sophisticated elite in the developing world, by and large, do not seem to have taken adequate cognizance of those issues in framing language and communication policies for the newly emergent nations.

The elitist system of education does not take into account the rich complexity of speech variation across dialects in flux (and in

plurilingual societies, often across languages) at the folk level. A large gap between the speech patterns of typical illiterate communities and the language values promoted through school education is evident from the examples of Marathi and Santhali heterogeneous speech groups, discussed elsewhere by the author (Khubchandani, 1981; 1983).

Literate cultures generally regard hybrid varieties (patois, pidgins, creoles, etc.) as a sign of inferior socialization, and discourage them in formal situations (such as schools), as is revealed from the pejorative attributes assigned to the pidgins evolved among the tribals (Sadani in Chhotanagpur, Nagamese in Nagaland). In this 'filter-down' approach of the educational elite, grassroots 'folk' multi-lingualism is devalued and language teaching gets focused on remedial programmes so that the 'backward' pupils speaking hybrid varieties become eligible for entry into the 'advanced' world through the mastery of standard language(s).

In school lore, the educational disadvantage for rural and poor children is often thought to have its origins in the language deprivation the child suffers at home during the pre-school years and afterwards (Bernstein, 1971). The rural 'non-standard' varieties are rated grammatically as 'incorrect' and 'bad', conceputally as 'deficient', and sociologically as 'deprived'.

A native speaker's use of speech in everyday life reality is an integral activity, relevant to the context and purpose of verbalization. His actual discourse in everyday life gets modulated on the scale of intentive and instinctive extremes. But the school interaction generally puts a premium on the explicit, unambiguous, overt manifestation through language, by laying undue stress on its rational and overt use.

Schools have a strong tendency to employ exclusively the 'representational' model of language, though irrelevant to the majority. The Barbiana Letter (1970), raising an accusing finger at the teacher who represents the higher-class values of speech, points to the fundamental rights of individuals: 'All citizens are equal without distinction as to language... But you honour grammar more than constitution... languages are created by the poor, who then go on renewing them forever. The rich crystallize them in order to put on the spot anybody who speaks in a different way or in order to make him fail exams.'

Most standardization devices in Indian languages today serve only to extend the conventional value system of the small urban elite. So far there does not seem to be much realization of the difficulties the rural population faces arising out of the unintelligibility of the highbrow standards projected in mother tongue textbooks. The pleas of language leaders for developing puristic 'academic' official standards of language—on the lines of the nineteenth century Latinized English and the Sanskritized or Perso-Arabicized literary styles of Indian languages, accentuates divergence in the home and the school environment and puts a heavy strain on the speakers of Sirmauri, Marwari, Chhattisgarhi, Magahi, acquiring literacy through the text books in high standard Hindi i.e., Khariboli. It also runs counter to the concerns for the facility of expression of students through mother tongue education, as stressed in the 1953 UNESCO Report.

Ironically, it falls upon the common man to acquire the language of academic discourse, which may be quite unnecessary for communication. No wonder, mother tongue text books in many tribal languages are 'originally written in English and then translated in local languages' as 'authors in the local languages are not available'! (Sharma, 1971).

Many language standardizing agencies (such as school), in evaluating the efficiency of communications, tend to be concerned exclusively with the homogeneous grasp of language skills. Yet this is only one factor, although no doubt a significant one, in human communication. In reality one does not find the 'schoolmasterly' dichotomy of right versus wrong (acceptable-unacceptable) utterances in a language. Deviations from the 'norm' in specific situations could be more appropriate, purposeful, amusing, pejorative, offending, ambiguous, hazardous, unintelligible, socially neutral, or identifying a group (characterizing region, class, etc.). The phenomenon of communicative sensitivity is distinct from proficiency in language skills. It allows a communicator to transform many diverse ad hoc fluid cues in speech to a degree of communicability for a particular purpose.

The grassroots approach emphasizes making education more meaningful, useful, and productive to work-experience. Sensitivity to speech variation and a grasp over the communication ethos prevailing in the society is, no doubt, enhanced by *doing* verbal events in natural settings. An elaboration of Gandhiji's thinking

concerning Basic Education could provide a useful focus in this regard. Gandhiji laid stress on integrating education with experience, and language acquisition with communicability, as advanced in his approach to Hindustani. This programme provided a viable basis for meeting the demands of universal literacy with minimum financial inputs. But such educational pursuits have not been recognized as education *proper* in the professional sense.

The developing world, by and large, is committed to launching mass programmes for the eradication of illiteracy to enable the masses to play an active role in social and cultural change. Under the spell of contemporary radical thinking in education, there is a greater awareness to make adult education relevant to the environment and learners' needs, and to diversify curriculum, teaching/learning methods and materials. With the aim of relating the learners' education to their personal, social and cultural needs, the stress is laid on learning rather than on teaching, on the use of spoken language, and on harnessing the mass media.

But at the operational level, one is not surprised to find the bureaucratic machinery not mustering enough courage, accepting departure from conventional thinking and commissioning its resources for preparing materials in 'standard regional or sub-regional languages/dialects' as an interim measure. In this endeavour diverse approaches of transmitting literacy skills on a universal basis have emerged on the scene, as pointed out in an earlier study (Khubchandani, 1981). Some of these approaches are mentioned below:

(1) Conventional educators profess strict adherence to the standard language of the region.

(2) Liberal educators recommend a bi-dialectal approach of gradual phasing in time from a home dialect to the standard speech, thus initiating literacy through a non-standard 'home' variety of learners as a transitory feature which helps to switch over to the standard language at a later stage.

(3) Some educators plead for a dichotomous approach, by accommodating a diversity of dialects/speech varieties at the spoken level, but at the same time insisting on the uniformity of standard language at the written level, i.e., at the level of acquiring literacy skills.

(4) Those supporting a grassroots approach for the universalization of education endorse the pluri-linguistic model

of literacy by which variation in speech is regarded as an asset to communication. It promotes cultivating positive values for the diversity of speech varieties/dialects prevailing in a group/individual in response to the demands of the situation, identity, and communication task.

In this scheme, literacy in the standard variety is, no doubt, promoted for economically-oriented situations and communication tasks; at the same time, learners are educated to diffuse the pejorative attributes to non-standard varieties which prevail in society and are often maintained or even enforced in conventional learning situations.

In the Indian tradition both oral and literate cultures have played a vital role. Our heritage rejects the supremacy of one culture over the other. As Bright (1988: 33) has pointed out, it is a 'tribute to Hindu culture, rather than an act of delegation, to recognize that a complex literature could be developed and perpetuated by the human mind and memory alone, without the "artificial" extension of writing systems'.

But the contemporary society has succumbed to what Borges (1960) calls 'the cult of the book'. Nowadays it is writing, not speech, which most educated people regard as basic, and indeed as a necessity. In the light of this, we need to look into the problem of how to tackle varying demands in the spoken and written genres of the same language. It is necessary to adopt a pragmatic approach to linguistic usage in education and take into account the mechanisms of standardization of language in plural societies. A new order is to build on the resources inherent in a wide range of speech settings which provide a characteristic profile of segmented communities in the country.

REFERENCES

Bernstein, Basil. 1971. *Class, Codes and Control*. London: Routledge and Kegan Paul.
Borges, Jorge L. 1960. *Otras Inquisiciones*. Buenos Aires: Emece.
Bright, William. 1988. 'Written and spoken language in south Asia'. In C. Duncan-Rose and T. Vennamann (eds) *On Language: Rhetorica, Phonologica, Syntactica*. London: Routledge, pp. 23–83.

Burrow, Thomas. 1955. *The Sanskrit Language*. London: Faber and Faber.

Clanchy, M.T. 1979. *From Memory to Written Record: England 1066–1307*. London: Arnold.

Garvin, P.L. 1973. 'Some comments on language planning'. In J. Rubin and R. Shuy (eds) *Language Planning: Current Issues and Research*. Washington D.C.: Georgetown University Press, pp. 24–33.

Grugeon, Elizabeth. 1972. 'Language and literature'. In A. Cashden and E. Grugeon (eds) *Language in Education: A Source Book*. London: Open University Press.

Halliday, Michael A.K., A. McIntosh and P. Strevens. 1964. *The Linguistic Science and Language Teaching*. London: Longman.

Hutton, J.H. 1933. *Census of India—1931*. Vol. I, Part I—Report. Govt. of India.

Jebasingh, Ananthi, 1990. *Script of Tribal Languages for the Promotion of Literacy*. Delhi: Amar Prakashan.

Kamat, A.R. 1978. 'NAEP: a critical assessment. *Janata* (Adult Education and Rural Health number).

Khubchandani, Lachman M. 1968. *Linguistics and Language Planning in India*. Special issue of the *Bulletin of the Deccan College Research Institute*, Pune 27: 1–2, also in the *Deccan College Building Centenary Series* No. 63,969.

———. 1981. *Language, Education, Social Justice*. Pune: Centre for Communication Studies.

———. 1983. *Plural Language, Plural Cultures: Communication, Identity and Sociopolitical Change in Contemporary India*. East-West Center Book, Honolulu: University of Hawaii Press.

———. 1992. *Identity and Communication among Tribal Societies*. Shimla: Indian Institute of Advanced Study.

Labov, William. 1970. 'The logic of non-standard English'. In F. Williams (ed) *Language and Poverty*. Chicago: Markham, pp. 153–89.

Letter to a Teacher by the School of Barbiana. Harmondsworth: Penguin.

Nanda, A.R. 1991. *Census of India, 1991: Provisional Population Totals*. Series 1: India, Paper 1 of 1991. Delhi: Registrar General, India.

Reneou, Louis. 1957. 'Introduction generale'. In J. Weckernagel, *Altindische Grammatik*, Vol. I, second ed. Gottingen: Vandenhoack and Ruprecht.

Saldanha, Denzil. 1989. 'Socialization of critical thought: responses to illiteracy among the adivasis in Thane district'. *Economic and Political Weekly* (July 29 issue), pp. 54–61.

Searle, Chris. 1973. *This New Season*. London: Calder & Boyars.

Sharma, R.K. 1971. 'Tribal education in Nagaland', *Proceedings of the Conference of Tribal Research Bureaus in India*. Mysore: Central Institute of Indian Languages.

UNDP. 1976. *The Experimental World Literacy Programme: a Critical Assessment*. Paris: The UNESCO Press.

UNESCO. 1953. *The Use of Vernacular Languages in Education*. Series: Monographs on Fundamental Education. Paris: The UNESCO Press.

Wilkinson, Andrew. 1975. *Language and Education*. London: Oxford University Press.

Section II

Literacy Practice: Pedagogy and Evaluation

6

NATIONAL LITERACY MISSION: 'PAST, PRESENT, AND FUTURE'

Lakshmidhar Mishra

The National Adult Education Programme (NAEP) which was launched by Morarji Desai, former Prime Minister of India, in 1977 was already in operation in 1985–86 when Rajiv Gandhi conceptualized the Technology Mission for eradication of illiteracy. The NAEP was a centre-based and supply driven programme where a large number of adult education centres had been opened in different parts of the country. Instructors and supervisors had been appointed to manage the centres and to impart functional literacy to adult learners in the 15–35 age group. The curriculum, course content and textual materials had been designed with the help of voluntary agencies of repute, managing State Resource Centres (numbering 15) in different parts of the country. The programme, however, had failed to produce the desired impact due to a variety of reasons, the most important of which was lack of adequate planning and preparation rooted in the native milieu, ethos, and culture, to arouse and awaken the people's demand for literacy before going in for actual delivery of literacy. Between 1978 and 1985 the programme was evaluated by a number of institutes of social science research and these evaluation studies had clearly pointed out some of the weaknesses in the programme.

The National Literacy Mission (NLM) drew inspiration and strength from the earlier National Adult Education Programmes

but sought to make a radical departure therefrom in terms of the following: .

- Identification and enumeration of the non-literate adults through surveys.
- Number of non-literate persons to emerge from the ground through such surveys instead of targets being imposed from the top in the typically prevalent culture of targetitis.
- The survey itself is intended to be like a festival deeply rooted in the native ethos and culture and is to act as a powerful instrument for the creation of an environment conducive to literacy.
- A systematic and methodical programme for the creation of a positive environment through harnessing the existing art forms in folk culture.
- Powerful messages rooted in the native language and idiom were to be designed as *nukkad nataks*, street theatre, skits, etc. These were to be disseminated amongst the target groups through folk cultural troupes.
- The programme was to be implemented in a campaign mode and directed towards total eradication of illiteracy in a particular area—be it a village or *Gram Panchayat* or Block or *Tehsil* or *Mandal* or District. It was to be area-specific, time-bound, cost-effective and result oriented.
- The total literacy campaign was to rest on the philosophy of 'each one owns, each one contributes and each one participates'.
- Instructors and learners were to be in the ratio of 1:10. The place for teaching/learning was to be embedded in the community and was to come through voluntary contribution either at the premises of the teacher or at the premises of the learner or any other place of public importance including places of public worship.
- This was one of the world's most inexpensive literacy programmes in as much as the per learner cost ranged between Rs 50 and Rs 70 and went up to Rs 80 only in rare and exceptional cases. The components of the cost included the cost of teaching/learning materials, teaching/learning aids— blackboard, roller board, slate, chalk, duster, charts, posters etc. A minimal amount was kept for conducting area-specific

surveys for environment building, training, monitoring and evaluation.

- The teaching/learning materials were to be designed on the principle of what is known as Improved Pace and Content of Learning (IPCL). The IPCL is a sequential approach in which one learns from stage to stage and as one proceeds from a simpler stage to a more complex stage, one acquires the individual strength to learn. In terms of operational strategy, the IPCL technique consisted of three primers which were multi-graded and integrated. At the end of each primer, drills and exercises were provided to enable the learners to practise what they had learnt and develop the confidence to solve the problems by themselves. In addition to the self-evaluation by the learners they were to undergo three tests at the end of each primer.

- While a duration of six months was to be spent on planning and preparation including survey and environment building, designing the need-based IPCL primer and training etc., six months were to be devoted exclusively to the teaching/learning process. It was expected that during this period and with the help of IPCL technique the learners will be able to acquire the minimal level of literacy.

- Training as an important tool of human resource development was recognized in TLC. Training implied essentially training of instructors but also included training of resource persons and master trainers. A cascading approach and strategy for imparting training was adopted. In other words, trainees of today became trainers of tomorrow under categories like key resource persons, resource persons, master trainers and volunteers. The training was to be primer-specific, dialogue and discussion oriented and not didactic or prescriptive.

- Monitoring and evaluation were important components of the entire strategy of TLC. Monitoring was to be done at each stage, i.e., at the learning centre level (which is coterminous with the village), *Gram Panchayat* level, Block level and District level. Monitoring was meant for collection, compilation and analysis of data. It was also meant for correction on the basis of the feedback. For this purpose, a set of co-ordinators at each level, were required to report the pace and progress

of learning as also various other attendant problems associ-
ated with learning to the next higher level. The report of the
co-ordinator was to be discussed in the *Saksharatha Samiti* or
Co-ordination Committees set up at the *Panchayat* level, Block
level and the District level. This was intended to provide total open-
ness and transparency in the entire operation.

- Like monitoring, evaluation was also intended to act as a tool
 of correction. Evaluation essentially implied self-evaluation
 by the learners, instructor, village community, master train-
 ers and key resource persons as also external evaluation by
 institutes of social science research or NGOs from outside.
 The evaluation was to be both concurrent as well as summa-
 tive. It was to cover the content, process as also the impact
 of the entire teaching/learning process.
- At the close of the campaign, on the basis of the results of
 the evaluation a Total Literacy Declaration Ceremony was to
 be held. An area was to be declared as fully literate if it had
 been fully covered in a particular age group, say 9–35 years
 or 9–45 years, and if 90 per cent of the learners were found
 to have acquired complete self-sufficiency in reading, writing
 and arithmetic.

Meticulous care was taken to select such areas initially where
the rate of literacy was high, where a ground swell could be
observed as a result of the environment building exercise, and
where the rate of failure both by way of dropout as well as by way
of non-acquisition of the minimum levels of learning would be
minimal.

This is how Ernakulam in Kerala was selected as the first
district in the country to demonstrate that a Total Literacy
Campaign is not a utopian idea or concept but something which is
achievable. The Ernakulam Campaign was essentially meant for a
target group of about two lakh potential learners in the 6–45 age
group with the help of about 20,000 learners in a record period of
one year. The Ernakulam experiment demonstrated the following:

- If the initial rate of literacy in a particular area is high it will
 be much easier to proceed to further higher dimensions with
 the help of a large number of potential instructors available in
 the area.

- Even though the potential learners come from a poor social background, potential instructors could come from any rank/ status or profession. They primarily had to have the inclination and commitment to teach the non-literate. Amongst the potential instructors women outnumbered men (70 per cent of the instructors in TLC in Ernakulam happened to be women).
- The Campaign for Total Literacy in Ernakulam became a campaign for protection and conservation of the environment, promoting women's equality and empowerment, and creating awareness about small family norms, national integration, and communal harmony.

The Ernakulam experiment became an important trend setter for the whole country. Ernakulam was followed by the whole of Kerala State, the whole of Pondicherry and Goa and over 200 districts in the rest of the country.

The success of the Ernakulam TLC experiment could be attributed to the following factors:

- The post of Collector/District Magistrate in charge of a district has ordinarily been associated with maintenance of law and order, and preservation of the status quo since colonial times. It has never been used as a catalytic agent for social mobilization. The Ernakulam experiment was largely successful on account of the imagination, vision, and commitment of the Collector of Ernakulam who was more a social activist than a traditional bureaucrat. He was the Vice President of the *Kerala Sastra Sahitya Parishad* (KSSP) and was more convinced than anybody else that if the TLC could succeed in Myanmar, Cuba, Nicaragua, Vietnam and Ethiopia, it could succeed in Ernakulam as well.
- The KSSP which has a unique socio-cultural background as an activist organization, with a large number of activists drawn from different strata of the society, lent its total energy to promote the TLC in Ernakulam. It also sustained it after the campaign phase was formally concluded, so that the impact of the campaign could be felt across the length and breadth of the Kerala State.
- Eminent men and women of public life and scores of other activists, creative thinkers, writers, artists and playwrights contributed their best to the success of the campaign.

- The fact that Ernakulam had a very high rate of literacy (around 77 per cent) at the time of launching the campaign, was itself a major contributory factor for the success of the campaign. It was an important source of strength as it provided a sufficient number of potential instructors *vis-à-vis* the potential learners, as also a highly literate environment and made the principle of a teacher-pupil ratio of 1:10 workable.

The next point which may be noted is that the rest of the country and notably Santhal Paraganas and Singhbhum districts of Bihar, the Chhattisgarh region of Madhya Pradesh, eastern parts of Uttar Pradesh, southern parts of Orissa, desert districts of Rajasthan, and tribal tracts of Gujarat and Maharashtra, Andhra Pradesh, Karnataka and Tamil Nadu are not placed in the same situation of geographical and cultural advantage as that of Kerala. Could the Kerala experiment be replicated in the rest of the country? The question may also be asked on the rationale of extending the strategy of the Total Literacy Campaign which was tried out in a big way first in Vietnam (1945–77) and later in Cuba (1959–61), Myanmar (1969–74), Ethiopia (1974–79), and Nicaragua (1985–90). In these countries there was first a revolution which brought in its wake sweeping social, political, economic and cultural changes, along with a change of Government. Literacy was an offshoot of that revolution; it was also facilitated by the revolution. The campaign for total literacy, as a matter of fact, became an important springboard for national reconstruction. Stories of success of the Total Literacy Campaigns in these countries have been meticulously documented which go to show that the campaign became successful largely on account of the political will and commitment of the leadership of the national and provincial governments. Its success could also be correlated to the mass upsurge and euphoria which took place in the wake of the revolution and which facilitated the process of social mobilization to use literacy as a tool for radical social, cultural and political transformation. As the story goes the pace of the campaign was not deterred by the fact that people were poor, that there was a hangover of colonialism/imperialism/dictatorship, that the landscape was barren and unapproachable and, that there were numerous social, cultural and linguistically divisive factors. As the story goes further, in Vietnam the back of the buffalo provided the slate, the brick kilns provided

the blackboard, the juice of plants provided the ink and the sticks from the forests provided the pen. In Vietnam, where the economy was ravaged by a long era of colonialism and war, the political vision of Dr Ho Chi Minh and the tremendous courage and determination with which he pursued the campaign for total literacy, as a tool for the social, economic and cultural emancipation of Vietnam, has few parallels in world history.

It is true that India is not the same as Myanmar, Cuba, Nicaragua and Ethiopia, either in terms of the total area or in terms of population. India will be several times the size of all these countries put together. Both the burgeoning population and the problems associated with a multilingual and multi-religious country like India are mind boggling. Such is the scale of diversity and heterogeneity in India that if there are 300 million people below the poverty line who are also illiterate, unemployed or under-employed, there can be as many as 300 strategies for the eradication of poverty, unemployment, under-employment and illiteracy. No quick-fix and simplistic solution is either feasible or can be straightway adopted and far less implemented. Conditions vary widely from state to state, region to region, and even within the same district. These diversities and variations notwithstanding, the campaign approach had an essence. That essence rested on certain premises and, therefore, it was thought appropriate to imbibe and assimilate that essence from the TLC experiment of the above countries even though there may not be any commonality between the conditions prevalent in those countries and the conditions existing in India at the time of launching the TLC.

In the 1920s, 30s and 40s one single call from Gandhi, the Father of the Nation, could energize and electrify the whole nation. Millions of men, women and children were aroused and awakened; they responded magnificently to his call and rallied round him with one force as also with remarkable courage and determination to liberate the country from colonialism. Those were the nascent days in the field of mass media. Television had not yet come to India and radio was in a very formative stage. Such, however, was the magnetic personality of Gandhi, such was the force of his communication skills that he succeeded not only in electrifying the whole nation but in fusing numerous diffused and uncoordinated currents of Indian history into one single rhythm—the mass movement for freedom. He successfully projected colonialism and

imperialism as negative forces and used national songs, slogans, idioms and imagery to infuse into the hearts and minds of people of India the idea that colonialism could be repulsed only by united resolve. Such resolve was possible only if people had access to information and literacy was an essential tool for the same. This is why Gandhi had stated with a lot of anguish that 'it is a matter of shame and sorrow that millions in India are illiterate; they have to be liberated from the curse of illiteracy if they are to be truly liberated'.

Gandhi is no more. It was, however, felt that there may not be just one Gandhi but millions of good Samaritans who could collectively equal his vision, imagination and determination. They needed to be mobilized and brought under the umbrella of a central body so that they could act as nucleating agents to make the mass campaign for total literacy a reality. It is this thought that gave birth to the *Bharat Gyan Vigyan Samiti* (BGVS). The Department of Education, Ministry of Human Resource Development, acknowledged with all humility that the Government could not directly take up social mobilization but could create conditions which would be conducive to such mobilization. Promoting and facilitating the formation of BGVS at the national level was one such very positive and constructive step which was initiated by the then secretary, Ministry of Education. The BGVS was a confluence of creative forces and energies and sought to bring under its umbrella thousands of creative thinkers, writers, artists, playwrights, actors and actresses on the stage and on the streets who could write, sing, dance, perform, and as they did this they could arouse and awaken the masses, make them perceive their predicament, correlate it to illiteracy and discover the wherewithal for liberation through literacy. To spread the message of literacy across the length and breadth of the country, BGVS adopted a unique strategy of harnessing the folk culture and folk medium of communication through what is known as *kalajathas*. It brought together thousands of folk artists to constitute cultural troupes, organized training camps for members of this group, composed numerous songs, slogans, *nakkud nataks*, role plays and simulation exercises and on 2nd October, 1990 launched the *Bharat Gyan Vigyan Jatha*. The BGVJ went round the country for a period of 45 days (2-10-90 to 14-1-91) and covered one lakh out of six lakh villages spread over 300 districts. This was a tumultuous period of Indian

history when the class and caste war had unleashed numerous divisive forces which were playing havoc with the lives of innocent people. Such, however, was the determination of thousands of volunteers of BGVS that they remained undaunted in the face of such divisive forces and went on spreading the message of literacy in an unconventional, and yet, most effective manner of communication. The *kalajathas* performed by the BGVS artists churned the critical consciousness of both the literate as well as the non-literate. While the literate resolved to act as potential instructors, the non-literate resolved to use literacy as a weapon against bondage, deprivation and exploitation. As one spark ignites another these folk artists fired and ignited the imagination of numerous good Samaritans all over the country to come together under the banner of BGVS and to pledge their solidarity and support to the cause of Total Literacy Campaign.

Once the groundswell had been created leading to a churning of critical consciousness of the masses, one could proceed to structure the entire campaign for total literacy. The campaign was not intended to be a loose or unstructured activity but a planned, and concerted activity. At the national level was the National Literacy Campaign Authority with a Governing Council and an Executive Committee headed by the Minister for Human Resource Development and Secretary, Education respectively. Similar bodies were to be set up at the state level. The body at the district level was to be known as *Zilla Saksharata Samiti* and similar *Saksharata Samitis* were to be organized at the block, *panchayat* and village levels. All these bodies were to comprise of men and women who had the vision, and commitment to literacy. The most important and essential feature in all these structures was that while people would contribute their spare time to the campaign they would do it free and of their own volition without there being any coercion or regimentation. None was to be paid for contributing to the TLC. Only some of the genuine components of cost like travel and some incidental expenses were to be reimbursed. The reigning spirit in the campaign could be summed up in the following words: if you have the urge, inclination and commitment to contribute to the task please do so without any fear and inhibition, without any expectation of awards, rewards and incentives and without any strings attached. If you do not have any heart for this rather unconventional programme it will be much better if you remain

away from the programme rather than remaining in the programme for the sake of putting up a façade.

The campaign for total literacy was also to be the nucleating force for launching similar campaigns against a number of other social evils, and at the same time, campaign for several socially and economically worthwhile programmes. To illustrate, a TLC could be the springboard for a campaign against untouchability, campaign for women's equality and empowerment, and against gender discrimination. A TLC could also be a campaign for promoting the small family norm and for protecting and conserving the natural habitat and the environment. A TLC could also be the harbinger of national integration, secularism and communal harmony.

Selectivity was yet another essential principle of the TLC. Selectivity implied adopting the campaign approach where there is a groundswell, where there are several constructive forces of society willing to pledge their solidarity and support to the campaign, and where the possibility of success is much higher. Whatever be the size of the area—be it a village or a *panchayat* or a block or a district—once it was decided to take up the campaign the whole area was to be brought within the ambit of the campaign ensuring the test of universal coverage which means that all persons in a targeted age group were to be covered. If a district was unduly large and had large pockets of illiteracy and backwardness and there was a problem of finding an adequate number of potential volunteers/instructors, the campaign for total literacy in the district could be taken up in several phases instead of taking it up as one unit in one go.

The fallout of the campaign has been positive. There has been a remarkable change in the attitude, approach, perception and insight of the bureaucracy at various levels. Several Collectors and District Magistrates who were remotely connected with the lives of the ordinary people have owned the campaign in their district and in the process have come to identify themselves with the hopes and aspirations of the unlettered masses. The campaign provided them with a unique opportunity to travel across the length and breadth of the district in hot sun, heavy rains and muddy tracts forgetting the normally expected creature comforts, and putting in unremitting hard work of 18 to 20 hours for the cause of literacy. Campaigns for total literacy have led to social, economic and linguistic integration. The potential volunteers/instructors and

learners coming from different strata of society, different faiths and beliefs, come under the roof of a teaching/learning centre where they share their thoughts and ideas, emotions and experiences, promoting better understanding and goodwill and in the process facilitate social and emotional integration. Innovative experiments like *pudupongal* in the Pudukkottai district of Tamil Nadu brought the volunteers and learners together so close that they cooked and shared their food on the day of *pongal* reaching thereby a remarkable level of emotional integration through literacy. There were instances where learners already literate in one language, which is different from the state's standard language, preferred to be literate in the state's standard language and came to attend the literacy classes. This is how the TLC promoted linguistic integration. In the entire campaign women came to play a lead role and wherever women were volunteers in larger numbers they contributed significantly to the success of the campaign largely an account of the sincerity and selfless devotion and dedication with which they worked for the campaign. The campaigns for total literacy promoted and encouraged women's equality and empowerment in a big way. Women became aware, responsive and articulate. They also became critically conscious of their rights and aggressive champions of these rights. The TLC gave birth to what is known as the anti-*arrack* agitation of Andhra Pradesh which started from a Literacy Centre in Dubagunta village of Nellore district and which spread rapidly, almost like a forest fire, through the length and breadth of the state, embracing thousands of women in its fold and making them pledge their total solidarity, commitment and support to liberate their menfolk from addiction to alcohol, which was responsible for the social and economic ruin of their household. Such was the force with which the anti-*arrack* agitation was launched in Andhra Pradesh that it eventually forced the government of the day to go in for total prohibition on 2nd October, 1992. Thus women, through this campaign, forced their husbands and other male members in the family to give up their addiction to liquor through a series of measures including ostracism from the family and village. The impact of the campaign on the lives of women could be clearly seen in the districts of Pusumpan, Muthuramalingam, Thevar and Pudukkottai districts of Tamil Nadu. Women who were confined to the household came out into the open on account of their participation in

literacy campaign; they learned karate for self-defence and cycling for better mobility.

Literacy was woven around economic activities like gem cutting and gem polishing by girls and stone cutting and stone breaking by women in Pudukkottai. TLC in Midnapore demonstrated how a person who was afflicted with the curse of leprosy and who was almost ostracized by the members of the village community could be brought back to the fold of the village due to his untiring devotion and selfless work for literacy. The campaign for total literacy also became a war against fads, taboos, obscurantism and practices like witchcraft, animal sacrifice etc., in several parts of the country, most notably in Tumkur and Bijapur districts of Karnataka and Nizamabad district of Andhra Pradesh. *Devadasis* of Andhra Pradesh and Karnataka started correlating their own plight and predicament to their illiteracy and resolved that they would not allow this to happen to their daughters. Thousands of contract labourers in the steel plant of Durgapur in Burdwan district of West Bengal began to perceive the roots of their plight and predicament in illitaracy and resolved to become literate to put an end to that plight. Members of the ST community in parts of Orissa, Andhra Pradesh, Bihar, Madhya Pradesh and Rajasthan after becoming literate saw the pernicious role of middlemen who had exploited them for years by cheating them both in terms of weight and payment. Thousands of mothers in Midnapore and Burdwan districts of West Bengal carried children in their arms and went to the Office of the *sabhadhipati* of *Zilla Parishad* to demand education as a matter of fundamental human right for their children and to open new schools and appoint new teachers so that all children in the area could have universal and free access to literacy and education. Thus the campaign for total literacy established the truth that adult literacy and universal primary and elementary education are two sides of the same coin; they supplement, complement and reinforce each other.

While these are some of the positive fallouts of the campaign there were negative fallouts as well although neither the campaign approach nor the people who were in charge of the campaign could be faulted for this. In a few states political forces perceived a threat to their own power, from the mass movement for literacy and the mass euphoria associated with it. There were reprisals by way of seizing the primers and other teaching/learning materials

on the grounds that these were spreading sedition and dissension. Nothing could be farther from the truth. In a particular Union Territory the government of the day took exception to a lesson in the primer which showed how poverty had not ended despite a lot of money having gone into poverty eradication programmes, and this unleashed forces which could result in a fear psychosis for the people. There were debates in assemblies of several States/Union Territories through which representatives of the people openly condemned the selfless acts of volunteers on the ground that this was weakening the formal system of primary and elementary education by attracting children to the TLC. Nothing could be more divorced from reality than this.

Some of these could be termed as aberrations. Notwithstanding such aberrations or threat perceptions it can be clearly and convincingly stated that literacy has come to occupy a pride of place in the agenda of national action. There has been a sizeable increase in funding for literacy, an increase in the number of projects, and an increase in the number of potential learners and instructors and of other functionaries. Starting with Ernakulam on 26th January, 1989, the number of TLCs has crossed 400 within a period of eight years. Literacy campaigns have come to stay in the life of the nation as a landmark event and in the lives of the people as an important barometer of their development and advancement. Nobody today doubts or disputes the rationale and validity of the campaign approach for total literacy. Nobody doubts or disputes the achievements which have emerged from the campaign. The very fact that India has received successive UNESCO awards for its outstanding performance in the field of literacy during 1989–92 goes to show that a firm base has been created which can be reinforced and consolidated further but which cannot be weakened by any means.

This by itself does not indicate that we have reached the terminal stage of planning and preparation, far less, of achievement. Even today there are numerous gaps and omissions in the operationalization of the campaign approach. Literate volunteers are not available as instructors, so also the place of learning. All 5.83 lakh villages of India are not electrified and kerosene oil is not easily available at affordable prices. The mission at its initial phase was launched as a Technological Mission for eradication of illiteracy and the findings of scientific and technological research

were to be harnessed for the benefit of the deprived sections of the society. As many as 60 collaborating agencies like the Indian Institute of Petroleum, Dehradun; Indian Petrochemical Corporation, Baroda; National Building Research Centre at Roorkie and a few amongst 42 CSIR laboratories were identified to take up action research, to design, innovate and patent improved lanterns, petromax lights, blackboards, slates, chalks and pencils. Yet, nothing very significant has happened on this front so far. In parts of Rajasthan (desert districts of Barmer, Jaisalmer, Jalore, Sikar, Bikaner and Jodhpur) where one *dhani* is at a distance of at least 5 to 10 kilometres from another; or, in Bastar and Betul districts of MP or Dang and Panchamahal districts of Gujarat, or Santhal Paraganas and Singhbhum regions of Bihar even today one cannot easily come across a single printed word for miles. There is an aura of false consciousness about the value of literacy in a society which is full of cynics and sceptics who spread misinformation about literacy *vis-à-vis* acquiring quick gains through dubious means. Bureaucratic procedures do not make the timely release of funds possible thus thwarting sincere attempts at the grassroots level. Voluntary agencies have not evinced as much interest as they should have in owning the campaign approach as they once owned the traditional centre-based approach in the 1960s, 70s, and 80s. The game of numbers approach which has been responsible for flooding the country with a number of TLC districts has given a jolt to the principle of selectivity which implied that the campaign approach should be implemented only in areas where it is achievable rather selectively instead of spreading it too thin. The very fact that a large number of districts (over 400) have been brought within the ambit of the campaign in a period of eight years (1992–97) has given rise to numerous problems of monitoring, supervision and co-ordination. Differences of perception leading to a loss of high political priority was directly responsible for the failure of the campaign in many parts of the country. Lots of reservations and mistaken notions in the minds of the representatives of the people about the efficacy of the campaign approach continued to be the main stumbling blocks for spreading the campaign approach effectively.

More than anything else, the fragile base of post-literacy and continuing education continues to be a major threat to the success of the campaign approach. It will be incorrect to say that

all learners, regardless of their endowment and level of learning, can acquire complete self-sufficiency in reading, writing and arithmetic within a period of six months of the teaching/learning process. The base which is acquired by them is bound to be fragile and it needs to be sharpened and refined further through exercises in post-literacy and continuing education. This necessitates adoption of the same planned, co-ordinated, and scientific approach as in the case of basic literacy and can be outlined in the following manner:

- Identification of neo-literates.
- Assessment of the level reached by the neo-literates (some would be at the level of primer 1, others at the levels of primers 2 and 3). Some may be at the stage of complete self-sufficiency in reading, writing and arithmetic while some others may be at an incipient stage.
- Identification of volunteers who would be willing to continue at the post-literacy and continuing education stage.
- Designing through workshops a host of supplementary readers and post-literacy materials with the help of SRCs and other NGOs.
- Pre-testing these materials and adjudging their suitability before adoption.
- Organizing orientation and training programmes for post-literacy volunteers after the post-literacy materials have been designed, pre-tested and found suitable.
- Taking up construction of post-literacy and continuing education centres.
- Organizing book donation and book voyage programmes to build up a library service as a movement for new entrants in the Post-Literacy Centres.
- Monitoring the pace and progress of learning.
- Organizing a host of other activities such as *charcha mandals* or group discussions.
- Developing inexpensive newspapers with simple news items with bold print and illustrations for generating interest amongst the neo-literates to know more about themselves and the world around.
- Organizing programmes for skill formation and skill improvement with the help of development functionaries (village level

worker, *anganwadi* workers, sanitation workers, other grassroots level functionaries, school teachers etc.). Such skills would be communication skills, survival skills, vocational skills, entrepreneurial and managerial skills etc.

- Mainstreaming of neo-literates with the formal system of education after establishing a proper level of equivalence for them.

No authentic data is available to date regarding the number of adults who have been deprived of access to educational opportunity and who, therefore, continue to be illiterate. We have, according to the 1991 census, a total number of 297 million children in the 0–14 age group. Every year 21 million children are being born, 8 million children die and 13 million children survive. In other words, between 1991 and 1997 we would have added $13 \times 6 = 78$ million children. The total number of children in the 0–14 age group at the beginning of 1998, therefore, would be $297 + 78 = 375$ million. The number of children in the 5–14 age group is 203 million according to the 1991 census. Taking the number of children in this age group as two-third of the total number of children we can safely add 203 million + 52 million or 255 million children in the beginning of 1998 in the school going age group. According to the findings of the 6th Education Survey about 120 million children are in the formal and non-formal school system. In other words, nearly 130 million children would be outside the school system. It is not known as to what such a large number of children would be doing, i.e., whether they would be sitting idle at home or they will be supporting their parents or they will be doing some work in agricultural and allied occupations as a part of household occupations for which they may not be receiving wages. It is evident, therefore, that these children will soon cross the threshold of childhood and will enter adulthood. It may be safe, therefore, to put the total number of adults who have been deprived of the access to educational opportunity somewhere between 100 to 150 million. (Such a wide range has been kept as no precise estimate is available about the number of children who may be dying after entering adulthood i.e., after crossing 14.) This is a formidable number and by no stretch of imagination can we push them to the wayside. They are not responsible for being deprived of access to educational opportunity. When they were of

school going age, they were sent to work by their parents (either wage employment or non-wage employment) and this has been corroborated by successive studies conducted by the institutes of social science research. In other words, it is not these adults alone but the whole society and the State which must own full responsibility for educational deprivation of such a large number of adults. This must be acknowledged as a criminal negligence on the part of the society and the State. Where do these adults go when they do not have access to literacy? What will their position be in history? How do they enter the 21st century without minimal skills in reading, writing and arithmetic? How do they encounter and overcome numerous organized onslaughts that would undermine their effectiveness? Are they aware of their own strength and weaknesses? Are they aware of the strength and weaknesses of the forces around them which may often be hostile to them? Can literacy provide the wherewithal for their empowerment so that they can stand up and face the odds and onslaughts of life with strength, courage and confidence? If so, why not make them literate? If the campaign approach has turned out to be the most inexpensive or time bound and result oriented why not adopt the same, particularly when its efficacy has been proven beyond doubt?

IN RETROSPECT AND PROSPECT

The National Literacy Mission was launched on 5th March 1988 by Rajiv Gandhi, the former Prime Minister of India. The National Literacy Mission Authority was formed subsequently. The Governing Council of the NLMA was intended primarily to enlist the solidarity and support of all national level political parties and all sections of society and to lay down broad directions on policy matters relating to adult literacy. The Executive Committee of the NLMA was, however, vested with the following mandate:

- Identifying districts on the basis of preliminary surveys and positive feed back from a variety of sources on the possibility of launching a TLC.
- Deputation of pre-appraisal mission(s) to the districts to study and ascertain if the ground swell necessary for the success of TLC exists.

- Assist the *Zilla Saksharata Samitis* in formulation of the project proposal with the help of the pre-appraisal mission.
- Consideration of the project proposal in the Executive Committee of the NLMA by inviting the Collector to make a detailed presentation of the salient features of the proposal before according its approval.
- Deputation of teams of officers to visit the district to assist the *Zilla Saksharata Samiti* to implement the TLC, sanctioning and releasing of funds, arranging evaluation of the content, process and impact of the project by the deputation of external evaluation teams for both mid-course correction, if necessary, as also for consolidation of the gains achieved.
- Consideration and approval of the proposal for post-literacy and continuing education programmes after successful completion of the first phase of the TLC.

It was natural and inevitable that the Executive Committee of the NLMA would be meeting at regular intervals to discharge this important mandate on a continuous basis keeping in view the principle of selectivity and the principles on the basis of which the TLC should normally be launched and implemented. Of late, however, the procedure for the deputation of pre-appraisal missions has been dispensed with and the project proposals received from *Zilla Saksharata Samitis* are being considered straightaway. This arrangement has been evolved in a bid to enlarge the ambit of TLC and with a view to covering as many districts in as short a time as possible. This was, however, not the original intention. If we spread TLCs too thin it is quite likely that the limited resources—human, material and financial, would be frittered away and the desired impact may not be achieved. The resource crunch will be obvious in our bid to bring down the fiscal deficit by reducing public expenditure in a liberalized regime. Besides, opening up the flood gates in a campaign approach is bound to be counterproductive in monitoring, supervision and co-ordination. This number oriented approach has been one of the major weaknesses inhibiting the programme. Second, post-literacy and continuing education has not received the type of primacy in the wake of successful conclusion of TLCs in certain districts as expected. Post-literacy and continuing education has

to be as much a structured, and well supervised programme as the TLC and is required to be implemented in the same voluntary and campaign mode as the TLC. This has not happened to a large extent. Wherever there has been a gap between the date of successful completion of TLC and the date of launching of post-literacy and continuing education programmes it is quite likely that a large number of neo-literates who were on the threshold level of literacy would have reverted to illiteracy. This has happened in a number of cases. Third, the campaign for total literacy is essentially intended to be for a short duration of time. If it is spread over a long period of time, as is evident in some of the large districts where the programme is on for several years, it is likely to become a test of human patience, fortitude and physical stamina. In such a situation volunteers may not be willing to work as volunteers for a very long period as it is quite likely that many of these volunteers would like to seek alternate avenues of employment. At the same time it will not be desirable to dilute the voluntary character of the campaign and introduce a system of payment which will impart a cash commercial character to the campaign and will completely dilute or destroy its essence which rests on voluntarism. In such a situation it is much better to proceed in a systematic manner in areas where chances of success in the TLC under the leadership of *Zilla Saksharata Samitis* are bright, to be followed by programmes of adult literacy and education in other areas through voluntary agencies and social action groups. These voluntary agencies and social action groups also need to be persuaded to take up such campaigns for total literacy in the same voluntary mode as under the auspices of the *Zilla Saksharata Samiti*. In other words, instead of adopting TLC as the only model it is possible to work out alternative strategies to be implemented by voluntary agencies and social action groups without diluting the basic campaign character. Fourth, while environment building is extremely important in a campaign it is quite likely that the desired results may not be achieved through short duration environment building exercises which are undertaken in one go. It is necessary and desirable to make this open ended and take the help of a variety of agencies and missions. In other words, environment building exercises need to be repeated over and over again in a particular area till the churning of critical consciousness of all sections of the society

in favour of the TLC has been fully accomplished. For this purpose the Department of Education, Ministry of Human Resource Development, Ministry of Information and Broadcasting, Song and Drama Division, Field Publicity units etc., need to work in much closer collaboration and co-ordination right from selection of the agency to the preparation of software, transmission, audience research and so on. Fifth, it is quite likely that despite the cascading character of training, training of instructors might not have been very effective and there may be several deficiencies in the teaching/learning process as a result of weak training. The dropping out of adult learners could be the inevitable fallout of weak and deficient training which may make the teaching-learning process dull, de-motivating and unexciting. Sixth, a number of important observations and conclusions have emanated from successive evaluation studies conducted by institutes of social science research on the content, impact and importance of TLC. These need to be given due weight and their recommendations need to be implemented with due urgency and seriousness. Seventh, numerous agencies and individuals are involved in a TLC. The contribution of one participant at one level, howsoever modest, is as important as the other. It is necessary and desirable, therefore, to evolve a scheme through which good, qualitative and constructive work of individuals and groups made for the TLC can be recognized and public recognition through letters of appreciation, mementos and certificates can be given. Similarly, villages, *panchayats*, blocks and districts which have given a genuinely good account of themselves can be suitably rewarded for their outstanding contribution by launching special development projects in these areas. Eighth, even though there are a lot of achievements of a TLC, there may be cynics and sceptics who may be spreading rumours or carrying on canards against the campaigners or volunteers. These need to be countered through both electronic and print media so that the central message behind the TLC is transmitted in the right manner by countering false propaganda. Ninth, orientation and sensitization programmes need to be conducted for representatives of the people (MPs, MLAs and MLCs, Municipal Councillors, representatives of *Panchayats*), policy formulators, opinion moulders and government functionaries so that all of them develop positive perceptions about literacy. Lastly, there is a need for continuous interaction and sharing of ideas, information, and

experiences amongst the TLC districts so that the success stories are allowed to be replicated while timely correctives are adopted to remove gaps and omissions and bring about qualitative change and improvement in one district by learning from the experience of another.

THE KERALA EXPERIENCE IN MASS LITERACY

P. K. Ravindran

INTRODUCTION

The Ernakulam district in Kerala was declared the first totally literate district in the country on 4th February 1990. This declaration marked the successful completion of a peoples' experiment aimed at evolving a novel model for mass literacy. This model, successfully field tested in Ernakulam, was adopted for implementation in the remaining districts of Kerala by the Kerala Saksharatha Samithi and the people of Kerala. Within the next year the effectiveness of the campaign model for mass literacy was established beyond doubt. The Kerala experience was responsible for bringing illiteracy eradication back onto the national agenda. The people's science movement of Kerala, known as the KSSP was honoured by the United Nations, with the King Sejong award for literacy for its leading role in this historic experiment.

The book, *National Literacy Campaigns: Historical and Comparative Perspectives* edited by Robert Arnor and Harvey Graff (Plenum press, New York, 1987) gives a critical overview of the various literacy campaigns that have taken place during the past three to four centuries in several countries like Germany, Scotland, Sweden, USA, Russia, China, Cuba, Tanzania, Nicaragua, etc. It also contains an analysis of the Indian experience which includes the description of the National Adult Education Programme (NAEP) by H.S. Bhola. The NAEP was visualized by its formulators as a means to bring about a fundamental change in the process of

socio-economic development; from a situation in which the poor remain passive spectators at the fringe of developmental activity to being enabled to be at its centre and as active participants. The emphasis of the learning process is on literacy but also stresses the importance of functional upgradation and of raising the aware-ness levels. This is a radical and revolutionary way of looking at adult literacy. Education and literacy can be used not only to preserve the existing structures and establishments but also to change them.

For 30 years since our independence the rulers did not find adult education important enough to be taken up as a programme. It was hoped that adult illiteracy would be eliminated in a span of one generation or two by the universalization of elementary education. However, neither of these visions materialized. The launching of NAEP in 1978 was thus a step of historic importance. The manifesto of NAEP was radical and out-spoken. It proclaimed that literacy is a political act, that it is not merely knowing the word but also knowing the world, that literacy and poverty are two sides of the same coin, and that to become literate means to become aware of the reasons of one's own poverty. The experi-ence of the initial decade of NAEP shows how difficult it is to generate and maintain an ideological commitment which is counter to the interests of the ruling class. The dangerous ideological contents were removed and the campaign spirit was killed by the Government in 1980.

1988 saw the third incarnation of the literacy programme as the National Literacy Mission (NLM). The formulators of the mission were well aware of the weaknesses of both the NAEP and the Adult Education Programme (AEP). There was no political commitment. There was no force to make it a people's programme or mass campaign. It was called 'Adult Education Programme' and not literacy campaign. Many people do not accept a campaign mode for literacy promotion. Another group was of the view that literacy campaigns cannot succeed in India because no revolution has taken place or is taking place in India.

INTERVENTION OF THE PEOPLE'S SCIENCE MOVEMENT

Though the NLM had acknowledged the weaknesses of the NAEP and AEP the NLM programme of action had nothing new to counter these weaknesses. Neither eradication of illiteracy nor

universalization of elementary education was on the priority agenda of the major political parties. The models available with the NLM were the 'each one teach one' and other such centre-based models. The bulk of the centres were run under the Adult Farmers' Literacy Programme (AFLP) or State Adult Education Programme (SAEP)... all bureaucratic programmes with no social involvement.

It was under these circumstances that the KSSP and other people's science movements (PSMs) became associated with the NLM. The people's science movements were of the opinion, like Paulo Freire, that literacy is liberative. PSMs are committed to inverting the power structure which perpetuates injustice and inequality. A new political understanding is required, based on genuine participative democracy. The most important element is to make each and every citizen aware of their predicament, that she/he has to liberate herself/himself (since there are no liberators) and that she/he has to acquire capabilities and establish an organization for doing this. PSMs conceived science communication in the early stages, and mass literacy campaigns later, with the above objectives in mind.

The absence of a revolutionary situation and the consequent rigidity of the people were sought to be compensated for by the following:

a. mounting a massive environment creation campaign,
b. arousing local, regional, and national patriotism,
c. giving a leading role to a task oriented people's organization at national, state, and other levels down to the village hamlet,
d. giving a people's face to the bureaucracy, and
e. setting up an efficient 'head quarters' — a control room for meeting and consciously planning every detail, as in a war, well in advance.

THE ERNAKULAM CAMPAIGN

The Ernakulam literacy campaign was the first experiment based on the above premise. The campaign had the Kerala Sastra Sahitya Parishad (KSSP) as the lead people's organization, Ernakulam had a collector who himself is a life member of the KSSP and was previously its Vice President, its literacy rate was already fairly high, and it had strong progressive and radical political forces. All

the facts were favourable. Yet, it could have failed but for certain cardinal features, which were later to become features of all other successful campaigns. They were:

a. The campaign was conceived as a Societal Mission. Instructors, master trainers and resource persons were not paid anything. They worked because they enjoyed it and they felt it to be their duty,

b. Close co-operation between NGOs and the administrative machinery resulting in a considerable degree of de-bureaucratization and transparency,

c. Institution of a three-legged implementation machinery namely, the administration, people's committees at all levels and a 24-hour project office with the necessary number of full-time personnel, and

d. Massive propaganda including house to house visits, several times to generate awareness and motivate learners.

Finally the forum which evolved in Ernakulam was a 'team' with a crusading district collector leading it and with close lieutenants drawn from the non-governmental sector as well as the governmental sector. Many of these 'NGO lieutenants' were in fact government servants but they were taken on deputation to the KSSP and had become temporarily 'free citizens'. They were not hierarchically controlled by the collector, but had equal footing in the specially formed district literacy commitees. The Ernakulam experiment was successful in making all sceptics silent. More than the necessary number of volunteers came forward and more than 75 per cent of the identified illiterates attained literacy (see Table 1):

Table 1: Ernakulam campaign statistics

Age group covered	6 to 60
No. of illiterate people identified	1,74,000
No. of people who became literate	1,35,000
No. of voluntary workers involved	21,200
Date of launching the campaign	26th January 1989
Date of declaration	4th February 1990
Average literacy rate at completion of the project	96.5%

Even before the Ernakulam campaign came to a close, similar campaigns were started in Pondicherry and in South Kanara and Bijapur districts of Karnataka State. Pondicherry had a reputed NGO, the Pondicherry Science Forum, that took on the active role played by the KSSP in Ernakulam, whereas, South Kanara and Bijapur did not have similar organizations. The authorities felt that they could either build up such a grassroots level people's organization or even go without it. In South Kanara they succeeded to some extent to excite the people and the campaign was somewhat successful. But, in Bijapur the authorities did not succeed.

KERALA AND BEYOND

On 4 February 1990, along with the conclusion of the Ernakulam campaign, Total Literacy Campaigns were launched in the remaining 13 districts of Kerala. The State Government, with its commitment to the cause, was aware of the importance of people's participation. The KSSP, an autonomous body to which the campaign was entrusted was able to provide a good number of its activists bitten by the literacy bug to manage the round-the-clock project offices. KSSP was also able to lead the people's level committees down to the village level. Nearly 2.5 lakh voluntary workers helped more than 70 per cent of the identified illiterate people become literate in the span of one year (see Table 2) and Kerala became the first totally literate state in India, with a literacy rate of over 90 per cent.

Table 2: Kerala campaign statistics

Age group covered	6 to 60
No. of districts involved	13
No. of illiterate people identified	22,80,000
Attainment rate	70%
No. of voluntary workers involved	2,50,000
Date of launching the campaign	4th February 1990
Date of declaration	18th April 1991
Average literacy rate at completion of the project	91.6%

The role played by KSSP in Kerala and PSF in Pondicherry is being played by Bharat Gyan Vigyan Samiti (BGVS) in most of the

states today. More than 400 districts have carried out total literacy campaigns or are doing so. However, the model has degenerated a lot. Once the mass campaign model was accepted by the Government of India and the Central Advisory Board of Education (CABE) as the dominant mode it became 'official'. A people's programme with bureaucracy playing only a supportive role has degenerated into a purely bureaucratic operation and the failure rate is alarming.

But the fact that more than 8 million volunteers and 80 million learners were mobilized is not a small thing. The quality of literacy achievement may be poor, but the awareness content is considerable. This has taken various forms. Indications of local level power shifts—if not inversions—are visible in some parts, especially in the people's plan campaign in Kerala. KSSP is consciously attempting to convert the people's plan campaign into a movement for establishing genuine decentralized participative democracy based on *grama sabhas* and neighbourhood committees.

8

EVALUATING THE SOCIAL IMPACT OF LITERACY: SOME LESSONS FROM THE LITERACY CAMPAIGN IN NELLORE

Duggirala Vasanta, Sonya Gupta, and P. Devi

INTRODUCTION

> 'I can write letters to my son who is working in the city'
> 'I pull up the grocer if he dares to cheat me now'
> 'What is the use of teaching us about immunization when there are no doctors to vaccinate our children?'
> 'Why instruct us to use clean water if the tube wells in the village do not work?'

These were the responses some neo-literate adults gave to the evaluator who was looking for qualitative information to assess the social impact of literacy among the predominantly tribal population in three different districts of West Bengal (see Banerjee, 1992). Impact evaluation studies underscore the relevance (to literacy evaluation) of qualitative information such as (1) the employment background of the voluntary teachers involved in the literacy campaign (e.g., how many of them had experience of working as *anganwadi* workers), (2) whether there were any social/political movements in the area covered by the literacy campaign, (3) whether the government officials actively involved in the literacy campaign had been transferred, if so, how often?

(4) whether there was any demand from the learners for primers written in the local dialects, (5) how many loan applications had the district administration received from the neo-literates since the literacy campaign has ended, (6) had there been any significant developmental activity (e.g., laying of new roads, construction of new school buildings, improved bus services etc.) in the area covered by the literacy campaign, (7) whether the literacy campaign was interrupted by elections, floods and other such natural calamities, and (8) whether there was a significant increase in the number of children immunized and/or enrolled in primary schools, in the area covered by the literacy campaign.

Commenting on the relevance of such information, Banerjee (1992: 449) stated that 'it is this long-term impact rather than the immediate aim of functional literacy that one expects from the National Literacy Mission's (NLM) ambitious programmes'.

The Ministry of Human Resource Development (MHRD) appointed an expert group (henceforth Arun Ghosh Committee) to look into the progress, problems, and evaluation of the Total Literacy Campaigns (TLC) initiated by the National Literacy Mission (NLM). A report of this committee, published in 1994, also stressed the need for literacy evaluation to go beyond the percentage of success or failure to mention the social impact of literacy. Towards this end, the committee had suggested many measures including, abolition of the concept of total literacy; measuring the rate of change of literacy rather than the Minimum Levels of Learning (MLL) originally proposed by the National Council of Educational Research and Training (NCERT) and adopted by the NLM for mass literacy programmes; use of different textbooks and pedagogic approaches to different age groups of learners; organization of mobile eye camps and provision of reading glasses to deserving adult neo-literates; better co-ordination between the state-run primary education programmes and the TLCs.

Yet, a majority of the external evaluation reports declare the results in terms of graded levels (in percentages) of literacy attainment with respect to reading, writing and arithmetic skills (see for instance, Krishnamurti and Ramabrahmam, 1995, with respect to literacy campaigns in Chittoor and Nizamabad districts of Andhra Pradesh). While some of these reports do contain descriptions of the *Kalajathas* (cultural programmes to spread the message of literacy) conducted during the environment building phase that

precedes the teaching/learning phase, they seem to hold little, if any, relevance to the assessment or reporting of the literacy outcomes. A majority of the evaluation reports concentrate only on the final test results pertaining to the acquisition of the 3Rs by the learners in a randomly selected sample to declare the success or failure of a literacy campaign in a given district. It appears that the goal of many such NLM-guided evaluations is to generate statistics of literate/illiterate populations according to age, gender, caste, occupation, and other such variables in a selected geographical location so that strategies can be evolved to reach the ultimate target—a fully literate India by the year 2005 (NLM document 1).

This does not however mean that the NLM has not recognized the importance of recording qualitative changes in the lives of the neo-literates, although the manner in which such information gets incorporated into the assessment, we feel is problematic. For instance, Krishnamurti (1998) cited an NLM document pertaining to a study conducted by the Centre for Media studies, New Delhi. The researchers took a sample of 1,068 neo-literates (treatment group) and 601 non-literates (control group) from three districts of Bilaspur (M.P), Birbhum (West Bengal) and Dumka (Bihar). The aim of this study was to see if there was a change in the thinking and lifestyle of neo-literates as opposed to non-literates. The results of this study reportedly revealed that the neo-literates in all the three districts have (1) a positive attitude on the education of their children as revealed by higher enrollment in schools, (2) less gender disparity among themselves, (3) a better knowledge of health, hygiene and family planning, (4) given up some of their earlier habits such as drinking etc., and (5) improved skills which will fetch them employment.

Confining the discourses of literacy to the acquisition of the basic skills of reading, writing and numeracy, imparting these skills in a hurry within a short period of six to nine months, and yet expecting the learners to gain a positive attitude to overcome all real-life problems with the help of newly acquired 'literacy skills' is a mockery of the term 'literacy'. We go along with Agnihotri (1994: 53) who (in the context of describing a campaign-based mass literacy programme in Ambedkar Nagar colony, located in the suburbs of Delhi) asserted: 'the whole enterprise of literacy needs to be located in a struggle to eliminate the problems which

those in power have created for the powerless'. In the case of Ambedkar Nagar, the problems were restricted milk supply, lack of sanitation, irregular water supply, inadequate drainage and poor medical facilities. In a context like this, how can attaining level-3 literacy (highest on a four-point scale and defined as 60 per cent marks in the three components and 80 per cent in aggregate) help the learner cope with these problems? What difference does the success and/or failure rate make to the lives of these people?

Many other researchers the world over have reiterated the fact that higher levels of 'functional literacy' does not necessarily lead to better socio-economic development nor does it contribute to greater awareness about one's own rights. As pointed out by the members of the Arun Ghosh Committee it is not the backwardness of the learners that is responsible for the backwardness of the country's socio-economic development, but more the other way around. Literacy defined in a narrow sense of learning the 3Rs and measured against the NLM prescribed norms is of no use to any one. There is an urgent need to debate the methods of assessing the social impact of literacy training on people in different communities, which of course calls for an informed debate on what 'literacy' or 'evaluation' means. In this paper, we would like to make two main arguments: one, that the question of measuring the social impact of literacy is necessarily tied up with the way one defines the term, 'literacy', and two, that we need to engage in a radical rethinking of the current evaluation methods used in 'measuring' literacy outcomes. In the first part of the paper we will critique NLM's definition of (functional) literacy and re-examine its guidelines for assessment in the light of some new research findings pertaining to evaluation theory. In the latter part of the paper, we will examine the literacy campaign and the anti-*arrack* agitations that took place in Nellore district in the state of Andhra Pradesh during the period 1990–91 with a view to delineate the implications of the lessons learned from these movements for conducting impact evaluation studies of literacy.

DEFINING AND ASSESSING LITERACY

The way one uses the term literacy is influenced by one's ideology about one's culture, one's language and the concept of Nation (and of citizenship) as well. To quote Auerback (1992: 71):

'There can be no disinterested, objective and value-free definition of literacy. The way literacy is viewed and taught is always and inevitably ideological. All theories of literacy and all literacy pedagogies are framed in systems of values and beliefs which imply particular views of the social order and use literacy to position people socially'.

Krishna Kumar (1994) clarifies this point further in his article titled, 'Battle against their own minds' referring to the title chosen for a cassette produced by the *Kerala Saksharatha Samithi* (KSS) to popularize the tribal literacy programme (funded by the NLM) in Kerala. Apparently, the tribal population has posed a special challenge to the literacy drive in Kerala, even while the state of Kerala is supposedly totally literate by NLM standards. In December 1993, the NLM reportedly issued some advertisements in newspapers on the occasion of the 'Education for All' summit held in New Delhi. This time, the slogan was in sharp contrast to the one used by KSS — 'People have a right to their own minds'! After commenting on the state of the 'tribal literacy' programmes in Kerala, Krishna Kumar stated that the literacy programmes are not really concerned about teaching reading; they have a deeper ulterior motive, which is to acculturate the illiterate. It must be noted that reading the alphabet, writing one's name and counting to hundred may be sufficient to become 'literate' if you come from marginalized sections of the society. But an Indian 'citizen' is considered to be genuinely literate by the State only if he (and she?) can read the 'classics', the constitution and the daily newspapers. It is only that citizen who can contest the elections. What proportion of our population is genuinely literate and is it at all possible to achieve 'Total Literacy' of this kind? To understand the ideology behind the mass literacy campaigns planned by the NLM one need only to look at NLM's definition of literacy.

The NLM defines literacy as the achievement of reading, writing and numeracy skills of pre-determined (minimum) levels. The goal of literacy programmes however is said to go beyond the achievement of self-reliance in the 3Rs to 'functional literacy', which refers to the learner's ability to participate in the development process, skill development to improve one's economic

status, imbibing values of national integration, conservation of the environment, women's equality and observance of small family norms etc. (see NLM document 2) The NLM has been attempting to reach these objectives through (1) creating an environment conducive to the teaching/learning process by providing good instructional materials and training the volunteers in using the Improved Pace and Content of Learning (IPCL) and Word Method of Teaching (WMT), (2) building up the confidence of the learners about their potential to learn, (3) integrating basic literacy with Post Literacy (PL) and Continuing Education (CE), and (4) organizing orientation courses to develop the quality of human resources at all levels (see NLM document 3). The time frame for all these activities is approximately one year; about three months for environment building and six to nine months for actual teaching/learning in the night schools.

As per the guidelines for evaluation, NLM has specified the literacy norms for reading, writing and numeracy and provided specific guidelines for evaluation under each of these three areas: for example, NLM competency R(a) is defined as 'reading aloud with normal accent [a] simple passage on a topic related to the interest of the learners at a speed of 30 words per minute'; NLM competency R(b) is defined as 'reading silently small paragraphs in simple language at a speed of 35 words per minute'; NLM competency R(c) is 'reading with understanding road signs, posters, simple instructions and newspapers for neo-literates'; NLM competency R(d) is the 'ability to follow simple written messages relating to one's working and living environment'; NLM competency W(a) is 'copying with understanding at a speed of seven words per minute'; NLM competency W(b) is 'taking dictation at a speed of five words per minute' and so on (for other details see NLM document 4).

Let us turn to the evaluation system set up by the NLM. There are three kinds of evaluations, viz., self-evaluation, concurrent evaluation and summative evaluation. Self-evaluation of learning outcomes has been built into the body of the three primers. Each primer contains three tests pertaining to reading, writing and numeracy skills. The concurrent evaluation is to be carried out by agencies within the state and the summative evaluation is to be carried out by agencies outside the state. The concurrent evaluation focuses on various activities in the process of implementation

of the programme such as survey, environment building, training etc., but the forms and protocols prescribed are so elaborate that there is a scope for mis-reporting (see NLM document 5). Summative evaluation is aimed at assessing learning outcomes, evaluating the success rate *vis-à-vis* the target population and the impact of the campaign on the social, cultural and economic environment of the project area. The purpose of these broad definitions, however are, defeated by the stated literacy norms under the headings; reading, writing and numeracy mentioned above, which guide the blueprint of the final test.

The gap between the NLM's aim of eventually turning India into a fully literate State so that all the citizens can take part in the development process, and the manner in which 'literacy' is being imparted and assessed is so wide that the Arun Ghosh committee (1994) recommended doing away with the concept of 'total literacy' so that there is no risk of the figures being fudged. Literacy theorists coming from different disciplines have also critiqued the concept of Total (Universal) literacy. For instance, Miller (1988: 1294) aptly pointed out that it is meaningless to talk about universal literacy or even functional literacy, for the criterion keeps shifting such that 'as technology advances, so does the definition of 'literate'. To illustrate, in 1975, the US census bureau used the criterion of six years of schooling for defining Universal literacy, but today, USA has a huge semi-literate underclass that is expected to grow at a phenomenal rate. Therefore, for the USA, it was proposed that a meaningful national goal should be attainment of twelfth grade literacy by all adults. Yet, the report submitted by the National Assessment of Educational Progress (NAEP) and Educational Testing Service in (ETS) 1986 revealed that only 56.4 per cent of young adults in the USA meet this criterion. Thus the extent of semi-literacy in a given society can be anything one likes, depending on how one defines literacy. Further, universal literacy will always remain an unmet challenge for all nations at all times because it is an unattainable goal. It is unattainable because literacy is linked to much more complex problems in a given society—social, economic, educational, and employment problems among several others. There is an urgent need therefore, to rethink literacy programmes—we need to rethink fundamental concepts, not just

make minor changes to the content of the literacy primers or introduce new teaching techniques.

Reconceptualizing 'Literacy'

The term 'literacy' is one of the most semantically saturated terms and it has carried different meanings in different times and different contexts. A select list of these meanings have been compiled and included in the appendix to this paper, primarily to underscore the point that the commonly used term, 'functional literacy' is of no relevance to the lives of a majority of the learners in our context because they are not likely to encounter the conditions in which their newly acquired skills can be put to use. The modified definition of functional literacy given by Wells (1991, cited in Verhoeven, 1994) — being able to cope with the demands of everyday life that involve written language also entails a limited control of literacy practices and in any case, NLM is not defining or using the term functional literacy in this sense.

A close examination of the various definitions and the contexts in which the term 'literacy' acquires widely differing meanings (see appendix) suggests that it is not advisable to continue to treat 'literacy' either as a given 'state', or a 'skill' or an 'action'. Instead, as suggested by Langer (1988) we need to rethink the concept, 'literacy' as something that incorporates all these three dimensions; something whose meaning is given by the learners and not the instructors (or the funding agencies or the evaluators); something which makes the learners use their language (i.e., their dialect not the standard language of the text books) to bring about socio-political and economic transformation of their society in the way they have envisaged it; something which treats the learners as subjects and not the objects of literacy instruction; something that assumes that knowledge production is a part of the pedagogic encounter between the teachers and the taught, rather than assuming that knowledge exists in the head of the educator/teacher.

It is necessary therefore that we abandon the NLM's definition of functional literacy and think of a new definition that draws from the meanings of the terms, action literacy, critical literacy, emancipatory literacy, local or community literacy, proper literacy and reflection literacy (see appendix to this paper for a detailed discussion of each of these terms and the context in which they

were used). Of course, the task ahead of us is not to put together yet another definition with a different choice of words. We need to do a lot of empirical work before we can define literacy in our context. We need to listen to people; ask them what literacy means to them in their communities, and exchange notes gathered from different parts of the country. In other words, we need to engage in a kind of ethnographic fieldwork that results in the compilation of stories and not just numbers. We also need to ask ourselves whether it is at all necessary to set up a dichotomy between literacy and education (see Agnihotri in this volume) and about the artificial boundary that has been set up between literacy and Post Literacy (PL).

Of course, such learner-centred definitions will necessarily call for alternative methods of evaluation which also draw on qualitative information to decide the actual outcomes of a literacy programme and its long-term impact on a given society. For this, we need to look at recent research from many different disciplines that have a bearing on the notion of literacy.

RETHINKING ASSESSMENT OF LITERACY

Much of the traditional evaluation research focuses on the construction and use of evaluations by those who govern the lives of others, as for example, the State sets out a testing programme for schools by defining what is to be evaluated and how it is to be evaluated (Levin, 1996). Traditional (evaluation) methods place little, if any, emphasis on whether the capacities of those studied are enhanced by the inquiry. Further, the goal of traditional evaluation is systematic investigation of the worth or merit of an object. By contrast, *empowerment evaluation* uses evaluation concepts and methods to promote the self-determination of the people (Fetterman, 1994). It requires that the design, implementation, and use of evaluations, incorporate the input of those who will be affected by the consequences of their use. ·

Empowerment evaluation, which has its roots in community psychology and action anthropology has been put into practice in the last decade by researchers and activists involved in school education of high-risk children, special education programmes for the disabled; feminism (e.g., management of battered women's homes), women's studies programmes, community health

initiatives and a variety of social programmes initiated by the American Government (see Fetterman, Kaftarian and Wandersman, 1996). It draws on the theory of empowerment (Zimmerman and Rappaport, 1988) that makes a distinction between empowerment processes and empowerment outcomes.

> 'Empowerment processes are ones in which attempts to gain control, obtain needed resources, and critically understand one's social environment are fundamental. Empowering processes for individuals might include organizational or community involvement; empowering processes at the organizational level might include shared leadership and decision-making and empowering processes at the community level might include accessible government, media and other community resources. Empowered outcomes on the other hand refer to operationalization of empowerment so that we can study the consequences of citizens' attempts to gain greater control in their community or the effects of interventions designed to empower the participants...' (Zimmerman cited in Fetterman et al., 1996: 4).

For prospects for self-determination (index of empowerment) to increase, one's capacity must increase. More importantly, the opportunity must become favourable and a person must engage in that opportunity. What is measured within this new concept of *empowerment evaluation* then is not limited to measures of individual capacity, but also measures of optimalities of social opportunity with respect to an individual's capacity and measures of the individual's engagement of opportunities for self-determined ends.

At the organizational level, *empowerment evaluation* is a powerful tool that helps participants in an organization connect their needs, interests, and abilities with the means and ends that define the organization's activities and purpose. At the societal and cultural level, it is implicated in a process that determines the extent to which all members of a society have a fair chance of pursuing those self-determined ends in life that are most fulfilling. The basic philosophy underlying this approach is acknowledgement of the simple but often neglected facts; that merit and worth are not static values, that populations shift, goals shift, knowledge about programme practices and their value changes and that

external forces acting on the programme are highly unstable. To accommodate these shifts, one must find ways of institutionalizing self-evaluation processes and practices. Participants will have to learn to continually assess their progress towards self-determined goals and plan strategies. However, Fetterman insists that *empowerment evaluation* and traditional evaluation are not mutually exclusive and that *empowerment evaluation* is capable of producing rich data that enables a more comprehensive external evaluation. It is outside the scope of this paper to outline the actual steps involved in conducting an *empowerment evaluation* at any of the three levels—individual, organizational or societal—especially with respect to literacy programmes.

However, in the next section we will first describe the literacy programme and the anti-*arrack* agitation in Nellore district and then attempt to analyze the outcome of these movements in the light of the theoretical discussions about defining and assessing literacy included in this section.

THE LITERACY AND ANTI-*ARRACK* MOVEMENTS IN NELLORE

In October 1990, the NLM adopted a campaign approach in the coastal district of Nellore in Andhra Pradesh. A number of *Akshara Kala Jathas* were organized to prepare the ground for teaching the 'illiterates' in the night schools and to motivate the literate people to enlist as volunteer-teachers. Nearly 800 artists were drawn from all over the district, predominantly from rural areas who could perform using the local idiom and the dialects familiar to the village folk. These artists conducted street plays, sang songs and acted in the dance dramas all designed by the Nellore district unit of the *Bharat Gyana Vigyana Samithi* (BGVS), registered on 28th August 1990. The themes of these art-forms pertained mainly to problems faced especially by the illiterates such as low wages, untouchability, dowry, heavy drinking, and wife-beating. But there were other themes too, reiterating what literacy can do. A free translation of a couple of poems is given below:

1. You will learn how to put your thoughts on paper
 without opening your mouth
 You will learn how to read something private
 without letting others know...

2. You will know how the day is different
 from the night
 what causes the rain
 between thunder and lightning?
 You will know how things are made—
 the hammer on your shoulder
 how the kerosene stove works
 how to make the wick of the lantern
 and the incense stick you light for the Goddess
 You will know how the red-bus works
 and the wheels of the bicycle
 the pick-axe you use...

 Don't be afraid of education, it is like dawn
 when you can see the whole world
 It is like the smile of a new-born baby
 It is like a tree laden with flowers and fruits
 come, come to the night school and learn.

 —From BGVS booklet, *Caduwu Velugu*

Initially, these *jathas* drew young boys in the age range of 16–25 years. The activists working with the Andhra Pradesh *Jana Vignana Vedika* (APJVV) and the Nellore branch of the BGVS coaxed the boys to bring into the *jatha* young women from the families they knew. Eventually, there were 439 men and 64 young women in the age range 15–30 years who came forward and toured around the district for several weeks. These women who were not trained artists, who had never left their homes, suddenly found themselves singing and dancing and living with a newly formed community of artists, a majority of whom were males. These women found themselves in a situation where they could have as much food as the men (and did not have to eat what is left over); they learnt that they had as much physical stamina as the men to put up the performances and ride bicycles, they could sit late into the nights, sing and dance. At the end of the *jatha* and several hundred performances, commented an activist belonging to the APJVV, 'these women were transformed in ways that no assessment can ever capture'. It was no wonder that many of them became the volunteer-teachers in the night-schools later. For a detailed account of this phase of the Nellore campaign see Malyadri's report.

The literacy rate of Nellore district at the time when the campaign was launched in January 1991 was 49.06 per cent as against the national average of 52.11 per cent and state average of 45.11 per cent. The 46 mandals of the district with 4.5 lakh (450,000) illiterate people needed at least 45,000 volunteers to teach in the night schools. As with the other campaign-based literacy programmes, a large number of women were drawn into the campaigns who served as learners, volunteer-instructors and grassroots organizers. The *Kala Jathas* were so effective that about 55,000 volunteers had reportedly registered their names. Each village had many schools, each school catering to 10 students headed by one volunteer. During the 200 hour contact programme (at the rate of two hours per day and six days a week between 8 and 10 p.m.), the learners were required to complete three different primers and take 10 tests before claiming a certificate (Shatrugna, 1998).

The collector of the district, with the help of a team of dedicated officers constituted an academic committee to prepare the primers for the target group of learners, and guide books for the volunteer teachers. The district collector of Nellore (belonging to the scheduled class community) headed the *Zilla Saksharatha Samithi* (also called, District Literacy Centre), which was supported by many voluntary organizations including BGVS and the Andhra Pradesh *Jana Vignana Vedika* (APJVV). The finances for the programme came from both the State Government as well as the National Literacy Mission. The training imparted to the resource persons and volunteer teachers was of a very short duration (one to two weeks).

The Adult Literacy primers produced by the District Literacy Centre dealt with lessons (in Telugu) such as, 'Don't accept low wages', 'Untouchability is a crime', 'Should you give dowry to your daughter?, 'The fair-price shops are meant for the poor', 'A woman who has given birth recently should receive good food' and so on. Many of the members of the BGVS and the APJVV who were responsible for choosing such socially relevant content for the primers were surely aware of the fact that the teaching/learning process would not be empowering and liberating, unless the lessons are drawn from the social milieu of the learners. They had ensured that the content of the lessons was not reduced to mere slogans, and that it should be challenging. The text was

designed to urge the people to participate effectively as subjects in the reconstruction of their lives instead of remaining passive objects or recipients of literacy instruction. This is evident in the lesson cited below:

UNITY

Siripuram is a wealthy village, but the women there have no happiness. It is full of *arrack* and wine shops. All the earnings of the men-folk are spent on drinks. Women who come in the way of the men get beaten up. How to make the men give up drinking is the problem faced by the women.

All of them went to Seethamma. They believed that the educated Seethamma could guide them. Seethamma understood their sufferings. 'If you are united, you can do this' she said and told them what they should do.

As she suggested, they all joined hands. The local youth also helped them. All of them went in a procession and forced the *arrack* shops to close. For this the women were tortured by their men-folk, but the women were steadfast and convinced their men. Eventually they stopped drinking. If there is unity, anything can be achieved. This was proved by the women of the village.

A lesson from *Akshara Deepam,* one of the adult education primers used in the Nellore campaign: English translation from *Frontline*, December 4, 1992

In the month of April 1991, volunteers were trained to take part in the literacy campaign in the village of Dubagunta in Nellore district. While illustrating how to teach each lesson, the above mentioned lesson titled 'Unity' came up for discussion. This lesson was used in many adult literacy centres around that time. The centre also tried another experiment in teaching—after every lesson, during the last 15 minutes, the volunteer-teacher intro- duced an item, 'The news for the day' that dealt with something new—a story or an event or even a conversation. The learners were expected to add their own experiences and take the

discussions further. In May 1991, at Dubagunta village, three drunken labourers lost their way and were drowned in the village well. The women of the village marched to the local *arrack* shop with sticks and bricks and forced its closure. There were other incidents such as that of a child dying because his drunkard father could not get medicines on time. Many of these incidents were discussed as 'today's news' in the literacy classes (Balasubramaniam, Ms). The pent-up emotions of the agitated women needed only a spark and this was provided by the death of the three drunken men. The neo-literate women joined together, took their broomsticks and chilli powder and managed to close the *arrack* shop in that village. This happened around June 1991. The word spread and soon similar closures were being forced in nearby villages.

The main literacy campaign in Nellore district was completed by November 1991. The post-literacy movement began in this district in April 1992. A new booklet titled, *Caduwu Velugu* 'The Light of Knowledge' was prepared in which the Dubagunta episode found its way into the primer in the form of a lesson titled *Aadavaallu Ekamaitee* 'When Women Unite'. It is instructive to quote excerpts from this lesson (taken from Shatrugna, 1998):

This is not a story. This is the achievement of women who studied in the evening schools. Our village is Doobagunta. We are wage earners. We produce gold from earth. But what is the use? All our labour and hard earned money is spent by our men on *toddy* and *arrack*. When our menfolk do not have money, they sell away rice, butter, *ghee* or whatever else they can lay their hands on and sell for purchasing the liquor. Apart from drinking, they abuse us, pick up rows with us, slap our children. They make our day to day existence miserable. We are women, what can we do? Then, the night schools have come. The volunteers are being trained in our village. During the training, they read the story of Seethamma. They asked us 'Who was responsible for this death?'. Her story fits well into our lives. We started thinking. The *Akshara Deepam* centres have begun. We women got together. Everyday we discussed the menace of *toddy* and *arrack*. We discussed what to do in the fields, near

the well and ultimately we decided. One day we went and told the *Sarpanch* to close the *arrack* and *toddy* shops. He agreed that it was a good suggestion, but he could not succeed in getting the shops closed.

The next day, a hundred of us got together. We walked for a mile outside the village. We stopped the cart ferrying the *toddy*. We warned the owner not to enter the village and demanded him to throw away the liquor. We said we would contribute a rupee each to compensate for his loss. He was terrified. That is all. From that day, no *toddy* entered our village. Meanwhile, the jeep carrying *arrack* arrived in the village. We *gheraoed* the vehicle. We politely asked him (the owner) to go away. He left without unloading the liquor sachets. The police arrived after two days. Those who had won the *arrack* auctions had the right to sell the liquor, they said. We said we know everything. We threatened to go to the District Collector to lodge a complaint. This warning sent a shiver down the spine of the contractor. But even then he tried several tricks to sell the *arrack* but did not succeed. Ultimately he closed his shop.

With this victory, we became very strong, got confidence that we can fight. We also realized that this victory was possible only through the literacy we received. We studied well. This year no one dared to participate in the *arrack* auctions. Why can't you too do it? Think...

It must be noted that the learners, mostly women had by then acquired some literacy skills. For the first time newspapers were reaching all the post-literacy centres every day and the news of the anti-*arrack* agitation was reaching the remotest villages and homes. During the first part of the year 1992, the APJVV published another booklet for the neo-literates titled *Uuru Meelukondi* 'The Awakening of a Village'. The contents are organized as a series of letters between two friends, one a voluntary woman teacher (Vasantha) in a literacy centre in Sayipet and a neo-literate woman (Sitha) who is enrolled in the *Akshara Deepam* literacy centre in Gangavaram. Vasantha informs her friend about

the anti-liquor agitation that took place in Sayipet in which several hundred women and some men participated, demanding the closure of the *arrack* shops... how they had managed not only to close down the *arrack* shops but also stopped the contractors from entering the village and how all this news was reported in the Telugu newspaper, *Enaadu*—'Today'. Sitha writes back to Vasantha stating that she had in fact read about the women's participation in the anti-liquor campaign in Sayipet in *Eenaadu*, and saw all the pictures and that was when she realized how education can help bring women together to fight for the resolution of their problems.

By August 1992, women's committees were formed in several villages of A.P. and it was clear that the campaign for literacy had shifted its focus and it was by then centred around procuring a total ban on *arrack*. The literacy schools continued, but the village atmosphere was charged with the anti-*arrack* campaigns (Shatrugna, 1998). Towards the end of 1992, several urban women's groups visited Nellore and recorded the first hand experiences of women who participated in the anti-liquor movement (see Anveshi's report, 1993; Asmita's report, 1994). Many of these reports established that a clear-cut connection exists between the lessons in the literacy primers and women's participation in these movements. The general secretary of APJVV however commented that the literacy movement merely served as a catalyst to the anti-*arrack* movement in that if there was no literacy movement there would not have been an anti-*arrack* movement. That this was so, is evident by the anti-liquor movement in Kurnool, which was stated to have been a spillover of the Nellore movement (see Ilaiah, 1997). The movement spread to 800 villages in a matter of months and by the end of 1992, over 500 liquor shops had been forcibly closed. All *arrack* transactions were made illegal and by December 1994, the Government had no choice but to institute prohibition in the state of A.P.

Anveshi's report pointed out that the problem of *arrack* intersects and crystallizes a number of issues as articulated by the village women. For instance, some of the women who were interviewed complained of the deteriorating socio-economic conditions—the rise in the price of rice, the absence of basic amenities like water and health care, the absence of even primary schools

and the increasingly abusive family relationships—the daily harassment they and their children suffered from men who came home drunk and deprived them of a good night's sleep. In the absence of any central leadership, these women have been able to effectively challenge the power of the State and destabilize its economy. While concluding their findings, Anveshi's report stated 'In developing unique forms of struggle and resistance, women who have never been involved in politics as it is traditionally practised are redefining its meaning' (p. 6).

THE POLITICS OF THE ANTI-LIQUOR MOVEMENT IN NELLORE

The literacy workers associated with the BGVS and APJVV had been supporting the poor rural women in their struggle against the Government's supply of *arrack* in their villages all along. Once the anti-*arrack* agitation received media attention, several other women's organizations got involved and from them, the neo-literate women learnt that it was not enough to get the local shops closed in village after village and that a more effective course of action would be to prevent excise auctions from taking place in Nellore, because the right to sell *arrack* was decided in these State-sponsored auctions. Initially these women could not understand why the police were siding with the *arrack* shop owners when they were demanding the closure of the shops. However, it took them no time to realize that there is a powerful nexus between the Government and the liquor lobby.

It is also important to note that these women were not fighting against the sale of *arrack* in their villages on high moral grounds. Their fight must be seen against the deteriorating socio-economic scenario existing in A.P. at that time. Several of these women who took part in the anti-liquor movement came from the poor sections of the society (and they were mainly agricultural labourers). They were earning as little as Rs 12, while the men's daily wages were Rs 24. In many families the men used up their wages for buying three sachets of *arrack* (one sachet of 100 ml of *arrack* cost Rs 8). When they ran out of money, they began to sell off goods like brass utensils, clothes, kerosene lamps and started mortgaging other belongings to get money to buy more liquor. This was the time when the earlier food subsidy scheme—Rs 2 for a Kg of rice and a quota of 25 Kg per family—introduced by the Telugu

Desam party was scuttled by the successor Congress (I) Government. The entitlement was reduced to 16 Kg per family and the price of rice was raised to Rs 3.50 per Kg. More importantly, the offtake through the Public Distribution (PDS) became most erratic. It was around this time that the paddy fields were being converted to fish ponds or fruit orchards causing substantial reduction in work-days. The contract system of labour introduced in response to these changing patterns of agriculture (replacement of traditional crops by cash-crops) also left many older members out of work, depriving the families of their income. In some cases, men were the sole earners and the fate of the family was ruined if they were addicted to liquor. In the absence of an adequate food subsidy, women were forced to buy rice at Rs 9 per Kg in the open market out of their hard earned daily wages of Rs 12. Against this bleak economic scenario, it was not surprising that crimes against women had increased—wife beating and beating of children by drunken husbands was a daily matter in most homes. The elders could not exercise any control over their family members and there was a steady deterioration of community life. There were no social occasions for the women to come together and share their experiences. It is against this back drop, that the literacy centres at night attracted a large number of women who joined them both as learners as well as volunteer-teachers.

Initially, the women could not understand or accept the State's dogged determination to force *arrack* into their villages especially since it was decidedly apathetic when it came to providing much needed services such as water supply, health-care and education for their children. But, slowly they learnt how powerful the liquor lobby of *arrack* contractors was, with at least 100 MLAs of the ruling Congress party in it. The Government was earning over two crore rupees through the sale of *arrack* from its 860 shops. Yet, the neo-literate women of A.P. not only managed to challenge the might of the State Government, but also the powerful lobby of *arrack* contractors. Support also came from other quarters—the media, the opposition parties, women's organizations and other NGOs. But the women braved the threat of police arrests, the physical attacks by the *goondas* hired by the contractors and the reaction of their own husbands at home. What was happening to their literacy training amidst this movement?

THE POLITICS OF THE LITERACY CAMPAIGN IN NELLORE

Though the Government banned the sale of liquor, it also took a number of coercive measures to contain the movement such as withdrawing the original textbooks, transferring a number of committed officials and teachers to their parent departments etc. (see for instance the article in the *Indian Express* Nov. 25, 1992). This should not be altogether surprising, commented Athreya and Chunkath (1996), 'since the process of mass literacy campaign involves organizing the rural poor around the issue of literacy and is bound to come into conflict with rural vested interests and existing patronage networks'. A decentralized participatory mass campaign for literacy also runs counter to the prevalent ethos and structure of a centralized bureaucratic government.' The Nellore experience shows that though the Government may initially ignite a movement, its class/caste interests do not permit it to support it for long. The movement should adopt an autonomous course ultimately if it has to sustain its existence (Shatrugna, 1998). See Saxena (this volume) for an argument against referring to government-sponsored mass literacy campaigns as 'movements'.

The withdrawal of the post-literacy primer *Caduwu Velugu* by the government certainly caused a set-back to the PL/CE movement in this district. Two years after the prohibition was imposed, APJVV conducted a sample survey in five districts of A.P., viz., Guntur, Nellore, Kurnool, Chittoor and Nizamabad involving 289 respondents (120 women and 169 men) about people's opinion on the imposition of prohibition in the State. The information gathered was published in the form of a small booklet. APJVV was also working with ZSS in printing and distributing a magazine to the neo-literates in the Nellore district through post-literacy centres as well as mobile libraries. By early 1995 the ZSS organizers distributed a set of booklets on health awareness as if to pick up the threads of the literacy movement. Attempts have also been made to set up hundreds of health awareness campaigns called *aarogyadiipam* 'the light of health' and thrift societies, popularly known as '*podupulakshmi*' groups, each one managed by one teacher and one accountant. The positive gains of these health and savings movements experienced by rural women in Nellore district have been documented elsewhere (see Ramachandran, 1995, 1996 cited in Anita Dighe's Post-script to Shatrugna, 1998). However,

Nitya Rao (1996) has argued that mere access to productive resource is not sufficient to build a sustainable organization of women, though it could be an entry point. What is most needed is access to information regarding policies, laws, technology inputs, markets, support services etc. That the neo-literate women of A.P. can organize themselves is evident by the fact that a sizeable number of them have recently contested elections for local bodies. However, there exists a great need for setting up libraries (in place of the so-called post-literacy centres) and making specially designed reading materials for the neo-literates.

LESSONS FROM THE NELLORE MOVEMENTS

It is evident from the description of the two movements—literacy and anti-liquor—and the politics connected to them that the State-led 'movements for literacy' will not work because the (functional) literacy it imparts is designed only to decode messages, not question those in power. During the teaching/learning phase, they may have learnt rudiments of what Hasan has called 'recognition literacy' (see appendix) which taught them how to decode letters and read words/sentences, but surely it is not this literacy that prepared the women learners to lead the anti-liquor agitation and win. The political awareness that the Nellore women acquired was imparted not just in the teaching/learning phase, but right from the start of the environment building phase and it was the activists connected to organizations like the APJVV and BGVS and the volunteer-teachers (most of whom belonged to the same community as the learners) who imparted this 'knowledge' as part of the pedagogic encounter in the night schools. They did this by select-ing topics straight from the daily lives of the learners and raising an open discussion ('the topic of the day') drawing the learners into a discussion mode of learning. They were responsible for the critical literacy/ emancipatory literacy/reflection literacy (see appendix for a detailed discussion of the meanings of these terms) that went on during the entire period of the TLC. Yet, we do not hear the voices of these activists or volunteer-teachers. Why are they not involved in the evaluation?

IMPLICATIONS FOR EVALUATION

We would like to argue that the primary goal of literacy/education is to increase the political awareness in learners—awareness about

their rights to demand better living conditions: access to health care facilities, adequate drinking water facilities, opportunities for primary education and so on. Nag (1989: 418) defines political awareness as the 'consciousness of people regarding their deprivation of civil rights as well as the consciousness that an effective means for achieving their rights is through group action, particularly through sustained movement, agitation, confrontation, strike or rebellion against appropriate agencies'. He has discussed many examples with regard to Kerala and West Bengal to show that it is possible to assess political awareness. On the question of the relationship between political awareness and literacy, Nag states that the circulation of newspapers in vernacular languages (and the widespread habit of reading newspapers) is an index of higher literacy achievement. In this respect, he has pointed out that Kerala has always been far ahead of West Bengal. He has also emphasized the role of village school teachers belonging to the Left parties for the spread of primary education in rural Kerala as compared to West Bengal. However, what Krishna Kumar (1994) had to say about the post-literacy scenario in Kerala is not at all encouraging. Talking about community libraries, he pointed out that in 1977, the State had taken over the village libraries managed by the *Kerala Granthasala Sangham* (KGS) and that this was a sad turning point in the history of library movement in this state. With dwindling community support and lack of government grants, today they are in no position to serve as post-literacy centres. He was very critical of the total neglect of the rural libraries and the diversion of a major chunk of the resources available to 'environment building', 'training' programmes, and salaries. The Nellore experience has taught us that the volunteer-teachers from the community and the activists of the NGOs involved in literacy programmes needed very little training. They have shown that very little investment is needed to bring about political awareness among rural poor and especially the women. To sustain this awareness and to empower the learners to solve their own problems, the State must invest in lasting structures like libraries in all the villages of the district it selects, to support autonomous literacy movements.

The connections between the literacy movement and the anti-liquor movements that took place in the Nellore district of A.P. force us to rethink the question of assessment of literacy. An

activist associated with APJVV commented that while selecting the evaluators, NLM does not tell them about their own understanding of what literacy is and often they do not select the right kind of people. Academicians with little or no activist backgrounds, who have no experience of working in the field of literacy are being involved in evaluation. There is a need, he lamented, for designing and training evaluators on how to conduct impact evaluation studies of literacy.

Another outcome of the mass movements for literacy like the one that took place in Nellore is the formation of *vanitha kalajathas* comprising women artists who are going to spread the message not only that of literacy, but of equality between the sexes. *Samatha*, 'equality', an educational campaign for the equality of women has already been launched at a national level (see Athreya and Chunkath 1996b). Little, if any thinking has gone into what implications these developments have for assessing the social impact of literacy campaigns. It is instructive to quote Sundararaman (1996):

> If literacy efforts stop with the mere provision of alphabetic knowledge, then the learning it will lead to is likely to be loaded with the values of dominant sections.... However, if the process of provision of literacy skills is built upon consciously by women's movements, only then would its full emancipatory potential be realized... We must look beyond to building up another phase (of the literacy campaign) in the not too distant future—a phase where unlike in the first phase, the women's mobilization and empowerment role is not accidentally discovered by the activists, but where it would be the campaign's chief purpose.

For this to happen and to be able to 'measure' the social impact of literacy using empowerment evaluation methods, we have to do a lot of work, both theoretical and empirical. First on the list of priorities is to undertake research into what literacy means to the lives of rural poor (different age groups and different social classes) in their own settings. Such a research involves an interdisciplinary engagement of researchers as well as activists. Such a pre-programme research should be followed up by a programme design, preparation of materials based on the inputs from the community, discussion of pedagogic methods, and evolving procedures

to see how people involved in the literacy programmes can monitor and evaluate their own programmes. All this is not easy to spell out. We can only hope that our paper will raise the much needed debate on the purpose or usefulness of the ongoing TLCs and the way literacy is being measured today.

APPENDIX

Aboriginal/Indigenous Literacy

Commenting on the contents of a book titled *They Write Their Dreams on the Rock Forever*, David Olson (1994) talked of aboriginal literacy to make the point that rock writings are not mere art forms because they involve repeatable symbols with conventionalized meanings and that they serve to preserve and communicate information through graphic means. He argued that if writing is not viewed as a device for transmitting speech, rather it is seen as a means for preserving and transmitting information (about a culture), then native cultures have been literate all along. Olson's argument underscores the need to distinguish the role writing plays in indigenous literacy (in aboriginal languages) as opposed to school literacy (in French or English) in the Canadian context. Olson, D. 1994. 'Aboriginal literacy'. *Interchange*, 25:4, pp. 389–94.

Action Literacy

Hasan (1996) talks of action literacy to introduce a new approach to literacy pedagogy which aims at getting the pupils to produce (written) texts that belong to various educational genres. They will have to realize that talking about science is different from writing science, which is different from writing history which is again different from writing about literature etc. This kind of genre-based pedagogy will enable students to learn to produce language of the type that is required of them to succeed in the educational system. However, critics of genre-based pedagogy have pointed out that action literacy ends up teaching pupils to go on doing what others have been doing in their society, thus reproducing existing social relations. However, Hasan argues that while the issue of social reproduction stands in need of deeper reflection, this does not render action literacy unfit as a pedagogic programme because to fail to master

educational genres is to collude in the reproduction of inequalities of the social system at the cost of precisely those whose voice is absent from the educational curricula.

Hasan, R. 1996. 'Literacy, everyday talk and society'. In R. Hasan and G. Williams (eds), *Literacy and Society*. London and New York: Addison Wesley Longman Ltd.

Community Literacy

Langer (1988) made an attempt to classify various definitions of literacy as denoting an *action*, a *skill* or a *state*, with each stemming from a different set of traditions and accompanying divergent emphases of investigation. David Peat (1994) provided an informed critique of Langer's analysis and argued for the need to integrate the three perspectives, which he calls an Integrative Systems Model of literacy. After discussing the research and pedagogic implications of this model, Peat goes on to elaborate how it can be used to minimize social, cultural and intellectual disruption of literacy instruction using a case study of community literacy in the Yukon territory in Canada. The terms, L2 literacy, biliteracy have also been used to refer to situations where peoples' native language does not have literary status as is the case for instance, in parts of the erstwhile Soviet Union and Germany.

Langer, J.A. 1988. 'The state of research on literacy'. *Educational Researcher*, pp. 42–46.
Peat, D. 1994. 'Towards minimizing social, cultural, and intellectual disruptions embedded in literacy instruction'. *Interchange,* 25:3, pp. 261–79.

Critical Literacy

Drawing on the ideas of Italian Social theorist Antonio Gramsci, Henry Giroux (1987) offered a more radical view of literacy, which was termed critical literacy, as something that accords high priority to political and cultural issues. Literacy in this sense should become a vehicle for examining how cultural definitions of gender, race, class and subjectivity are constituted as both historical and social constructs. Implicit in this analysis is the notion that illiteracy signifies at one level, a form of political and intellectual ignorance and at another, a possible instance of class, gender, racial, and cultural resistance. Members of working class and other subordinate groups may consciously or unconsciously refuse to learn the specific cultural codes and competencies authorized

by the dominant culture's view of literacy. The refusal to be literate in such cases provides the pedagogical basis for engaging in critical dialogues with those groups whose traditions and cultures are often the object of massive assault. There is also attempt by the dominant culture to delegitimate and disorganize the knowledge and traditions such groups use to define themselves and their world. Critical literacy calls for theorizing of literacy as a form of cultural politics; it argues that knowledge is not produced in the head of the educator/teacher, instead it is also contained in the productive meanings that students bring to classrooms—that it is produced as part of a pedagogical encounter.

Giroux, H.A. 1987. Introduction. Paulo Freire and Donaldo Macedo (eds), *Reading the Word and the World.* London: Routledge.

Cultural Literacy

Hirsch (1987) coined this term for depicting literacy as a state. He talked of cultural literacy referring to the network of information that all competent readers possess. It is the background information, stored in their minds, that enables them to take up a newspaper and read it with an adequate level of comprehension, getting the point, grasping the implications, relating what they read to the unstated context which alone gives meaning to what they read. He went on to list topics constituting common culture, something he asserted that every American should know.

It is not surprising that Hirsch's attempt to take the nation as the basic socio-cultural unit and set up universal goals of literacy with respect to this unit came under severe attack. Many critics took objection to Hirsch's underlying assumptions of cultural homogeneity within the nation state and that different people involved in the same socio-cultural activities in daily life require the same type of functional literacy and the same level of literacy skill throughout the society. Others pointed out that Hirsch ignored the distinction between literacy and language and had little to say about the influence of TV or computers on the culture of the youth in America.

Hirsch, E.D. 1987. *Cultural Literacy.* New York: Houghton Mifflin.

Emancipatory Literacy

Freire and Macedo (1987) argued that literacy instruction in the language of the dominant groups merely reproduces existing social

formations and empowers ruling classes by sustaining the status quo. In the context of a discussion on literacy programmes designed for African and Portuguese colonies, they talked of emancipatory literacy which places emphasis on learners becoming subjects rather than mere 'objects' (of literacy instruction). Here, literacy becomes a vehicle by which the oppressed groups learn to participate in the socio historical transformation of their society. As part of the instruction, they should learn to reclaim those historical and existential experiences that are devalued in everyday life by the dominant culture. This is possible only when the instruction is given in the students' language. Thus, argued Freire and Macedo, a person is literate to the extent he or she is able to use language for social and political reconstruction.

Freire, P. and D. Macedo. 1987. *Reading the Word and the World.* London: Routledge.

Epistemic Literacy/Reflection Literacy

Hasan (1996) also noted that the pedagogies of action literacy assume that the norms of knowledge and/or discourse are stable, arrested at some point in time. It does not enable pupils to produce knowledge. Drawing on Gordon Well's (1987) views on different levels of literacy, in particular, his notion of epistemic literacy (to have available ways of acting upon and transforming knowledge and experience that are in general unavailable to those who have never learned to read and write), Hasan proposed yet another kind of literacy, reflection literacy, which places emphasis on the speaker's semantic orientation (and hence their ideological stance). The pedagogies based on reflection literacy encourage pupils not simply to note the way the text is structured, but ask questions about why it is structured the way it is, and what would change, for whom, and at what price, if the structure were to be changed. They will learn to question the norms of discourse. Thus, schooling in reflection literacy is literacy for education to produce knowledge. It promotes a pedagogy which will create a perspective that refuses to consider accepted ways of doing things in a culture as beyond questioning. In other words, it seeks to examine the norms of education itself.

Hasan, R. 1996. 'Literacy, everyday talk and society', in R. Hasan and G. Williams (eds), Literacy and Society. London and New York: Addison Wesley Longman Ltd.

Wells, G. 1987. 'Apprenticeship in literacy'. *Interchange,* 18(1–2), pp. 109–23.

Emergent Literacy

Literacy is an amalgam of social practices and conceptions of reading and writing that are bound to a given culture. Pontecorvo (1994) commented that when we talk of the social practices that all children in urban cultures in more or less developed societies are engaged in, between the ages of four and six years, it is reasonable to use the term emergent literacy as opposed to literacy acquisition beyond school years which is commonly termed adult literacy, out-of-school literacy or work-place literacy. According to Carter (1995) theories of emergent literacy underline the integrated and mutually reinforcing nature of literacy skills development. In this view of literacy, children's language is not seen as incorrect but rather as a series of incomplete stages through which they pass towards a more complete mastery. Critics argue that it is excessively individualistic and centred on the child and can give rise to pedagogic practices which are inappropriate for teaching large classes.

Carter, R. 1995. *Keywords in Language and Literacy.* London: Routledge.

Pontecorvo, C. 1994. 'Emergent literacy and education', in L. Verhoeven (ed.), *Functional Literacy.* Amsterdam: John Benjamins.

Family Literacy

The realization that children from minority language groups do not succeed in school, primarily because there is a mismatch between home literacy practices and school literacy practices gave rise to the notion of family literacy, which involved teaching English to immigrant women in language minority communities in the U.S.A. (see Auerback, 1989). The terms, English literacy and Second-language literacy are equally applicable to the situation described above.

Auerback, E.R. 1989. 'Literacy and ideology'. *Annual Review of Applied Linguistics,* 12, pp. 71–85.

Functional Literacy/Basic or Survival Literacy

The much used term, functional literacy was first coined by the US Army during World War II to indicate 'the incapacity to understand written instructions necessary for conducting basic military functions and tasks ... a fifth grade reading level' (cited in DeCastell, Luke and Egan, 1986: 7). This term is still used in the Canadian and American testing of vocationally related literacy. It is from this definition that the terms basic literacy and survival literacy have evolved. The 1971

UNESCO definition of functional literacy which states: 'A person is literate when he has acquired the essential knowledge and skills which enables him to engage in all those activities in which literacy is required for effective functioning in his group or community' was thought to be too general to be of any use in empirical studies. Wells (1991: cited in Verhoeven 1994) described functional literacy as being able as a member of a particular society to cope with the demands of everyday life that involve written language. Such demands include being able to read a popular newspaper, write a job application, follow the instructions that explain how to use a household gadget or complete an official form. It should be noted that functional literacy entails a limited control of literate practices. Not only that, it also affirms in the disadvantaged groups a view of the world that leads them to accept it as inevitable, and to participate in the very practices and relations that disadvantage them. Lankshear (1985, cited in Hammond and Freebody, 1994) stated that such programmes of functional literacy are mere exercises in domestication.

De Castell, S., A. Luke and K. Egan (eds), 1986. *Literacy, Society and Schooling: A Reader.* Cambridge: Cambridge University Press.

Hammond, J. and P. Freebody, 1994. 'The question of functionality in literacy: a systematic approach', in L. Verhoeven (ed.), *Functional Literacy.* Amsterdam: John Benjamins.

Verhoeven (ed.), 1994. *Functional Literacy.* Amsterdam: John Benjamins.

Lay Literacy

Illich (1987: 9) described lay literacy as follows:

'A distinct mode of perception in which the book has become the decisive metaphor through which we perceive of the self and its place... a mind-frame defined by a set of certainties which was spread within the realm of the alphabet since late medieval times. The lay literate is certain that speech can be frozen, that memories can be stored and retrieved, that secrets can be engraved in conscience, and therefore examined, and that experiences can be described...a new type of space in which social reality is reconstructed: a new kind of network of fundamental assumptions about all that can be seen or known.

Illich, I. 1987. 'A plea for research on lay literacy'. *Interchange*, 18 (1–2), pp. 9–22.

Local or Vernacular Literacy

In a discussion on questioning the basic assumptions about literacy, Street (1990) argued that most people in the contemporary world have some acquaintance with literacy which may be termed, local or vernacular literacy and that therefore it is misleading to create a dichotomy between the terms literate and illiterate. More recently Barton and Hamilton (1998) elaborated this term by describing the literacy practices of one community in UK They hold that literacy is essentially social and that it is located in the interaction between people. Their work has shown that studies of local literacies have contributed to a theory of literacy as social practice and a collective resource.

Barton, D. and M. Hamilton. 1998. *Local Literacies: Reading and Writing in One Community.* London: Routledge.

Street, B. 1990. 'Cultural meanings of literacy', in F.E. Leach (ed.), *Education in Developing Countries: A Reader.* UNESCO International Bureau of Education.

Modern Literacy

While the traditional view that literacy is a technical skill that is neutral and universal across societies (also endorsed by the dictionaries) is no longer tenable, a majority of the literacy studies reportedly examine literacy in the context of modernization and nation-building. This kind of 'modern literacy' (Heath, 1986) is concerned with learner's reception of primers, literacy programmes and other adult literacy activities imposed on the community from outside. This externally imposed literacy is often thought to provide links between individuals and controlling bureaucratic institutions of modern societies. Modern literacies often privilege the 'standard' language of the dominant class over vernacular dialects of students. Since the norms of evaluation are based on formally schooled populations, there is no attempt to separate literacy effects from schooling effects.

Heath, S.B. 1986. 'Critical factors in literacy development', in S. DeCastell, A. Luke and K. Egan (eds), *Literacy, Society and Schooling: A Reader.* Cambridge: Cambridge University Press.

Proper Literacy

The Freirean model and the notions of emancipatory and critical literacies are also linked to the notion of what Lankshear and Lawler (1987) called proper literacy to refer to critical analysis of social systems and

institutions, for the development of action plans and political projects geared towards both cultural and economic transformation. The best example of what proper literacy entails can be found in the documented literature on literacy movements in Latin American countries like Nicaragua.

Lankshear, C. and M. Lawler. 1987. *Literacy, Schooling and Revolution.* London: Falmer Press.

Recognition Literacy

The teaching of sound-shape correspondence (e.g., bat-mat-pat) has been the major thrust of literacy teaching world over and Hasan (1996) has termed it, recognition literacy. Here language is not seen as a mode of social action. Yet, popular ideas about literacy are informed by recognition literacy. To elaborate, when politicians, ministers of education or newspapers talk about declining standards of literacy, what they often have in mind is spelling, punctuation conventions, and such other obvious features of linguistic form. By presenting language as something that is not socially motivated, recognition literacy creates an ideology of language as powerless, something that passively reflects pre-existing meanings when in fact much of our social universe is created and maintained by the language we use. The ideas of recognition literacy demand that pupils do not ask questions and they are likely to follow wherever authority in the guise of teacher leads them. They have to be students who do not expect educational knowledge of language to have any relevance to what they do with language at home, in the living of their life.

Hasan, R. 1996. 'Literacy, everyday talk and society', in R. Hasan and G. Williams (eds), *Literacy and Society.* London and New York: Addison Wesley Longman Ltd.

Semi-literacy

Miller (1998) argued that the United States has a considerable semi-literate underclass living in poor urban neighbourhoods and that this number is steadily increasing. Many of these semi-literate people are unable to follow written instructions, pass a test for a driver's license, answer a help-wanted advertisement or even understand a pamphlet telling them where to go for help. He stated further that semi-literacy is a symptom that will not disappear until much deeper social problems are solved.

Miller, G.A. 1988. 'The challenge of universal literacy'. *Science*, Vol. 241. 9th September.

Social Literacies

Street (1995) uses this term to shift the focus of the newly emerging field of literacy studies to the social nature of reading and writing practices in different times and different societies. According to this view there is no one universal view of the oral and the written and therefore one can only talk about (local) literacies. He also stressed the need to distinguish between literacy practices from literacy events. The former refers to both the behaviours and the social and cultural conceptualizations that give meaning to the uses of reading and writing whereas the latter are the particular activities in which literacy has a role.

Street, B. 1995. *Social Literacies: Critical Approaches to Literacy in Development, Ethnography and Education.* London: Longman.

Universal Literacy/Total Literacy

The United States Census Bureau reportedly used six years of schooling by everyone as a criterion to declare a country to have achieved Universal literacy. Miller (1988) critiqued the functional measures used to measure literacy and demonstrated that the extent of semi-literacy in the USA can be anything one likes, depending on how one defines literacy.

Miller, G.A. 1988. 'The challenge of universal literacy'. *Science*, Vol. 241, 9th September.

<div align="right">Compiled by D. Vasanta</div>

REFERENCES

Agnihotri, R.K. 1994. 'Campaign-based literacy programmes: The case of Ambedkar Nagar experiment in Delhi'. In D. Barton (ed), *Sustaining Local Literacies.* Clevedon: Multilingual Matters, pp. 47–56.

Anveshi, 1993. 'Stemming the tide: A report from the Anveshi research centre for women's studies, Hyderabad on the anti-liquor movement in A.P.' *Women's Review of Books* X:10–11.

Arun Ghosh Committee, 1994. Evaluation of Literacy Campaigns in India: Report of Expert Group. New Delhi: NLM.

Asmita, 1994. *Saaramsam—A report on the anti-arrack movement in A.P.* by Asmita resource centre for women, Secunderabad.

Athreya, V.B. and S.R. Chunkath. 1996a. 'A massive challenge: The experience with adult literacy campaigns'. *Frontline*. September 6.

Athreya, V.B. and S.R. Chunkath. 1996b. *Literacy and Empowerment*. New Delhi: Sage.

Auerback, E.R. 1989. 'Towards a social-contextual approach to family literacy'. *Harvard Educational Review*. 59:2, pp. 165–81.

Balasubramaniam, V. (Undated). Literacy movement and anti-*arrack* movement. Telugu manuscript unpublished.

Banerjee, S. 1992. 'Uses of Literacy: TLCs in three West Bengal Districts'. *Economic and Political Weekly*. Feb. 29, pp. 445–49.

Fetterman, D.M. 1994. 'Steps of empowerment evaluation'. *Evaluation and Program Planning*. 17:3, pp. 305–3313.

Fetterman, D.M., S.J. Kaftarian and A. Wandersman (eds). 1996. *Empowerment Evaluation: Knowledge and Tools for Self-Assessment and Accountability*. London: Sage.

Ilaiah, K. 1997. 'A.P.'s anti-liquor movement'. In B. Sarveswara Rao and G. Parthasarathy (eds) *Anti-arrack Movement of Women in A.P. and Prohibition Policy*. New Delhi: Har Anand Publications, pp. 80–87.

Krishnamurti, Bh., I. Ramabrahmam, and C.R. Rao, 1995. *Evaluation of TLCs in Chittore and Nizamabad Districts in A.P.* Hyderabad: Booklinks Corporation.

Krishnamurti, Bh. 1998. *Literacy, Society and Education*. New Delhi: Sage.

Kumar, Krishna. 1994. 'Battle against their own minds: Notes on literate Kerala'. *EPW*. Feb., 12th issue, p. 345.

Levin, H.M. 1996. 'Empowerment evaluation and accelerated schools'. In D.M. Fetterman, S.J. Kaftarian and A. Wandersman (eds) *Empowerment Evaluation: Knowledge and Tools for Self-Assessment and Accountability*. Thousand Oaks, CA: Sage.

Malyadri, G. (Undated). A report in Telugu on the *akshara dipam* programme in Nellore District. Nellore: APJVV.

Nag, M. 1989. 'Political awareness as a factor in accessibility of health services: a case study of rural Kerala and West Bengal'. *EPW*. Feb., 25th issue, pp. 417–26.

NLM document 1: *Literacy Facts at a Glance*. New Delhi: NLM.

NLM document 2: *National Literacy Mission, a People's Movement*. New Delhi: NLM.

NLM document 3: *Towards a Literate India*. New Delhi: NLM.

NLM document 4: *How to evaluate learning outcomes of TLC's?* New Delhi: NLM.

NLM document 5: *Concurrent Evaluation of TLC Districts*. New Delhi: NLM.

Shatrugna, M. 1998. 'Literacy as liberation: the Nellore experience'. In S. Shukla and R. Kaul (eds) *Education, Development and Under development*. New Delhi: Sage, pp. 241–64.

Street, B. 1994. 'Cross-cultural perspectives on literacy'. In L. Verhoeven (ed), *Functional Literacy*. Amsterdam: John Benjamins, pp. 55–61.

Sundararaman, S. 1996. 'Literacy campaigns: lessons for the women's movement' *EPW*. 31: May 18th issue.

Zimmerman, M.A. and J. Rappaport 1988. 'Citizen participation, perceived control, and psychological empowerment'. *American Journal of Community Psychology*. 16:5, pp. 725–50.

9

Evaluation of Total Literacy Campaigns: The Andhra Pradesh Experience

D. Subba Rao and B.S. Vasudeva Rao

Introduction

The launch of the National Literacy Mission (NLM) in the year 1988 was a landmark in the history of the Adult Education movement in India. The mission approach was further strengthened with the success of the Ernakulam (Kerala State) literacy campaign. The cohesive commitment of the Ernakulam district administration, educational institutions, educated youth and other volunteers are the fundamental reasons for this phenomenal success. This had ushered in a mammoth movement for total literacy in around 50 districts immediately. At present 430 districts have already been covered and 200 districts are in the post-literacy/continuing education phase.

The main objectives of the Total Literacy Campaign (TLC) are that campaigns should be area-specific, time-bound, volunteer-based, cost-effective and outcome oriented. This article is a report on the evaluation of the TLC in Nellore district of Andhra Pradesh. Some of the major findings are provided below.

Attitude of Instructors

The instructors felt that literacy would benefit the learners both individually and socially in their overall development. They agreed that they received useful training and felt it should be more

comprehensive and interactive. They did not report any significant obstacles that seriously hampered the programme. These findings clearly indicate that the instructors had a positive attitude towards the campaign and made their best contribution.

LEARNERS

Female learners performed better than male learners in tests of writing and arithmetic. Housewives performed slightly better than unmarried women. The learners' sex, religion, marital status, and income seemed to influence their performance in the literacy test conducted by us. The learners' caste, occupation and to some extent age had no major influence on their literacy performance.

LITERACY RATE

The literacy rate was calculated according to the guidelines given by the NLM and the main observations are: 57.08 per cent of the learners from the entire sample attained literacy as per NLM norms. The retention of literacy is noteworthy among learners who attended *Jana Chaitanya Kendras* (JCKs), particularly the men.

LEARNERS' VIEWS AND OPINIONS

Female learners perceived the benefits of literacy more than the male learners. The learners expressed their dissatisfaction with the nature of involvement and contribution of local organizations. The literacy rate is the lowest among the fishermen. The JCKs have played a pivotal role in sustaining the literacy achievements of the learners. Special mention should be made of the mini *grandhaalayaas* (libraries) established for the benefit of the learners.

These findings drawn from the sample obtained from Nellore district indicate that the learners have appreciated the benefits of literacy. They were satisfied with the facilities at the centre, they found the instructors' performance satisfactory and they liked the teaching, especially the (word) method and subject matter of the material used in the classes.

MATERIAL PREPARATION

The academic committee of the *Zilla Saksharata Samithi* (ZSS) took great care to see that the material would suit the daily lifestyle and the needs of both neo-literates and the general population. The

bridge primer *Chaduvu Velugu* 'The Light of Education' developed by an energetic and realistic academic committee used a language style that helped the neo-literates to attain the self-learning stage. Besides this, the ZSS also supplied about 45 booklets relating to general awareness components like health, savings schemes, child care and other socially relevant issues to the JCKs.

TEACHING LEARNING MATERIAL

The third primer contained a story called *'Seethamma Katha'*, 'The story of Seethamma'. This story explains the problems faced by a family because of the drunken husband in detail. It is reflective of the tensions and stresses faced by many other women in their homes. The womenfolk under the leadership of the literate Seethamma, organized a movement and forced the closure of the *arrack* (country liquor) shop in their village. The impact of this story can be understood only if one cares to examine the manner in which the women of Dubagunta village in the Kalikiri *mandal* of Nellore district reacted to the incident that took place in the year 1993. This incident is about three men who consumed liquor at a local *arrack* shop and later drowned in the village tank. The village womenfolk marched down to the *arrack* shop, and forced its closure by blaming the shop owner for the incident. The message spread to the adjoining villages and more shops were closed in the process. The political parties moved in and made a demand for total prohibition in the State (see Sandeep, 1994).

These incidents led to the women questioning the suppression of their basic right to survival with dignity, a better quality of life, and better conditions for child rearing. They formed village committees and organized street theatre, rallies, door-to-door campaigns, and public meetings to communicate their feelings effectively. With the support of NGOs, political activists and the functionaries of ZSS at Nellore, they organized mass oath ceremonies to abstain from liquor, carried out a social boycott of liquor addicts and even threatened them with broomsticks and chilli powder. All these movements resulted in the subsequent implementation of total prohibition in the State of Andhra Pradesh.

The literacy rate of the district has gone up by 10 per cent. The ZSS, Nellore did a creditable job of making the campaign success-ful. It motivated the learners, instructors, government officers, NGOs, politicians and others to actively participate in the *Akshara*

Deepam, 'the light of letters', programme. The pro-literacy propaganda campaign was carried out effectively and an appropriate environment was created to sustain the interest of the learners. The efforts of the *Jana Vignana Vedika* (APJVV) and its volunteers have borne fruit. The academic committee of the ZSS had taken pains to make the lessons relevant and useful. The *Jana Chaitanya Kendras* have achieved their objective of making the learners realize the long-term benefits of literacy in terms of individual as well as community development. However, it must be mentioned that the local organizations' participation needs to be improved. Finally, the instructors should be given comprehensive and interactive training apart from providing effective audio-visual aids to make this more successful.

One cannot conclude with certainty that the acquisition of literacy skills leads to a direct social change or transformation. But the genuine commitment of the organizing body, the resolute will of the key level functionaries, the strong zeal of the learners and effective monitoring, will definitely have a strong influence on the outcome.

The evaluation of the TLC in Nellore district indicated that Nellore can be considered as a positive example of success in the field of Total Literacy Campaigns (TLCs). The eager participation of learners, instructors, and both governmental and non-governmental organizations in addition to the contents of the learning material have contributed to its success.

EVALUATION STUDIES: AN APPRAISAL

The increased importance being attached to the eradication of illiteracy by making it a social movement, necessitates the development of a comprehensive evaluation model encompassing the entire gamut of literacy campaign activities. In fact 'Ongoing Beneficiary Contact Monitoring' (OBCM) should be an in-built aspect of each campaign to constantly monitor, assess and judge the situation, and finally undertake remedial measures in order to achieve time-bound results.

This model of evaluation should take care of the four important aspects of literacy campaigns, namely, the physical aspects, programme aspects, the pedagogy, and the achievement of the participants. Besides this the monitoring and evaluation mechanism should identify the direct and indirect indicators in

advance in order to enable the programme organizers to tackle the situation at any time or stage in regard to the four aspects mentioned above. For each of these aspects the stage-wise outputs and results should be spelt out clearly. This will facilitate the programme organizers to understand the positive as well as negative factors contributing to the results achieved.

The monitoring and evaluation mechanism of each literacy campaign should clearly gauge the direct and indirect impact of the campaign. Such a wide web of monitoring and evaluation mechanisms would facilitate identification of the appropriate policy implications.

Finally, a word about the concept of Total Literacy. A perusal of the concept of Total Literacy in its totality makes one wonder whether the adjective total, refers to quantity, quality, or both. There is quite an amount of diversity of opinions regarding whether greater weightage should be given to the number of people made literate, or the retention of literacy, or on developing the potential of individuals to the fullest capacity, to facilitate effective participation in National development (Gaytonde, 1992).

REFERENCES

Andhra University. 1996. *Evaluation of Total Literacy Campaign: Nellore District* (External Evaluation Report).

Sandeep, P. 1994. *Seethamma Katha: Does Literacy Engineer Social Change?* New Delhi: I.U.A.C.E.

Gaytonde, S.N. 1992. *Participatory Approach to Total Literacy.* New Delhi: Indian Adult Education Association.

Vasudeva Rao, B.S. 1988. *National Adult Education Programme in Visakhapatnam District.* Bombay: Himalaya Publications.

10

Literacy and Empowerment: An Experiential Account of Using REFLECT as an Innovative Approach to Adult Education in Andhra Pradesh

Girijana Deepika, Yakshi, and Anthra

In this paper we discuss our experiences of using REFLECT (Regenerated Freirean Literacy through Empowering Community Techniques), an innovative approach to adult education and empowerment processes. In the year 1995–96, REFLECT was initiated on a pilot basis in the country, in 10 villages in the *adivasi* (tribal) areas of East Godavari district in Andhra Pradesh. This initiative took place through the collaborative efforts *of Girijana Deepika*, an *adivasi* people's organization supported by two Hyderabad-based NGOs, Y*akshi* and *Anthra*. The focus of this paper is on the evolution of this approach, the context-specific innovations in the process of its adaptation in the *adivasi* context, our key learnings from this experience and some reflections on the challenges and the potential that the use of this approach entails.

A Context for REFLECT

East Godavari district in Andhra Pradesh is located on the eastern side of the Godavari River and shares common borders with Orissa to the north, Vishakapatnam in the north-east, Khammam and West Godavari to the west and the Bay of Bengal running down the eastern and southern borders of the district. For administrative

purposes the district is divided into 57 revenue *mandals*, of which 11 are *adivasi mandals*. The district has a total population of 454 lakhs. The population of scheduled tribes is 1.73 lakhs or 3.8 per cent of the total population. The tribes inhabiting the 11 *adivasi mandals* are mainly comprised of the Konda Reddis, Koya Doras and Konda Kammaris.

The initiation of REFLECT came at a point when the *adivasi* society in the area was witnessing rapid transformations on all fronts. Land alienation was a major issue owing to large areas of *adivasi* land being occupied by non-*adivasis*. Agriculture in the area underwent a major shift from food production to commercial cropping of tobacco and cotton. Low crop yields due to uncertain monsoons as well as fluctuating market prices resulted in high indebtedness, serious food and fodder scarcities, and a deterioration of the overall health of the people. The rapid depletion of forest cover and increased commercialization and monopoly of forest produce by some agencies also failed to ensure fair returns to the people.

The concomitant impact of all these sweeping changes was a gradual erosion and collapse of the *adivasi* customs and cultural practices. Culturally, a range of outside influences such as popular cinema, music etc., made their gradual entry into *adivasi* society and culture over time. One cultural practice where this change is very obvious is the collective celebration of traditional festivals through singing and dancing which today are accompanied by the screening of popular cinema and music for entertainment. Construction of temples and celebration of Hindu festivals such as Ram Navami are gaining more ground in favour of local festivals. With regard to marriage too, practices are gradually changing from *woli*—'bride price'—to dowry. An important dimension of the whole practice of marriage is the question of tribal certificates, which are becoming increasingly necessary for gaining entry into educational institutions, access to employment opportunities etc. In many instances, marriages by outsiders to *adivasi* women occur merely as a means to gain certificates or to convert and register *adivasi* lands to their name.

Conflicting political forces in the area have prevented the emergence of any independent leadership amongst the people. Development interventions in the area have failed to provide any sustainable solution, largely because they failed to take into

account people's knowledge, needs and perceptions in the conception and implementation of several programmes. Health and education are two areas that have received relatively little attention in the *adivasi* villages in the district. Some of the major diseases affecting people in these areas are tuberculosis, malaria, goitre, gastroenteritis, skin diseases etc. Over 60 per cent of the women suffer from a range of gynaecological problems. The health facilities remain largely inadequate to meet the demands of the people. Private healthcare is limited and out of the reach of most *adivasis.* Lack of easy accessibility remains a major problem as most of the hospitals and primary health centres are located far away from the villages at *mandal* headquarters. There is also a gradual deterioration of indigenous treatment and healing practices with more and more people opting for modern allopathic drugs that are widely sold by petty traders and shopkeepers in villages.

With regard to education, a lot remains to be done. Even while going by official figures, the overall literacy rate for the district is 49 per cent and the literacy rate for the four *adivasi mandals* where the REFLECT approach was initiated ranged from 13 per cent (Gangavaram) and 16 per cent (Y. Ramavaram) to 26 per cent (Rajavommangi) and 27 per cent (Addateegala) respectively.

The government had made efforts to promote adult literacy in the area as part of the overall total literacy drive in the state. The *Akshara Godavari* project which aimed at adult literacy was introduced in the district. This programme however failed to make a mark owing to problems like lack of adequate infrastructure and poor participation from people. In most villages in the district, the adult literacy centres had functioned for a very short time before being closed down.

In the past decade or so, there has been a growing awareness amongst community based *adivasi* organizations in the area. In this context, the emergence of *Girijana Deepika* as an independent, *adivasi* people's organization is significant. The group was formed in 1989 with active support from local people. This was a response both to the clear absence of any local leadership in the area as well as limitations with several development interventions being promoted by NGOs, government and political parties. *Girijana Deepika* is a forum for the articulation of issues concerning *adivasis* and an expression of the *adivasi* people's struggle both for their identity as well as the demand for securing rights and control over

their resources. The core activists of the group are young *adivasi* men and women belonging to the native Konda Reddi, Koya Dora and Konda Kammari communities. In their ongoing initiative, *Girijana Deepika* has been supported by *Yakshi* and *Anthra* in training, capacity building, and financial support.

Despite our distinctive identities as three different organizations, our collaborative work over the past several years has formed a key basis for the conception of the REFLECT process in the *adivasi* context. The partnership has also been a continuous process for learning, sharing, growing, sharpening and redefining our perspectives and strategies over time.

ABOUT THE ORIGIN AND KEY ASPECTS OF THE REFLECT APPROACH

REFLECT, as an innovative approach to adult education, evolved as a specific response to an increasing awareness that adult education programmes the world over are failing. In the most fundamental sense, the failure of literacy programmes began to be attributed to the stagnation and standardization of literacy methodologies which are popularly characterized by the use of a 'primer', a centrally produced text meant for the learners.

In the early part of this decade, ACTIONAID, an international development organization in UK, sought to develop a new methodology with PRA (Participatory Rural Appraisal techniques), literacy and empowerment as key elements. The need and attempt in developing this approach was to both revitalize literacy and meaningfully link it to a development process enabling people to effectively decide the form and content of their learning and empowerment processes. This approach was first piloted in three countries—El Salvador, Uganda and Bangladesh—in three continents in very diverse contexts. It showed some very encouraging outcomes. In 1994 this approach was formally named through an acronym REFLECT—Regenerated Freirean Literacy through Empowering Community Techniques.

REFLECT draws upon and has evolved out of a diversity of theories and grassroots experiences which include the work of Paulo Freire, PRA, feminism, popular education, empowerment-based approaches to development, and the practical work experiences of several organizations in different countries, which continue to contribute to its further evolution and expansion.

The year 1998 brought several REFLECT practitioners together for a workshop organized to enable sharing of experiences, concerns, and innovations in using the approach. The workshop also explored some basic questions regarding the conception of literacy, power, knowledge, gender, stratification, and development in relation to the practice of REFLECT.

Based on intensive discussions on the above issues, the following definition for REFLECT was agreed upon which best captures its key aspects and practice today:

> REFLECT is a structured participatory learning process which facilitates people's critical analysis of their environment placing empowerment at the heart of sustainable and equitable development. Through the creation of democratic spaces, the construction and interpretation of locally generated texts, people build their own multi-dimensional analysis of global and local reality challenging dominant development paradigms and redefining power relationships in both public and private spheres. [Participatory Learning and Action (PLA) notes 32, International Institute of Environment and Development (IIED), London, June, 1998].

As this exhaustive definition indicates, the most fundamental characteristic of REFLECT is the absence of a primer as the starting point for learning. Instead, participants in a REFLECT process generate their own learning materials using a range of different participatory methodologies. They construct maps, matrices, calendars, and diagrams analyzing various key aspects of their lives in great depth and systematizing their existing knowledge. Intensive discussions, dialogues and, debates form the core of this process.

An aspect for which REFLECT is perhaps best known is its use of visualization representing local issues through the use of PRA techniques. Transferring the visual from the ground to the flip chart or a large sheet of paper forms the basis for introducing literacy in a meaningful context. Through a REFLECT process, each community will have a detailed analysis of the socio-economic, cultural and, political aspects of their lives. This analysis forms the critical resource and basis for community planning in order to evolve appropriate interventions which would shift the development agenda from the control of outsiders to the hands of people in the process.

REFLECT essentially is not a blue print model but a set of approaches which must be adapted to suit the local reality of each context where it is used. In practice then, no two REFLECT processes are similar despite sharing some common characteristics.

Revival and Redefinition of the *Gotti* — A Basis for Introducing REFLECT

Before we talk about our experiences with REFLECT, it is important to also talk about the revival of the *gotti*, which formed the most important basis for initiating the approach. *Gotti* was an informal community forum amongst the *adivasi* communities residing in the area. Long ago the *gotti* was an active forum, where people sat together to discuss their problems, resolved local conflicts, took collective decisions to celebrate festivals and for exchanging information in an informal manner. However, the impact of several changes over the decades have seen the gradual erosion of this forum in the *adivasi* area. The initiative to revive this forum by *Girijana Deepika* came against a context marked by a clear absence of any forum where people could interact on a regular basis, discuss issues, share information, analyse their own situation and evolve suitable strategies to address issues. The process of reviving the *gotti* began about six years ago. *Girijana Deepika* used theatre as a major medium for reviving the forum in the villages.

While people gradually began to get together through the *gotti*, in many villages, it was important to sustain this process and enable them to meet on a regular basis. In order to create a vibrant forum for discussion and sharing, there was a great need for initiating a creative educational process which would help people to organically link and relate issues and placing the same in a macro framework, examine internal contradictions within the community and stimulate debate and discussion.

In 1994, a member from *Yakshi* had the opportunity to participate in the first international REFLECT workshop at Bangladesh which marked the introduction of the approach in the area. Given the wide-ranging nature of issues that people in the *adivasi* area were confronted with, REFLECT as an innovative approach appeared to have immense potential in engaging people in a process which enables them to collectively identify major

issues affecting them, systematically analyse and understand the wider processes of change in order to evolve appropriate strategies for addressing their problems. The acquisition of literacy skills would also become meaningful in the process. In REFLECT then, there appeared to be possibilities for interweaving both learning and empowerment as mutually reinforcing processes.

REFLECT IN PRACTICE THROUGH THE *GOTTI*

Once the *gottis* were revived in the villages it was important to mobilize people on a regular basis, facilitate discussions and debate on issues and provide information wherever necessary.

Identification and training of facilitators

To begin with, local facilitators were identified from the villages. The facilitators were young men and women from the same community with educational backgrounds ranging from the fourth standard to the tenth standard. The facilitators were trained in a range of innovative approaches such as PRA techniques, theatre, participatory research, communication skills, human and animal health aspects. Gender and development were areas where perspective clarity was built as part of the theoretical orientation to the REFLECT process. Training however was not a one-time event but took place at regular intervals in response to feedback and the needs of facilitators.

Identification of key issues and analysis

The REFLECT process in the *gottis* was initiated with people identifying some of the major issues in the area and prioritizing the same, using visualization techniques. Some of the key issues which emerged after intensive discussions were those related to their livelihoods and survival such as agriculture, forest, health, livestock, gender etc. They were then used as the basis for the design and creative use of appropriate PRA methods, which would enable facilitators to explore various aspects of the above issues in an in-depth manner with the people.

To illustrate an example, people in most of the *gottis* began with agriculture as the first major issue. With the help of facilitators people constructed agricultural maps of the area, a seasonal calendar of crops, a matrix ranking of different crops and their uses, and a comparative analysis of production dynamics. They carried out a

profit-loss assessment of food and commercial crops, and analyzed gender roles, decision-making, and control in agriculture. This extensive analysis on various critical aspects involved in-depth discussions and debate at every stage. This analysis helped people to understand the shift in agricultural practices over time from slash and burn hill slope cultivation (*podu*) to settled cultivation and the causes for the same. The analysis further involved examining the impact of the above processes on changing cultural practices such as singing, dancing, and collective celebration of festivals. The construction of these visuals involved active participation of people and the process was marked by a lot of discussion, cross-checking and sharing information.

Literacy and numeracy components

The visual maps and calendars on the above issues, prepared on the ground, were transferred onto flip charts and this was used as a basis for introducing the literacy and numeracy components. People began with sets of key words and phrases associated with critical issues visualized in agriculture. They began by recognizing the shape and sound of the letters and gradually learned to write the same. Several creative techniques such as puzzles, theatre, games, stones, sticks, thread, song, dance, body movements etc. were used as part of the literacy process, making learning an enjoyable activity.

The local language used for teaching and learning (Telugu) was one that the participants are familiar with in their daily lives. All the key words and phrases used as a starting point for learning had a deep association with issues confronted by people. While these were commonly in use in a spoken form, many were in the written form. As the learning process progressed gradually, the participants also became acquainted with many words and phrases used in official Telugu. The numeracy element was facilitated through the use of money (currency notes and coins) keeping in mind the increased interaction of people with money and markets over time. While most of the participants can count, the focus of the numeracy component is to engage participants in simple arithmetic like addition and subtraction, and learning to write numbers using stones, sticks and local materials used in the PRA/visualization process.

Linking analysis to collective action for change

The most significant aspect of REFLECT in our experience is that the entire process of in-depth analysis, discussions and debate on local issues which is integrated with literacy activities does not stop here. This is further extended to a process of action for change, where the rich analysis generated collectively is used as a basis for planning and evolving suitable strategies and interventions to address the issues. To cite an example, a major initiative taken by people following the detailed analysis of agriculture, was the decision to grow traditional varieties of food crops to address issues of food security. There was the long-term objective of initiating community seed banks to conserve and regenerate seeds of traditional food crops. Other practical interventions have been in the form of collective attempts to protect and innovatively utilize local water resources in some villages, the development of backyard poultry as a viable economic enterprise, the conservation of rare and valuable medicinal plants through herbal nurseries etc. These initiatives over the years have been actively supported by *Girijana Deepika*, *Yakshi* and *Anthra*.

SOME CONTEXTUALLY MEANINGFUL INNOVATIONS IN REFLECT

In order to adapt REFLECT to the regional context, innovation was central to the process. To summarize some of our important innovations are

- The initiation of REFLECT through the *gotti* has been the most important innovation that has sustained the process. People have identified strongly with the *gotti* and the learning-sharing process associated with the forum. The initiation of *gotti* has over the years led to its democratization and redefinition giving rise to newer forms such as women's *gotti*, healer's *gotti* etc., enabling different groups of people in the villages to come together to discuss and address specific issues which affect them.
- There has been no packaged approach to the training of the facilitators. Need-based training and capacity building in a range of skills on a continuous basis has been a key factor in adopting this approach. Concurrent inputs on various aspects

were provided by *Yakshi, Anthra* and other resource persons on a regular basis. This capacity building process has also contributed immensely towards the development of self-confidence amongst the facilitators who have made a direct qualitative impact on the nature and depth of the analysis and discussions on different issues in the *gotti*. Inputs provided by the facilitators have built upon the analysis done by the people, enabling them to widen their information basis and link micro issues to macro factors and influences.

- Linking REFLECT to a parallel participatory research process has further enriched the process. REFLECT facilitators were engaged in a participatory research process, which focused on the indigenous knowledge systems of the *adivasis* in the area. The *gotti* formed a strong basis both for learning and sharing the outcomes of this research process. A large collection of songs, stories, puzzles, games and proverbs etc., collected through the documentation process were used for evolving fun activities in the *gotti*.

- Other innovations involve the creative use of local materials for visualization of issues as well as integrating local communicative practices such as singing, dancing, body movements, theatre, games, puzzles and the use of local language in order to make the *gotti* a vibrant place for learning and enjoyment. This also attracted greater participation by the people.

- To assess the impact of the process both on the facilitators and participants we also attempted to develop some innovative participatory monitoring and evaluation indicators. In some cases while this has been through collective reflection of experiences and learning, in other cases it has been through the use of participatory techniques and development of indicators such as attitudinal changes, level of awareness, greater gender sensitivity, increased self-confidence etc. Participants used games and puzzles innovatively in some instances to assess literacy skills.

- The expansion of REFLECT to some more villages through animal health workers, who facilitated this process marked an important shift in the process. REFLECT was innovatively integrated with livestock as an important livelihood issue and its close linkages to agriculture (cropping practices, fodder), forest (grazing, loss of important forest species), water,

diseases, indigenous healing practices and treatment methods, and gender roles in the management of livestock system etc. While participants in the *gotti* sought to systematize their vast knowledge and analysis on the above issues, an important value addition to this process was the innovative use of visuals in the form of posters and flip charts with additional information on these issues. In some instances, these were also used creatively for literacy practices.

SOME KEY LESSONS LEARNT

The practice of REFLECT in the area has seen many ups and downs over the years. This process was also marked by several intensive discussions, debates and critical reflection by both field facilitators and the support groups on various aspects of the approach. These sessions at various points also provided us an opportunity to look at the strengths, shortcomings, challenges, and potential of this process which are summarized here as key lessons learnt.

OUR MEANINGFUL PARTNERSHIP

The collaborative involvement of people from the three groups in the initiation of this approach has perhaps been its biggest strength and it proved to be a meaningful experience for everybody involved. This brought a fusion of ideas, perspectives, experiences, skills and inputs from different individuals. We also drew upon the experiences and resources of many individuals from outside. The active involvement of *Girijana Deepika* as a group with a strong political ideology and clear understanding of local issues gave a definite direction to the process.

REFLECT AND *GOTTI* AS MUTUALLY SUSTAINING PROCESSES

The active participation of people in the REFLECT process through the *gotti* has strengthened their ownership of the process. Both *gotti* as a forum and REFLECT as a process within it have evolved over the years as mutually supportive and strengthening processes. The *gotti*s were revived in the villages at a point when it was extremely important for people to discuss issues affecting them. The introduction of REFLECT then provided a structured participatory process for learning, sharing and strategizing for change. People strongly identify with this process through the *gotti*. Today, in almost all villages where there is a *gotti*, people have attempted to

give this forum a sense of permanence through the construction of *gotti pakha*, a thatched roof structure where they meet regularly. In some villages these are being used as schools for children during daytime.

FACILITATORS' OWNERSHIP OF THE PROCESS

Facilitators along with people have also been actively involved in the construction and generation of learning materials which has strengthened their ownership of the process. Given the fact that they belong to the same community, experiencing the same set of issues, internalization of the process by them has been as important while facilitating the same for others. Facilitators also regularly write and share their experiences with others through *Gotti Kaburlu*, a quarterly newsletter in Telugu (see Appendix). Information from the newsletter on various development issues is regularly used for providing inputs during discussions with people in the *gotti*. For instance, in the December 1999 issue of *Gotti Kaburlu* an article titled 'Who is responsible for people's health' is an outcome of the discussion in one of the *gotti*s. It dealt with the issue of common health problems (e.g., malaria, cholera, typhoid, diarrhea etc.) prevalent in the agency areas and the lack of health care facilities. The article raised questions about the role of the government, the NGOs and the family in protecting the health of people especially in the present context of globalization and privatization. The readers were asked to send their responses to these questions.

WOMEN'S *GOTTI* AND REFLECT

Much more than the revival of the *gotti*, its redefinition in the form of women's *gotti* has been very significant. This forum has provided women a critical space to voice their concerns and problems as well as understand the nature and forms of oppression in their lives. Today when women speak of increased self-confidence through their participation in the *gotti*, they are also speaking of a learning-sharing process which has enabled them to assert their right to speak and be heard in a patriarchal society. Equally significant is the impetus that this process has given them for a long-term training and capacity-building process. Women from these *gotti*s are assuming important decision-making positions in all the development interventions in the villages.

REDEFINING LITERACY THROUGH REFLECT

The practice of REFLECT has in our experience helped to strengthen our understanding and redefine literacy in new ways, by generating a whole range of alternative meanings including what is now referred to as 'communicative practices'. These include an interwoven set of practices such as singing, dancing, body movements, speaking, listening, reading, writing, language, and perhaps many more evolving forms taking literacy to a new and sophisticated plane.

Quite central to the practice of a REFLECT process is a 'negotiated curriculum' where people actively define and decide the content and direction of their learning process. Questions of power, participation, gender inequality, social stratification and the politics of development have formed part of this negotiation process. More importantly, this process has enabled *Girijana Deepika* as an *adivasi* people's organization to redefine and enlarge its own political agenda, significantly to include women's concerns and perspectives, as well as decision-making on various issues.

Much more than tangible gains in the form of literacy skills, for most people, participation in the REFLECT process has meant identification of major issues affecting their lives, exploring the micro and macro linkages of these issues, systematizing their knowledge base, critically interrogating their indigenous traditions and cultural practices as well as strengthening the best ones with changing times. At a personal level, for many, the process has meant attitudinal changes, increased self-confidence, higher levels of awareness, greater decision-making powers and confidence in their interaction with outsiders. In many instances the involvement of adults in the process has resulted in increased interest in ensuring children's participation in schools, the regular presence of the teacher, and the improvement of the quality of education.

A critical area within REFLECT, which is only beginning to receive more attention in recent years and is perhaps the less theorized is the issue of gender. It is also an area where this approach has immense potential, particularly at a point where many organizations involved in coordinating women's groups today, are looking for creative ways to sustain the mobilizational process.

In our experience, as REFLECT expands even within the same geographical context, the process assumes different forms and

directions. The challenge clearly is to sustain the quality of the process in a meaningful way. The availability of financial resources remains a challenge too, particularly with regard to the training of facilitators who play a catalytic role in a REFLECT process. Reflecting back on our experiences so far, the key to success we believe, is to interweave the process of discussion, dialogue and learning with the process of empowerment. At another level the challenge is also whether REFLECT can achieve the same level of micro-level mobilization and empowerment at a macro-level without diluting the process.

APPENDIX

P. 44 from *Gotti Kaburlu* magazine Bulletin 4, December 1999, is reproduced with permission. It is a collage of letters written by neo-literates who learnt through REFLECT. The gist of each letter is given on p.207

(1) I learnt about a common gynaecological problem from *Gotti Kaburlu*—P. Rupulamma

(2) The report about the farming practices of tribals from Khammam District is very good, but I would have liked to see names from our area—A. Tata Rao

(3) Thank you for writing about our village *Gotti*—P. Satyananda Reddy

(4) All items in the July 1999 issue of *Gotti* are very good. We are so happy to spread the news about our village *Gotti* to neighbouring places. Our people liked everything you included in this issue, which were written by the members of our *Gotti*—Srinu Babu

(5) I liked the report 'Are goats ruining the forest?' very much—A. Ramayamma

SOME PERSONAL REFLECTIONS ON LITERACY ISSUES

Rajesh Sachdeva

Having chosen to dwell on personal reflections there is an obvious danger that I may begin to talk of myself as the primary object and make my reflections secondary, and therefore, the need to dissociate the issues that lie buried under my perceptions is the first task on hand. Then, there is another task, of resurrecting from that lot those issues that are literacy related, grounded in everyday life that one chances to experience, but which leave their mark on our individual self, and which on being shared I hope, may be allowed an opportunity to become collective.

DILIP DAS ON THE HOWRAH RAILWAY STATION

While coming from Guwahati to Hyderabad, I had to change trains at Howrah, where I was forced to spend a couple of hours on the platform. Sitting on one of the concrete benches, I began thinking of an activist group in Bombay who had commenced literacy classes for the platform dwellers (a report on this had appeared on one of the TV channels), and in an effort to apprise myself of the complexities associated with such a task, started talking to some coolies, vendors and others, mentally constructing their linguistic and literacy profiles, diagnosing the causes of their migration and so on. Just then a shoe-shine boy, or rather a young man in his early twenties, walked up to me, and looking at my suede shoes that had gathered a fair deal of dust, asked if he

should polish them. Despite sensing the need for clean shoes, I was apprehensive about the efficacy of his method, but decided to succumb to the temptation of learning the technique, hoping also to have a bit of a dialogue to gather one more profile!

Off came the shoes as I pushed myself back to see the man in action.

'Kahaan ke rahne vaale ho?' (Which place do you belong to?), I asked.

'Orissa', replied the man.

'Kyaa tum padhnaa likhnaa jaante ho?' (Can you read and write?), I continued.

'Nahiin' (No), was his reply.

'Kyaa naam hai tumhaaraa?' (What's your name?).

'Dilip Das'.

'Ye nimn jaati ka hai na' (He is from the lower caste), I heard the young man sitting next to me say. I had been completely oblivious of my neighbour until then, but was immediately struck by the information he had chosen to give... an explanation of a social situation that he had gathered from the name and the correlation that he had struck in a moment, as though it was normal for a lower caste to be illiterate!

'Aur app kahaan ke hain?' (And where are you from?), I turned to that neighbour and asked, wondering if he too was from the state of Orissa and had thus understood the situation there.

'Bihar ke' (From Bihar).

I turned my attention back on Das who had begun transforming my shoe with his soap solution. What struck me was that he made no attempt to change the information given by the man from Bihar, as though the disclosure had explained not only his identity but also the occupation he had adopted on his arrival to this city.

For a few minutes I sat and watched him do the job as I continued making small conversation with both the men and learning more about the many migrants to the city from these adjacent states. When he had finished the job and was waiting for me to pay him the three rupees that he had truly earned and which I was happy to give, I decided to pull out my note-book and pen from the hand bag with the hope of teaching him how to write his name. The pen

had slid into some remote corner of that crowded bag and I was cursing myself audibly, declaring it was lost, when suddenly Dilip Das pulled out a pen from his box (which I thought contained only shoe polish and brush) and passed it to me!

The sight of a pen in his hand completely amazed me. An illiterate man with a pen! What could he be using it for?

'Aap kyaa karte hain is pen kaa?' (What do you do with this pen?), I asked him, my surprise all too evident. He opened his box again and pulled out a small blue diary. Opening the pages he thrust it in my hand. Several statements of accounts were written in legible handwriting.

'Is men hisaab rakhtaa hun' (I keep track of my accounts in this) He announced with a distinct look of contentment.

His declaration delighted me immensely. I was overcome with a strong sense of emotion. Here was a man who had learnt what he needed most. I wrote out his name in the *devanagari* script on that diary. Was there an ideology guiding my choice of script? He observed me keenly as I wrote. I was almost certain that as and when he was willing, he would acquire a script too.

A VILLAGE SAYING

I return to a setting in which I found myself an year ago in Mysore. This was a workshop on Sustainable Development. It was organized by a group that was committed to develop viable technologies for rural areas, where many concerned scholars from different fields had come to share their experiences. The organizers had thoughtfully invited a few people from the field of adult education as well. After a long time, having maintained a rather low and silent profile as listeners, one of these adult functionaries wanted to speak out his mind and in the session related to Alternatives in Education, he got an opportunity. He was seriously interested in questioning the role of education in rural development and fed us with the following saying from his village that has stayed in my mind:

'Thodaa padhaa kaam chhodaa 'Studied a little, left work,
Aur padhaa gaaon chhodaa Studied more, left the village,
Bahut padhaa desh chhodaa' Studied a lot, left the country.'

I have not ceased to wonder at the profundity of the village saying ever since. Education in its contemporary form is seen as uprooting the villager—taking him away from his traditional occupation, away from his village and people, away from his country. Surely we need to attend to this problem. As literacy workers isn't it our task to create a sense of rootedness, or do we not have an answer? When I shared this saying with a friend of mine, she immediately related it with the learning of standard languages, Hindi and English. Each language while helping to create links with another larger group, also insulates the learner and weans him/her away from the rural lot. Can one think of linguistic remedies of the kind the National Literacy Mission advocates—the use of spoken languages in literacy instead? The matter is far from simple and cannot be resolved with ease.

Before dwelling on these issues any further, let me take you to a village where I found myself after taking charge of a programme on Wagdi-Hindi bilingual education, meant to promote literacy and education among the primary school children of the Bhil tribes in South Rajasthan, which was initiated by the Central Institute of Indian Languages, Mysore, in 1984.

Mota Gaon

Mota Gaon is a large village in the Banswada District of Rajasthan. I had been brought to stay there so that I could visit the experimental schools chosen in another village, Sava ka Pada, considered to be rather backward and remote and which, I was told, may not have any secure place to stay. One of the Brahmin teachers, Mahendra Kumar Pandya, who had attended our orientation programme at Udaipur a few months before was from Mota Gaon and I was advised to stay with him, so that he could act as an escort and take me to that remote school. The Pandya family agreed to play the host, and in fact spared no effort to make me feel at home. A *chaarpaayi* in the verandah of their house became my abode for the next five days.

Since this was my first experience of living in a village, I felt excited about it and tried to find out as much about the village as possible. I discovered that it was a multi-caste village with each caste having its own territorial area. The residence patterns

were rather interesting. In the centre of the village was a temple and the upper castes, the Brahmins and the Baniyas, stayed in its vicinity, whereas the lowest castes stayed on the periphery. It was as though one could plot one's caste by plotting this distance from the temple! I am told that this is true of many a village elsewhere too.

In the village there is a primary school and also a high school. The Principal of the primary school had befriended us and having been impressed by our novel bilingual primers (in which both languages had been used and printed in different colours to help demarcate the boundaries), had taken one to try it out in his school. He insisted that we visit his school and I happily agreed. A few days later, I decided to go because by then, Bunty, Mahendra's seven year old son, who had become very friendly and was studying there, had also started insisting that I go. He wanted me to visit his class and I promised to do so. And so around ten in the morning I was in the school. Mr Jain, the Principal was very happy to receive us. He felt his school was a model school for the entire village which had been voted as a model village and received an award too. The school premises looked fairly clean and well kept and the children were busy as evidenced by the loud repetition drills in some rooms, and the clear voices of the teachers engaged in teaching in others. We were taken to one of the classrooms and as soon as we entered the children got up almost immediately, wishing us in unison and harmony. We asked them to sit down and then I could notice that there were children from all the strata of society in there. There was some difference between the more well to do, fairer, cleaner lot who seemed to be sitting right in the front and the ones in the last few rows. It was the same sort of a feeling when I entered the next class and then another class. Suddenly I found myself in Bunty's class-room, and there he was in the very first row, closest to the teacher. I immediately recognized some of his other friends who belonged to the upper castes sitting along side. I looked at the children on the periphery of the classroom and asked for their names. As the names were being given, the class-teacher also began to give me their caste background. There was a distinct pattern in the way the children were seated—the upper caste children in the front, closest to the teacher and the lower castes occupying the

peripheral space, almost, as though, the demographic residential patterns had been recreated in the classroom, and the teacher had taken the place of the temple deity!

This mapping of social structure, reinforcing the boundaries that exist on a caste-basis, enraged me, and I even mentioned it to the Principal, summoning my diplomacy skills to aid my manner of speaking, concealing my feelings to an extent. His point of view was that this arrangement was not at his insistence, but that the children themselves had created the patterns. Whatever be the factors behind this design of things, one cannot help but feel that inequality is socially constructed and reconstructed to be perpetuated. That these patterns were enduring was all too evident when two years later I went back to the school, this time with a TV crew, and captured similar pictures on the camera.

It would be no surprise, if one were to get additional linguistic evidence about socially differentiated varieties of Wagdi language from the setting. For instance, the upper castes use[r] where the tribals use[L] and so on. Since our primers had given primacy to the tribal variety, some of the upper caste teachers had debated the use of this non-standard variety and it had taken considerable effort on our part to convince them that our object of focus was the 'backward' tribal child.

A TRIBAL LEADER IN KHERWADA

Another incident that comes back with great intensity is the interaction with a local tribal MLA of Kherwada, in the Udaipur District of Rajasthan. Kherwada had been chosen as one of the places for the introduction of our bilingual education experimental programme and I had been there on a few occasions to launch and evaluate the programme. In fact, part of the programme was to orient 30–40 teachers every year at a camp in the State Council for Educational Research and Training (SCERT), Udaipur, who could help run the programme as it spread beyond the experimental schools. During one of these programmes it was decided that all the teachers be taken to those schools for a try-out of their techniques of teaching. And so we all landed in Kherwada in a hired bus. Having completed a rather arduous, but enjoyable task, and having begun feeling that we were

really doing something worthwhile, all of us had gone for a cup of tea to a nearby *dhaaba* (a small eatery) in the evening. I had my tea sooner than the others and returned to the bus, when one of the teachers came back to me asking me to go and meet the local MLA who wanted to speak to me. I asked for his name and was surprised to learn it was the same person who was the *Pradhaan* (village chief) when I had come in 1984 to launch the programme. He had seemed helpful on that occasion and therefore I walked to meet him without hesitation.

The MLA was seated in the same *dhaaba* and didn't look too friendly. When he saw me he began hurling accusations at me, my organization and the Government, for starting this programme—the teaching of Wagdi in schools at the cost of Hindi. His point of view that was conveyed in a most agitated tone propounded the viewpoint that their tribal mother tongue was quite useless for education and any attempt to continue the programme would only harm the tribals by reinforcing their separateness. Hindi was far more useful and worthwhile, in his opinion. Surely he had a right to express his opinion, but was this the best way? And then, it occurred to me, perhaps he was using the occasion to project himself as the champion of people's cause, which he thought, he understood best. The whole lot of teachers who had come to our camp formed a large audience, and the stage was set for him, especially because there were also some State Government officials besides us from the Central Government. It was provocative indeed, and could easily have resulted in an ugly scene. One had to summon the entire rationale into the response that was carefully articulated, knitting a discourse of complex issues such as (a) that the literacy level in the tribal areas was among the lowest in the world; (b) that the attempt to move to 'Hindi only' was dysfunctional as the children and the parents knew Hindi only partially. Wagdi being the mother tongue was the better known language; (c) that the experimental programme was using the mother tongue as a strategy rather than its goal and; (d) that the tribal dialects were not worthless as he made them out to be. The encounter did come to an end with some amount of misgivings on both sides.

As time has passed, the heat may be no longer real, but the question of attitudes and their roles in shaping literacy programmes

has survived. Must one take these attitudes into account while deciding on the choice of code? What if within the same community there are opposite tendencies or points of view? Do we have the right to experiment and portray our views as more valid prior to their being proven conclusively? Should we ever advocate the same solution for all? Can diversity be sustained by policies that are entrenched in uniformity? What are we to do about discourses that seek to link diversity with disparity, making the former a cause for the latter?

ON LINGUISTIC REMEDIES

On that trip to Rajasthan, I was beginning to believe that mother tongue education was indeed a remedy to many of the ailments in the domain of education, a panacea of sorts that could transform the illiterate setting into a literate one. It took me some time to come out of this framework to realize the *naïveté* of the view, for in according the mother tongue the pivotal role, one had either concealed or ignored the many other complex, dimensions which are separable more in theory than in actual reality: social, psychological, cultural, economic, and political—each no less important than the others. In engaging ourselves in literacy work, our remedies need not be biased by our expertise. Don't we need to emancipate literacy issues from the clutches of those experts who envision modes of intervention that maximize their own relevance and minimize the relevance of others?

The linguist's job is to lend his/her expertise to issues that are intrinsically linguistic, as for instance, those involved in describing felt linguistic boundaries and the problems that the learner may have to confront in transcending them. In the Rajasthan programme, our interest in creating better control of the school language, Hindi, by utilizing the literacy skills in the mother tongue Wagdi, did provide an opportunity to design explicit code-differentiation techniques, which helped the learner to recognize the differences that exist between them, as also the many similarities that helped in actualizing the transfer. This exercise was helped in no small manner by the correspondence patterns that prevailed between the languages, which could be systematized to obtain many pairs of partially differentiated sets of words, for example:

Hindi		Wagdi	
ch,chh, sh	→	*s*	
s	→	*h*	
h	→	*zero* (i.e., this sound is not pronounced)	
chaand	→	*saand*	'moon'
chhatri	→	*satri*	'umbrella'
shaam	→	*saam*	'evening'
saap	→	*haap*	'snake'
haath	→	*aat*	'hand'

Such simple pairs were given in the exercises and that did help in creating certain mechanisms for recognizing the linguistic boundaries, as also the kinds of errors tribal children have been 'programmed' to commit in their acquisition of the school language. While the efficacy of this pairing technique was enhanced by resorting to the use of two different colours, red for Wagdi and blue for Hindi, we need more empirical data for a wider application involving unrelated and distant languages.

A POINT OF DEPARTURE

If literacy is a socially constructed phenomenon so also must be illiteracy. It is to this point that I turn while making a final disconnected piece of discourse, but I will also leave behind a suggestion for those interested in a concrete line of action.

When I say that literacy is socially constructed, I am pointing at the role of the conscious human effort that has gone into it, and when I include illiteracy in it, I am pointing at the two possibilities that either this conscious effort has been inadequate to cope with the ever increasing number of illiterate people or more cynically speaking, it has succeeded in keeping the issue of illiteracy and inequality intact. Yet, at this point I am going to adopt a more optimistic line. One need never wait for utopian situations to occur before commencing the construction of literacy. That many a factor—motivated learner, sympathetic teacher, literacy background of the community, materials in the mother tongue etc.,— contribute to a conducive environment for successful learning is well documented. But what is more important to note is that none of these constitute essential or necessary conditions whose absence is sufficient to prevent literacy from taking root. On the

contrary, even if one of these factors is made to optimize its functioning, it may compensate for the malfunctioning or non-functioning of the others. Therefore, a truly motivated teacher may be able to achieve his/her goal even if he/she has no primers in hand, has no blackboard to write on and no money being offered, for he shall construct his materials on the spot, use the mother earth to write on with a twig if need be, and seek contentment even in the blessing of motivating the learner through his involved performance. This might sound idealistic to some, if not impossible, but to my mind it offers a point of view that has the seeds of emancipation. As a linguist, I feel inclined to suggest that even the sharedness of language, much less the existence of a settled script, to be used may be secondary to the seriousness of intent: if a Malayali from Kerala lands in Nagaland in an Angami village, he can commence a literacy class in Devanagari script or Malayalam or Roman script. That the literacy is in a script that no one else will understand may invite the sceptic to say that this will lead to dysfunctional literacy, but, to my mind, that is not the central issue. The point is — the literacy endeavour need not be viewed as conditional. How else would one explain the work of the missionaries? The only condition that is necessary is that of human agency — either in the form of one's own self or another — committed to the act of literacy creation by setting aside time for the purpose.

A Plea for a Forum

Literacy is not to be the concern of any one nation alone, for it affects the fate of mankind in general. To actualize the slogan 'education for all', all those who are educated need to delve into their deeper selves and participate in some way or the other to be involved in bringing about this change. Since the size of the problem is large, the solution must be proportionately large. Yet, if the endeavour has to succeed, it must allow each of us to continue with our own lives, and simultaneously, participate to some extent in the process of creation. We need to create an ever expanding 'literacy forum'. There are illiterate, semiliterate and less literate people all around us. We need to take a conscious decision to initiate participation in our everyday lives by alloting whatever time we can set aside — daily, weekly, fortnightly — to talk to the maid who comes home, to talk to the vegetable sellers, the cobblers,

drivers, peons and all those who may be receptive. Even teaching 'one word' a day to someone can create a micro-link in the bridges we want to build. We need to get organized at the neighbourhood level—just our own immediate vicinity. Literacy must become an issue of communication in everyday life. The snowball effect of this can be quite exciting and all of us can collectively participate in building our own society.

12

LITERACY PEDAGOGY: THE WEST BENGAL SCENARIO

Sandip Bandyopadhyay

The recent decades have been witnessing a growing interest in language which is now considered central to any socio-cultural discourse. Alongside this, literacy, an integral component of language, has also assumed new dimensions and is no longer treated as an act of recognizing the alphabet only. It is, as Freire (1987) notes, an act of 'knowing and creating', an act of 'critical thinking'. In line with the same paradigm, Gumperz (1986) and Street (1984) have stressed the ideological and social construction of literacy. While Gumperz defines literacy as 'a meta-cognitive process which makes other cognitive and social developments Literacy Pedagogy possible' (p. 3), Street's ideological model insists on knowing the learners' social context and the practices they are interested in. Reading and writing skills, observes Street, become relevant only when a 'proper context' is created for them.

Along with the current studies in linguistics, the new concepts of learning propounded by Piaget (1971), Olson (1985), and others, have also brought about a radical change in the theory and practice of literacy. Knowing, argues Piaget, does not mean receiving information only; it means reacting to it (the reality) and transforming it by reconstructing a new world of knowledge. This holds true for literacy as well. To read a word is also to read the world, observes Freire.

These new dimensions, however, have hardly left any impact on the pedagogic thinking and practice in our country. Save

a few innovative attempts, while the nineteenth century convention of teaching the alphabet through sounds and letters continues to prevail, the content of literacy primers often reflects an outlook that treats the learners as passive recipients of some prescribed information only.

The present paper which concentrates on West Bengal seeks to make a critical review of the teaching-learning process now taking place in the state in the field of literacy and adult education. It also aims to suggest an alternative approach in line with recent studies. Finally, I shall try to illustrate my point with bits of my experience of working in literacy over the past several years. To be precise, the paper will not go into the statistical evaluation of the ongoing programmes and will concentrate on the pedagogic aspect only.

IN THE NAME OF NON-FORMAL EDUCATION

The teaching-learning practice as found in the so-called non-formal education (NFE) centres run by the NGOs presents a bizarre scenario. While, one section still clings to *Varna Parichaya* (1855), the celebrated Bengali primer written by Iswar Chandra Vidyasagar over 140 years ago, another section makes do with cheap bazaar primers that have nothing to do with NFE. And some organizations use the primers prepared by Bengal Social Service League, which is the State Resource Centre (SRC). Whatever be the book, the method in practice remains almost the same: the students learn to spell words by rote and copy out their graphic forms written on the blackboard by the teacher. They do this exercise often without knowing what the words they are learning, stand for. At several centres, when I asked the teachers how they would explain the meanings of the words which were completely alien to the learners' real life, they frankly admitted that they never cared to explain.

Words, we know, acquire meanings in relation to the context in which they are used. This context stimulates the learners' thinking and induces them to construct meaning on the basis of their prior knowledge, or what Chomsky terms 'competence' (1988). Listening and reading is thus a meaning making process. The graphic code of language itself provides no meaning. As the child listens or reads, s/he supplies her/his conceptual input to move from the code to the message and thus get to the meaning, which is the ultimate goal of learning. The meaning of a word, as

Vygotsky (1962) put it, is thus 'a close amalgam of thought and language' (p. 120).

Now, if the learners are exposed to a list of alien words and then asked to memorize only their phonics, the essential creative part of the process is lost. The exercise ceases to be an interaction between thought and language and results in, what Goodman (1982) calls, a 'short circuit' in the learning process. Children, in this process, only learn to spell and write (read 'copy') a set of words given in the book. They cannot find their meanings; nor can they 'generate' new words/expressions on their own. To cite my personal experience, it so happens that a child who has learnt to write such unfamiliar words as *gagan* 'the sky', *dhaval* 'white' given in the book, fails to write, say, *ghar* 'home', *jal* 'water' or *bol* 'ball'. The crude fact is that she has never been helped to learn the words which are far more relevant to her day-to-day life. She fails to make new words because of the inherent defect in the teaching system which insists on rote learning only. Drills in patterns, Chomsky has consistently maintained, does not lead to language acquisition: it is more important to internalize the underlying system of rules.

THE STATE PROGRAMMES

Since the early 1980s, literacy primers produced by the official agencies in West Bengal have done away with the old alphabetical method and have been following the whole-word approach. *Kisholaya* which is used in all the Bengali-medium primary schools in the State introduces the alphabet through a series of couplets each of which highlights a key word. *Parbe Esho*, Developed by the SRC and meant for the NFE centres for learners in the 9–14 age group, also follows the word method.

While both the primers break through the age-old convention, the innovative prospect offered by the new approach has been belied by inept handling of the methodology and the dull cultural content of the books. For example, in *Kisholaya* each couplet is, in fact, a statement and often a moral instruction which poses no question and is often too remote from the child's universe. Consider the following verse; 'If you get into debt, you'll repent afterwards'. What sense does it make to a child?

The NFE primer, *Parbe Esho*, begins with a picture of several children playing, flying kites etc. The picture is captioned

aamra 'We' —the first key word the book seeks to introduce. A pre-captioned illustration, I would argue, doesn't stir the learner's imagination and offer him the freedom to decode the figure on his own. In practice, as I have seen, no child identifies the children in the picture as 'we'. She rather describes them as: a boy is flying a kite, a girl is playing, and so on.

This mode of descriptions is very significant because children, as it has been found, use less lexical items and prefer to describe a thing or an event in the form of a story. Their mode of narration is often 'process-like' and story-based (Halliday, 1987). Once, in a Calcutta slum, I showed some children the picture of a family staying on the street. I asked them why they were staying so; the answer I got was: 'These people had their home in the village. It was destroyed in the floods. So they have come to the city'. But why are they on the street? Why haven't they taken a room in a *bustee* (slum)?, I asked again and expected that the children would point to the paucity of living space in the already overcrowded slums. But the reply they gave proved far more knowledge-based. 'They didn't go to a *bustee,* because in a *bustee* one has to pay rent for a room, you know', explained a boy.

Learning, says Piaget, involves creating a new world of knowledge; and knowledge is not a static entity; it evolves in the process of interaction between the prior knowledge and the lived experience (Olson, 1985). The above example bears this out in clear terms. The picture presented had a message encoded in it. The children not only decoded the message but added a new meaning to it. Supplying pre-packaged information, in the name of teaching, fails to explore this potential.

Saksharatar Pratham Path, the National Literacy Mission (NLM) primer for adult learners, introduces the same word *aamra* 'we' as the first generative word and the method it prescribes is this: The teacher is to write down the word *aamra* on the blackboard, tell the learners that he/she has written *aamra* and then go on to point out the individual constituent letters such as *aa, ma* etc.

The problem with this method is that it may end up in grafting sounds to signs (letters) and thus go against our natural experience which is the other way round. Signs themselves have no sounds intrinsic to them just as printed marks are not surrogates of sounds. We utter speech sounds by a natural,

'innate' process and then learn to recognize certain letters as signs or symbols of those sounds. Moreover, words spoken do not represent their corresponding signs at the alphabetical level. We deal not with individual letters but with a word as a whole and learn to identify the letters as the constituent elements of that word.

At the second stage, the method under review shows the learners how the letters recognized can be joined together to make new words and how sentences can be framed with them. This exercise doesn't encourage the learner to speak her own word and often produces mechanical sentences which serve a didactic purpose only. For example, on page three of the said book, adult learners are asked to read such sentences as: 'Houses are close to each other. Various types of mangoes. Karim and Raghav are close by'. Such unconnected and often artificial sentences lack the dynamism of language in use. Bruno Bettelheim (1982) thoroughly discards such 'empty sentences', because they dull the learner's mind. The text, observes Bettelheim, should give the reader the feeling that 'I am reading something that adds to my life'. It is on this score that the said primers notoriously fail.

A pedantic and proscriptive tone actually informs the entire cultural gamut of these books and it is more pronounced in the NFE primers designed by the SRC. The learners, most of them working children, are asked to remember the following maxims: 'we must work', 'we are not idle', 'we do not neglect our duties'. Scanning through the pages of this primer one cannot but have the impression that we have only one thing to do to our children: advise; and children have only one thing to do: to remember the rules of good conduct.

This pattern of thinking also permeates the NLM primers. These adult learners are advised to unite because unity ensures strength, to be careful and economical about money and not to beget too many children because 'that will create problems. They (the children) will lack proper means and suffer from diseases frequently'.

Let us look at the question more closely by concentrating on two textual pieces; the first one is from the NFE primer for the teenagers and the second from the NLM primer for adult learners.

Text-1: 'We work a lot. We play in our spare time. We never neglect our duties. We don't have much work to do in the

afternoon. And then we play. We go to swim. We jump about. We play (with a) ball. Playing makes a sound mind. It makes one strong.' (*Parbe Esho:* 15)

It is obvious from the text that 'we' here does not represent the children's voice. Sentences have been composed by the author(s) and just put in the children's mouths. The text in no sense reflects how children actually think.

Normative in approach and pedantic in tone it embodies adult ideology—an adult's notion of how children should look at themselves. It violates the basic principle of critical pedagogy which holds that the learning material should be sensitive to the learner's life-world, should respect her own language and encourage her to bring her prior knowledge and experience of language to the learning situation.

Text-2: 'We suffer in various ways. We are mostly to blame for this. We suffer because we do not know how to read and write. We do not know the new techniques of work; and for many other reasons. The society—the State structure is responsible for some of our sufferings. It needs to be changed.... However, we ourselves can eliminate some of [the] causes; for example, our lack of literacy, our ignorance of the (new) techniques of work, our lack of awareness of our rights and laws and the benefits of a small family.' (*Saksharatar Pratham Path*, p. 43).

The presumed intention of the text is to make adult people aware of their rights and responsibilities. But behind this noble intention, there is a 'hidden curriculum'. First, people's suffering has been presented as a 'problem' not a structural problem but one related to people's ignorance. Hence people themselves have been held responsible for their plight. Second, in the text, a problem is given, and the solution is also given. There is no room for dialogue; people have no freedom to reflect upon their condition and find out how they can change it. The reference to the 'State structure' sounds like a stray comment; it doesn't invite the learners to express their views on the State. Third, poverty here has been linked with population and people have been given to understand that the problem of poverty can be resolved by controlling population. Finally, the text seeks to drill into the learners' mind that they must change their behaviour and attitudes in order to improve their condition of living.

Obviously, the entire text has been designed from the perspective of the State and not from that of the learners. It is a glaring example of how the State ideology penetrates into a pedagogic practice and seeks to mould people's cognitive structures with its chosen norms, values and morals. Such a practice aims, according to Freire, to 'domesticate' the learners and in effect alienates them from the very learning process. It is pedagogically wrong and ethically atrocious, to say the least.

TOWARDS A NEW LITERACY

The first point to note is that neither a child, nor a non-literate adult approaches language with a clean slate. She has an innate language faculty and a rich conceptual framework which she has acquired through her experience of life. The task of literacy is to enable the learner to bring to the learning process the knowledge that she already has and help her build on it.

Second, we use language not merely to receive or communicate information. It is with language that we make sense of the semiotics of things and phenomena around. Language is a means of both reflecting and acting on things. As we learn a thing, we also learn how to mean it and thus develop a 'meaning potential'. The method of language learning therefore should see what language can do or rather, as Halliday (1978) puts it, 'what a speaker, child or adult can do with it'.

Third, knowledge has no one authoritative source; it is a product of an interactive process in which both the subject and the object take part. Literacy therefore cannot disregard the learner's intuitive or common sense view of the world and should aim to encourage discourse-based understanding through dialogue (Freire). Instead of preaching instructions, literacy should start from where the learner is and explore what s/he already knows. Rabindranath Tagore kept this in mind when he included in his Shantiniketan curriculum an item of 'sense-training'.

As knowledge is culturally constructed, the curriculum needs to be culture and community specific and sensitive to the learners' milieu. In our country Mahatma Gandhi had envisaged need-based and context-specific education long before the idea became popular.

We are therefore not proposing something too ambitious; nor are we drawing upon 'foreign' ideas only. Nearer home, we have

the glorious example of Nellore in Andhra Pradesh where an adult literacy programme sparked off an anti-liquor movement led by village women. The innovations made by KSSP in Kerala, Eklavya and now the now defunct Kishore Bharati in Madhya Pradesh are some of the outstanding examples referred to at the outset of this paper. In Calcutta also, some organizations are trying to make a breakthrough. The Ashirbad School at St. Joseph is an example.

As a literacy worker, I have seen how children create new expressions and add new meanings to things. One day I was looking for the right expression for the word: *majuri* 'wages'. A boy who works as a daily wage labourer helped me out: *'khatnir paisa'* —'money received for labour' —was the expression he rattled off spontaneously. Another day we wanted to know: why does a rainbow come out? 'It comes out', explained a girl, 'to say that the rain has come to an end.'

In the literacy primer I developed for the Calcutta sex workers, we began a chapter with the traditional definition of family. Our intention was to see how the students would react to the definition that was certainly not relevant to their life-context. They did react and the dialogue that followed, tore apart the given definition. In the process they created a new expression to differentiate between a housewife and a sex worker. A sex worker, they said, is a public woman—*barbanita,* whereas a housewife is a *gharbanita* 'a woman tied to a home'. The first chapter of the said primer began with the picture of a woman sitting alone in a room, apparently lost in thought. The figure had some visible hints to indicate that the woman was a sex worker and she was thinking of her original village home. Our students perfectly decoded the picture on the basis of the suggestions given and identified the woman as 'a girl like us'.

The question—what is the woman thinking about?—however, yielded different answers based on different impressions. While one learner said that the woman hailed from a village and was thinking: 'shall I ever be able to return to my home?'; another one explained: 'lured away and later deserted by a young man, this woman finally rented a room in a red light area. She had to borrow a huge sum of money for this. And she is now anxious about how she will repay the loan'. The third answer held that 'the woman was now earning (money), but she had "no happiness in her mind";

and she sits alone, wondering: Oh, shall I ever be able to get out of this unclean world!'

All the three answers reflect a dilemma that is intrinsic to a sex worker's life. And what is interesting is that the learners try to frame a story and then hint at the dilemma in the course of their narration. Brought up in the oral culture, these women have little acquaintance with the dense form of the written mode and their language is therefore process-like, descriptive and often story-based. Marked by distinct semiotics, their language seems to have a specific model of signification.

My contention is that literacy material should try to grasp this specificity and be sensitive to the learners' own language. Otherwise, literacy will not enable the learners to use language for communication of meanings and messages. Exposure to the learner's own language actually induces her reading skill. It so happens that a learner who is not good at reading can perfectly read a sentence if it is his/her own. I would sometimes write a sentence on the blackboard which one of the learners had just uttered and ask her to read it. The response in most cases was positive. While working with slum children one day I asked them to say the things they were seeing around. They said various things and when I was writing them down on the blackboard, a boy cried out: 'You see, master has taken up my word!'. By 'word' he obviously meant language and for him it was a discovery that his language has been transformed into another form. This discovery creates in the child the same sense of wonder that she has when she first sees her photograph or her reflection in a mirror. And once she feels it, language learning, indeed becomes fun to her. Naturally, the child will try to get more fun by playing the game herself.

We can cite numerous such instances to show what the students, child or adult, can do with language if they are only given the freedom to speak up. The pedagogy of literacy, as it is usually practised, rarely offers them this freedom. This is the most tragic part of our literacy enterprise.

REFERENCES

Bettelheim, Bruno and Karen Zelan. 1982. *On Learning to Read.* New York: Alfred A. Kno pf.

Chomsky, Noam. 1988. *Language and Problems of Knowledge.* Cambridge: MIT Press.

Freire, Paulo and Donaldo Macedo. 1987. *Literacy: Reading the Word and the World.* London: Routledge & Kegan Paul.

Goodman, K.S. 1982. *Language and Literacy.* London: Routledge & Kegan Paul.

Gumperz, J.C. (ed) 1986. *The Social Construction of Literacy.* Cambridge: Cambridge University Press.

Halliday, M.A.K. 1978. *Language as Social Semiotic.* London: Edward Arnold.

————. 1987. 'Spoken and written modes of meaning'. In R. Herewitz (ed) *Comprehending Oral and Written Language.* New York: Academic Press, pp. 79–80.

Olson, D.R. (ed) 1985. *Literacy, Language and Learning.* Cambridge: Cambridge University Press.

Piaget, Jean. 1971. *Biology and Knowledge.* Chicago: The University of Chicago Press.

Street, Brian V. 1984. *Literacy in Theory and Practice.* Cambridge: Cambridge University Press.

Vygotsky, L.S. 1962. *Thought and Language.* Cambridge: MIT Press.

13

Culture-Specific Literacy Work: The Chhattisgarh Experience

Ilina Sen

Introduction

This paper discusses the experience of Rupantar, an NGO based in Raipur district of Chhattisgarh (erstwhile eastern Madhya Pradesh) in carrying out a literacy programme based on peoples' existential needs, in their mother tongue, utilizing their existing organizational structures. The period is 1990–92, and the experience was made possible through a project grant from the National Literacy Mission (NLM) for the express purpose of trying out an innovative approach. In this article we will briefly discuss the general approach of Rupantar, the specificities of the regional context, the premises and parameters of the literacy innovations carried out by it, and attempt to draw some general conclusions.

Rupantar: The Implementing Agency

Rupantar was registered as a public charitable trust in New Delhi in the year 1994. However, the group that formalized itself as Rupantar began work in and around Raipur in erstwhile eastern Madhya Pradesh, present day Chhattisgarh, from 1989, with developmental and educational activities. This was in keeping with Rupantar's charter of working with those who have been marginalized in the formal process of development.

An element of conscious choice was involved in the setting up of Rupantar. The founders of the organization had been until then, full time activists with the workers' movement in Chhattisgarh, and had worked in the southern part of Durg district. The move to Raipur was intended to gain access to issues of development from a more centrally located regional perspective, to analyze and seek solutions to the dysfunctional aspects of development from a non-sectarian platform, and to play a greater role in the intellectual and social life of the region.

In the early years, most of the activities were carried out on a voluntary basis. However, the collaboration and support of other organizations, irregular but committed financial support, and the support and response from the community, helped the organization to establish itself and formalize its activities. Over the years, Rupantar's work has come to be focused on the thematic areas of education, health, gender, and biodiversity conservation. It has a dual focus and involves itself in macro-level advocacy issues as well as community work.

The founders of Rupantar were fortunate to have had the opportunity to have worked with two of the major experiments in social development in Madhya Pradesh, viz., Kishore Bharati, and the Chhattisgarh Mines Shramik Sangh (CMSS). Kishore Bharati was an educational and developmental effort located in the Hoshangabad district of Madhya Pradesh, which parented the work in discovery-based education in the state, and whose educational work was taken over by the Bhopal based Eklávya after its demise. The CMSS, located in Durg district in the Chhattisgarh region later grew into the Chhattisgarh Mukti Morcha (CMM). Founded by the late Shankar Guha Niyogi, it was a unique trade union that combined militant workers' struggles with social sector experiments under the control and management of the workers in the areas of health, education, and culture. Rupantar benefited greatly from the philosophical insights of these efforts, and throughout the years, the effort has been to maintain theoretical and ideological clarity about the interventions we make.

THE REGIONAL CONTEXT

Before proceeding further, we would like to introduce a small backdrop to the Chhattisgarh region where Rupantar has

chosen to concentrate its efforts. Chhattisgarh is an ecologically, linguistically, and culturally distinctive region. Administratively, it comprises the seven eastern most districts of Madhya Pradesh, viz., Raipur, Durg, Rajanandgaon, Bilaspur, Surguja, Raigarh and Bastar. In the winter of 1998, some of these districts had been subdivided into smaller administrative units. The common spoken language in the area is Chhattisgarhi, and its several variants. Chhattisgarhi is commonly believed to be a derivative of eastern Hindi. Unlike the other branches of eastern Hindi however, it does not have grammatical gender, and is quite distinct in its vocabulary and usage. The culture of Chhattisgarh is considerably influenced by the culture and ecology of the areas on its border, Mirzapur, Ranchi, Gumla, Gadechiroli and the Telengana districts of Andhra Pradesh. The Chhattisgarh region has a large area under forest cover, rich mineral reserves (limestone, quartzite, iron ore, bauxite, alexandrite). It also has a large tribal population. The river Mahanadi flows through the central part of the region, and the plains areas in the river valley are famous for rice cultivation, with input-intensive heavy yielding varieties having replaced traditional seeds in much of this region. Along the railway lines that pass through the valley centre, there has sprung up over the last 20 years an industrial belt with three large cement plants, steel rolling and re-rolling mills, and a large mixed industrial estate. The population is mixed around this industrial and urban belt. In the rural areas of the Mahanadi valley, Other Backward Castes (OBCs) like the Sahus and the Kurmis dominate agriculture, and the Satnamis form a major part of the scheduled caste population. Caste tensions have been a fact of life, particularly in the eastern part of Raipur, and in the Bilaspur district. While the process of modernization seems to be apparent in the valley areas, the situation in the forest and hill areas on the periphery of the district is quite different. Although being affected more and more by invasive forest and mineral exploitation, traditional lifestyles and population compositions have survived to a far greater extent here. Some of the areas, dominated by the Gond, Halba, Kamar/Bhujia and Oraon tribes have recently been included in the sixth schedule notifications.

Chhattisgarh was known as the rice bowl of Madhya Pradesh. However, the large mineral reserves have led, to a major

industrialization process in the post-independence years, beginning with the Bhilai Steel Plant in Durg in the 1950s. This has impinged on the soil and water resources of the region, and major displacement has been caused by this brand of development. There has also been a major influx of outsiders to these centres of industrialization. This, together with the prevailing pattern of seasonal migration of the impoverished rural poor to the brick kilns and construction sites of upper India, has changed the population composition over the years.

There has been a traditional distinction between the *chatar raj* (the governance in the plains), and the *jangal raj* (the governance in the forests and hills). This distinction has been reinforced by the process of development where the jungle has become the material reserve and hunting ground of the plains. Dams have been constructed in the hills and the plains (e.g., Gangrel Madamsilli and Rudri dams in Raipur on the Mahanadi river and Bango dam on the Hasdeo river in Bilaspur) to feed into the industrial process, and a situation has emerged in which the exploitation of mineral reserves under the soil cover is in direct conflict with the preservation of what is above—the forest, agricultural soils, and water. Politically, the demand for a separate state was articulated by the big landowners and traders turned industrialists. This contributed to the communalization of politics and the onslaught on the democratic self-organization of local movements.

RUPANTAR'S LITERACY PROGRAMMES

Between 1990 and 1992, Rupantar ran an innovative literacy programme in 90 villages, spread over parts of Raipur district. During the programme, a literacy primer called *Nawa Anjor* 'new light' was developed, and considerable work was done on teacher identification, motivation and training. A teachers' book called *Saksharata Sangwari*—'literacy companion'—was also developed. The programme had the following main dimensions.

Organizational aspects

One of the assumptions behind the formulation of the programme was that literacy programmes had historically been unsuccessful because they had been imposed from above, and bore

no relationship to the lives and struggles of ordinary people. It was argued that the chances of the successful acceptance of the programme by the community would be greater, if the programme was woven around the existing organizational structures of the people. This argument was carried to its logical conclusion in the implementation of the programme. Each of the 90 villages was chosen on the basis of the ongoing organizational processes there, be they workers' organizations, caste groups, women's organizations, or youth groups. An interesting experience from the period of mobilization was that workers' organizations and trade unions which were affiliated to a larger body, had a lot of hesitation in allowing their members to be associated with a literacy programme. · In two cases, we put in a lot of time and energy into establishing a dialogue with such organizations. In both cases, we were ultimately unsuccessful in answering all the questions and clearing all the doubts from the minds of the organizers and the leadership of the organizations. In contrast to this, small and autonomous organizations were much more interested, and ultimately formed the backbone of the programme. In the first two years their enthusiasm and support was very helpful in sustaining the programme. It is important to stress that the organizational aspects of the programme were *at least* as important as the curricular ones.

In the third year, during the processes leading up to the elections to the Panchayati Raj Institutions, village polity was politicized, and we found that there was a polarization among such groups. The dynamics of this polarization spilled over to the literacy work, and we too found ourselves asking many questions about whether we should work with organizations per se, or only with organizations holding secular democratic values. The contradictions articulated as a result of the political polarization were not fully played out because the programme wound up after the completion of the third year.

Teacher aspects

In all cases where literacy classes were launched, considerable importance was attached to the teacher selection process. On our part we discussed certain minimum levels of academic and social attainment, and left the actual selection of the teacher to the group concerned. Once the teacher was nominated by common

consensus of the group, we undertook a fairly extensive training and motivational exercise with the teacher group selected. This included the theory and practice of literacy programmes, our own analysis about culture-specific learning material, specific skills in learning associated skills like origami, puppetry, as well as intensive training on the cultural media of the region. At these sessions, the style was kept informal and discursive, and lectures were avoided. After a participatory training programme conducted at intervals spread over two years, a teachers' training book called *Saksharata Sangwari* was printed.

Pedagogical and Content aspects

After the initial selection and identification exercise was over, and teacher motivation and training was taken up, we began the actual teaching activity in the villages. Our literacy centres were mostly rural. Ultimately only two out of 90 centres became functional in urban slums. The literacy classes were initially interspersed with teacher training sessions; at a somewhat later stage, the learners kept the literacy classes going even during the absence of the teacher during training activities. We did not begin the centre activity with any pre-designed learning material. On the contrary, at the initial stages, listening, leading discussions, and collection of material for building up a primer was the main activity of the teacher. The discussions were about livelihood or social issues sometimes even political issues or whatever else formed part of the day-to-day world of the learners. Once the centres became fully functional and this process of dialogue was established, we began a simultaneous process of development of literacy material. The literacy primer that we did develop, *Nawa Anjor*, was based on a distillation of the literacy centre's experience carried out during training sessions. The material in the chapters was selected from the same base. The chapters in *Nawa Anjor* went through several drafts as the material developed at the training and resource building sessions was adapted and modified after trying it out in the centres. It was finally printed in the third year of the programme.

Language aspects

This was a major part of our content development strategy, and needs to be considered separately. From the beginning, our

interaction with the village organizations, teacher training programmes, and learner interactions were all conducted in the Chhattisgarhi language. This was a dignity and social justice issue as much as a pedagogic point we were trying to make. The Chhattisgarhi language differs considerably from standard Hindi, and native speakers of Chhattisgarhi have considerable difficulty in managing to speak what is called standard Hindi, let alone read or write it. There has also been an articulation of the Chhattisgarhi identity, a sense of being the victims of uneven development in the state of Madhya Pradesh that has gathered strength throughout the 1970s, 1980s, and 1990s culminating in the formation of the state of Chhattisgarh in 2000. The primacy given to Chhattisgarhi in our programme therefore, touched a chord at a very basic level, and did a lot to secure the legitimacy of the programme.

From the point of view of classroom practice, the initial reaction to our proposal that we would conduct literacy classes in Chhattisgarhi was one of disbelief. Many of our teachers and learners equated education with learning the Hindi language, and did not think it was possible to be literate in Chhattisgarhi. A familiar reaction was that Chhattisgarhi could not be written as it had no script! The entire argument about the difference between language and script, about what constitutes a language had to be gone through several times. But finally once the learning had begun, progress was excellent because the struggle to learn a new language was eliminated from the struggle to learn to read and people really took the idea to heart.

Writing the primer however posed several problems and raised many new questions. We began to write out the chapters in the primer prior to printing it, sometime in the second year. We soon discovered that the absence of a written tradition combined with the existence of several variants of the same word, posed difficulties about making a choice of the version to select in the written text. For example, 'I go' can be spoken, and as a corollary, written, variously as *main jaathon, main jaat hon,* or *main javat hon.* In the absence of a standardized writing style, how was one to select the version to use? Chhattisgarhi also had fairly distinct regional variants, for example the language spoken around Raipur was significantly different from that spoken around

Bilaspur or Sarangarh. In some cases, the particular Chhattisgarhi word for an object could be different in the two areas, in some cases the usage was different. Tomato is *patal* around Raipur, and *bangala* south of Balod. 'Rani has gone' translated as *Rani gise* in Durg, and *Rani jaisei* in Charama. The writing of a non standardized language was an extremely difficult challenge, and in the end, the resolution was totally ad hoc, depending on the expertise and experience of the group writing the primer.

A major problem for literacy and post-literacy activity was the absence of written material in Chhattisgarhi. We had to create everything, from alphabet chart to primer to a post-literacy magazine called *Sandesiya.* Ultimately, for continuation of reading practice we had to fall back on standard texts in Hindi. While this was not a problem technically, because the Devanagari script had been mastered, it was taken by the teachers and learners as a defeat of sorts. In fact in this entire experiment, the aspect that drew the largest popular support was the language aspect. In 1997, when an evaluation was carried out by an independent study team, it was found that what learners and teachers remembered about the programme was what had been taught to them in Chhattisgarhi. The other aspects of organization and pedagogy were not remembered.

Conclusion

The programme closed down at the end of 1993. This was a time when the Total Literacy and IPCL approaches were becoming dominant in the literacy programme nation-wide. A programme like this, which was designed to achieve qualitative and value based education could not more or less by definition, aim to be total. The invitation extended by NLM officials, to take over at least a whole block was thus not accepted, as it was felt that this would bureaucratize the programme and destroy the foundations of its success so far. Our primer, developed before IPCL was adopted as *the* approach to literacy pedagogy, was based on the non-dogmatic approach that we would try out all methods including alphabet charts that became necessary in the learning process. In fact, as we have indicated above, making out alphabet charts in Chhattisgarhi became an important

participatory activity in our classes. There was a direct conflict between the approach that stressed need-based innovation and openness and one that stressed homogenization across the board. Since the latter approach was fashionable, the first lost out, and we were not able to secure resources for the continuation of the programme beyond 1993.

14

THE BGVS EXPERIENCE IN MASS LITERACY

K.K. Krishna Kumar and S.R. Sankaran

INTRODUCTION

This paper attempts to trace the evolution of the *Bharat Gyan Vigyan Samiti* (BGVS), a nation-wide voluntary organization striving for the development of a People's movement for Education and Science and also to analyze its experience with regard to the Total Literacy Campaigns (TLC) in the country. The first part of the paper discusses the origins of the organization, the second part deals with the character of its intervention in and involvement with the TLCs and related educational programmes and the third part attempts to analyze the BGVS experience with respect to TLCs and related programmes.

ORIGIN AND EVOLUTION OF THE BGVS

The concept of BGVS originated from three different sets of experiences. The first one is the vast experience of the *Kerala Sastra Sahitya Parishad* (KSSP), a People's Science movement in Kerala, which has been actively involved in the popularization of science and also in attempting to make use of science and technology as instruments of social transformation for the past 30 years. The second set of experiences relate to the *Bharat Jan Vigyan Jatha* (BJVJ-1997), a nation-wide science popularization campaign, undertaken jointly by the KSSP and 26 other organizations soon after the Bhopal gas tragedy (in 1984), and also to the All India

People's Science Movement (AIPSN) which was born out of the BJVJ process. The third set of experiences relate to the rethinking on the part of the union government regarding the literacy programmes and to the subsequent formation of the National Literacy Mission (NLM).

The intermixing of these three sets of experiences led to two significant developments in the period 1988–89. One: The KSSP decided to initiate a major literacy campaign in the Ernakulam district of Kerala, in collaboration with the district administration, and the NLM agreed to provide financial support for this programme. Two: The NLM suggested to the KSSP and other members of the AIPSN to initiate a nation-wide mass campaign on literacy. The first decision resulted in the implementation of the first Total Literacy Campaign in the country which led to what is today known as the Ernakulam Model. Discussions between the NLM and the AIPSN on the suggestion made by the NLM led to the formation of the *Bharat Gyan Vigyan Samiti* (BGVS) which undertook a nation-wide campaign called *Bharat Gyan Vigyan Jatha* (BGVJ) in the year 1990.

EVOLUTION OF THE ERNAKULAM MODEL

Ernakulam was one of the most literate districts of Kerala even when the total literacy campaign was launched in 1988. KSSP chose this district for operationalizing the idea of a volunteer based Total Literacy Campaign because of two reasons. The most important reason was the presence of a highly committed District Collector, who himself was closely associated with the KSSP for several years. The Collector and his team were willing to take up the programme in right earnest and give it top priority. The second reason was the comparatively manageable number of non-literate people in the district (around 1.5 lakh). These factors enhanced the possibility of success.

Before starting the Ernakulam campaign, there was clarity about the following fundamental principles:

(a) The campaign should be conducted in a people's movement mode and not as a governmental/departmental programme. The idea was that the people should own and conduct the programme, and the administration should carefully limit its role to facilitating this process;

(b) Efforts should be made to involve all sections of people in all aspects of the campaign through a major environment creation programme using *Kalajatha* and other media;

(c) People should be persuaded to participate in this programme voluntarily. It should be conceived as a patriotic programme and not as a paid programme; and

(d) From the very beginning the linkages between literacy and other aspects of life such as social development should be explained to the organizers, volunteers, and the society at large.

There were also areas which lacked clarity. The administrative and organizational aspects of the campaign were not very clear. The project was sanctioned in the name of KSSP by the NLM. People in the administration as well as other voluntary agencies, naturally had some identity problem in working wholeheartedly in a project sanctioned specifically to KSSP. At this point, the KSSP in consultation with the NLM and the District Collector decided to subsume its identity to a new formation called the Ernakulam District Literacy Society (DLS) under the chairmanship of the Collector. This society became the forerunner of the *Zilla Saksharata Samiti* (ZSS) concept which later became the accepted implementing agency for the TLC programmes. The DLS became an effective interface between the district administration and voluntary agencies. KSSP was able to play its crucial role in the campaign, even though it had to keep its individual banner folded.

A detailed analysis of the Ernakulam Campaign is outside the scope of the paper. However, it would be useful to summarize the main strengths and weaknesses of this campaign since it has strongly influenced the nature of TLCs and the role of BGVS in them in a large number of campaigns that followed. The main strengths of the campaign were the following:

(a) The near perfect understanding between the governmental and non-governmental agencies involved in the campaign;

(b) A credible implementation machinery involving government departments, people's committees and a slim full-time coordination structure at all levels;

(c) An effective environment creation programme which could invoke the spirit of voluntarism in the minds of a

large number of village youth, teachers, and members of
the bureaucracy;

(d) Extremely good participation of women as learners, and
also as voluntary teachers;

(e) Creative participation of the village community in different
aspects of the campaign; and

(f) Sound academic and pedagogic support provided by the
KSSP and the academic community of the district;

The success of the Ernakulam Campaign led to the initiation of
the Kerala Total Literacy Campaign and it also led the NLM to
change its strategy to a people's movement mode. Further, the
Ernakulam Campaign provided a model for the implementation of
a people's campaign for literacy.

The Ernakulam Campaign was quite successful in terms of
enrolment, retention and achievement of norms. However, the
campaign did not succeed in evolving a proper Post Literacy (PL)
programme to consolidate the gains of the literacy stage. The
absence of a long-term programme and vision was one of the
major weaknesses of the campaign. The organizational mecha-
nisms created for the implementation of a high pitched short-term
campaign was not suitable for a long-term PL programme. The
programme failed in consolidating and communitizing the immense
enthusiasm, voluntarism and creativity shown by the volunteers,
learners, and other members of the community by linking it up
with innovative programmes related to the life of the people and
the development of the district. Here and there attempts were
made by the district administration to develop linkages with some
of the governmental programmes. But these were mechanical and
could not succeed. However, from some of the recent experiences
it seems that the enthusiasm generated during the literacy
campaign never died off. Was it lying dormant? The participation
of a large number of TLC volunteers and resource persons in the
recently started People's Planning Campaign is worth a detailed
study from this angle.

THE BHARAT GYAN VIGYAN JATHA—1990

As mentioned earlier, the interaction between the NLM and the
All India People's Network led to the formation of the *Bharat
Gyan Vigyan Samiti* in the latter half of 1990. The *Samiti* was

conceived of as a broad platform of educationists, scientists, social activists, and members of the People's Science Movements in different parts of the country.

At the time of its formation, the *Samiti* had only a single point agenda. This was to organize a nation-wide mobilization programme called the *Bharat Gyan Vigyan Jatha* with the objective of preparing ground for a People's Movement for Literacy. The successful implementation of the Ernakulam Total Literacy Campaign was an added morale booster for this programme. The *Bharat Gyan Vigyan Jatha* was conducted using the medium of *kalajatha*, a unique street theatre technique which was perfected by the KSSP and other People's Science Movements through a series of campaigns. The BGVJ was organized in October 1990. The groundwork was done in more than 400 districts, and the actual *jatha* programme was undertaken in around 350 districts. Through the songs, dramas and dances the *jatha* troupes were invoking the desire among the villagers to learn about the word and the world. The *jatha* was conceived of as a tool for mobilization as well as for organization building. By the time the programme concluded, more than 40,000 villages had been covered.

The BGVJ succeeded in motivating a large number of non-literate people, volunteers, and administrators all over the country. By the time the *jatha* concluded, a number of districts came forward with the idea of taking up total literacy programmes. The success of the Ernakulam Campaign and the impact of the BGVJ thus initiated the era of TLCs in the country.

THE ROLE OF BGVS SINCE THE BGVJ

Soon after the success of the BGVJ, the NLM requested the BGVS to continue its support to the Mission in providing field level support to districts in various aspects of TLC implementation. Thus, from 1991 onwards, the BGVS started its efforts to provide support to the NLM as well as the *Zilla Saksharata Samitis* in environment creation, training, orientation programmes, material preparation and so on. Once the TLC model was found successful in a number of districts like Dakshin Kannada, Midnapore, Burdwan etc., more and more districts from different states started coming forward to take up the campaign.

By 1992, the Central Advisory Board for Education and other policy making bodies of the Government of India had accepted

TLC as the predominant mode for implementation of literacy programmes in the country. As a result, a larger amount of money was made available to the NLM for the extension of TLC programmes in different parts of the country.

At this point BGVS made earnest efforts to develop its own capabilities to provide effective field and academic support to the districts. BGVS state units were established in 17 states and 2 Union Territories. BGVS was also involved directly or indirectly in the implementation of TLCs in around 150 districts. But with the availability of a larger amount of funds at its disposal, the NLM slowly started moving towards mechanical targets. In the initial days of the campaign there was a clear understanding that the districts should do a sufficient amount of ground work by way of mobilization, training and so on, before launching the campaign. BGVS had helped the NLM in identifying certain parameters to determine whether a particular district was really ready to launch the campaign. BGVS had also warned against the mechanical adoption of the 'model'. However, slowly all these parameters were conveniently set apart and 'targets' and 'allocations' started ruling the roost.

By 1993–94, the TLC programmes had started getting more and more standardized, routinized and bureaucratized. BGVS was engaged in fighting these tendencies at different levels. The flow of grants from the NLM, in the absence of proper orientation and motivation, had led to the creation of strong vested interests. These vested interests were bent upon resisting the TLC from remaining as a people's movement. This fight between those who wanted to retain the people's movement mode of literacy campaigns and those who wanted to transform it into a standardized, bureaucratic programme is likely to continue.

Standardization of the TLC model is a major threat that the literacy programme is facing now. The implementation of the TLC programmes in the low literacy districts of the Northern States have clearly established that the Collector-centric district model of the TLC has outlived its purpose. The presence of a very large number of non-literate people, the difficulty in identifying volunteers, and the absence of capable and committed voluntary social movements, make it almost impossible to take up a whole district for implementing the campaign. Against this background, BGVS has been arguing for immediate decentralization of the

campaign. Unfortunately, as it often happens in the case of government agencies, the NLM is still clinging fast to the existing model. The only way out is to prove the feasibility of alternate models on the ground. BGVS is today committed to the creation of a series of grassroots level literacy programmes.

CHALLENGES AHEAD

Nine years of total involvement in the literacy movement has provided the BGVS with a whole lot of very rich experience. The most satisfactory aspect of this experience is the fact that a massive movement for literacy has been created in our country. More than 10 million selfless volunteers were mobilized and about half of them were women. More than 100 million learners have acquired different levels of literacy.

This has been one of the biggest movements in our country ever since the independence movement. Even in terms of money and resources, people have contributed much more to this movement than the government. It has been, with all its limitations, a very creative movement. This movement has the inner strength and capability to resist all attempts to transform it into a mere fund driven, target oriented programme.

The possibility of inter-linkages that have emerged out of these campaigns are several. BGVS has been trying to develop a movement for gender equality around the literacy programme. The *Samata Kalajatha* organized by the BGVS with this objective was very successful. The sudden increase in the demand for primary education has been another major achievement of this movement. BGVS believes that this provides us with an excellent opportunity to develop a nation-wide people's movement for primary education. BGVS has made some serious efforts to link up the literacy movement with a people's health movement. It has also developed an innovative method of participatory resource mapping which could play a crucial role in people's involvement in local area development. The People's Planning Campaign of Kerala has been modelled around the Total Literacy programme.

Even though the present state of the TLC in the country is quite disturbing, there are several silver linings among the black clouds. Several possibilities are available within the programmes of Post Literacy and Continuing Education. If appropriate interventions can be made by people's movements, a major cultural movement

incorporating a movement for the creation of a culture of reading, and a people's library movement can be developed.

Is it sunset or sunrise? The answer depends on which side of the earth you are on. This seemingly failing programme carries the seeds of immense potential. BGVS is bent upon identifying and capitalizing on them.

15

LITERACY AND LANGUAGE PEDAGOGY: A CASE STUDY OF MAHABOOBNAGAR DISTRICT

V. Swarajya Lakshmi

INTRODUCTION

The nature of literacy programmes, their planning and functioning depends upon the definition given to the concept of literacy. From the functional point of view literacy means being able to partici- pate effectively in social processes by working with written language. Literacy in this sense is the construction of an 'objecti- fied' world through the grammar of the written language (Halliday, 1996). A dominant aspect of literacy is obviously the authority of the written word which accords high status to the social contexts of writing. What is significant is the equal status granted to the written words themselves and their interaction with the social contexts of writing. In other words, the authority of the text rests ultimately on the perceived resonance of form and function. The form of the written language means both the script as well as linguistic properties. The function of written language implies the socio-cultural processes by which its value and scope of action are defined. From this point of view, to be literate is not just to have mastered the written registers but to be aware of their ideological force. Literacy pedagogy should be designed accordingly.

The aim of this paper is to point out certain shortcomings in the pedagogical aspects of literacy programmes. For this purpose, the literacy centre at Mahaboobnagar district in the state of Andhra

Pradesh was selected. The structure of the literacy programme in the district is as follows: the district was divided into four revenue divisions in addition to four municipalities, which in turn have been divided into 64 *mandals* with each *mandal* covering a group of villages. Throughout the district 55,154 literacy centres were identified. Each literacy centre was assigned to a volunteer who works as a teacher in the day school. The State Resource Centre (SRC) imparts training to district officials connected with adult literacy, who in turn train *mandal* level Resource Persons (MRPs). The MRPs train village coordinators, who in turn impart training to volunteers who actually interact with the learners in the literacy centres. The reading material prepared by the SRC is supposed to be modified according to the social context of the district.

I visited a centre in Nawabpet *mandal*, which is said to be the most active one, where specially designed tests were administered to some of the learners. Thirty words and ten sentences were chosen from their reading material for the dictation test. A passage was chosen from the book for the comprehension test. The learner was asked to read the passage first. Then questions were asked based on the content of the passage. Seventeen learners took the test out of which one answer script was not legible, so it had to be dropped. Based on the results, certain observations are made with regard to the preparation of the reading material and about the teaching methodology.

The errors found in reading, dictation and comprehension tests have been classified into three categories:

- errors occuring due to the gap between the native dialect and the text-book language,
- errors due to the complexity of the script, and
- errors due to the shortcomings in the pedagogy.

ERRORS DUE TO THE GAP BETWEEN THE NATIVE DIALECT AND THE TEXTBOOK LANGUAGE

The State Resource Centre (SRC) prepares teaching material along with a teacher's guide, *Adhyapaka Darshini*. The teaching materials and guides are expected to be modified both in content and language according to the social situation of the district. In reality, the teaching material is not prepared keeping the dialect spoken in the region in view. The language used in the primers is not always

in consonance with the dialect that is spoken in Mahaboobnagar at phonological, morphological and lexical levels. Since the dialect spoken in the coastal regions of Andhra Pradesh is considered to be the standard one, the writers have used it in the preparation of textbooks. To cite an example, speakers from the Telangana region which includes Mahaboobnagar, tend to shorten the vowels in the medial syllables.

NATIVE DIALECT	STANDARD DIALECT	GLOSS
annaDu	annaaDu	'He told me'
aDigiNDu	aDigEEDu	'He queried'

The written form is very clearly different from the spoken form. In the process of matching the written language with their spoken language, the learners showed the following patterns:

1. Interchange of long and short vowels

Out of 16 learners tested, 15 used short vowels for long vowels and vice versa in their writing. For example:

LEARNERS EXPRESSION		STANDARD FORM	GLOSS
unnam	for	unnaam	'we are here'
cestunnamu	for	ceestunnaamu	'we are doing'
maku	for	maaku	'to us'
puTnalu	for	puTnaalu	'a kind of pulses'
iittanu	for	ittanu	'I shall give'
kaalustaa	for	kalustaa	'I shall meet'

In their reading also, the learners have shortened the long vowels. In the words where the learners use short vowels in their normal dialectical speech instead of the long vowels as shown in the book, written in the standard form, they had considerable confusion with regard to the lengthening of the vowel in writing. Therefore we find instances of their using a long vowel even when the written text has a short vowel. For example:

LEARNERS EXPRESSION		STANDARD FORM	GLOSS
iittanu	for	ittanu	'I shall give'

2. Gap between the native words and those used in the textbook

To examine how lexical variation can cause problems in comprehension, a test was conducted in the literacy centres at

Mahaboobnagar. A passage was chosen from one of the primers and the learners were asked to read it. After that, questions were asked based on the content of the passage (from book 3, p. 92). The theme of the passage concerned growing castor, with which they are all familiar. When they were answering the questions they were using their own prior knowledge rather than what they had read in the book. For instance, the word is *garapa neelalu* (dry red soil) used in the lesson. Whereas the learners have used *dubba bhuumulu, nallabhuumulu, reegaDi polaalu* (different varieties of soil) instead of *garapa neelalu*. Some of them have wrongly answered the questions because they did not know the meaning of *garapa neelalu*.

They have also used the following words instead of the words written in the book.

LEARNERS EXPRESSION		STANDARD FORM	GLOSS
jaalu paTTee	for	*nilava uNDee*	'water logged land'
aayidaalu	for	*aamudaalu*	'Castor seeds'

Since the topic was familiar to them, they could understand the questions and answer the same using their native words though they were not familiar with the words used in the textbook. While they could read the unfamiliar words, they could not reproduce them in writing. Therefore they chose to use their native words in providing answers to the questions asked during the comprehension test. If the words chosen in the reading material were drawn from the dialects of their respective regions, their overall performance would probably have been better. Different variations of a language are to be given due importance in the preparation of reading material and classroom teaching.

ERRORS DUE TO THE COMPLEXITY OF THE SCRIPT

The various scripts used for orthographic representation of different Indo-Aryan and Dravidian languages in modern India are based on the ancient Indian writing system, *Brahmi*, which evolved during the third century B.C. Telugu being one of the Dravidian languages, is written in a script derived from *Brahmi* which is called Southern *Brahmi* (Ramachandra, 1979). All the vocalic and consonantal phonemes have graphemic counterparts. The alphabetic segments are combined to form syllabic units which are spatially delimited. In this process, the shapes of the vocalic

graphemes change in non-initial positions. For these vocalic graphemes, different locations are designated around the consonantal graphemes. In written syllabic configurations, the consonantal grapheme remains central, while the vocalic graphemes are placed to the right, above and below (Patel, 1987). In Telugu (unlike in Hindi), consonant clusters are represented graphically as follows:

1. The first member is always represented with primary graphs;
2. The second member, which is audible completely because of the following vowel is represented as a secondary graph. The vocalic segment which goes along with the second consonant sound is represented in script along with the primary graph.

Because of such complexity that exists in the script, the following types of errors are found when a dictation test was administered to the learners.

1. Adding epenthetic vowel /u/ to simplify the cluster. Both elements of the cluster now have a vocalic graph attached to it as in the examples given below:

LEARNERS EXPRESSION	STANDARD FORM	GLOSS
balubu	for balbu	'bulb'
బలుబు	బల్బు	
namasukaram	for namaskaaram	'greeting'
నమసుకరం	నమస్కారం	
daruja	for darja	'status'
దరుజ	దర్జా	

2. Simplifying the cluster by omitting the first member and writing the second member of the cluster as the primary graph:

LEARNERS EXPRESSION	STANDARD FORM	GLOSS	
uttarakate	for	uttarakaarte	'name of a season'
ఉత్తరకతె		ఉత్తరకార్తె	
vaadaanam	for	vaagdaanam	'promise'
వాదానం		వాగ్దానం	

paadaatam	for	*padaartham*	'material'
పాదాతం		పదార్థం	

3. Another characteristic of their writing is that they write the first member of the cluster without the secondary form of the vowel and represent the second member graphically by using the primary graph as shown in the examples below:

LEARNERS EXPRESSION		STANDARD FORM	GLOSS
vaak-daanam	for	*vaagdaanam*	'promise'
వాక్ దానం		వాగ్దానం	
namas-kaaram	for	*namaskaaram*	'greeting'
నమస్ కారం		నమస్కారం	
bhal-bu	for	*balbu*	'bulb'
భల్బు		బల్బు	

One learner has interchanged the places of consonants in a consonant cluster. For example:

LEARNERS EXPRESSION		STANDARD FORM	GLOSS
utarakaatre	in place of	*uttarakaarte*	'name of a season'
ఉతరకాత్రె		ఉత్తరకార్తె	

In view of the complexity of the script in representing the consonant clusters, the rules of the script are to be taught to the learners in order to help them write consonant clusters correctly.

ERRORS DUE TO SHORTCOMINGS IN THE PEDAGOGY

In Telugu the graph 'O' (*sunna*) is used as a cover symbol to represent homorganic nasals while it is actually realised as [m] before bilabial consonants, [η] before dentals and alveolars and [N] before retroflex consonants, [ñ] before palatals and [η] before velar stops. While testing the writing skills, several words with 'O' were also given. Out of 16 learners only two made no errors in words containing 'O'. The rest of the learners have written the words incorrectly.

Six learners have doubled the consonants following the 'O' as shown in the following examples:

LEARNERS EXPRESSION		STANDARD FORM	GLOSS
koNDDa	for	koNDa	'hill'
కొండ్డ		కొండ	
paNTTa	for	paNTa	'crop'
వంట్ట		వంట	

Eight of them used 'O' when they did not have to, as shown in the following examples:

LEARNERS EXPRESSION		STANDARD FORM	GLOSS
umni	for	unni	'wool'
ఉంని		ఉన్ని	
amyya	for	ayya	'address term'
అంయ్య		అయ్య	
amnmayya	for	hanumayya	'name of a person'
అంన్మయ్య		హానుమయ్య	
pranti	for	prati	'each one'
ప్రంతి		ప్రతి	
kancu	for	kharcu	'expenditure'
కంచు		ఖర్చు	

Other learners have dropped 'O' altogether in words such as:

LEARNERS EXPRESSION		STANDARD FORM	GLOSS
satanam	for	santaanam	'offspring'
నతనం		నంతానం	
koDa	for	koNDa	'hill'
కొడ		కొండ	
baaku	for	bEEnku	'bank'
బాకు		బ్యాంకు	
kuTubamu	for	kuTumbamu	'family'
కుటుబము		కుటుంబము	

These errors must have been committed by the learners since they were not aware of the status of 'O' in Telugu. In the teacher's guide (*Adhyapaka Darshini,* ZSS Mahaboobnagar: p. 11), the methodology to teach the word *sampaadana* 'earnings' consists of teaching the learners to sequence 'O' with the consonant /s/. The volunteer (teacher) was asked to teach the syllable, 'sam' together and the rest of the word separately. While teaching the alphabet also 'O' is always taught as the second segment following either a vowel or a consonant. In such a situation learners are generally under the impression that 'O' goes with the preceding consonant instead of the following consonant. The three kinds of errors with regard to the use of 'O' must have resulted because of this wrong pedagogic notion. In the first category of errors, the learners kept 'O' after the first graph and doubled the following consonant. The teacher while teaching a given word, split the word in such a way that the post-nasal consonant is perceived as a long consonant as evident in the '*koNDDa*—hill' example cited earlier. If the learners were to know that it is the nasal which goes with the following consonant causing it to sound more like a long consonant, they would not have doubled it. In the second category of errors, they simply used 'O' after the first consonant because they have learnt 'O' along with the consonant preceding it as, in *sam, kam* and so on. In order to make them learn the correct usage of 'O' in Telugu, the explanation given in the teacher's guide must be modified.

CONCLUSION

If the objectives of the literacy programmes are to be achieved, due attention should be paid to pedagogy. That is, adequate consideration must be given to the preparation of the reading material as well as the teaching methodology keeping in view both the structure of the language as well as the social functions of the language.

REFERENCES

Halliday, M.A.K. 1996. 'Literacy and linguistics: a functional perspective'. In Ruquiya Hasan and Geoff Williams (eds), *Literacy in Society*. London and New York: Addison Wesley Longman Ltd, pp. 339-76.

Patel, P.G. 1987. 'Acquisition of reading and spelling in a syllabo-alphabetic writing system'. *Language and Speech*. Vol. 30. Part 1, pp. 69-81.

Ramachandra, Thirumala. 1979. 'Telugu lipi pariNaamam'. In Bh. Krishnamurti (ed), *Telugu Bhasha Charitra*. Hyderabad: Andhra Pradesh Sahitya Akademi, pp. 343-56.

Teaching materials referred to in the paper:

1. *Vayoojana Vaachakam* 1, 2, 3, 'Adult education primers' prepared by *Zilla Saksharata Samiti* (ZSS), Mahaboobnagar district, A.P.
2. *Adhyapaka Darshini* 'Teacher's guide'. ZSS, Mahaboobnagar, A.P.

About the Editors and Contributors

EDITORS

Aditi Mukherjee is Professor of Linguistics at the Centre of Advanced Study in Linguistics at Osmania University, Hyderabad. She has recently completed a research project on 'Literacy in the Indian Context' at the Indian Institute of Advanced Study in Shimla. She also teaches child domestic workers in Ananda Bharati (a non-formal educational project in Hyderabad). She is a member of the school education group at Anveshi research centre for women's studies in Hyderabad.

Duggirala Vasanta is Associate Professor at the Centre of Advanced Study in Linguistics at Osmania University, Hyderabad. She has conducted research on the education of hearing impaired children, for many years. She is a member of the school education group at Anveshi research centre for women's studies in Hyderabad.

CONTRIBUTORS

Rama Kant Agnihotri is a Professor of Linguistics at Delhi University. He has had a long association with NGOs involved in literacy and primary education, in particular with Eklavya and the District Primary Education Programme (DPEP).

Sandip Bandyopadhyay was formerly a school teacher. He was associated with the Adult Education Programme under the All India Institute of Hygiene and Public Health, Calcutta. He has developed Bangla primers for street children and sex workers.

P. Devi is an activist with the NGO, *Andhra Pradesh Jana Vijnana Vedika* (APJVV).

Sonya Gupta teaches Spanish at the Central Institute of English and Foreign Languages, Hyderabad.

Lachman M. Khubchandani is the Director of Centre for Communication Studies, Pune. He has published extensively in areas related to language and education, multilingualism, Language planning and language identity among minority groups.

K.K. Krishna Kumar is an active member of the Kerala Sastra Sahitya Parishad (KSSP). He has been the secretary of the *Bharat Gyan Vigyan Samiti* (BGVS) since its inception.

Lakshmidhar Mishra is the former Director General of the National Literacy Mission (NLM). He is currently the Secretary, Ministry of Labour, Government of India.

P.K. Ravindran has been actively associated with the Kerala Sastra Sahitya Parishad (KSSP) and later with the Total Literacy Campaign (TLC) in Kerala.

Rajesh Sachdeva teaches Linguistics at the North Eastern Hill University (NEHU), Shillong. He has been involved in bilingual education, particularly in rural and tribal areas of India.

S.R. Sankaran is a retired IAS officer. He was actively involved in the literacy movement and was the President of the BGVS.

Sadhna Saxena is currently working with the National Institute of Adult Education. For more than a decade, she was associated with the Hoshangabad Science Teaching Programme (HSTP) and Kishore Bharati, an NGO working in the area of primary education, in rural Madhya Pradesh.

Ilina Sen was involved with grassroots level work in Madhya Pradesh for more than a decade. She was the coordinator of Rupantar, an NGO involved in promoting literacy as part of the mobilization of workers and women in Raipur, Chhattisgarh.

Brian V. Street is the Chairperson, Language in Education, King's College, London. He has published extensively on literacy. Some of his writings have influenced theoretical perspectives in literacy studies in the last two decades.

D. Subba Rao is the Director of the Department of Adult Education, Andhra University.

V. Swarajya Lakshmi is currently Professor of Linguistics the Centre for Advanced Study in Linguistics at Osmania University, Hyderabad.

B.S. Vasudeva Rao is a project officer with the Department of Adult and Continuing Education, Andhra University.

Yakshi, Anthra and Girijana Deepika are three NGOs involved in furthering literacy and education in Andhra Pradesh.

INDEX